Leonardo's Notebooks

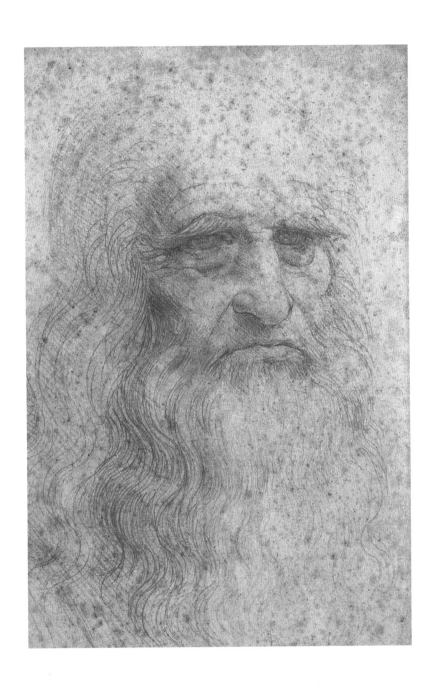

Leonardo's Notebooks

Writing and Art of the Great Master

Edited by

H. ANNA SUH

BLACK DOG
& LEVENTHAL
PUBLISHERS
NEW YORK

Black Dog & Leventhal Publishers
Hachette Book Group
1290 Avenue of the Americas
New York, NY 10104

www.blackdogandleventhal.com

Printed in China

Cover and interior design by Elizabeth Driesbach

IM

First Edition: June 2005
10 9 8 7

Black Dog & Leventhal Publishers is an imprint of Hachette Books, a division of Hachette Book Group.
The Black Dog & Leventhal Publishers name and logo are trademarks of Hachette Book Group, Inc.

The Hachette Speakers Bureau provides a wide range of authors for speaking events.
To find out more, go to www.HachetteSpeakersBureau.com or call (866) 376-6591.

The publisher is not responsible for websites (or their content) that are not owned by the publisher.

Library of Congress Cataloging-in-Publication Data available upon request.

ISBN-13: 978-1-57912-946-0

CONTENTS

INTRODUCTION

Five hundred years after the life of Leonardo da Vinci (1452–1519), this artist, inventor, and quintessential Renaissance man continues to fascinate and mystify us. In addition to his dozen or so enigmatic and beautiful paintings, Leonardo left an extensive body of sketches, notes, and writing, which resonates with a modern audience no less than they did with his admiring contemporaries.

Comprising some four thousand pieces of paper, what are loosely called Leonardo's notebooks are actually several different collections and compilations of his manuscripts. Ranging from subjects as diverse as anatomical studies to the details of grinding and mixing pigments, they offer nearly unfettered access to the great master's fertile imagination.

While Leonardo's breathtaking draftsmanship has earned him well-deserved renown, his extensive writings are less well known. They present a challenge to the modern reader, not least because of his famous "mirror" writing, which did not result from dyslexia or a paranoid need for secrecy, as often thought. It was simply his character-istically resourceful solution to the challenges faced by all left-handed writers, who tend to smear ink with their hands as they move from left to right.

In addition, the notebooks are widely scattered and, with a few notable exceptions such as the Codex Leicester and the Codex Madrid, treat a vast range of subjects, sometimes even within a single page. Combined with the language barrier and the relative scarcity of translated materials, a further exploration of Leonardo's genius can devolve into an exercise in frustration for the interested lay reader.

This volume is an attempt to overcome these difficulties. Aside from the editorial in-troductions to each section, the book is composed entirely of Leonardo's own images and writings. They are presented in an edited format, and organized into chapters and sections. Although this categorization takes some liberties with Leonardo's highly syncretic approach to his endeavors, it is intended to provide a more comfortable structure for the contemporary reader.

Largely self-taught, Leonardo had a chip on his shoulder about his lack of classical education, stating several times that he learned from empirical evidence and his (formidable) powers of observation. This autodidactic approach resulted in an unconventional approach to all his endeavors, from the depiction of landscapes to the construction of war machines. It is hoped that this book will bring the genius of Leonardo da Vinci to a new audience.

—H. Anna Suh

EDITOR'S NOTE

Numbers preceding texts refer to the illustrations that bear the same numbers. Some illustrations are pertinent to more than one text and therefore appear more than once throughout the book. Text in italics refers to exact text matches with the writing on the illustration. In cases where there are several blocks of text on a single illustration, both the original blocks of text and the translated text are marked with corresponding letters.

This book is not a scholarly work of academic research. For those interested in further readings in the vast body of scholarship on Leonardo, essential bibliographies of English, French, German, and Italian sources are provided at the end of the volume.

Part I

Beauty, Reason, and Art

Leonardo da Vinci's modern-day reputation rests largely on his artistic accomplishments. During a time of remarkable developments in the techniques and expressive possibilities of pictorial art, Leonardo's contributions were especially valuable. He combined his interests in observation and experimentation with a keen aesthetic sensibility and unparalleled artistic skills to produce a remarkable body of sketches and writings on different aspects of pictorial representation.

This section introduces his thoughts and instructions on different aspects of the painter's craft. "On Painting" presents his general ideas about the essentials of paintings, such as the role of light in compositions, guidelines for different kinds of paintings, and tips for the aspiring painter. "Human Figures" compiles Leonardo's extensive studies of proportion and balance in the depiction of the human body, considered the noblest subject of Renaissance art. "Light and Shade" consists of his meticulous studies on the interplay of bright and dark in painting.

In "Perspective and Visual Perception," Leonardo contributes to the landmark accomplishment of the Renaissance—the techniques of creating a realistic space within the picture plane. These techniques derived from a realization that as objects recede into the distance, they are proportionally reduced in size, color clarity, and detail. Leonardo was a master of these various kinds of perspective, as demonstrated by his characteristic sfumato, or smoky atmospheric effects in such paintings as the *Mona Lisa* and his *Virgin and Child with Saint Anne*.

And in "Studies and Sketches," a number of his studies, including those for his famous fresco of *The Last Supper*, appear alongside his remarkable notes for these projects. This section also includes images of allegorical and fantastic creatures, which demonstrate that Leonardo, for all his faith in the powers of observation, also had a powerfully creative imagination.

The first drawing was a simple line
drawn round the shadow of a man
cast by the sun on a wall.

I. On Painting

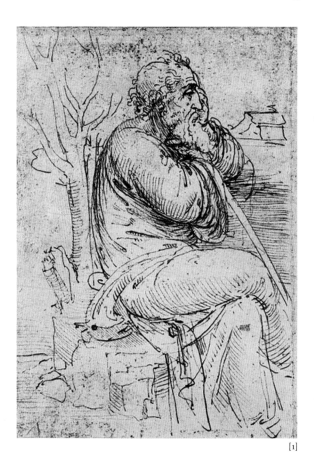

[1]

The mind of the painter must resemble a mirror, which always takes the color of the object it reflects and is completely occupied by the images of as many objects as are in front of it. Therefore you must know, O Painter! that you cannot be a good one if you are not the universal master of representing by your art every kind of form produced by nature. And this you will not know how to do

if you do not see them, and retain them in your mind. Hence as you go through the fields, turn your attention to various objects, and, in turn, look now at this thing and now at that, collecting a store of diverse facts selected and chosen from those of less value.

But do not do like some painters who, when they are wearied with exercising their fancy dismiss their work from their thoughts and take exercise in walking for relaxation, but still keep fatigue in their mind, which, though they see various objects [around them], does not apprehend them; but even when they meet friends or relations, saluted by them, although they them, take no more cognizance if they had met so much empty air.

❦

Painting surpasses all human works by the subtle considerations belonging to it. The eye, which is called the window of the soul, is the principal means by which the central sense can most completely and abundantly appreciate the infinite works of nature; and the ear is the second, which acquires dignity by hearing of the things the eye has seen. If you, historians, or poets, or mathematicians had not seen things with your eyes you could not report of them in writing.

And if you, O poet, tell a story with your pen, the painter with his brush can tell it more easily, with simpler completeness and less tedious to be understood. And if you call painting dumb poetry, the painter may call poetry blind painting. Now which is the worse defect? To be blind or dumb? Though the poet is as free as the painter in the invention of his fictions, they are not so satisfactory to men as paintings; for, though poetry is able to describe forms, actions, and places in words, the painter deals with the actual similitude of the forms, in order to represent them. Now tell me which is the nearer to the actual man; the name of man or the image of the man? The name of man differs in different countries, but his form is never changed but by death.

[2]
Though you may be able to tell or write the exact description of forms, the painter can so depict them that they will appear alive, with the shadow and light that show the expression of a face; which you cannot accomplish with the pen though it can be achieved by the brush.

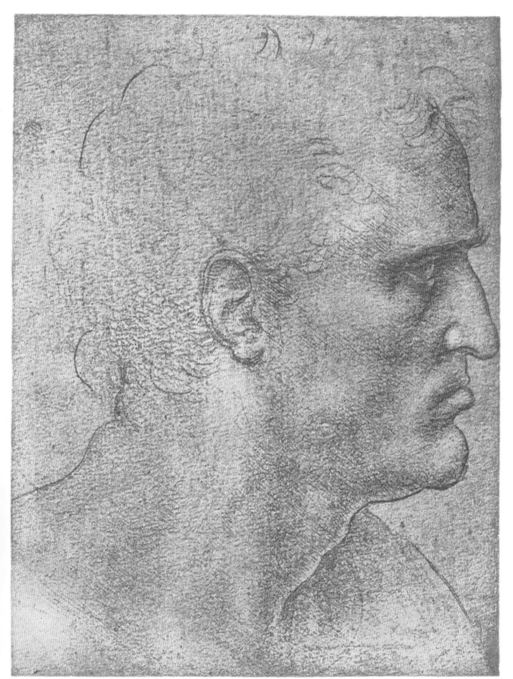

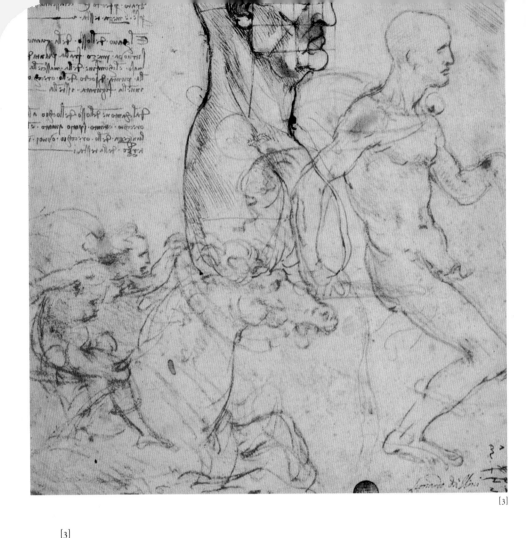

[3]

[3]
The first thing in painting is that the objects it represents should appear in relief, and that the grounds surrounding them at different distances shall appear within the vertical plane of the foreground of the picture by means of the three branches of Perspectives, which are: the diminution in the distinctness of the forms of the objects; the diminution in their magnitude; and the

diminution in their color. And of these three classes of Perspective the first results from [the structure of] the eye, while the other two are caused by the atmosphere that intervenes between the eye and the objects seen by it. The second essential in painting is appropriate action and a due variety in the figures, so that the men may not all look like brothers.

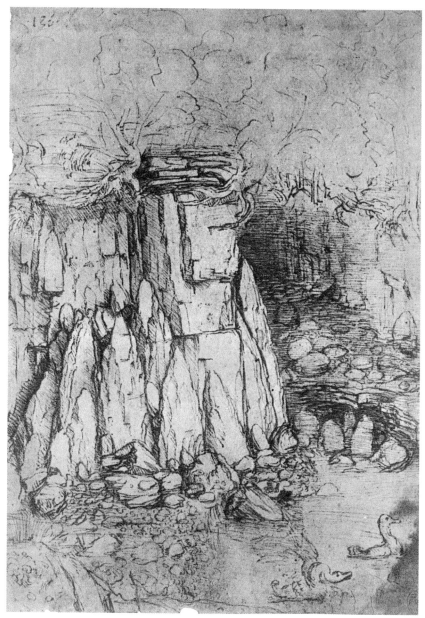

[4]

When you want to see if your picture corresponds throughout with the objects you have drawn from nature, take a mirror and look in that at the reflection of the real things, and compare the reflected image with your picture, and consider whether the subject of the two images duly corresponds in both, particularly studying the mirror. You should take the mirror for your guide—that is to say a flat mirror—because on its surface the objects appear in many respects as in a painting. Thus you see, in a painting done on a flat surface, objects that appear in relief, and in the mirror—also a flat surface—they look the same. The picture has one plane surface and the same with the mirror. The picture is intangible, insofar as that which appears round and prominent cannot be grasped in the hands; and it is the same with the mirror. And since you can see that the mirror, by means of outlines, shadows and lights, makes objects appear in relief, you, who have in your colors far stronger lights and shades than those in the mirror, can certainly, if you compose your picture well, make that also look like a natural scene reflected in a large mirror.

☾

The boundaries of bodies are the least of all things. The proposition is proved to be true, because the boundary of a thing is a surface, which is not part of the body contained within that surface; nor is it part of the air surrounding that body, but is the medium interposed between the air and the body, as is proved in its place. But the lateral boundary of this body is the line forming the boundary of the surface, which line is of invisible thickness. Wherefore, O Painter, do not surround your bodies with lines, and above all when representing objects smaller than nature; for not only will their external outlines become indistinct, but their parts will be invisible from distance.

[5]

It is indispensable to a painter to be thoroughly familiar with the limbs in all the positions and actions of which they are capable, in the nude. [Then he will] know the anatomy of the sinews, bones, muscles, and tendons so that, in their various movements and exertions, he may know which nerve or muscle is the cause of each movement and show those only as prominent and thickened, and not the others all over [the limb], as many do. [Many poor painters], to seem great draughtsmen, draw their nude figures looking like wood, devoid of grace, so that you would think you were looking at a sack of walnuts rather than the human form, or a bundle of radishes rather than the muscles of figures.

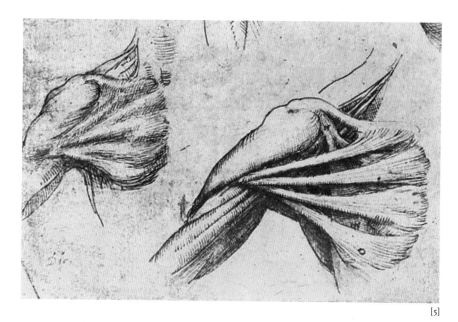

[5]

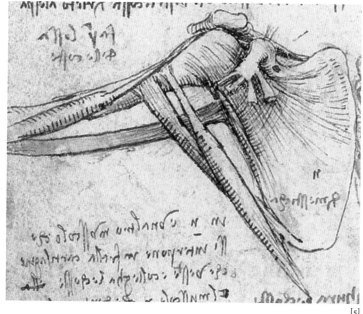

[5]

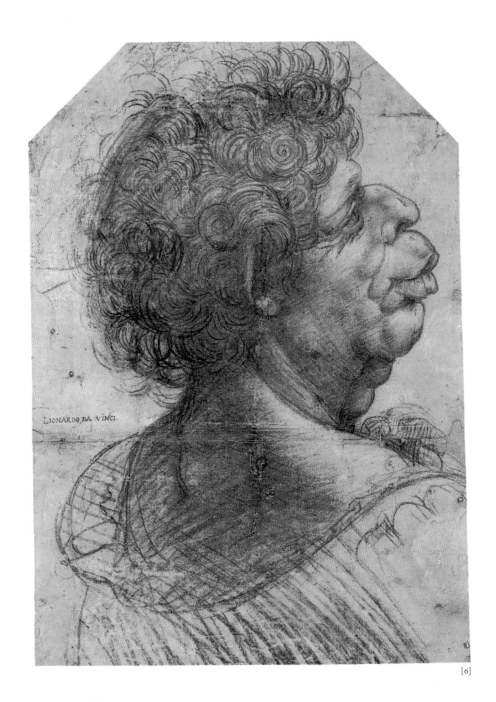

LIONARDO DA VINCI.

[6]

[6]

How Light Should Be Thrown upon Figures.

The light must be arranged in accordance with the natural conditions under which you wish to represent your figures: that is, if you represent them in the sunshine, make the shadows dark with large spaces of light, and mark their shadows and those of all the surrounding objects strongly on the ground. And if you represent them as in dull weather, give little difference of light and shade, without any shadows at their feet.

If you represent them as within doors, make a strong difference between the lights and shadows, with shadows on the ground. If the window is screened and the walls white, there will be little difference of light. If it is lighted by firelight make the high lights ruddy and strong, and the shadows dark, and those cast on the walls and on the floor will be clearly defined and the farther they are from the body the broader and longer will they be. If the light is partly from the fire and partly from the outer day, that of day will be the stronger and that of the fire almost as red as fire itself.

[6]

Above all see that the figures you paint are broadly lighted and from above, that is to say, all living persons that you paint; for you will see that all the people you meet out in the street are lighted from above, and you must know that if you saw your most intimate friend with a light [on his face] from below you would find it difficult to recognize him.

《

Lights cast from a small window give strong differences of light and shade, all the more if the room lighted by it be large, and this is not good for painting.

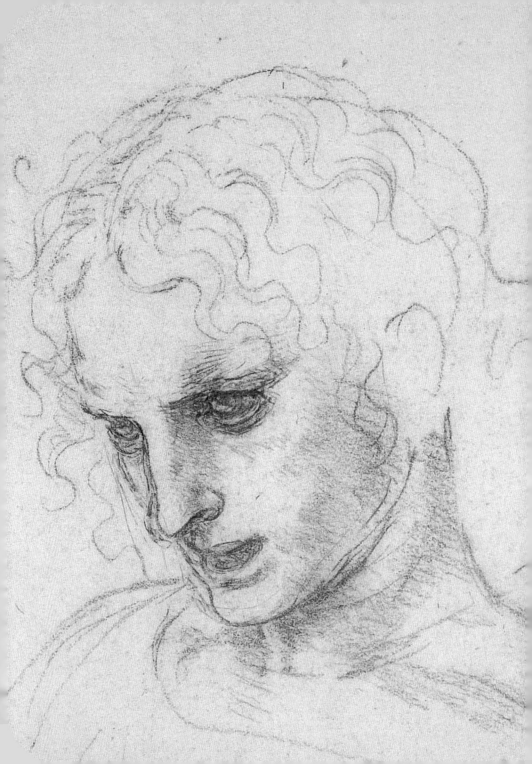

[7]

An object will display the greatest difference of light and shade when it is seen in the strongest light, as by sunlight, or, at night, by the light of a fire. But this should not be much used in painting because the works remain crude and ungraceful.

An object seen in a moderate light displays little difference in the light and shade; and this is the case towards evening or when the day is cloudy, and works then painted are tender and every kind of face becomes graceful. Thus, in every thing light gives crudeness; too little prevents our seeing. The medium is best.

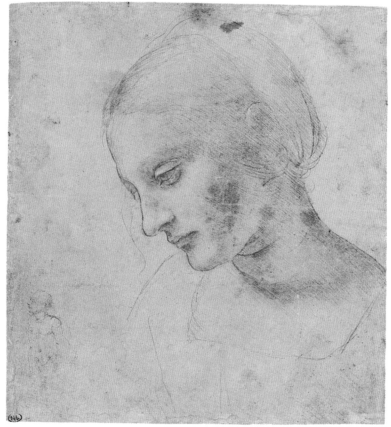

[7]

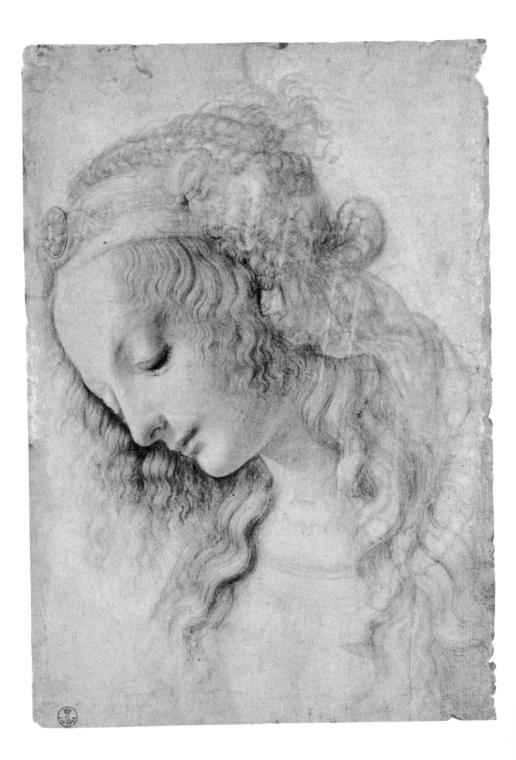

《

Make the shadow on figures corre-
spond to the light and to the color of
the body. When you draw a figure and
you wish to see whether the shadow
is the proper complement to the light,
and neither redder nor [more] yellow-
ish than in the nature of the color you
wish to represent in shade, proceed
thus. Cast a shadow with your finger
on the illuminated portion, and if the
accidental shadow that you have made
is like the natural shadow cast by your
finger on your work, well and good; and
by putting your finger nearer or farther
off, you can make darker or lighter
shadows, which you must compare with
your own [depiction].

《

The painter who draws merely by
practice and by eye, without any reason,
is like a mirror that copies everything
placed in front of it without being con-
scious of their existence.

《

To draw figures for historical pictures,
the painter must always study on the
wall on which he is to picture a story
the height of the position where he
wishes to arrange his figures; and when
drawing his studies for them from na-
ture he must place himself with his eye
as much below the object he is draw-
ing as, in the picture, it will have to be
above the eye of the spectator. Other-
wise the work will look wrong.

《

Historical pictures ought not to be
crowded and confused with too many
figures.

[8]
To compose [groups of] figures in
historical pictures, when you have well
learnt perspective and have by heart the
parts and forms of objects, you must go
about, and constantly, as you go, observe,
note, and consider the circumstances and

[8]

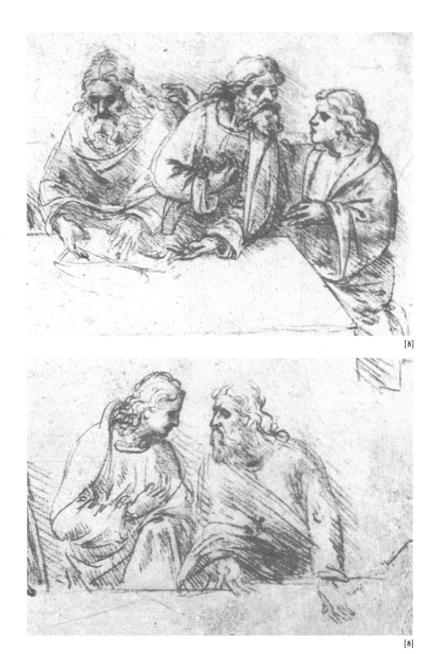

[8]

[8]

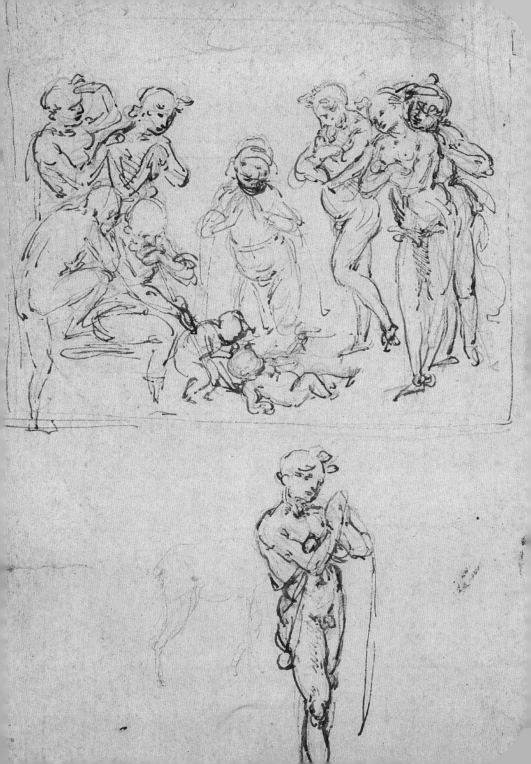

behavior of men in talking, quarreling, or laughing or fighting together; the action of the men themselves and the actions of the bystanders, who separate them or who look on.

And take a note of them with slight strokes in a little book that you should always carry with you. And it should be of tinted paper, that it may not be rubbed out, but change the old [when full] for a new one; since these things should not be rubbed out but preserved with great care; for the forms, and positions of objects are so infinite that the memory is incapable of retaining them, wherefore keep these [sketches] as your guides and masters.

[9]
Of the Way of Represeenting a Battle.

First you must represent the smoke of artillery mingling in the air with the dust and tossed up by the movement of horses and the combatants. And this mixture you must express thus: the dust, being a thing of earth, has weight; and although from its fineness it is easily tossed up and mingles with the air, it nevertheless readily falls again.

[10]
The more the combatants are in this turmoil the less will they be seen, and the less contrast will there be in their lights and shadows.

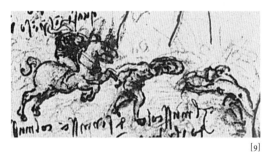

[9] [10]

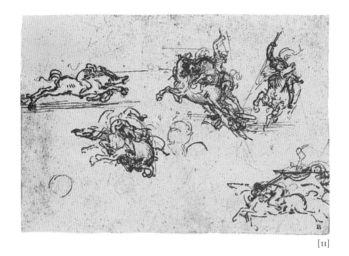

[11]

[11]
And if you introduce horses galloping outside the crowd, make the little clouds of dust distant from each other in proportion to the strides made by the horses.

[12]
The air must be full of arrows in every direction, some shooting upwards, some falling, some flying level. The balls from the guns must have a train of smoke following their flight. The figures in the foreground you must make with dust on the hair and eyebrows and on other flat places likely to retain it. The conquerors you will make rushing onwards with their hair and other light things flying on the wind, with their brows bent down.

《
And if you make anyone fallen, you must show the place where he has slipped and been dragged along the dust into blood-stained mire; and in the half-liquid earth around show the print of the tramping of men and horses who have passed that way. Make also a horse dragging the dead body of his master, and leaving behind him, in the dust and mud, the track where the body was dragged along.

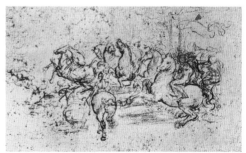

[11]

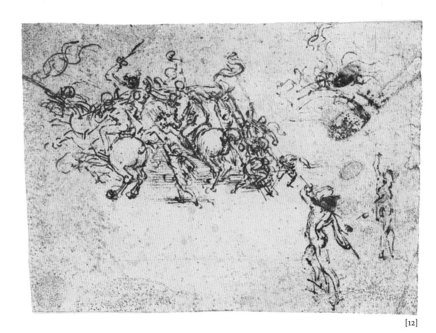

[12]

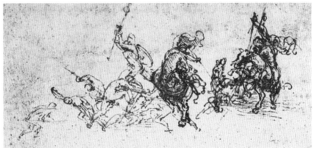

[12]

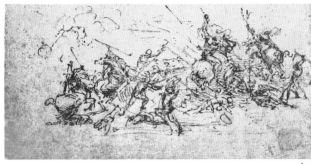

[12]

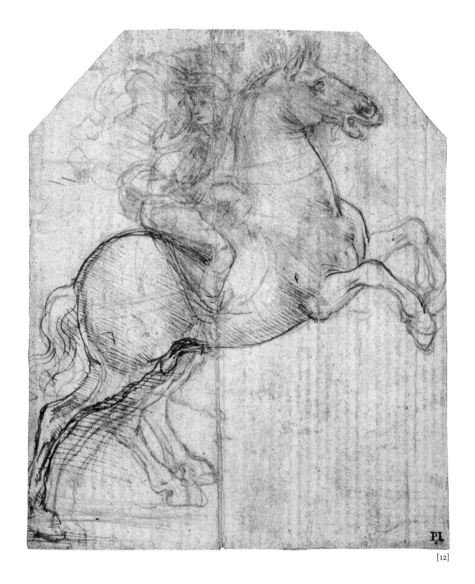

PL

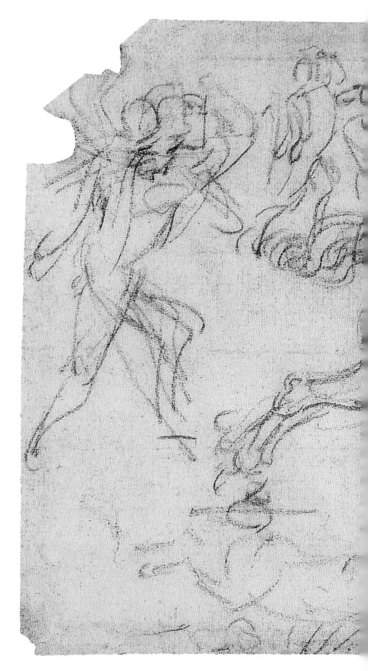

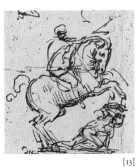

[13]

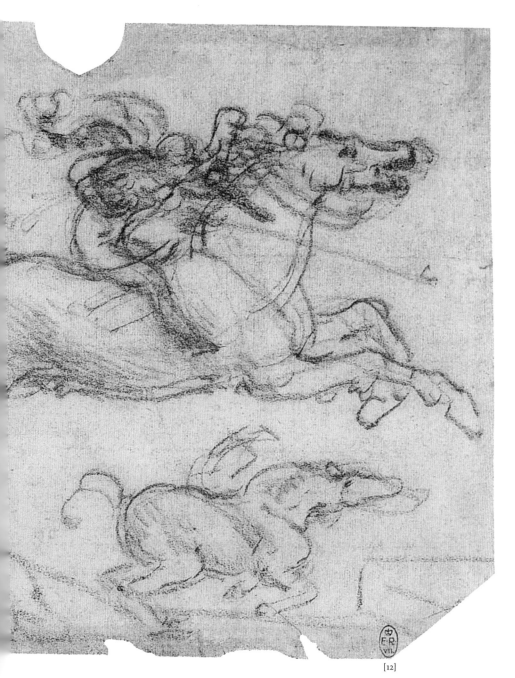

[12]

Make some one shielding his terrified eyes with one hand, the palm towards the enemy, while the other rests on the ground to support his half-raised body. Others represent shouting with their mouths open, and running away. You

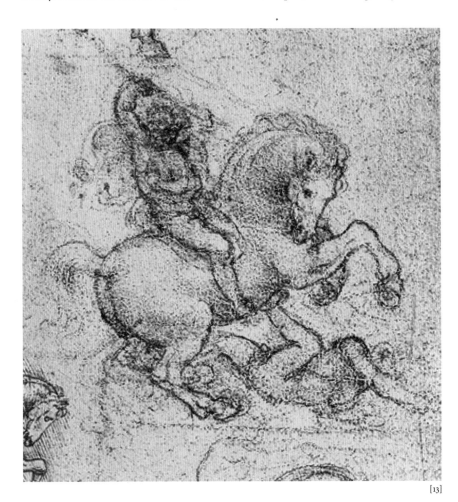

[13]

must scatter arms of all sorts among the feet of the combatants, as broken shields, lances, broken swords, and other such objects. And you must make the dead partly or entirely covered with dust, which is changed into crimson mire.

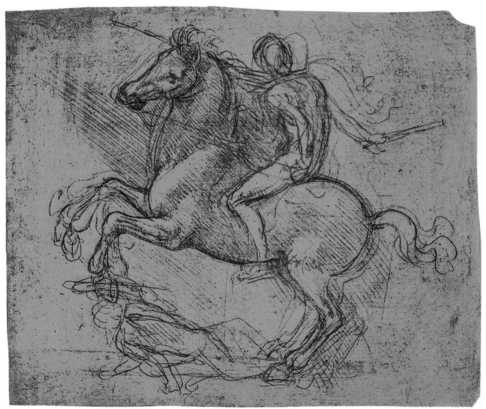

[13]

[14]
Some might be shown disarmed and beaten down by the enemy, turning upon the foe, with teeth and nails, to take an inhuman and bitter revenge. You might see some riderless horse rushing among the enemy, with his mane flying in the wind, and doing no little mischief with his heels. Some maimed warrior may be seen fallen to the earth, covering himself with his shield, while the enemy, bending over him, tries to deal him a deathstroke.

There again might be seen a number of men fallen in a heap over a dead horse.

[15]
And there may be a river into which horses are galloping, churning up the water all round them into turbulent waves of foam and water, tossed into the air and among the legs and bodies of the horses. And there must not be a level spot that is not trampled with gore.

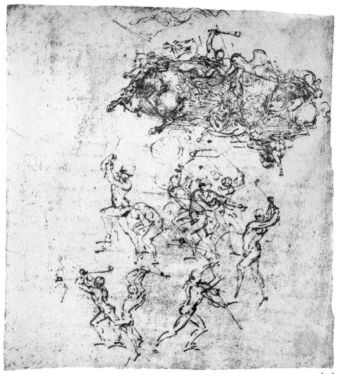

[14]

[

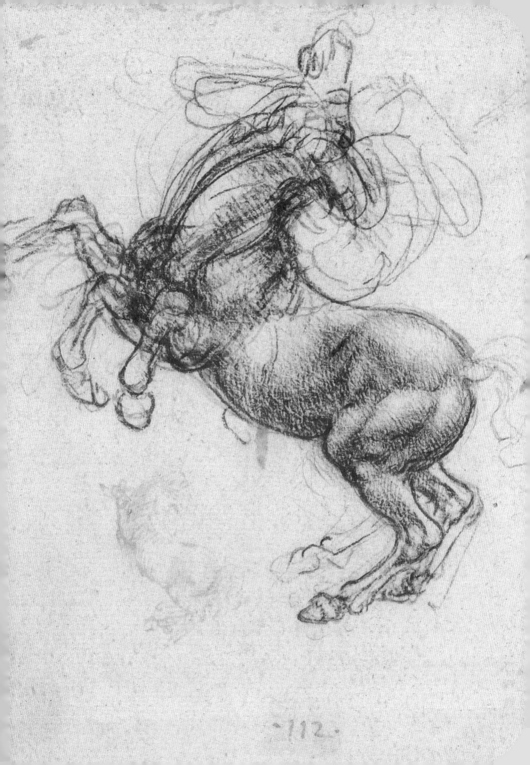

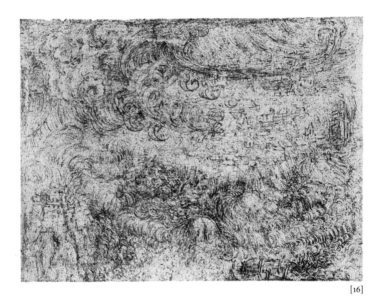

[16]
How to Present a Tempest.

If you wish to represent a tempest con-
sider and arrange well its effects as seen,
when the wind, blowing over the face of
the sea and earth, removes and carries
with it such things as are not fixed to
the general mass. And to represent the
storm accurately you must first show
the clouds scattered and torn, and flying
with the wind, accompanied by clouds
of sand blown up from the seashore,
and boughs and leaves swept along
by the strength and fury of the blast
and scattered with other light objects
through the air.

[17]
Trees and plants must be bent to the
ground, almost as if they would fol-
low the course of the gale, with their
branches twisted out of their natural
growth and their leaves tossed and
turned about.

☾

Of the men who are there, some
must have fallen to the ground and
be entangled in their garments, and
hardly to be recognized for the dust,
while those who remain standing may
be behind some tree, with their arms
round it that the wind may not tear
them away; others with their hands
over their eyes for the dust, bending to
the ground with their clothes and hair
streaming in the wind.

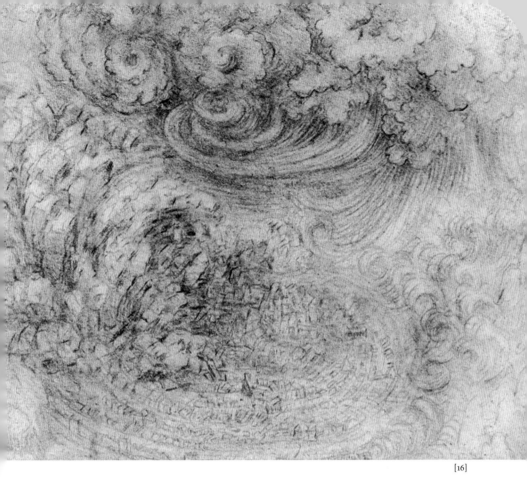

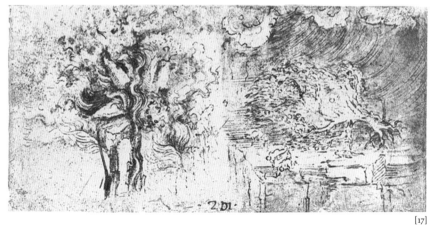

Let the sea be rough and tempestuous
and full of foam whirled among the
lofty waves, while the wind flings the
lighter spray through the stormy air, till
it resembles a dense and swathing mist.

Of the ships that are therein, some
should be shown with rent sails and the
tatters fluttering through the air, with
ropes broken and masts split and fallen.
And the ship itself lying in the trough
of the sea and wrecked by the fury of
the waves with the men shrinking and
clinging to the fragments of the vessel.

Make the clouds driven by the im-
petuosity of the wind and flung against
the lofty mountain tops, and wreathed
and torn like waves beating upon rocks;
the air itself terrible from the deep
darkness caused by the dust and fog and
heavy clouds.

[18]

The air should be darkened by the
heavy rain whose oblique descent,
driven aslant by the rush of the winds,
flies in drifts through the air. Let Eolus
with his winds be shown entangling the
trees floating uprooted, and whirling in
the huge waves.

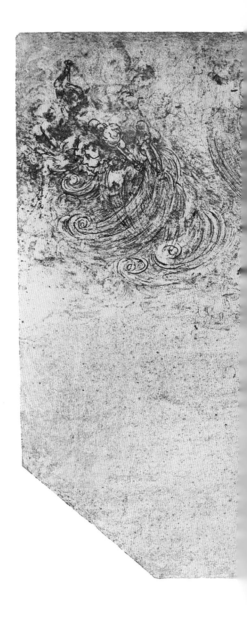

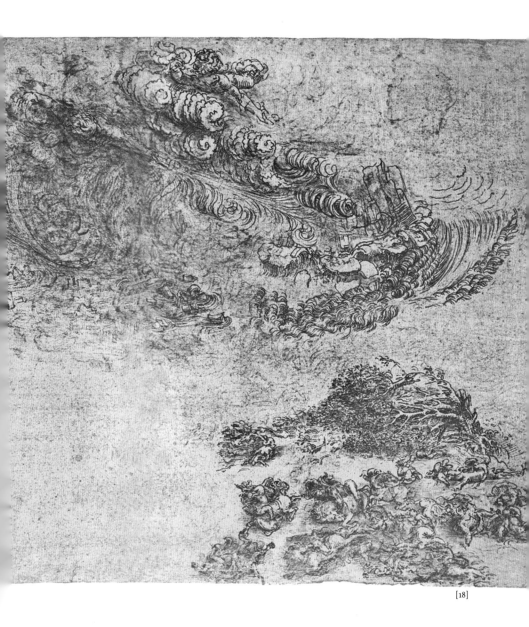

[19]

The waters that covered the fields with their waves should be in great part strewn with tables, bedsteads, boats, and various other contrivances.

[20]

All round should be seen venerable trees, uprooted and stripped by the fury of the winds. The air should be covered with dark clouds, riven by the forked flashes of the raging bolts of heaven, lighting up on all sides the depth of the gloom.

[21]

Let there be represented the summit of a rugged mountain with valleys surrounding its base, and on its sides let the surface of the soil be seen to slide, together with the small roots of the bushes, denuding great portions of the surrounding rocks. And descending ruinous from these precipices in its boisterous course, let it dash along and lay bare the twisted and gnarled roots of large trees overthrowing their roots upwards; and let the mountains, as they are scoured bare, discover the profound fissures made in them by ancient earthquakes.

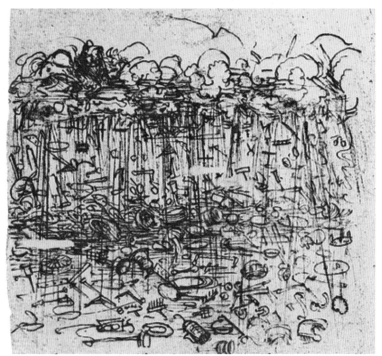

[19]

[2

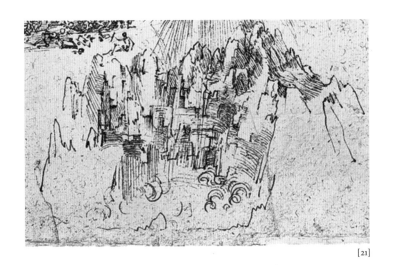

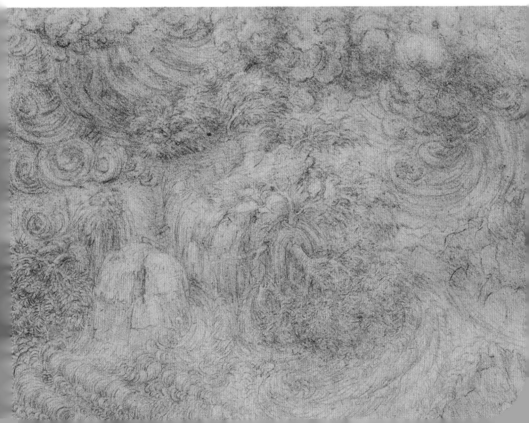

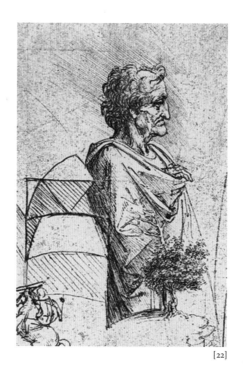

The base of the mountains may be in great part clothed and covered with ruins of shrubs, hurled down from the sides of their lofty peaks, which will be mixed with mud, roots, boughs of trees, with all sorts of leaves thrust in with the mud and earth and stones. And into the depth of some valley may have fallen the fragments of a mountain forming a shore to the swollen waters of its river; which, having already burst its banks, will rush on in monstrous waves; and the greatest will strike upon and destroy the walls of the cities and farmhouses in the valley.

❊

Darkness, wind, tempest at sea, floods of water, forests on fire, rain, bolts from heaven, earthquakes and ruins of mountains, overthrow of cities. Ships broken to pieces, beaten on rocks.

❊

We know for certain that sight is one of the most rapid actions we can perform. In an instant we see an infinite number of forms; still we only take in thoroughly one object at a time.

Supposing that you, Reader, were to glance rapidly at the whole of this written page, you would instantly per-

ceive that it was covered with various letters; but you could not, in the time, recognize what the letters were, nor what they were meant to tell. Hence you would need to see them word by word, line by line to be able to understand the letters. Again, if you wish to go to the top of a building, you must go up step by step; otherwise it will be impossible that you should reach the top.

Thus I say to you, whom nature prompts to pursue this art, if you wish to have a sound knowledge of the forms of subjects begin with the details of them, and do not go on to the second [step] till you have the first well fixed in memory and in practice. And if you do otherwise you will throw away your time, or certainly greatly prolong your studies. And remember to acquire diligence rather than rapidity.

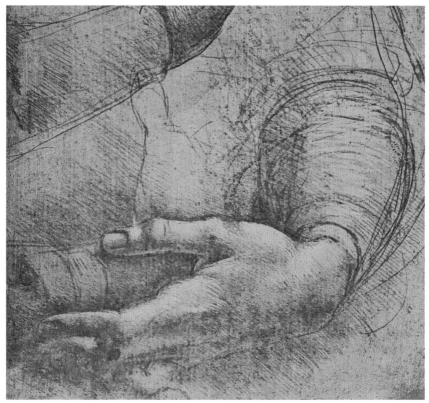

[23]

[22]

Which is best, to draw from nature or from the antique? It is better to imitate the antique than modern work. But painting declines and deteriorates from age to age, when painters have no other standard than painting already done. Hence the painter will produce pictures of small merit if he takes for his standard the pictures of others as was seen in the painters after the Romans who always imitated each other and so their art constantly declined from age to age.

But if he will study from natural objects he will bear good fruit.

[23]

Many are they who have a taste and love for drawing, but no talent; and this will be discernible in boys who are not diligent and never finish their drawings with shading.

The youth should first learn perspective, then the proportions of objects. Then he may copy from some good master, to accustom himself to fine forms. Then [he may work] from nature, to confirm by practice the rules he has learnt. Then see for a time the works of various masters. Then get the habit of putting his art into practice and work.

[24]

When, O draughtsmen, you desire to find relaxation in games you should always practice such things as may be of use in your profession, by giving your eye good practice in judging of objects. Thus, to accustom your mind to such things, let one of you draw a straight line at random on a wall, and each of you, taking a blade of grass or of straw in his hand, try to cut it to the length that the line drawn appears to him to be, standing at a distance of 10 braccia; then each one may go up to the line to measure the length he has judged it to be. And he who has come nearest with his measure to the length of the pattern is the best man, and the winner, and shall receive the prize you have settled beforehand.

Again you should take foreshortened measures: that is, take a spear, or any other cane or reed, and fix on a point at a certain distance; and let each one estimate how many times he judges that its length will go into that distance. Again, who will draw best a line one braccio long, which shall be tested by a thread. Such games give occasion to good practice for the eye, which is of the first importance in painting.

《

[Also], when you look at a wall spotted with stains, or with a mixture of stones, if you have to devise some scene, you may discover a resemblance to various landscapes, beautified with mountains,

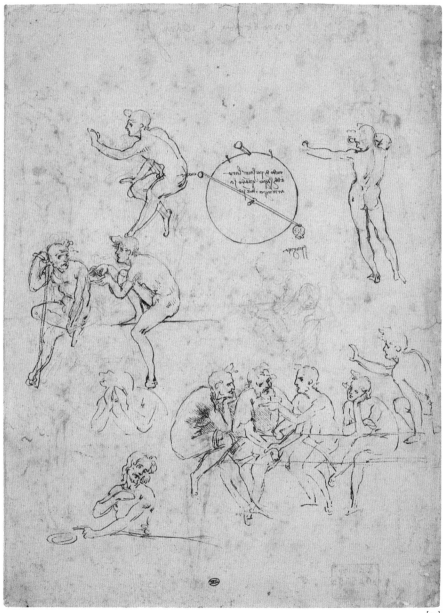

rivers, rocks, trees, plains, wide valleys, and hills in varied arrangement; or again you may see battles and figures in action; or strange faces and costumes, and an endless variety of objects, which you could reduce to complete and well drawn forms. And these appear on such walls confusedly, like the sound of bells in whose jangle you may find any name or word you choose to imagine.

《

He is a poor disciple who does not excel his master.

[25]

Nor is the painter praiseworthy who does but one thing well, as the nude figure, heads, draperies, animals, land-scapes or other such details, irrespective of other work; for there can be no mind so inept, that after devoting itself to one single thing and doing it constantly, it should fail to do it well.

[25]

《

A painter is not admirable unless he is universal. Some may distinctly assert that those persons are under a delusion who call that painter a good master who can do nothing well but a head or a figure. Certainly this is no great achievement; after studying one single thing for a life time who would not have attained some perfection in it? But, since we know that painting embraces and includes in itself every object produced by nature or resulting from the fortuitous actions of men, in short, all that the eye can see, he seems to me but a poor master who can only do a figure well.

For do you not perceive how many and various actions are performed by men only; how many different animals there are, as well as trees, plants, flow-ers, with many mountainous regions and plains, springs and rivers, cities with public and private buildings, machines, too, fit for the purposes of men, diverse costumes, decorations, and arts? And all these things ought to be regarded as of equal importance and value, by the man who can be termed a good painter.

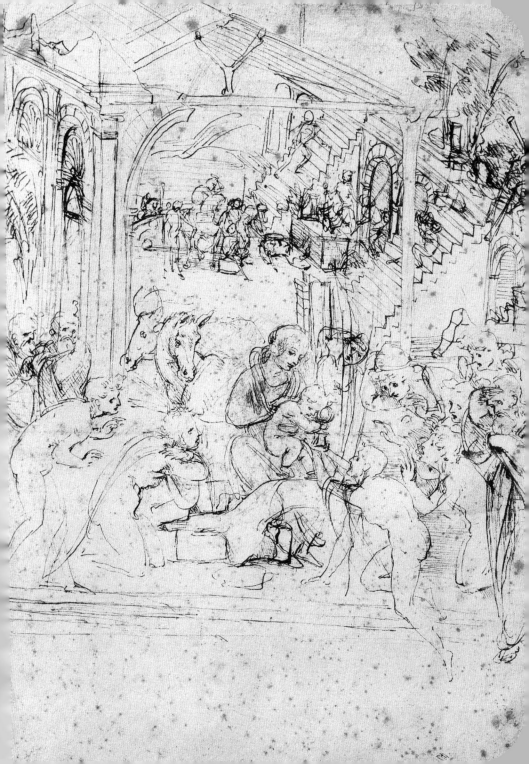

That figure is most admirable
which by its actions best expresses
the passion that animates it.

II. Human Figures

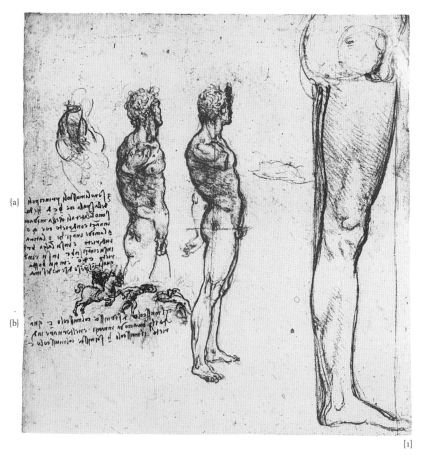

{a}

{b}

[1]

[1]
{a} *Three are the principal muscles of the shoulder, that is b c d, and two are the lateral muscles which move it forward and backward, that is a o; a moves it forward , and o pulls it back; and b c* *d raises it; a b c moves it upwards and forwards, and c d o upwards and backwards. Its own weight almost suffices to move it downwards.*

[2]

{a} *Vitruvius, the architect, says in his work on architecture that the measurements of the human body are distributed by Nature as follows: that is, that 4 fingers make 1 palm and 4 palms make 1 foot, 6 palms make 1 cubit; 4 cubits make a man's height. And 4 cubits make one pace and 24 palms make a man; and these measures he used in his build-*

ing. If you open your legs so much as to decrease your height 1/14 and spread and raise your arms till your middle fingers touch the level of the top of your head you must know that the centre of the outspread limbs will be in the navel and the space between the legs will be an equilateral triangle.

The length of a man's outspread arms is equal to his height.

{c} *From the roots of the hair to the bottom of the chin is the tenth of a man's height; from the bottom of the chin to the top of his head is one eighth of his height;*

from the top of the breast to the top of his head will be one sixth of a man. From the top of the breast to the roots of the hair will be the seventh part of the

whole man. From the nipples to the top of the head will be the fourth part of a man. The greatest width of the shoulders contains in itself the fourth part of the man. From the elbow to the tip of the hand will be the fifth part of a man; and from the elbow to the angle of the armpit will be the eighth part of the man. The whole hand will be the tenth part of the man; the beginning of the genitals marks the middle of the man. The foot is the seventh part of the man. From the sole of the foot to below the knee will be the fourth part of the man. From below the knee to the beginning of the genitals will be the fourth part of the man. The distance from the bottom of the chin to the nose and from the roots of the hair to the eyebrows is, in each case the same, and like the ear, a third of the face.

A picture or representation of human figures ought to be done in such a way that the spectator may easily recognize, by means of their attitudes, the purpose in their minds. Thus, if you have to represent a man of noble character in the act of speaking, let his gestures be such as naturally accompany good words; and, in the same way, if you wish to depict a man of a brutal nature, give him fierce movements; as with his arms flung out towards the listener, and his head and breast thrust forward beyond his feet, as if following the speaker's hands. Thus it is with a deaf and dumb person who, when he sees two men in conversation—although he is deprived of hearing—can nevertheless understand, from the attitudes and gestures of the speakers, the nature of their discussion.

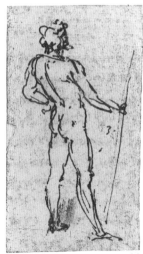

[3]

[3]

As regards the disposition of limbs in movement you will have to consider that when you wish to represent a man who, by some chance, has to turn backwards or to one side, you must not make him move his feet and all his limbs towards the side to which he turns his head. Rather must you make the action proceed by degrees and through the different joints; that is, those of the foot, the knee and the hip and the neck. And if you set him on the right leg, you must make the left knee bend inwards, and let his foot be slightly raised on the outside, and the left shoulder be somewhat lower than the right, while the nape of the neck is in a line directly over the outer ankle of the left foot. And the left shoulder will be in a perpendicular line left above the toes of the right foot. And always set your figures so that the side to which the head turns is not the side to which the breast faces, since nature for our convenience has made us with a neck that bends with ease in many directions, the eye wishing to turn to various points, the different joints. And if at any time you make a man sitting with his arms at work on something that is sideways to him, make the upper part of his body turn upon the hips.

《

A painter who has clumsy hands will paint similar hands in his works, and the same will occur with any limb, unless long study has taught him to avoid it. Therefore, O Painter, look carefully what part is most ill-favored in your own person and take particular pains to correct it in your studies. For if you are coarse, your figures will seem the same and devoid of charm; and it is the same with any part that may be good or poor in yourself; it will be shown in some degree in your figures.

[4]

{a} *In kneeling down a man will lose the fourth part of his height.*

{b} *When a man kneels down with his hands folded on his breast, the navel will mark half his height and likewise the points of the elbows.*

{c} *Half the height of a man who sits— that is from the seat to the top of the head—will be where the arms fold below the breast, and below the shoulders. The seated portion—that is from the seat to the top of the head—will be more than half the man's [whole height] by the length of the scrotum.*

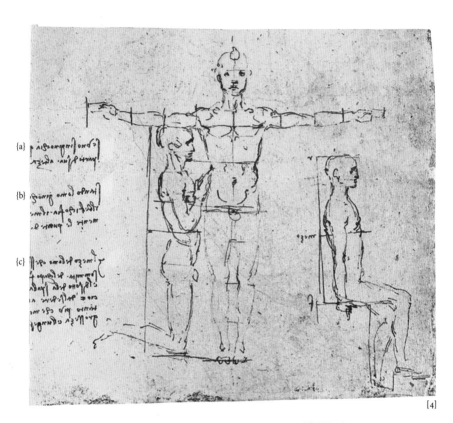

{a}

{b}

{c}

[4]

*The opening of the ear,
the joint of the shoul-
der, [and] that of the
hip and the ankle are
in perpendicular lines.*

a n is equal to m o.

The width of a man under the arms is
the same as at the hips.

Of the loins, when bent.

The loins or backbone being bent. The breasts are always lower than the shoulder blades of the back.

If the breast bone is arched the breasts are higher than the shoulder blades.

If the loins are upright the breast will always be found at the same level as the shoulder blades.

Top of the chin.

Hip.

The insertion of the middle finger. The end of the calf of the leg on the inside of the thigh.

The end of the swelling of the shin bone of the leg.

The smallest thickness of the leg goes three times into the thigh seen in front.

The distance from the attachment of one ear to the other is equal to that from the meeting of the eyebrows to the chin, and in a fine face the width of the mouth is equal to the length from the parting of the lips to the bottom of the chin.

The ear is exactly as long as the nose. The parting of the mouth seen in profile slopes to the angle of the jaw. The ear should be as high as from the bottom of the nose to the top of the eyelid. The space between the eyes is equal to the width of an eye. The ear is over the middle of the neck, when seen in profile.

a n o f are equal to the mouth.

a c and a f are equal to the space between one eye and the other.

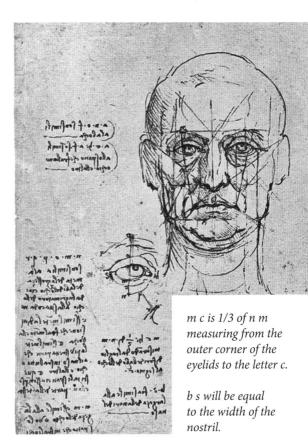

n m o p q r are equal to half the width of the eyelids, that is, from the inner corner of the eye to its outer corner; and in like manner the division between the chin and the mouth; and in the same way the narrowest part of the nose between the eyes. And these spaces, each in itself, is the 19th part of the head.

m c is 1/3 of n m measuring from the outer corner of the eyelids to the letter c.

b s will be equal to the width of the nostril.

m n is equal to the length of the eye or of the space between the eyes.

The cut or depression below the lower
lip of the mouth is halfway between the
bottom of the nose and the bottom of
the chin.

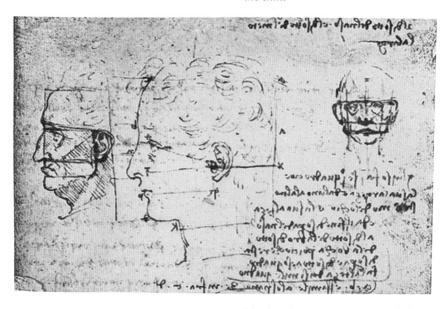

The face forms a square in itself; that
is, its width is from the outer corner
of one eye to the other, and its height
is from the very top of the nose to the
bottom of the lower lip of the mouth;
then what remains above and below
this square amounts to the height of
such another square. a b is equal to the
space between c d.

(a b) is equal to (c d).

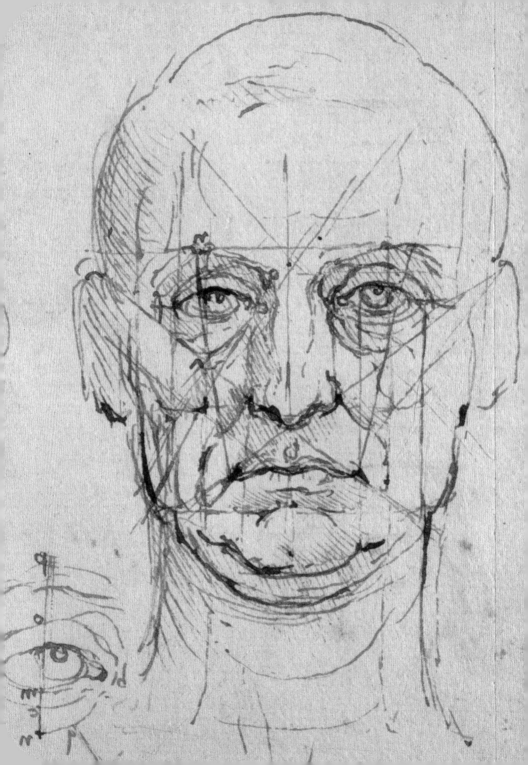

From the eyebrow to the junction of the lip with the chin, and the angle of the jaw and the upper angle where the ear joins the temple will be a perfect square. And each side by itself is half the head.

The hollow of the cheekbone occurs halfway between the tip of the nose and the top of the jawbone, which is the lower angle of the setting of the ear, in the frame here represented.

From the angle of the eye-socket to the ear is as far as the length of the ear, or the third of the face.

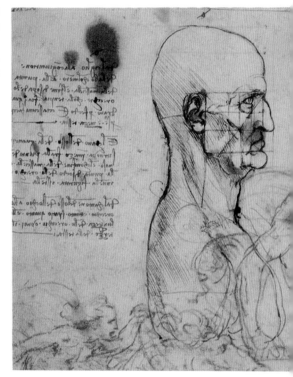

From a to b—that is to say from the roots of the hair in front to the top of the head—ought to be equal to c d—that is from the bottom of the nose to the meeting of the lips in the middle of the mouth. From the inner corner of the eye m to the top of the head a is as far as from m down to the chin s.

s c f b are all at equal distances from each other.

The space between the parting of the lips [the mouth] and the base of the nose is one-seventh of the face.

The space from the mouth to the bottom of the chin c d is the fourth part of the face and equal to the width of the mouth.

The space from the chin to the base of the nose e f is the third part of the face and equal to the length of the nose and to the forehead.

The distance from the middle of the nose to the bottom of the chin g h, is half the length of the face.

The distance from the top of the nose, where the eyebrows begin, to the bottom of the chin, i k, is two thirds of the face.

The space from the parting of the lips to the top of the chin i m, that is where the chin ends and passes into the lower lip of the mouth, is the third of the distance from the parting of the lips to the bottom of the chin and is the twelfth part of the face. From the top to the bottom of the chin m n is the sixth part of the face and is the fifty-fourth part of a man's height.

From the farthest projection of the chin to the throat o p is equal to the space between the mouth and the bottom of the chin, and a fourth of the face.

The distance from the top of the throat to the pit of the throat below q r is half the length of the face and the eighteenth part of a man's height.

From the chin to the back of the neck s t, is the same distance as between the mouth and the roots of the hair that is three-quarters of the head.

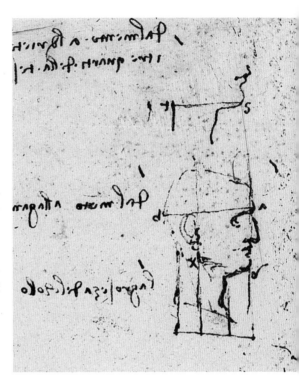

From the chin to the jawbone v x is half the head and equal to the thickness of the neck in profile.

The thickness of the head from the brow to the nape is one and one-half that of the neck.

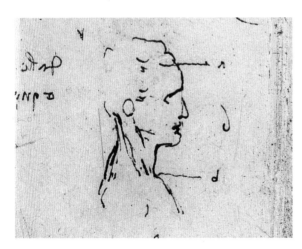

From the roots of the hair to the top of the breast a b is the sixth part of the height of a man and this measure is equal.

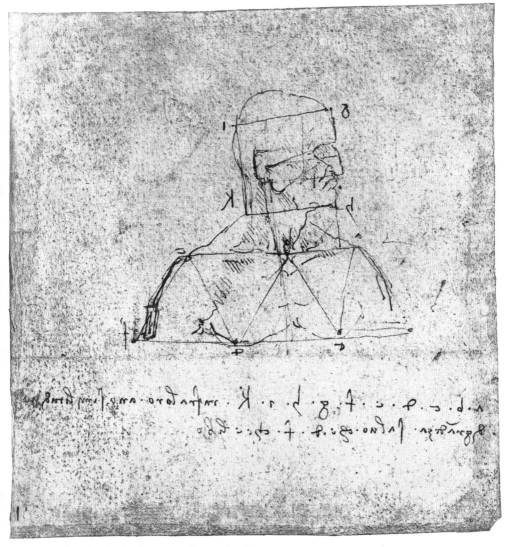

a b, c d, e f, g h, i k are equal to each other in size excepting that d f is accidental.

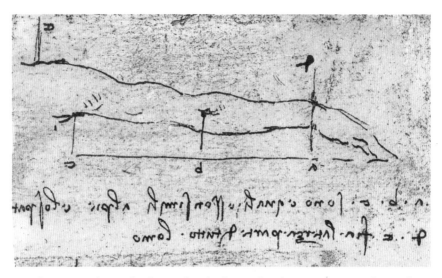

a b c are equal to each other and to the foot and to the space between the nipple and the navel. d c will be the third part of the whole man.

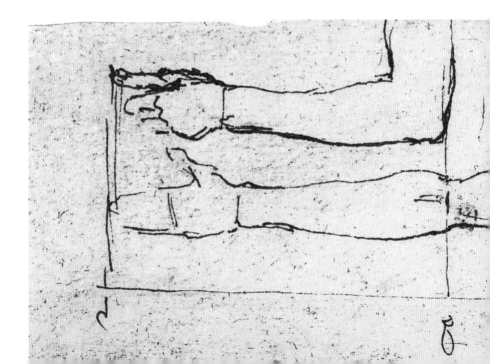

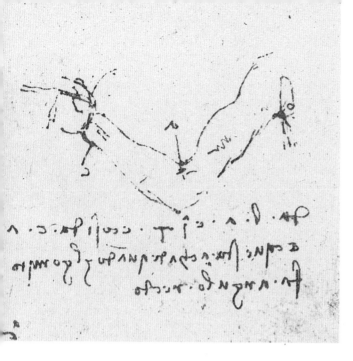

From b to a is one head, as well as from c to a and this happens when the elbow forms a right angle.

f g is the part of a man and is equal to g h and measures a cubit.

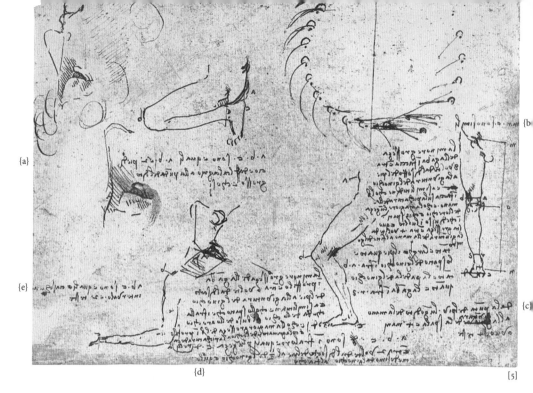

{a}

{e}

{d}

{b}

{c}

[5]

[5]

{a} *a b c are equal; a to b is two feet—that is to say measuring from the heel to the tip of the great toe.*

{b} *m n o are equal. The narrowest width of the leg seen in front goes eight times from the sole of the foot to the joint of the knee, and is the same width as the arm, seen in front at the wrist, and as the longest measure of the ear, and as the three chief divisions into which we divide the face; and this measurement goes four times from the wrist joint of the hand to the point of the elbow. The foot is as long as the space from the knee between a and b; and the patella of the knee is as long as the leg between r and s.*

{c} *From the tip of the longest finger of the hand to the shoulder joint is four hands or, if you will, four faces.*

The least thickness of the leg in profile goes six times from the sole of the foot to the knee joint and is the same width as the space between the outer corner of the eye and the opening of the ear, and as the thickest part of the arm seen in profile and between the inner corner of the eye and the insertion of the hair.

{d} *a b c [d] are all relatively of equal length. c d goes twice from the sole of the foot to the center of the knee and the same from the knee to the hip.*

{e} *a b c are equal and each interval is two heads.*

a e is equal to the palm of the hand, r
f and o g are equal to half a head and
each goes four times into a b and b c.
From c to m is a head; m n is 1/3 of a
head and goes six times into c b and
into b a;

a b loses 1/7 of its length when the
arm is extended; c b never alters;
o will always be the middle point
between a and s.

y l is the fleshy part of the arm and
measures one head; and when the
arm is bent this shrinks 2/5 of its
length; o a in bending loses 1/6 and so
does o r.

a b is 1/7 of r c.

f s will be 1/8 of r c, and each of those
two measurements is the largest of the
arm; k h is the thinnest part between
the shoulder and the elbow and it is
1/8 of the whole arm r c; o p is 1/3 of
r l; c z goes 13 times into r c.

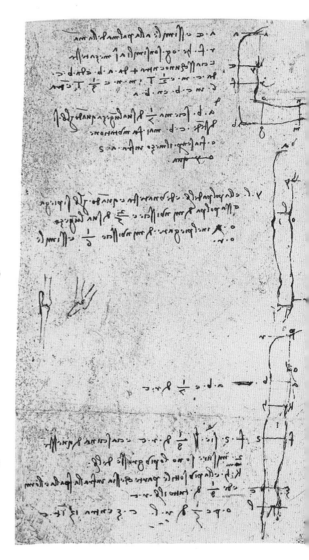

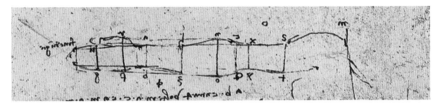

a b goes four times into a c and nine into a m.

[6]

The greatest thickness of the arm between the elbow and the hand goes six times into a m and is equal to r f. The greatest thickness of the arm between the shoulder and the elbow goes four times into c m, and is equal to h n g. The smallest thickness of the arm above the elbow x y is not the base of a square, but is equal to half the space h 3, which is found between the inner joint of the arm and the wrist joint.

The width of the wrist goes 12 times into the whole arm; that is, from the tip of the fingers to the shoulder joint; that is, three times into the hand and nine into the arm.

When the arm is bent at an angle at the elbow, it will produce some angle; the more acute the angle is, the more will the muscles within the bend be shortened; while the muscles outside will become of greater length than before. As is shown in the example; d c e will shrink considerably; and b n will be much extended.

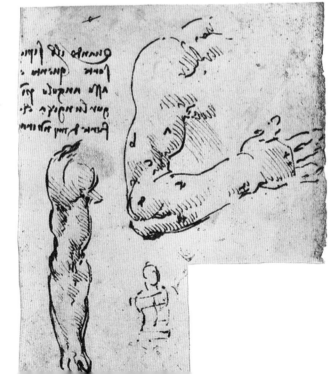

·2|2·

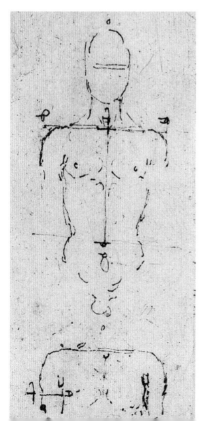

«

The principal movements of the hand are 10; that is forwards, backwards, to right and to left, in a circular motion, up or down, to close and to open, and to spread the fingers or to press them together.

«

From the outside part of one shoulder to the other is the same distance as from the top of the breast to the navel and this measure goes four times from the sole of the foot to the lower end of the nose.

The [thickness of] the arm where it springs from the shoulder in front goes six times into the space between the two outside edges of the shoulders and three times into the face, and four times into the length of the foot and three into the hand, inside or outside.

*a b c are equal to each other and to the space from
the armpit of the shoulder to the genitals and
to the distance from the tip of the fingers of the
hand to the joint of the arm, and to the half of the
breast; and you must know that c b is the third
part of the height of a man from the shoulders to
the ground; d e f are equal to each other and equal
to the greatest width of the shoulders.*

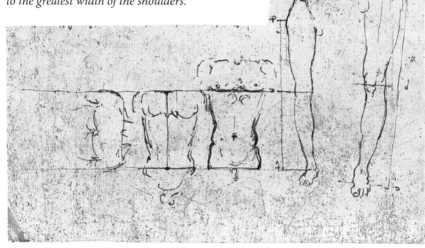

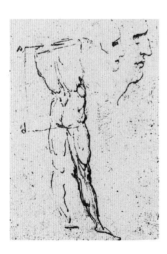

《

The torso a b in its thinnest part measures a foot; and from a to b is two feet,
which makes two squares to the seat—
its thinnest part goes 3 times into the
length, thus making three squares.

The greatest thickness of the calf of the leg is at a third of its height a b, and is a twentieth part thicker than the greatest thickness of the foot.

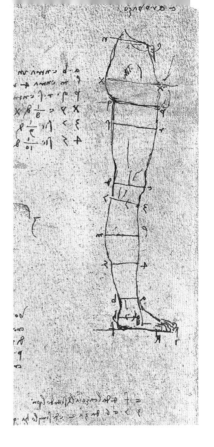

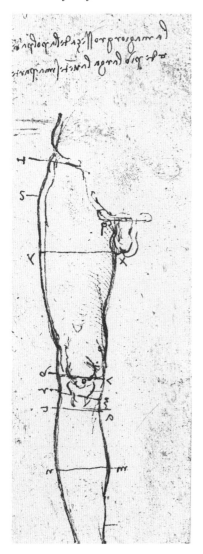

a c is the half of the head, and equal to d b and to the insertion of the five toes e f. d k diminishes one-sixth in the leg g h. g h is 1/3 of the head; m n increases one-sixth from a c and is 7/12 of the head. o p is 1/10 less than d k and is 6/17 of the head. a is at half the distance between b q, and is 1/4 of the man. r is halfway between s and b. The concavity of the knee outside r is higher than that inside a. The half of the whole height of the leg from the foot [to the point] r, is halfway between the prominence s and the ground b. v is halfway between t and b. The thickness of the thigh seen in front

is equal to the greatest width of the face, that is, 2/3 of the length from the chin to the top of the head; z r is 5/6 of 7 to v; m n is equal to 7 v and is 1/4 of r b, x y goes three times into r b, and into r s.

The sinew that guides the leg, and which is connected with the patella of the knee, feels it a greater labor to carry the man upwards, in proportion as the leg is more bent; and the muscle that acts upon the angle made by the thigh where it joins the body has less difficulty and has a less weight to lift, because it has not the [additional] weight of the thigh itself. And besides this it has stronger muscles, being those which form the buttock.

a b the tendon and ankle in raising the heel approach each other by a finger's breadth; in lowering it they separate by a finger's breadth.

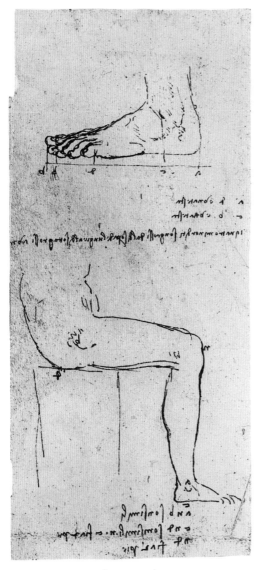

a d is a head's length.
c b is a head's length.

The four smaller toes are all equally thick from the nail at the top to the bottom, and are 1/13 of the foot.

a n b are equal;
c n d are equal; n c makes two feet;
n d makes two feet.

On painting

Of the nature of movements in man. Do not repeat the same
gestures in the limbs of men unless you are compelled by the
necessity of their action, as is shown in a b.

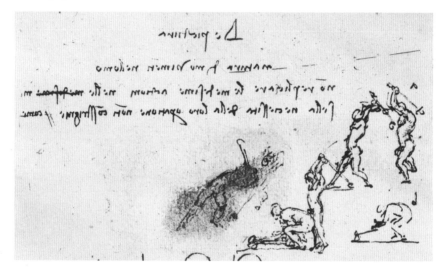

Of delivering a blow to the right or left.

[7]

When two men are at the opposite ends of a plank that is balanced, and if they are of equal weight, and if one of them wants to make a leap into the air, then his leap will be made down from his end of the plank and the man will never go up again but must remain in his place till the man at the other end dashes up the board.

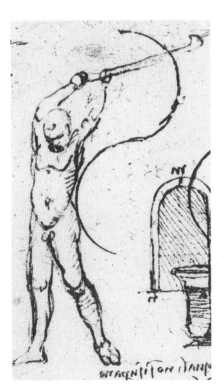

A sitting man cannot raise himself if that part of his body which is front of his axis [center of gravity] does not weigh more than that which is behind that axis [or centre] without using his arms.

A man who is mounting any slope finds that he must involuntarily throw the most weight forward, on the higher foot, rather than behind—that is, in front of the axis and not behind it. Hence a man will always, involuntarily, throw the greater weight towards the point whither he desires to move than in any other direction.

The faster a man runs, the more he leans forward towards the point he runs to and throws more weight in front of his axis than behind. A man who runs down hill throws the axis onto his heels, and one who runs up hill throws it into the points of his feet; and a man running on level ground throws it first on his heels and then on the points of his feet.

This man cannot carry his own weight unless, by drawing his body back, he balances the weight in front, in such a way as that the foot on which he stands is the center of gravity.

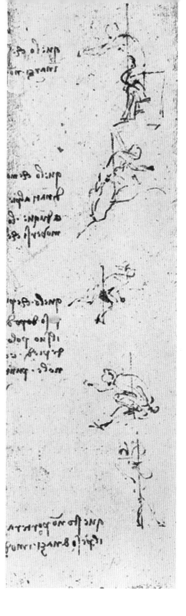

When a man wants to stop running and check the impetus, he is forced to hang back and take short quick steps.

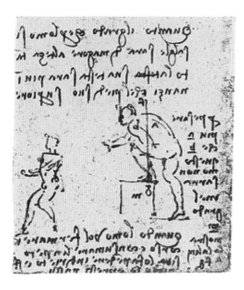

The higher the step is that a man has to mount, the farther forward will he place his head in advance of his upper foot, so as to weigh more on a than on b; this man will not be on the step m. As is shown by the line g f.

A man coming down hill takes little steps, because the weight rests upon the hinder foot, while a man mounting takes wide steps, because his weight rests on the foremost foot.

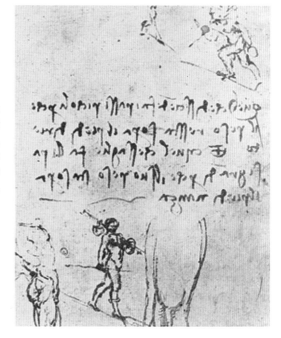

The center of gravity of a man who lifts one of his feet from the ground always rests on the center of the sole of the foot [he stands on].

A man, in going up stairs involuntarily throws so much weight forward and on the side of the upper foot as to be a counterpoise to the lower leg, so that the labor of this lower leg is limited to moving itself.

The first thing a man does in mounting steps is to relieve the leg he is about to lift of the weight of the body which was resting on that leg; and besides this, he gives to the opposite leg all the rest of the bulk of the whole man, including [the weight of] the other leg; he then raises the other leg and sets the foot upon the step to which he wishes to raise himself. Having done this he restores to the upper foot all the weight of the body and of the leg itself, and places his hand on his thigh and throws his head forward and repeats the movement towards the point of the upper foot, quickly lifting the heel of the lower one; and with this impetus he lifts himself up and at the same time extends the arm which rested on his knee; and this extension of the arm carries up the body and the head, and so straightens the spine which was curved.

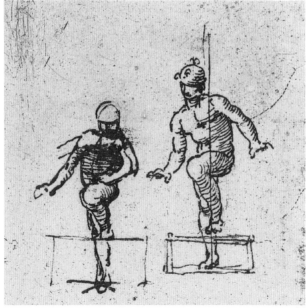

I ask the weight [pressure] of this man at every degree of motion on these steps, what weight he gives to b and to c.

Observe the perpendicular line below the centre of gravity of the man.

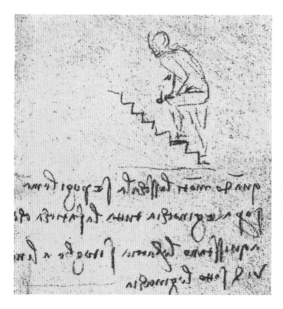

In going up stairs if you place your hands on your knees all the labor taken by the arms is removed from the sinews at the back of the knees.

Young boys have their joints just the reverse of those of men, as to size. Little children have all the joints slender and the portions between them are thick; and this happens because nothing but the skin covers the joints without any other flesh and has the character of sinew, connecting the bones like a ligature. And the fat fleshiness is laid on between one joint and the next, and between the skin and the bones.

But, since the bones are thicker at the joints than between them, as a mass grows up the flesh ceases to have that superfluity which it had, between the skin and the bones; whence the skin clings more closely to the bone and the limbs grow more slender. But since there is nothing over the joints but the cartilaginous and sinewy skin this cannot dry up, and, not drying up, cannot shrink.

Thus, and for this reason, children are slender at the joints and fat between the joints; as may be seen in the joints of the fingers, arms, and shoulders, which are slender and dimpled, while in man on the contrary all the joints of the fingers, arms, and legs are thick; and wherever children have hollows men have prominences.

Old men ought to be represented with slow and heavy movements, their legs bent at the knees, when they stand still, and their feet placed parallel and apart; bending low with the head leaning forward, and their arms but little extended.

Women must be represented in modest attitudes, their legs close together, their arms closely folded, their heads inclined and somewhat on one side.

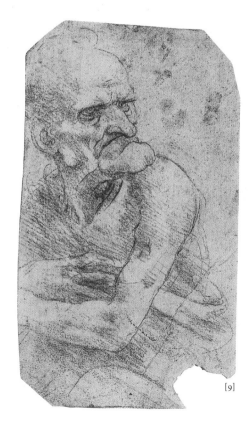

[9]

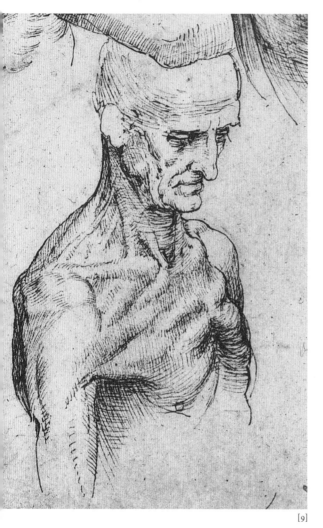

[9]

[9]

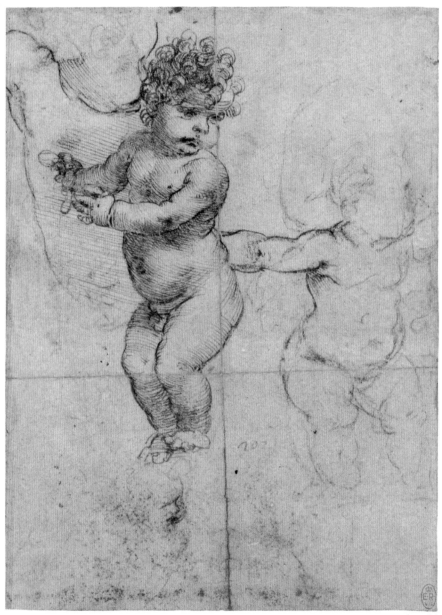

[9]

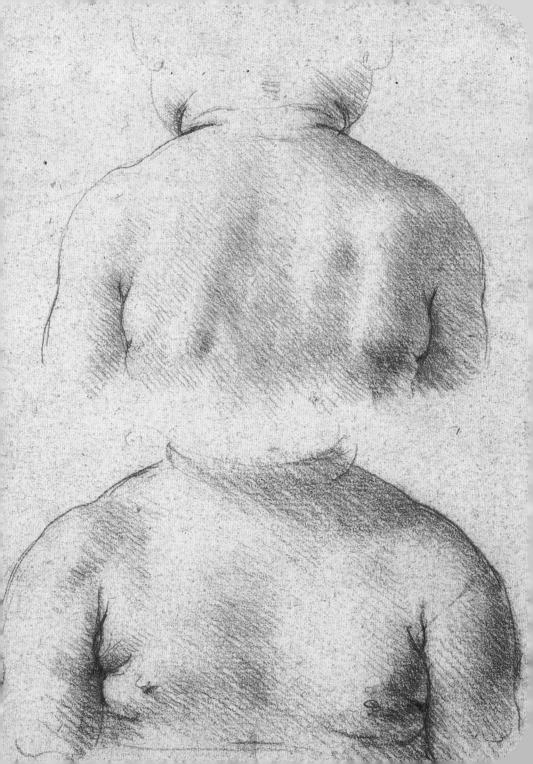

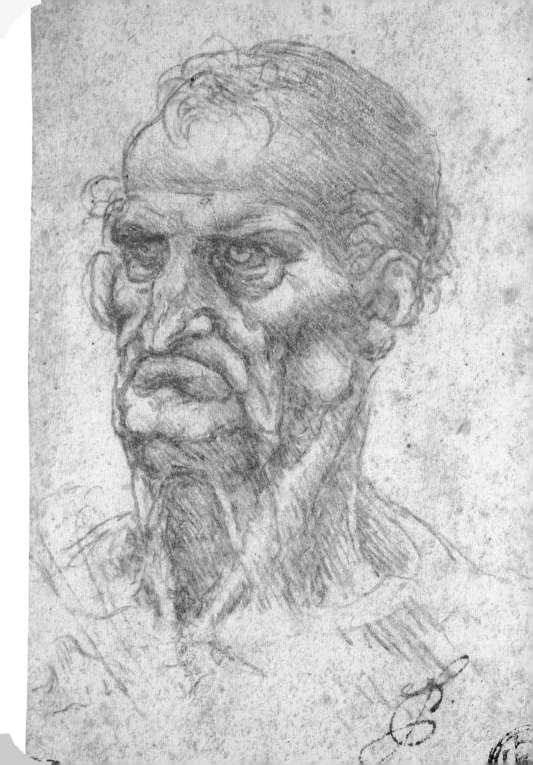

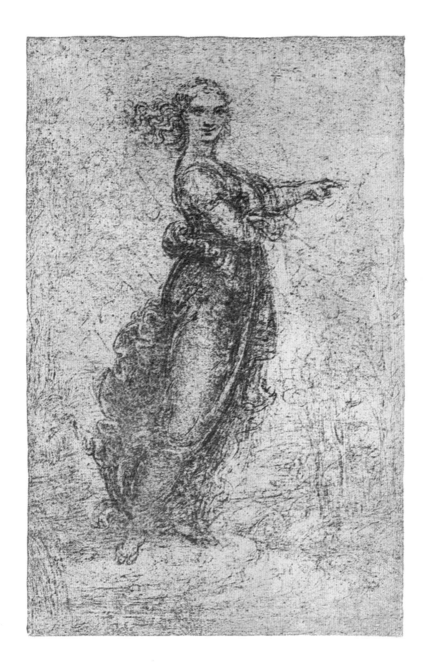

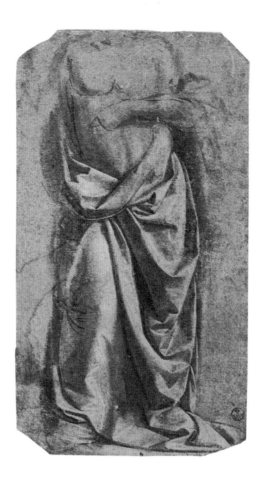

Figures dressed in a cloak should not show the shape so much as that the cloak looks as if it were next the flesh; since you surely cannot wish the cloak to be next the flesh, for you must suppose that between the flesh and the cloak there are other garments that prevent the forms of the limbs appearing distinctly through the cloak. And those limbs that you allow to be seen, you must make thicker so that the other garments may appear to be under the cloak.

Only give something of the true thickness of the limbs to a nymph or an angel, which are represented in thin draperies, pressed and clinging to the limbs of the figures by the action of the wind.

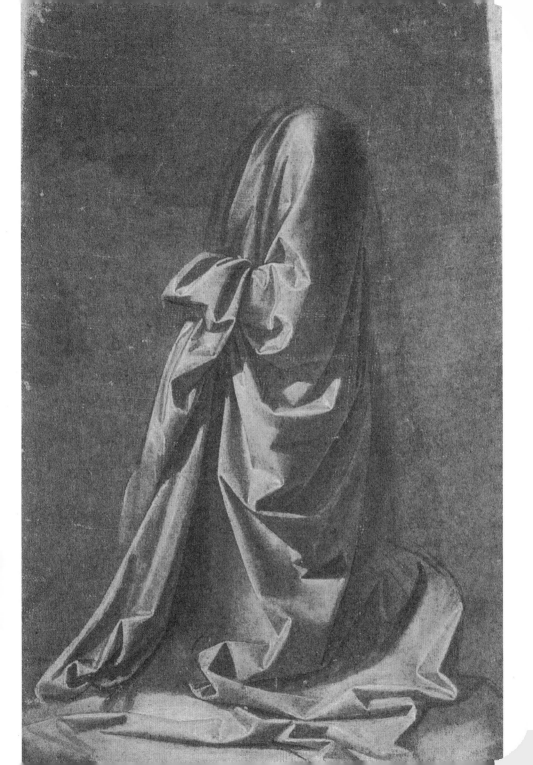

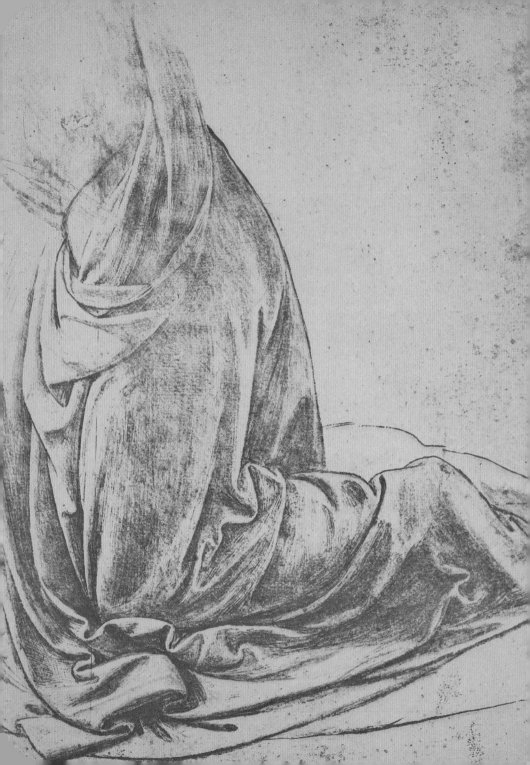

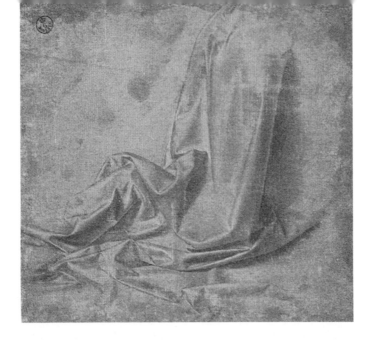

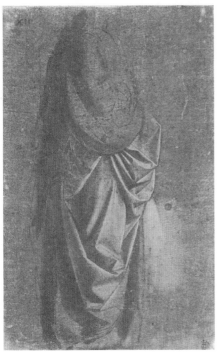

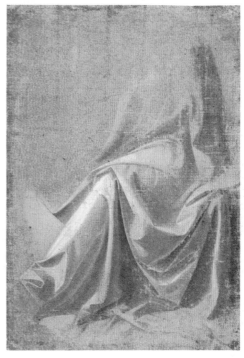

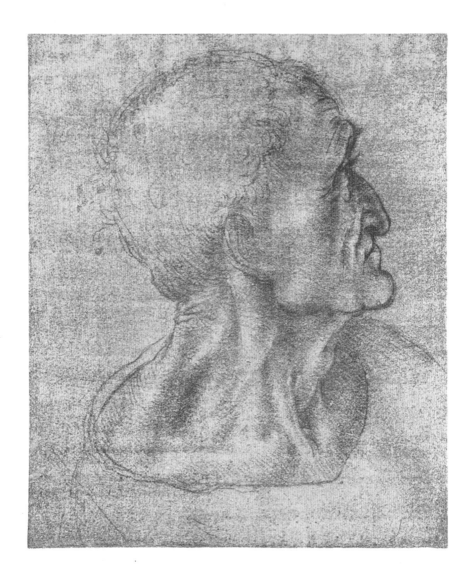

When representing a human figure or some graceful animal, be careful to avoid a wooden stiffness; that is to say, make them move with equipoise and balance so as not to look like a piece of wood; but those you want to represent as strong you must not make so, excepting in the turn of the head.

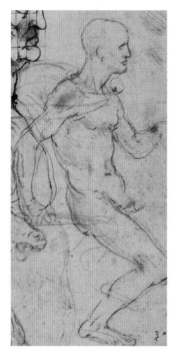 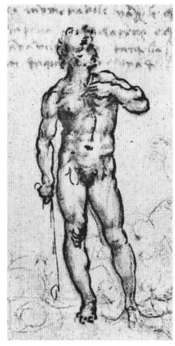

Every part of the whole must be in proportion to the whole. Thus, if a man is of a stout short figure he will be the same in all his parts: that is, with short and thick arms, wide thick hands, with short fingers with their joints of the same character, and so on with the rest. I would have the same thing understood as applying to all animals and plants; in diminishing, [the various parts] do so in due proportion to the size, as also in enlarging.

The limbs should be adapted to the body with grace and with reference to the effect that you wish the figure to produce. And if you wish to produce a figure that shall of itself look light and graceful you must make the limbs elegant and extended, and without too much display of the muscles; and those few that are needed for your purpose you must indicate softly, that is, not very prominent and without strong shadows; the limbs, and particularly the arms easy; that is, none of the limbs should be in a straight line with the adjoining parts.

And if the hips, which are the pole of a man, are by reason of his position, placed so that the right is higher than the left, make the point of the higher shoulder in a perpendicular line above the highest prominence of the hip, and let this right shoulder be lower than the left. Let the pit of the throat always be over the center of the joint of the foot on which the man is leaning. The leg that is free should have the knee lower than the other, and near the other leg.

The positions of the head and arms are endless and I shall therefore not enlarge on any rules for them. Still, let them be easy and pleasing, with various turns and twists, and the joints gracefully bent.

《

And again, remember to be very careful in giving your figures limbs, that they must appear to agree with the size of the body and likewise to the age. Thus a youth has limbs that are not very muscular not strongly veined, and the surface is delicate and round, and tender in color. In man the limbs are sinewy and muscular, while in old men the surface is wrinkled, rugged and knotty and the sinews very prominent.

O Anatomical Painter! beware lest the too strong indication of the bones, sinews and muscles be the cause of your becoming wooden in your painting, by your wish to make your nude figures display all their feeling. Therefore, in endeavoring to remedy this, look in what manner the muscles clothe or cover their bones in old or lean persons; and besides this, observe the rule as to how these same muscles fill up the spaces of the surface that extend between them, which are the muscles that never lose their prominence in any amount of fatness; and which too are the muscles of which the attachments are lost to sight in the very least plumpness. And in many cases several muscles look like one single muscle in the increase of fat; and in many cases, in growing lean or old, one single muscle divides into several muscles.

Again, do not fail [to observe] the variations in the forms of the above mentioned muscles, round and about the joints of the limbs of any animal, as caused by the diversity of the motions of each limb; for on some side of those joints the prominence of these muscles is wholly lost in the increase or diminution of the flesh of which these muscles are composed.

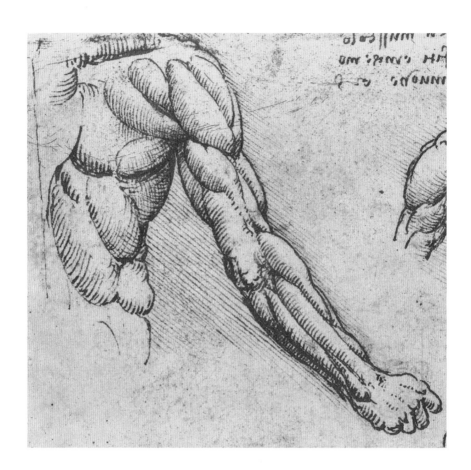

Light is the chaser away of darkness.
Shade is the obstruction of light.

III. Light and Shade

[1]
Shadow partakes of the nature of universal matter. All such matters are more powerful in their beginning and grow weaker towards the end, I say at the beginning, whatever their form or condition may be and whether their form or condition may be and whether visible or invisible. And it is not from

small beginnings that they grow to a great size in time; as it might be a great oak which has a feeble beginning from a small acorn. Yet I may say that the oak is most powerful at its beginning; that is, where it springs from the earth, which is where it is largest.

Darkness, then, is the strongest degree of shadow and light is its least. Therefore, O Painter, make your shadow darkest close to the object that casts it, and make the end of it fading into light, seeming to have no end.

☾

Shadow is the absence of light, merely the obstruction of the luminous rays by an opaque body. Shadow is of the nature of darkness. Light [on an object] is of the nature of a luminous body; one conceals and the other reveals. They are always associated and inseparable from all objects. But shadow is a more powerful agent than light, for it can impede and entirely deprive bodies of their light, while light can never entirely expel shadow from a body, that is, from an opaque body.

☾

Every visible body is surrounded by light and shade.

☾

An object represented in white and black will display stronger relief than in any other way; hence I would remind you, O Painter! To dress your figures in the lightest colors you can, since, if you put them in dark colors, they will be in too slight relief and inconspicuous from a distance. And the reason is that shadows of all objects are dark. And if you make a dress, there is little variety in the lights and shadows, while in light colors there are many grades.

If the sun is in the East and you look towards the West you will see every thing in full light and totally without shadow, because you see them from the same side as the sun.

And if you look towards the South or North you will see all objects in light and shade, because you see both the side towards the sun and the side away from it; and if you look towards the coming of the sun all objects will show you their shaded side, because on that side the sun cannot fall upon them.

☾

The image of the sun will show itself brighter in the small waves than in the large ones. This happens because the reflections or images of the sun occur more frequently in the small waves than in the large ones, and the more numerous brightnesses give a greater light than the lesser number.

The waves that intersect after the manner of the scales of a fir cone reflect the image of the sun with the greatest splendor; and this occurs because there are as many images as there are ridges of the waves seen by the sun, and the shadows that intervene between these waves are small and not very dark; and the radiance of so many reflections is blended together in the image that proceeds from them to the eye, in such a way that these shadows are imperceptible.

[3]
{a} *When the eye is placed between the luminous body and the objects illuminated by it, these objects will be seen without any shadow.*

☾

The conditions of shadow and light [as seen] by the eye are three. Of these the first is when the eye and the light are on the same side of the object seen; the second is when the eye is in front of the object and the light is behind it. The third is when the eye is in front of the object and the light is on one side,

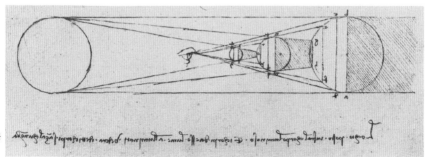

{a}

in such a way as that a line drawn from the object to the eye and one from the object to the light should form a right angle where they meet.

☾

If the eye, when [out of doors] in the luminous atmosphere, sees a place in shadow, this will look very much darker than it really is. This happens only because the eye when out in the air contracts the pupil in proportion as the atmosphere reflected in it is more luminous. And the more the pupil contracts, the less luminous do the objects appear that it sees. But as soon as the eye enters into a shady place the darkness of the shadow suddenly seems to diminish. This occurs because the greater the darkness into which the pupil goes, the more its size increases, and this increase makes the darkness seem less.

☾

The eye that turns from a white object in the light of the sun and goes into a less fully lighted place will see everything as dark. And this happens either because the pupils of the eyes that have rested on this brilliantly lighted white object have contracted so much that, given at first a certain extent of surface, they will have lost more than 3/4 of their size; and, lacking in size, they are also deficient in [seeing] power.

Though you might say to me: A little bird [then] coming down would see comparatively little, and from the smallness of his pupils the white might seem black! To this I should reply that here we must have regard to the proportion of the mass of that portion of the brain that is given up to the sense of sight and to nothing else.

Or—to return—this pupil in Man dilates and contracts according to the brightness or darkness of [surrounding] objects; and since it takes some time to dilate and contract, it cannot see immediately on going out of the light and into the shade, nor, in the same way, out of the shade into the light, and this very thing has already deceived me in painting an eye, and from that I learnt it.

[4]
The first of the lights with which opaque bodies are illumined is called particular, and it is the sun or other light from a window or flame. The second is universal, as is seen in cloudy weather or in mist or the like. The third is the composite, that is, when the sun in the evening or the morning is entirely below the horizon.

Among bodies in varying degrees of darkness deprived of the same light, there will be the same proportion between their shadows as there is between their natural degrees of darkness, and you have to understand the same of their lights.

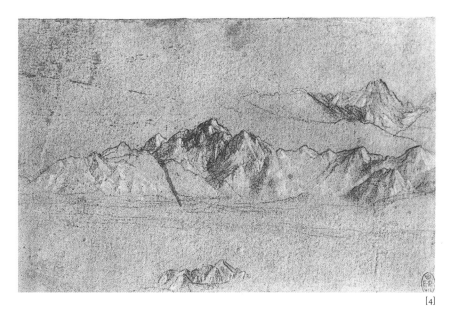

[4]

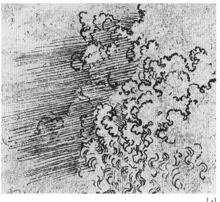

[4]

☾

Primary light is that which falls on objects and causes light and shade. And derived lights are those portions of a body which are illuminated by the primary light.

☾

The lights that may illuminate opaque bodies are of four kinds. These are: diffused light as that of the atmosphere, within our horizon. And direct, as that of the sun, or of a window or door or

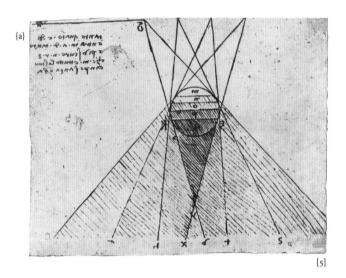

[5]

other opening. The third is reflected light; and there is a fourth which is that which passes through [semi] transparent bodies, as linen or paper or the like, but not transparent like glass, or crystal, or other diaphanous bodies, which produce the same effect as though nothing intervened between the shaded object and the light that falls upon it.

[5]

That portion of a body in light and shade will be least luminous which is seen under the least amount of light. That part of the object which is marked m is in the highest light because it faces the window a d by the line a f; n is in the second grade because the light b d strikes it by the line b e; o is in the third grade, as the light falls on it from c d by the line c h; p is the lowest light but one

as c d falls on it by the line d v; q is the deepest shadow for no light falls on it from any part of the window.

{a} *In proportion as c d goes into a d so will n r s be darker than m, and all the rest is space without shadow.*

❨

That portion of an illuminated object which is nearest to the source of light will be the most strongly illuminated. Every perfectly round body, when surrounded by light and shade, will seem to have one of its sides greater than the other, in proportion as the one is more lighted than the other.

❨

That place will be most luminous from which the greatest number of luminous rays are reflected.

[6]

{a} *The Proof and Reason Why among the Illuminated Parts Certain Portions Are in Higher Light than Others:*

{b} *[This] shows how light from any side converges to one point.*

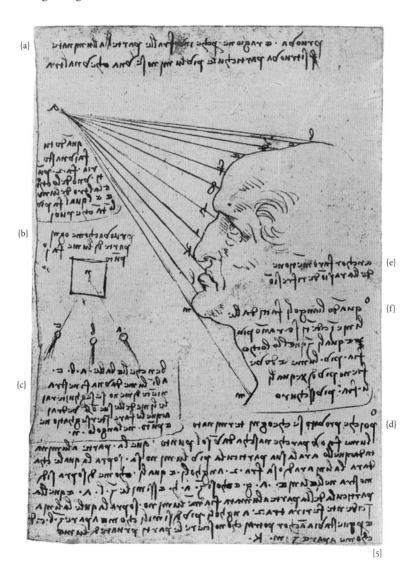

[5]

{c} *Although the balls a b c are lighted from one window, nevertheless, if you follow the lines of their shadows you will see they intersect at a point forming the angle n.*

{d} *Since it is proved that every definite light is, or seems to be, derived from one single point, the side illuminated by it will have its highest light on the portion where the line of radiance falls perpendicularly; as is shown above in the lines a g, and also in a h and in l a; and that portion of the illuminated side will be least luminous where the line of incidence strikes it between two more dissimilar angles, as is seen at b c d. And by this means you may also know which parts are deprived of light, as is seen at m k.*

{e} *I will make further mention of the reason of reflections.*

{f} *Where the angles made by the lines of incidence are most equal there will be the highest light, and where they are most unequal it will be darkest.*

[7]
The light which falls on a shaded body at the acutest angle receives the highest light, and the darkest portion is that which receives it at an obtuse angle and both the light and the shadow form pyramids. The angle c receives the highest grade of light because it is directly in front of the window a b and the whole horizon of the sky m x. The angle a differs but little from c because the angles which divide it are not so unequal as those below, and only that portion of the horizon is intercepted which lies between y and x. Although it gains as much on the other side, its line is nevertheless not very strong because one angle is smaller than its fellow.

The angles e i will have less light because they do not see much of the light m s and the light v x and their angles are very unequal. The angle k and the angle f are each placed between very unequal angles and therefore have but little light, because at k it has only the light p t, and at f only t q; o g is the lowest grade of light because this part has no light at all from the sky; and thence come the lines which will reconstruct a pyramid that is, the counterpart of the pyramid c; and this pyramid l is in the first grade of shadow; for this too is placed between equal angles directly opposite to each other on either side of a straight line that passes through the center of the body and goes to the center of the light.

The several luminous images cast within the frame of the window at the points a and b make a light that surrounds the derived shadow cast by the solid body at the points 4 and 6. The shaded images increase from o g and end at 7 and 8.

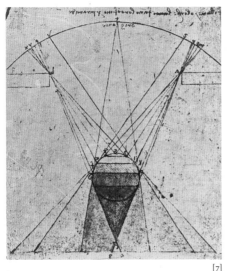

[7]

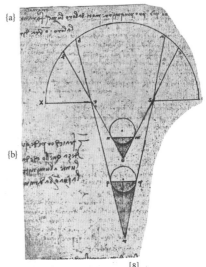

{a}

{b}

[8]

{a} *All bodies, in proportion as they are nearer to, or farther from, the source of light, will produce longer or shorter derived shadows.*

{b} *Among bodies of equal size, that one which is illuminated by the largest light will have the shortest shadow.*

Experiment confirms this proposition. Thus the body m n is surrounded by a larger amount of light than the body p q, as is shown above. Let us say that v c a b d x is the sky, the source of light, and that s t is a window by which the luminous rays enter, and so m n and p q are bodies in light and shade as exposed to this light.

[The body] m n will have a small derived shadow, because its original shadow will be small and the derivative light will be large, again, because the original light c d will be large and p q will have more derived shadow, because its original shadow will be larger, and its derived light will be smaller than that of the body m n because that portion of the hemisphere a b which illuminates it is smaller than the hemisphere c d which illuminates the body m n.

❦

When there are several bodies of equal size which are equally distant from the eye, that will appear the smaller which is against a more luminous background.

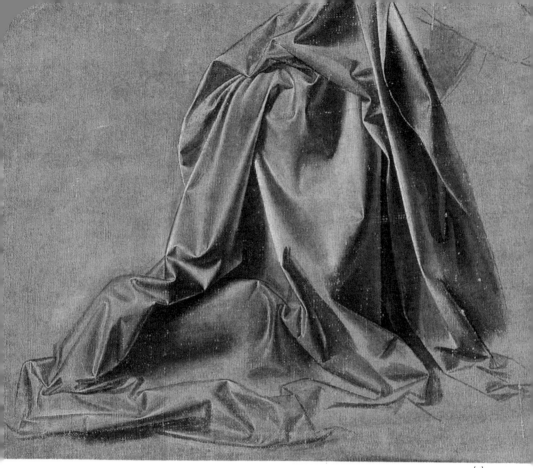

[9]
You will note in drawing how among shadows some are indistinguishable in gradation and form; and these spherical surfaces have as many different degrees of light and shadow as there are varieties of brightness and darkness reflected from the objects round them.

That part of an opaque body will be more in shadow or more in light which is nearer to the dark body that shades it, or to the luminous body that gives it light.

The surface of every opaque body partakes of the color of its object, but the impression is greater or less in proportion as this object is nearer or more remote, and of greater or less power.

Objects seen between light and shadow will appear in greater relief than those that are in the light or in the shadow.

The smaller the light that falls upon an object the more shadow it will display. And the light will illuminate a smaller portion of the object in proportion as it is nearer to it; and conversely, a larger extent of it in proportion as it is farther off.

A light that is smaller than the object on which it falls will light up a smaller extent of it in proportion as it is nearer to it, and the converse, as it is farther from it. But when the light is larger than the object illuminated it will light a larger extent of the object in proportion as it is nearer and the converse when they are farther apart.

❨

Darkness is the absence of light.

Shadow is the diminution of light.

A primary shadow is that which is attached to shaded bodies; it is that side of a body on which the light cannot fall.

Derived shadow is that which separates itself from shaded bodies and travels through the air.

Repercussed shadow is that which is surrounded by an illuminated surface.

The simple shadow is that which does not see any part of the light that causes it.

The simple shadow commences in the line that parts it from the boundaries of the luminous bodies.

It seems to me that the shadows are of supreme importance in perspective, seeing that without them opaque and solid bodies will be indistinct, both as to what lies within their boundaries and also as to their boundaries themselves, unless these are seen against a background differing in color from that of the substance; and consequently I say in this connection that every opaque body is surrounded and has its surface clothed with shadows and light. Moreover these shadows are in themselves of varying degrees of darkness, because they have been abandoned by a varying quantity of luminous rays; and these I call primary shadows, because they are the first shadows and so form a covering to the bodies to which they attach themselves.

From these primary shadows there issue certain dark rays, which are diffused throughout the air and vary in intensity according to the varieties of the primary shadows from which they are derived; and consequently I call these shadows derived shadows, because they have their origin in other shadow.

Moreover these derived shadows in striking upon anything create as many diVerent, effects as are the different places where they strike. And since where the derived shadow strikes, it is always surrounded by the striking of the luminous rays, it leaps back with

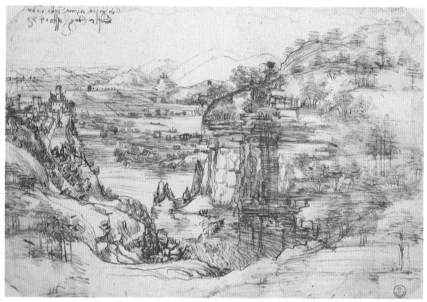

[10]

these in a reflex stream towards its source and meets the primary shadow, and mingles with and becomes changed into it altering thereby somewhat of its nature.

❮

Shadow is the diminution of light by the intervention of an opaque body. Shadow is the counterpart of the luminous rays which are cut off by an opaque body.

This is proved because the shadow cast is the same in shape and size as the luminous rays were that are transformed into a shadow.

[11]
Every shaded body that is larger than the pupil and that interposes between the luminous body and the eye will be seen dark.

❮

That place is most shaded on which the greatest number of shaded rays converge.

That place which is smitten by the shaded rays at the greatest angle is darkest.

❮

The simple derived shadows are of two kinds, that is to say, one finite in length and two infinite. The finite is pyramidal,

[12]

[11]

and of those that are infinite one is columnar and the other expanding. And all three have straight sides, but the convergent, that is, the pyramidal shadow, proceeds from a shaded body that is less than the luminous body, the columnar proceeds from a shaded body equal to the luminous body, and the expanding from a shaded body greater than the luminous body.

[12]
Of shadow:

{a} Derived shadows are of three kinds of which one is spreading, the second columnar, the third converging to the point where the two sides meet and intersect, and beyond this intersection the sides are infinitely prolonged or straight lines.

[13]
{a} The greatest depth of shadow is in the simple derived shadow, because it is not lighted by either of the two lights a b, c d.

{b} The next less deep shadow is the derived shadow e f n; and in this the shadow is less by half, because it is illuminated by a single light, that is c d.

{a}

{b}

{c}

{d}

{e}

[13]

[14]

{c} *This is uniform in natural tone because it is lighted throughout by one only of the two luminous bodies. But it varies with the conditions of shadow, inasmuch as the farther it is away from the light the less it is illuminated by it.*

{d} *The third degree of depth is the middle shadow. But this is not uniform in natural tone; because the nearer it gets to the simple derived shadow the deeper it is, and it is the uniformly gradual diminution by increase of distance which is what modified it: that is to say, the depth of a shadow increases in proportion to the distance from the two lights.*

The fourth is the shadow k r s and this is all the darker in natural tone in proportion as it is nearer to k s, because it gets less of the light a b, but by the accident [of distance] it is rendered less deep, because it is nearer to the light c d, and thus is always exposed to both lights.

The fifth is less deep in shadow than either of the others because it is always entirely exposed to one of the lights and to the whole or part of the other; and it is less deep in proportion as it is nearer to the two lights, and in proportion as it is turned towards the outer side x t; because it is more exposed to the second light a b. {e}

The forms of shadows are three: for if the substance that casts the shadow is equal in size to the light, the shadow is like a column which has no end; if the substance is greater than the light, its shadow is like a pyramid that grows larger as it recedes and of which the length has no end; but if the substance is smaller than the light, the shadow resembles a pyramid and comes to an end, as is seen in the eclipses of the moon.

☾

A shaded body will appear of less size when it is surrounded by a very luminous background, and a luminous body will show itself greater when it is set against a darker background: as is shown in the heights of buildings at night when there are flashes of lightning behind them. For it instantly appears, as the lightning flashes, that the building loses a part of its height.

And from this it comes to pass that these buildings appear larger when there is mist, or by night, than when the air is clear and illumined.

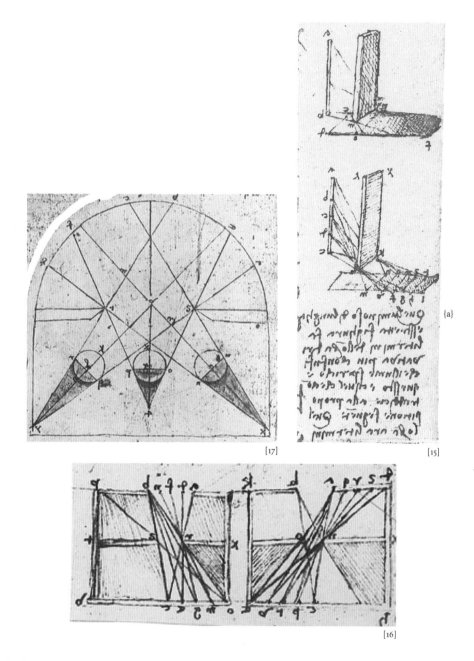

[17]

[15]

{a}

[16]

[15]

{a} *A luminous body that is long and narrow in shape gives more confused outlines to the derived shadow than a spherical light, and this contradicts the proposition next following: A shadow will have its outlines* more clearly defined in proportion as it is nearer to the primary shadow or, I should say, the body casting the shadow; the cause of this is the elongated form of the luminous body a c, etc.

[16]

The surroundings in shadow mingle their derived shadow with the light derived from the luminous body. The derived shadow of the dark walls on each side of the bright light of the window are what mingle their various degrees of shade with the light derived from the window; and these various depths of shade modify every portion of the light, except where it is strongest, at c.

To prove this, let d a be the primary shadow that is turned toward the point e, and darkens it by its derived shadow; as may be seen by the triangle a e d, in which the angle e faces the darkened base d a e; the point v faces the dark shadow a s, which is part of a d, and as the whole is greater than a part, e, which faces the whole base [of the triangle], will be in deeper shadow than v, which only faces part of it.

In consequence, t will be less darkened than v, because the base of the [triangle] t is part of the base of the [triangle] v; and in the same way it follows that p is less in shadow than t, because the base of the [triangle] p is part of the base of the [triangle] t. And c is the terminal point of the derived shadow and the chief beginning of the highest light.

[17]

Among the shadows cast by bodies of equal mass but at unequal distances from the opening by which they are illuminated, that shadow will be the longest of the body which is least in the light. And in proportion as one body is better illuminated than another, its shadow will be shorter than another. The proportion n m and e v k bear to r t and v x corresponds with that of the shadow x to 4 and y.

The reason why those bodies which are placed most in front of the middle of the window throw shorter shadows than those obliquely situated is that the window appears in its proper form and to the obliquely placed ones it appears foreshortened; to those in the middle, the window shows its full size, to the oblique ones it appears smaller; the one in the middle faces the whole hemisphere that is e f and those on the side have only a strip; that is, q r faces a b; and m n faces c d; the body in the middle having a larger quantity of light than those at the sides is lighted from a point much below its center, and thus the shadow is shorter.

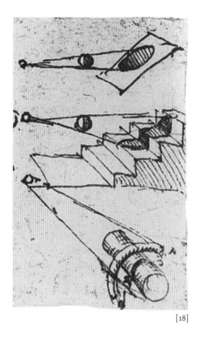

[18]

[18]

A shadow is never seen as of uniform depth on the surface which intercepts it unless every portion of that surface is equidistant from the luminous body. The shadow will appear lighter or stronger as it is surrounded by a darker or a lighter background. The background will be in parts darker or lighter, in proportion as it is farther from or nearer to the luminous body. Of various spots equally distant from the luminous body, those will always be in the highest light on which the rays fall at the smallest angles: The outline of the shadow as it falls on inequalities in the surface will be seen with all the contours similar to those of the body that casts it, if the eye is placed just where the center of the light was.

The shadow will look darkest where it is farthest from the body that casts it.

[19]

Although the breadth and length of lights and shadow will be narrower and shorter in foreshortening, the quality and quantity of the light and shade is neither increased nor diminished.

The function of shade and light, when diminished by foreshortening, will be to give shadow and to illuminate an object opposite, according to the quality and quantity in which they fall on the body.

In proportion as a derived shadow is nearer to its penultimate extremities the deeper it will appear. g z beyond the intersection faces only the part of the shadow [marked] y z; this by intersection takes the shadow from m n, but by direct line it takes the shadow a m hence it is twice as deep as g z. y x, by intersection takes the shadow n o, but by direct line the shadow n m a, therefore x y is three times as dark as z g; x f, by intersection faces o b and by direct line o n m a, therefore we must say that the shadow between f x will be four times as dark as the shadow z g, because it faces four times as much shadow.

Let a b be the side where the primary shadow is, and b c the primary light, d will be the spot where it is intercepted, f g the derived shadow and f e the derived light.

[20]

{a} *A spot is most in the shade when a large number of darkened rays fall upon it. The spot that receives the rays at the*

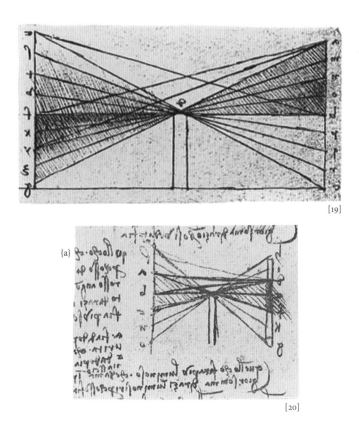

[19]

[20]

widest angle and by darkened rays at the widest angle will be most in the dark; a will be twice as dark as b, because it originates from twice as large a base at an equal distance. A spot is most illuminated when a large number of luminous rays fall upon it. d is the beginning of the shadow d f, and tinges c but a little; d e is half of the shadow d f and gives a deeper tone where it is cast at b than at f. And the whole shaded space e gives its tone to the spot a.

[21]

That part of the surface of a body on which the images from other bodies placed opposite fall at the largest angle will assume their hue most strongly. In this diagram, 8 is a larger angle than 4, since its base a n is larger than e n, the base of 4. This diagram below should end at a n 4 8.

That portion of the illuminated surface on which a shadow is cast will be brightest which lies contiguous to the cast shadow. Just as an object that is lighted up by a greater quantity of luminous rays becomes brighter, so one on which a greater quantity of shadow falls, will be darker.

The distribution of shadow, originating in, and limited by, plane surfaces placed near to each other, equal in tone and directly opposite, will be darker at the ends than at the beginning, which will be determined by the incidence of the luminous rays.

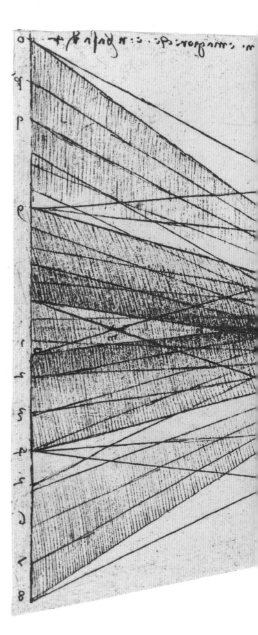

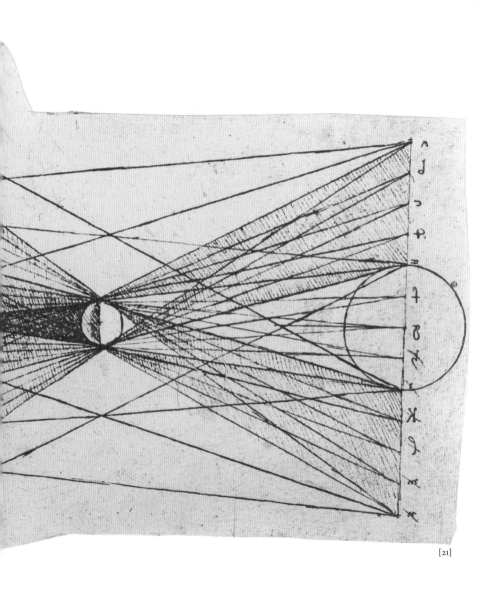

[21]

Why does the eye see a thing more clearly in dreams than the imagination when awake?

IV. Perspective and Visual Perception

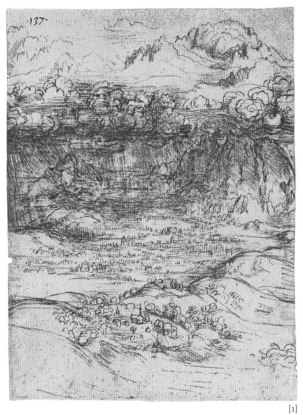

[1]

[1]
And the mountains will seem few in number, for only those will be seen that are farthest apart from each other, since at such distances the increases in the density creates a brightness so pervading that the darkness of the hills is divided, and quite disappears towards their summits. In the small adjacent

hills it cannot find such foothold, and therefore they are less visible and least of all at their bases.

《

Those who are in love with practice without knowledge are like the sailor who gets into a ship without rudder or compass and who never can be certain whither he is going. Practice must always be founded on sound theory, and to this, perspective is the guide and the gateway; and without this nothing can be done well in the matter of drawing.

《

Perspective is the best guide to the art of painting.

《

Perspective is of such a nature that it makes what is flat appear in relief, and what is in relief appear flat.

The perspective by means of which a thing is represented will be better understood when it is seen from the view point at which it was drawn.

《

Perspective is nothing else than the seeing of an object behind a sheet of glass, smooth and quite transparent, on the surface of which all the things may be marked that are behind this glass; these things approach the point of the eye in pyramids, and these pyramids are cut by the said glass.

《

Perspective is a rational demonstration whereby experience confirms how all things transmit their images to the eye by pyramidal lines. By pyramidal lines I mean those that start from the extremities of the surface of bodies, and by gradually converging from a distance arrive at the same point; the said point being, as I shall show, in this particular case located in the eye, which is the universal judge of all objects. I call a point that which cannot be divided up into any parts; and as this point, which is situated in the eye is indivisible, no body can be seen by the eye that is not greater than this point, and this being the case it is necessary that the lines which extend from the object to the point should be pyramidal.

《

All the cases of perspective are expressed by means of the five mathematical terms, to wit: point, line, angle, surface, and body.

Of these the point is unique of its kind, and this point has neither height nor breadth, nor length nor depth, wherefore we conclude that it is indivisible and does not occupy space.

A line is of three kinds, namely straight, curved, and bent, and it has neither breadth, height nor depth, consequently it is indivisible except in its length; its ends are two points.

An angle is the ending of two lines in a point, and they are of three kinds, namely right angles, acute angles, and obtuse angles.

Surface is the name given to that which is the boundary of bodies, and it is without depth, and in such depth as it has it is indivisible as is the line or point, being divided only in respect of length or breadth. There are as many different kinds of surfaces as there are bodies that create them.

Body is that which has height, breadth, length, and depth, and in all these attributes it is divisible. These bodies are of infinite and varied forms.

《

If you wish to represent a thing near, which should produce the effect of natural things, it is impossible for your perspective not to appear false, by reason of all the illusory appearances and errors in proportion of which the existence may be assumed in a medio-cre work, unless whoever is looking at this perspective finds himself surveying it from the exact distance, elevation, angle of vision or point at which you were situated to make this perspective.

Therefore it would be necessary to make a window of the size of your face or in truth a hole through which you would look at the said work. And if you should do this, then without any doubt your work will produce the effect of nature if the light and shade are correctly rendered, and you will hardly be able to convince yourself that these things are painted. Otherwise do not trouble yourself about representing anything, unless you take your view

point at a distance of at least twenty times the maximum width and height of the thing that you represent; and this will satisfy every beholder who places himself in front of the work at any angle whatever.

《

There are three branches of perspective; the first deals with the reasons of the [apparent] diminution of the volume of opaque bodies as they recede from the eye, and is known as Diminishing or Linear Perspective.

The second contains the way in which colors vary as they recede from the eye. The third and last is concerned with how the outlines of objects [in a picture] ought to be less finished in proportion as they are remote.

《

Among objects of equal size, that which is most remote from the eye will look the smallest.

《

The thing that is nearer to the eye al-ways appears larger than another of the same size that is more remote.

《

Small objects close at hand and large ones at a distance, being seen within equal angles, will appear of the same size.

There is no object so large but that at a great distance from the eye it does not appear smaller than a smaller object near.

A second object as far distant from the first as the first is from the eye will appear half the size of the first, though they be of the same size really.

Equal things equally distant from the eye will be judged by the eye to be of equal size. Equal things through being at different distances from the eye come to appear of unequal size. Unequal things by reason of their different distances from the eye may appear equal.

Among opaque bodies of equal magnitude, the diminution apparent in their size will vary according to their distance from the eye that sees them; but it will be in inverse proportion, for at the greater distance the opaque body appears less, and at a less distance this body will appear greater, and on this is founded linear perspective. And show secondly how every object at a great distance loses first that portion of itself which is the thinnest.

Thus with a horse, it would lose the legs sooner than the head because the legs are thinner than the head, and it would lose the neck before the trunk for the same reason. It follows therefore that the part of the horse that the eye will be able last to discern will be the trunk, retaining still its oval form, but rather approximating to the shape of a cylinder. It will lose its thickness sooner than its length from the second conclusion aforesaid.

If the eye is immovable the perspective terminates its distance in a point; but if the eye moves in a straight line the perspective ends in a line, because it is proved that the line is produced by the movement of the point, and our sight is fixed upon the point. Consequently it follows that as the sight moves, the point moves, and as the point moves, the line is produced.

Of things of equal size situated at an equal distance from the eye, that will appear the larger which is whiter in color.

Of things which are the same in size and color that which is farther away will seem lighter and less in bulk.

Many things of great bulk lose their visibility in the far distance by reason of their color, and many small things in the far distance retain their visibility by reason of the said color.

An object of a color similar to that of the air retains its visibility at a moderate distance, and an object that is paler than the air retains it in the far

distance, and an object which is darker than the air ceases to be visible at a short distance.

But of these three kinds of objects, that will be visible at the greatest distance of which the color presents the strongest contrast to itself.

[2]
In order to put into practice this perspective of the variation and loss or diminution of the essential character of colors, observe at every hundred braccia some standing in the landscape, such as trees, houses, men, and particular places.

Then in front of the first tree have a very steady plate of glass and keep your eye very steady, and then, on this plate of glass, draw a tree, tracing it over the form of that tree. Then move it on one side so far as that the real tree is close by the side of the tree you have drawn; then color your drawing in such a way as that in color and form the two may be alike, and that both, if you close one eye, seem to be painted on the glass and at the same distance.

Then, by the same method, represent a second tree, and a third, with a distance of a hundred braccia between each. And these will serve as a standard and guide whenever you work on your own pictures, wherever they may apply, and will enable you to give due distance in those works. But I have found that as a rule the second is 4/5 of the first when it is 20 braccia beyond it.

[2]

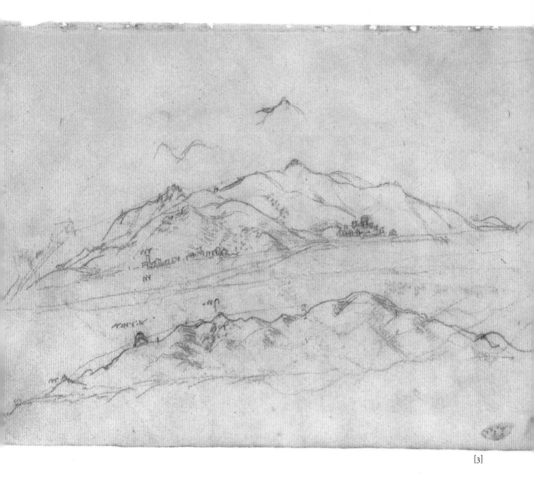

[3]

[3]

There is another kind of perspective which I call Aerial Perspective, because by the atmosphere we are able to distinguish the variations in distance of different buildings, which appear placed on a single line; as, for instance, when we see several buildings beyond a wall, all of which, as they appear above the top of the wall, look of the same size, while you wish to represent them in a picture as more remote one than another and to give the effect of a somewhat dense atmosphere. You know that in an atmosphere of equal density the remotest objects seen through it, as mountains, in consequence of the great quantity of atmosphere between your eye and them—appear blue and almost

of the same hue as the atmosphere itself when the sun is in the East. Hence you must make the nearest building above the wall of its real color, but the more distant ones make less defined and bluer. Those you wish should look farthest away you must make proportionately bluer; thus, if one is to be five times as distant, make it five times bluer. And by this rule the buildings which above a [given] line appear of the, same size, will plainly be distinguished as to which are the more remote and which larger than the others.

☾

Whenever a figure is placed at a considerable distance you lose first the distinctness of the smallest parts; while the larger parts are left to the last, losing all distinctness of detail and outline. What remains is an oval or spherical figure with confused edges.

☾

That dimness that occurs by reason of distance, or at night, or when mist comes between the eye and the object, causes the boundaries of this object to become almost indistinguishable from the atmosphere.

☾

When the sun rises and drives away the mists, and the hills begin to grow distinct on the side from which the mists are departing, they become blue and seem to put forth smoke in the direction of the mists that are flying away, and the buildings reveal their lights and shadows. Where the mist is less dense they show only their lights, and where it is denser nothing at all. Then it is that the movement of the mist causes it to pass horizontally and so its edges are scarcely perceptible against the blue of the atmosphere, and against the ground it will seem almost like dust rising.

☾

Buildings that face the west only show their illuminated side, the rest the mist hides.

☾

In proportion as the atmosphere is denser, the buildings in a city and the trees in landscapes will seem more infrequent, for only the most prominent and the largest will be visible.

☾

If the true outlines of opaque bodies become indistinguishable at any short distance, they will be still more invisible at great distances. And since it is by the outlines that the true shape of each opaque body becomes known, whenever because of distance we lack the perception of the whole we shall lack yet more the perception of its parts and outlines.

I say that the reason that objects appear diminished in size is because they are remote from the eye; this being the case it is evident that there must be a great extent of atmosphere between the eye and the objects, and this air interferes with the distinctness of the forms of the object. Hence the minute details of these objects will be indistinguishable and unrecognizable.

Therefore, O Painter, make your smaller figures merely indicated and not highly finished, otherwise you will produce effects the opposite to nature, your supreme guide. The object is small by reason of the great distance between it and the eye, this great distance is filled with air, that mass of air forms a dense body which intervenes and prevents the eye seeing the minute details of objects.

Experience shows us that the air must have darkness beyond it and yet it appears blue. If you produce a small quantity of smoke from dry wood and the rays of the sun fall on this smoke, and if you then place behind the smoke a piece of black velvet on which the sun does not shine, you will see that all the smoke that is between the eye and the black stuff will appear of a beautiful blue color. And if instead of the velvet you place a white cloth, smoke that is too thick hinders, and too thin smoke does not produce, the perfection of this blue color. Hence a moderate amount of smoke produces the finest blue.

Water violently ejected in a fine spray and in a dark chamber where the sunbeams are admitted produces these blue rays and the more vividly if it is distilled water, and thin smoke looks blue. This I mention in order to show that the blueness of the atmosphere is caused by the darkness beyond it.

In the morning the mist is thicker up above than in the lower parts because the sun draws it upwards; so with high buildings the summit will be invisible although it is at the same distance as the base. And this is why the sky seems darker up above and towards the horizon, and does not approximate to blue, but is all the color of smoke and dust.

The atmosphere when impregnated with mist is altogether devoid of blueness and merely seems to be the color of the clouds, which turn white when it is fine weather. And the more you turn to the west the darker you will find it to be, and the brighter and clearer towards the east. And the verdure of the countryside will assume a bluish hue in the half mist, but will turn black when the mist is thicker.

I say that the blueness we see in the atmosphere is not intrinsic color, but is caused by warm vapor evaporated in minute and insensible atoms on which

the solar rays fall, rendering them luminous against the infinite darkness of the fiery sphere that lies beyond and includes it. Hence it follows, as I say, that the atmosphere assumes this azure hue by reason of the particles of moisture which catch the rays of the sun.

Again, we may note the difference in particles of dust, or particles of smoke, in the sunbeams, admitted through holes into a dark chamber, when the former will look ash grey and the thin smoke will appear of the most beautiful blue. It may be seen again in the dark shadows of distant mountains when the air between the eye and those shadows will look very blue, though the brightest parts of those mountains will not differ much from their true colors.

But if anyone wishes for a final proof let him paint a board with various colors, among them an intense black; and over all let him lay a very thin and transparent [coating of] white. He will then see that this transparent white will nowhere show a more beautiful blue than over the black, but it must be very thin and finely ground.

«

Darkness steeps everything with its hue, and the more an object is divided from darkness the more it shows its true and natural color.

«

All colors, when placed in the shade, appear of an equal degree of darkness, among themselves. But all colors, when placed in a full light, never vary from their true and essential hue.

«

Since we see that the quality of color is known [only] by means of light, it is to be supposed that where there is most light the true character of a color in light will be best seen. Where there is most shadow the color will be affected by the tone of that [shadow]. Hence, O Painter! Remember to show the true quality of colors in bright lights.

«

Colors seen in shadow will display more or less of their natural brilliancy in proportion as they are in fainter or deeper shadow. But if these same colors are situated in a well-lighted place, they will appear brighter in proportion as the light is more brilliant.

Colors seen in shadow will display less variety in proportion as the shadows in which they lie are deeper. And evidence of this is to be had by looking from an open space into the doorways of dark and shadowy churches, where the pictures that are painted in various colors all look of uniform darkness.

Hence at a considerable distance all the shadows of different colors will appear of the same darkness. It is the light side of an object in light and shade that shows the true color.

《

Of various colors, none of which are blue, that which at a great distance will look bluest is the nearest to black; and so, conversely, the color that is least like black will at a great distance best preserve its own color.

Hence the green of fields will assume a bluer hue than yellow or white will, and conversely yellow or white will change less than green, and red still less.

《

Of several [patches of] color, all equally white, that [patch] will look whitest which is against the darkest background. And black will look most intense against the whitest background.

And red will look most vivid against the most yellow background; and the same is the case with all colors when surrounded by their strongest contrasts.

《

Every opaque and colorless body assumes the hue of the color reflected on it; as happens with a white wall.

《

The hue of an illuminated object is affected by that of the luminous body [that illuminates it].

《

The surface of every opaque body is affected by the [reflected] color of the objects surrounding it. But this effect will be strong or weak in proportion as those objects are more or less remote and more or less strongly [colored].

《

Every object devoid of color in itself is more or less tinged by the color [of the object] placed opposite. This may be seen by experience, inasmuch as any object that mirrors another assumes the color of the object mirrored in it. And if the surface thus partially colored is white, the portion that has a red reflection will appear red, or any other color, whether bright or dark.

《

A shadow is always affected by the color of the surface on which it is cast.

《

An image produced in a mirror is affected by the color of the mirror.

《

Every body that moves rapidly seems to color its path with the impression of its hue. The truth of this proposition is seen from experience; thus when the lightning moves among dark clouds the speed of its sinuous flight makes its whole course resemble a luminous snake. So in like manner if you wave a lighted brand its whole course will seem a ring of flame. This is because the organ of perception acts more rapidly than the judgment.

Just as a stone flung into the water becomes the center and cause of many circles, and as sound diffuses itself in circles in the air: so any object, placed in the luminous atmosphere, diffuses itself in circles, and fills the surrounding air with infinite images of itself. And is repeated, the whole everywhere, and the whole in every smallest part.

[4]
All bodies together, and each by itself, give off to the surrounding air an infinite number of images that are all-pervading and each complete. Each conveying the nature, color and form of the body that produces it.

{a} *It can clearly be shown that all bodies are, by their images, all-pervading in the surrounding atmosphere, and each complete in itself as to substance, form, and color. This is seen by the images of the various bodies that are reproduced in one single perforation through which they transmit the objects by lines that intersect and cause reversed pyramids, from the objects, so that they are upside down on the dark plane where they are first reflected.*

The air is filled with endless images of the objects distributed in it; and all are represented in all, and all in one, and

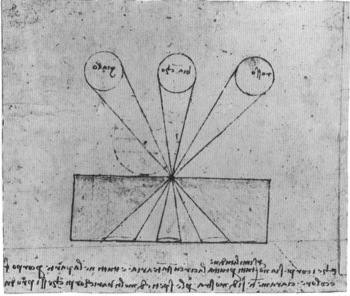

[4]

all in each, whence it happens that if two mirrors are placed in such a manner as to face each other exactly, the first will be reflected in the second and the second takes to it the image of itself with all the images represented in it. Among which is the image of the second mirror, and so, image within image, they go on to infinity in such a manner as that each mirror has within it a mirror, each smaller than the last and one inside the other. Thus, by this example, it is clearly proved that every object sends its image to every spot whence the object itself can be seen; and the converse: that the same object may receive in itself all the images of the objects that are in front of it.

Hence the eye transmits through the atmosphere its own image to all the objects that are in front of it and receives them into itself, that is to say, on its surface, whence they are taken in by the common sense, which considers them and if they are pleasing commits them to the memory. Whence I am of the opinion that the invisible images in the eyes are produced towards the object, as the image of the object to the eye. That the images of the objects must be disseminated through the air.

An instance may be seen in several mirrors placed in a circle, which will reflect each other endlessly. When one has reached the other it is returned to the object that produced it, and thence—being diminished—it is returned again to the object and then comes back once more, and this happens endlessly.

If you put a light between two flat mirrors with a distance of one braccio between them you will see in each of them an infinite number of lights, one smaller than another, to the last. If at night you put a light between the walls of a room, all the parts of that wall will be tinted with the image of that light. And they will receive the light and the light will fall on them, mutually, that is to say, when there is no obstacle to interrupt the transmission of the images. The same example is seen in a greater degree in the distribution of the solar rays that all together, and each by itself, convey to the object the image of the body which causes it.

That each body by itself alone fills with its images the atmosphere around it, and that the same air is able, at the same time, to receive the images of the endless other objects that are in it—this is clearly proved by these examples. And every object is everywhere visible in the whole of the atmosphere, and the whole in every smallest part of it; and all the objects in the whole, and all in each smallest part; each in all and all in every part.

☾

The image of the sun will be more brightly shown in small waves than in large ones—and this is because the reflections or images of the sun are more numerous in the small waves than in large ones, and the more numerous reflections of its radiance give a larger light than the fewer.

Waves that intersect like the scales of a fir cone reflect the image of the sun with the greatest splendor; and this is the case because the images are as many as the ridges of the waves on which the sun shines, and the shadows between these waves are small and not very dark; and the radiance of so many reflections together becomes united in the image that is transmitted to the eye, so that these shadows are imperceptible.

☾

I say that sight is exercised by all animals, by the medium of light; and if any one adduces, as against this, the sight of nocturnal animals, I must say that this in the same way is subject to the very same natural laws.

For it will easily be understood that the senses which receive the images of things do not project from themselves any visual virtue. On the contrary the atmospheric medium that exists between the object and the sense incorporates in itself the figure of things, and by its contact with the sense transmits the object to it. If the object—whether by sound or by odor—presents its spiritual force to the ear or the nose, then light is not required and does not act. The forms of objects do not send their images into the air if they are not illuminated; and the eye being thus constituted cannot receive that from the air, which the air does not possess, although it touches its surface.

If you choose to say that there are many animals that prey at night, I answer that when the little light which suffices the nature of their eyes is wanting, they direct themselves by their strong sense of hearing and of smell, which are not impeded by the darkness, and in which they are very far superior to man. If you make a cat leap, by daylight, among a quantity of jars and crocks you will see them remain unbroken, but if you do the same at night, many will be broken. Night birds do not fly about unless the moon shines full or in part; rather do they feed between sundown and the total darkness of the night.

No body can be apprehended without light and shade, and light and shade are caused by light.

☾

If the object in front of the eye sends its image to it, the eye also sends its image to the object, so of the object and of the image proceeding from it no portion is lost for any reason either in the eye or the object. Therefore we can sooner believe that it is the nature and power of this luminous atmosphere that attracts and takes into itself the images of the objects that are within it than that it is the nature of the objects which transmits their images through the atmosphere.

If the object in front of the eye were to send its image to it, the eye would have to do the same to the object, whence it would appear that these

images were incorporeal powers. If it were thus it would be necessary that each object should rapidly become less; because each body appears as an image in the atmosphere in front of it, that is, the whole body in the whole atmosphere and the whole in the part, and all the bodies in the whole atmosphere and all in the part, referring to that portion of it which is capable of receiving into itself the direct and radiating lines of the images transmitted by the objects.

For this reason then it must be admitted that it is the nature of this atmosphere which finds itself among the objects to draw to itself, like a magnet, the images of the objects among which it is situated.

All things transmit their image to the eye by means of pyramids; the nearer to the eye these are intersected, the smaller the image of their cause will appear.

If you should ask how you can demonstrate these points to me from experience, I should tell you, as regards the vanishing point that moves with you, to notice as you go along by lands ploughed in straight furrows, the ends of which start from the path where you are walking, you will see that continually each pair of furrows seem to approach each other and to join at their ends.

As regards the point that comes to the eye, it may be comprehended with greater ease; for if you look in the eye of anyone you will see your own image there; consequently if you suppose two lines to start from your ears and

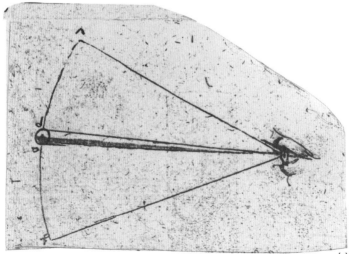

[5]

proceed to the ears of the image that you see of yourself in the eye of the other person, you will clearly recognize that these lines contract so much that when they have continued only a little way beyond your image as mirrored in the said eye they will touch one another in a point.

((

Nature has made the surface of the pupil situated in the eye convex in form so that the surrounding objects may imprint their images at greater angles than could happen if the eye were flat.

((

The images of the objects placed before the eye pass to the vitreous sphere by the gate of the pupil, and they intersect within this pupil in such a way that the vitreous sphere is struck on its left side by the right ray of the right sphere, and it does the same on the opposite side; afterwards it penetrates this vitreous sphere, and the rays contract and find themselves much closer together when they are on the opposite side of this sphere than when they strike it in the beginning.

((

When both eyes direct the pyramid of sight to an object, that object becomes clearly seen and comprehended by the eyes.

[5]

All the images of objects reach the senses by a small aperture in the eye; hence, if the whole horizon a d is admitted through such an aperture, the object b c being but a very small fraction of this horizon, what space can it fill in that minute image of so vast a hemisphere? And because luminous bodies have more power in darkness than any others, it is evident that, as the chamber of the eye is very dark, as is the nature of all colored cavities, the images of distant objects are confused and lost in the great light of the sky; and if they are visible at all, appear dark and black, as every small body must when seen in the diffused light of the atmosphere.

((

We see quite plainly that all the images of visible objects that lie before us, whether large or small, reach our sense by the minute aperture of the eye. If, through so small a passage the image can pass of the vast extent of sky and earth, the face of a man—being by comparison with such large images almost nothing by reason of the distance that diminishes it—fills up so little of the eye that it is indistinguishable.

Having also to be transmitted from the surface to the sense through a dark medium, that is to say, the crystalline lens which looks dark; no other reason can in any way be assigned. If the point in the eye is black, it is because it is full of a transparent humor as clear as air and acts like a perforation in a board;

on looking into it, it appears dark and the objects seen through the bright air and a dark [medium] one become confused in this darkness.

☾

Every object we see will appear larger at midnight than at midday, and larger in the morning than at midday.

This happens because the pupil of the eye is much smaller at midday than at any other time.

In proportion as the eye or the pupil of the owl is larger in proportion to the animal than that of man, so much the more light can it see at night than man can; hence at midday it can see nothing if its pupil does not diminish; and, in the same way, at night things look larger to it than by day.

☾

If the eye is required to look at an object placed too near to it, it cannot judge of it well—as happens to a man who tries to see the tip of his nose. Hence, as a general rule, Nature teaches us that an object can never be seen perfectly unless the space between it and the eye is equal, at least, to the length of the face.

☾

If the eye be in the middle of a course with two horses running to their goal along parallel tracks, it will seem to it that they are running to meet one another.

This occurs because the images of the horses that impress themselves upon the eye are moving towards the center of the surface of the pupil of the eye.

☾

But the images of the objects conveyed to the pupil of the eye are distributed to the pupil exactly as they are distributed in the air; and the proof of this is in what follows: when we look at the starry sky, without gazing more fixedly at one star than another, the sky appears all strewn with stars; and their proportions to the eye are the same as in the sky and likewise the spaces between them.

☾

The pupil of the eye contracts in proportion to the increase of light that is reflected in it. The pupil of the eye expands in proportion to the diminution in the daylight, or any other light, that is reflected in it. The eye perceives and recognizes the objects of its vision with greater intensity in proportion as the pupil is more widely dilated; and this can be proved by the case of nocturnal animals, such as cats, and certain birds—as the owl and others—in which the pupil varies in a high degree from large to small, when in the dark or in the light. The eye [out of doors] in an illuminated atmosphere sees darkness behind the windows of houses that [nevertheless] are light.

《

The pupil of the eye changes to as many different sizes as there are differences in the degrees of brightness and obscurity of the objects that present themselves before it. In this case nature has provided for the visual faculty when it has been irritated by excessive light by contracting the pupil of the eye, and by enlarging this pupil after the manner of the mouth of a purse when it has had to endure varying degrees of darkness.

And here nature works as one who, having too much light in his habitation, blocks up the window halfway or more or less according to the necessity, and who when the night comes throws open the whole of this window in order to see better within this habitation. Nature is here establishing a continual equilibrium, perpetually adjusting and equalizing by making the pupil dilate or contract in proportion to the aforesaid obscurity or brightness that continually presents itself before it.

You will see the process in the case of the nocturnal animals such as cats, screech owls, long eared owls, and suchlike that have the pupil small at midday and very large at night. And it is the same with all land animals and those of the air and of the water but more, beyond all comparison, with the nocturnal animals.

And if you wish to make the experiment with a man, look intently at the pupil of his eye while you hold a lighted candle at a little distance away and make him look at this light as you bring it nearer to him little by little, and you will then see that the nearer the light approaches to it the more the pupil will contract.

《

The eye that is used to the darkness is hurt on suddenly beholding the light and therefore closes quickly being unable to endure the light. This is due to the fact that the pupil, in order to recognize any object in the darkness to which it has grown accustomed, increases in size, employing all its force to transmit to the receptive part the image of things in shadow. And the light, suddenly penetrating, causes too large a part of the pupil that was in darkness to be hurt by the radiance which bursts in upon it, this being the exact opposite of the darkness to which the eye has already grown accustomed and habituated, and that seeks to maintain itself there, and will not quit its hold without inflicting injury upon the eye.

One might also say that the pain caused by the sudden light to the eye when in shadow arises from the sudden contraction of the pupil, which does not occur except as the result of the sudden contact and friction of the sensitive parts of the eye.

If you would see an instance of this, observe and note carefully the size of the pupil when someone is looking at a dark place, and then cause a candle to be brought before it, and make it rapidly approach the eye, and you will see an instantaneous contraction of the pupil.

☾

The eye, which sees all objects reversed, retains the images for some time. This conclusion is proved by the results; because, the eye having gazed at light retains some impression of it. After looking [at it] there remain in the eye images of intense brightness, that make any less brilliant spot seem dark until the eye has lost the last trace of the impression of the stronger light.

☾

If you look at the sun or other luminous object and then shut your eyes, you will see it again in the same form within your eye for a long space of time: this is a sign that the images enter within it.

☾

The eye will hold and retain in itself the image of a luminous body better than that of a shaded object. The reason is that the eye is in itself perfectly dark and since two things that are alike cannot be distinguished, therefore the night, and other dark objects cannot be seen or recognized by the eye. Light is totally contrary and gives more distinctness, and counteracts and differs from the usual darkness of the eye, hence it leaves the impression of its image.

☾

Since the eye is the window of the soul, the latter is always in fear of being deprived of it, to such an extent that when anything moves in front of it which causes a man sudden fear, he does not use his hands to protect his heart, which supplies life to the head where dwells the lord of the senses, nor his hearing, nor sense of smell or taste. The affrighted sense immediately not contented with shutting the eyes and pressing their lids together with the utmost force, causes him to turn suddenly in the opposite direction; and not as yet feeling secure he covers them with the one hand and stretches out the other to form a screen against the object of his fear.

It is said that the wolf has power by its look to cause men to have hoarse voices.

The basilisk is said to have the power by its glance to deprive of life every living thing.

The ostrich and the spider are said to hatch their eggs by looking at them.

Maidens are said to have power in their eyes to attract to themselves the love of men.

0, mighty process! What talent can avail to penetrate a nature such as this? Who would believe that so small a space could contain the images of all the universe?

What tongue will it be that can unfold so great a wonder? Verily, none! This it is that guides the human discourse to the considering of divine things.

The mind of the painter must resemble a mirror, which always takes the color of the object it reflects and is completely occupied by images.

V. Studies and Sketches

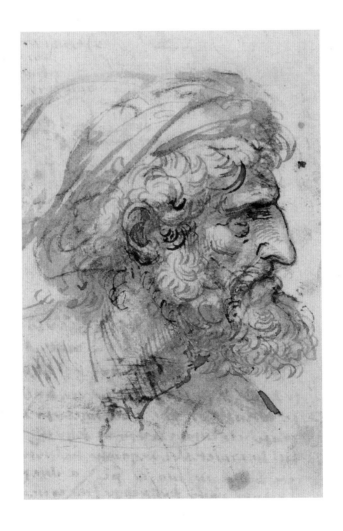

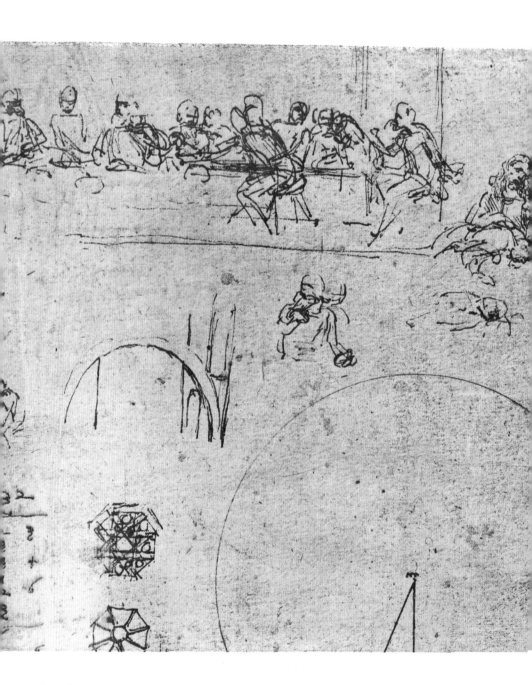

[1]

[1]
One who was drinking and has left the glass in its position and turned his head towards the speaker.

Another, twisting the fingers of his hands together, turns with stern brows to his companion. Another with his hands spread open shows the palms, and shrugs his shoulders up to his ears making a mouth of astonishment.

Another speaks into his neighbor's ear and he, as he listens to him, turns towards him to lend an ear, while he holds a knife in one hand, and in the other the loaf half cut through by the knife. Another, who has turned, holding a knife in his hand, upsets with his hand a glass on the table.

[2]
Another lays his hand on the table and is looking. Another blows [air out of] his mouth. Another leans forward to see the speaker shading his eyes with his hand. Another draws back behind the one who leans forward, and sees the speaker between the wall and the man who is leaning.

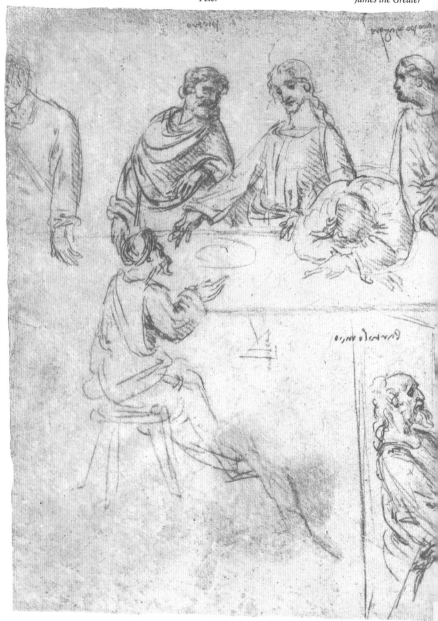

Bartholomew

Thomas Matthew Simon Philip

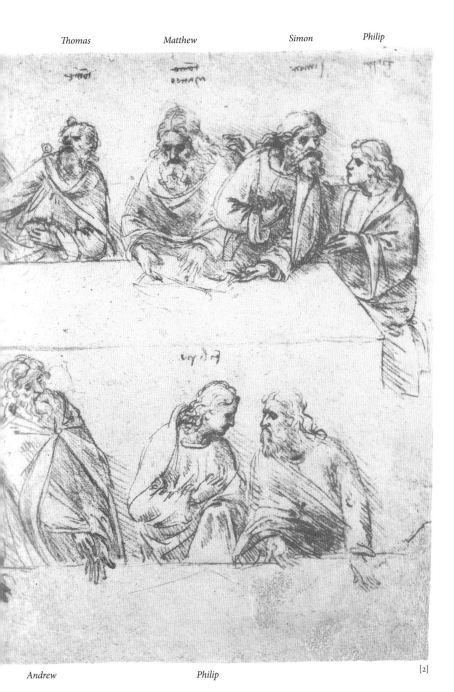

Andrew Philip

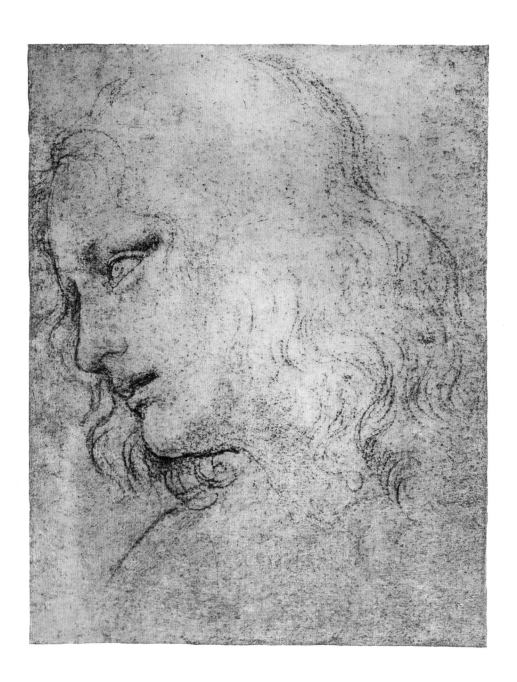

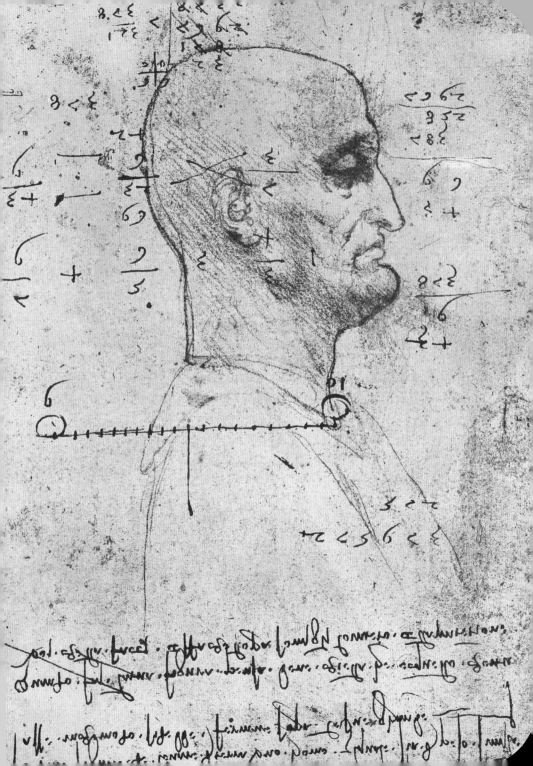

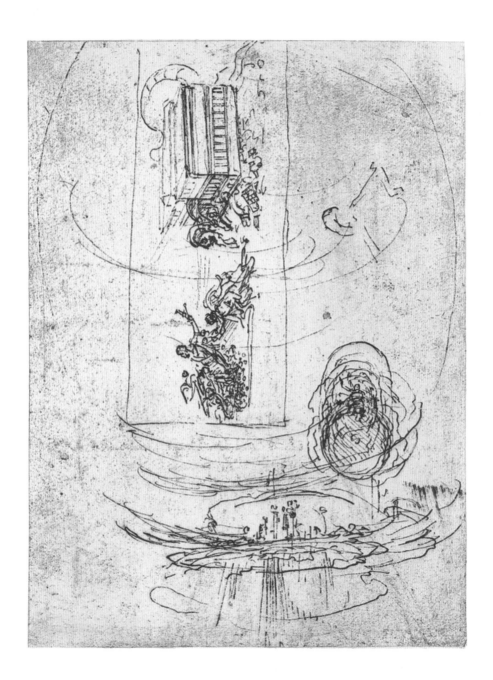

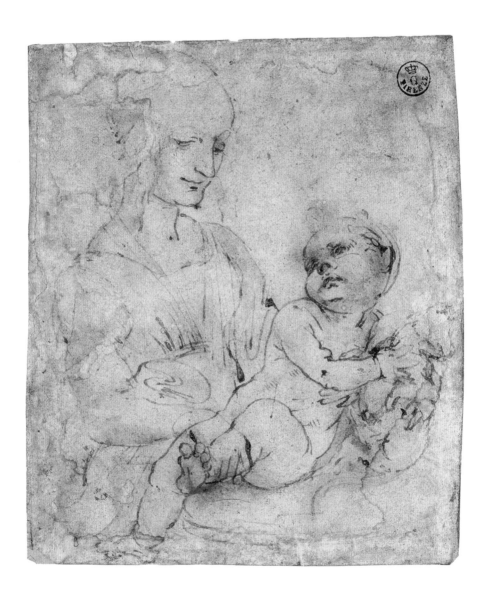

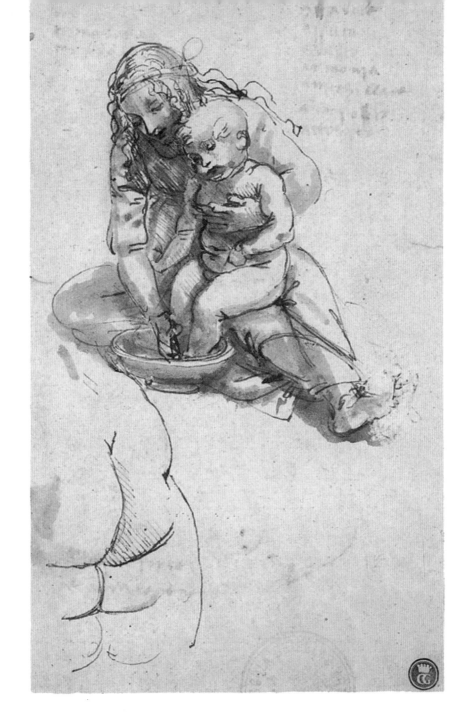

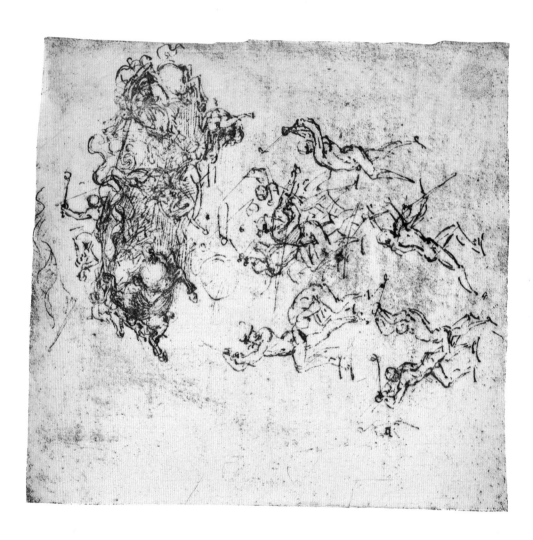

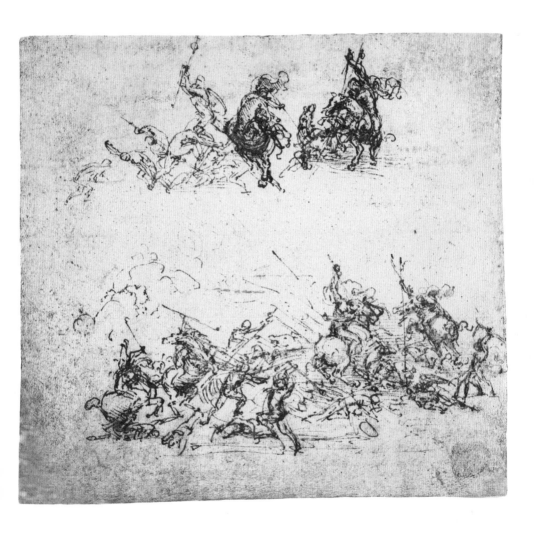

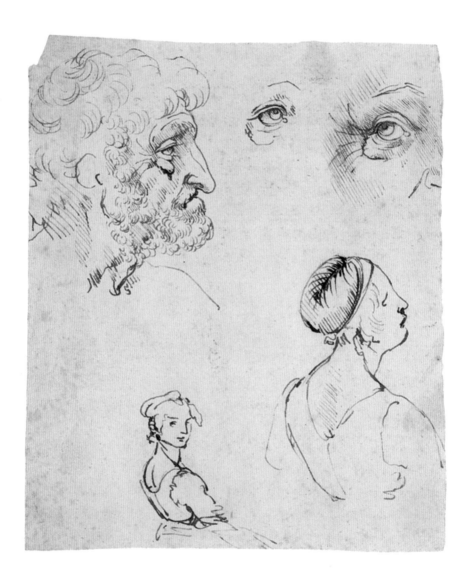

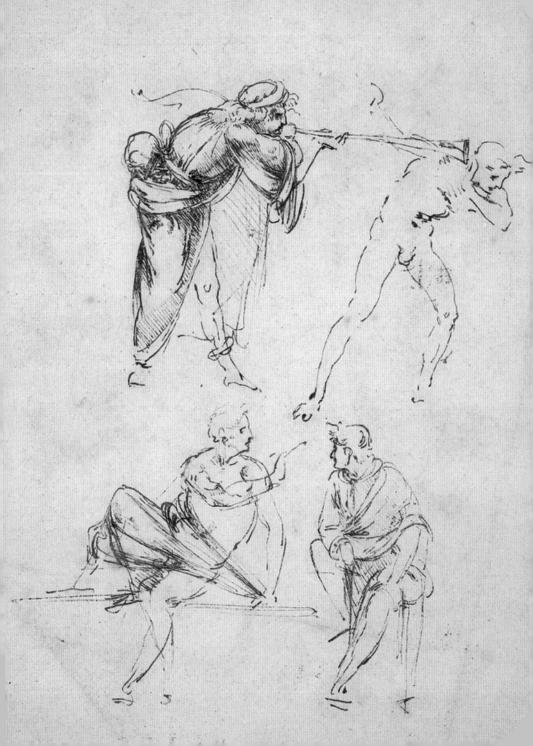

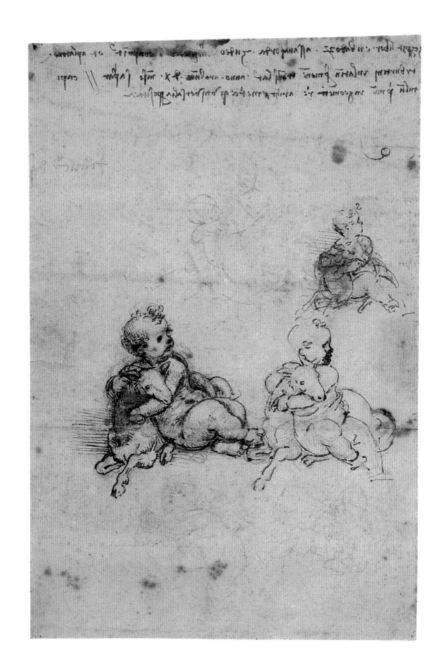

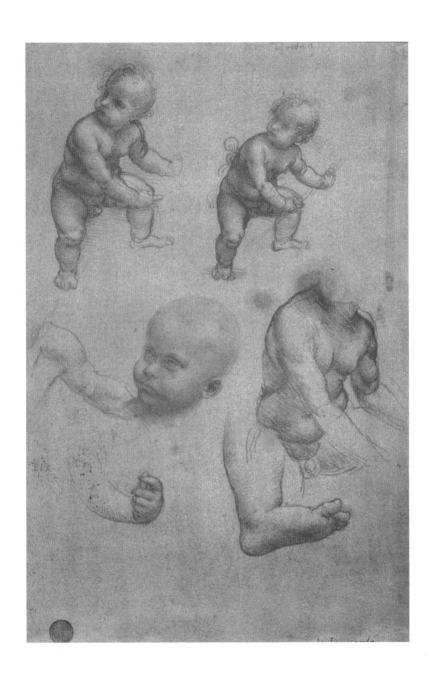

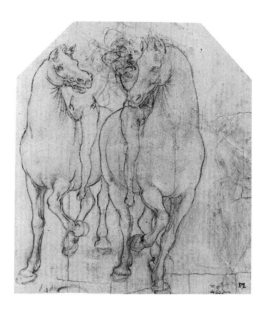

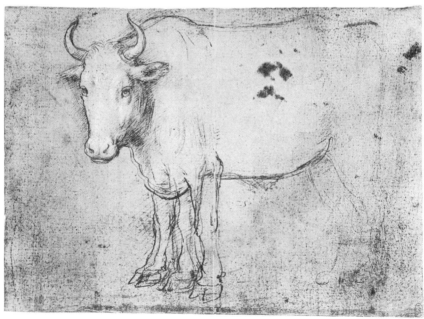

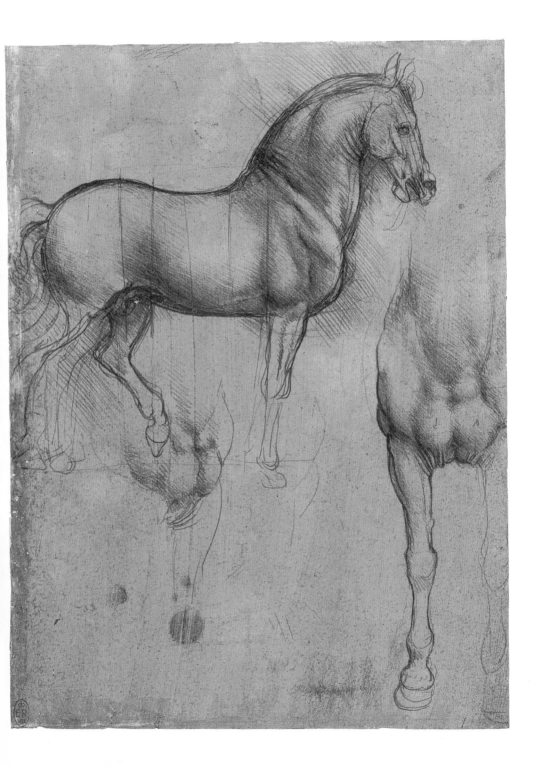

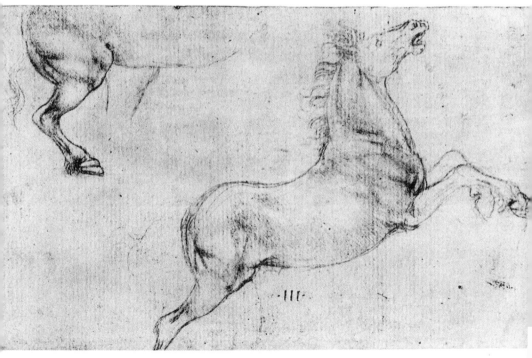

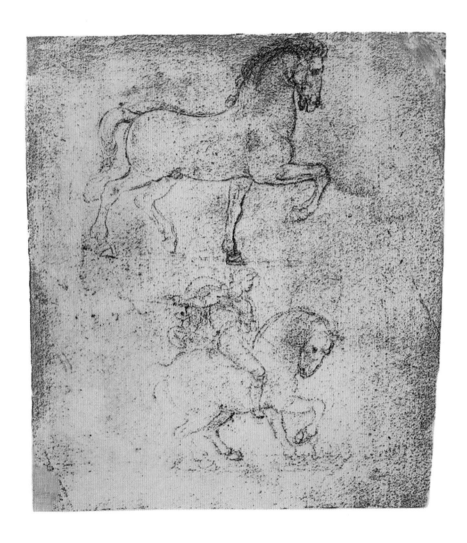

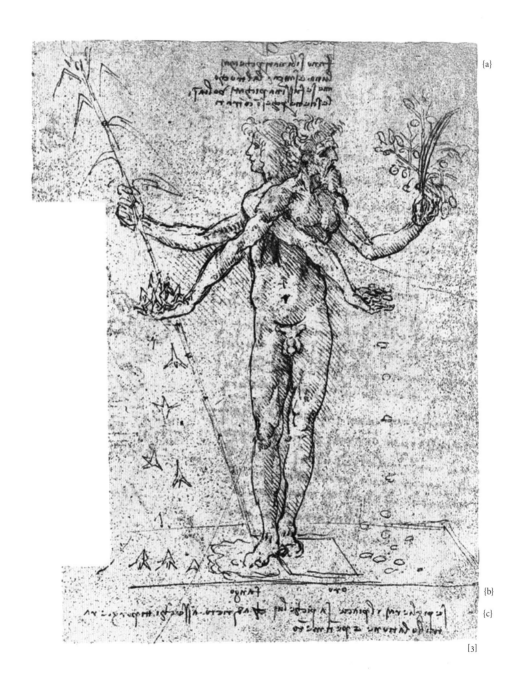

[3]

{a} *Pleasure and Pain represent as twins since there never is one without the other; and as if they were united back to back, since they are contrary to each other.*

{b} *Clay, gold.*

{c} *If you take pleasure know that he has behind him one who will deal you Tribulation and Repentance.*

This represents Pleasure together with Pain. Show them as twins because one is never apart from the other. They are back to back because they are opposed to each other. They exist as contraries in the same body, because they have the same basis, inasmuch as the origin of pleasure is labor and pain, and the various forms of evil pleasure are the origin of pain.

Therefore it is here represented with a reed in his right hand, which is useless and without strength, and the wounds it inflicts are poisoned. In Tuscany they are put to support beds, to signify that it is here that vain dreams come, and here a great part of life is consumed. It is here that much precious time is wasted, that is, in the morning, when the mind is composed and rested, and the body is made fit to begin new labors. There again many vain pleasures are enjoyed, both by the mind in imagining impossible things, and by the body in taking those pleasures that are often the cause of the failing of life. And for these reasons the reed is held as their support.

[4]

{a} *Evil thinking is either Envy or Ingratitude.*

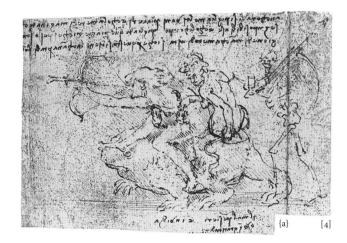

{a} [4]

{a}

{b}

{d}

{c} [5]

[5]
Truth—the sun.

Falsehood—a mask.

Innocence

Malignity.

{a} *Fire destroys falsehood—that is, sophistry—and restores truth, driving out darkness.*

{b} *Fire may be represented as the destroyer of all sophistry, and as the image and demonstration of truth; because it*

is light and drives out darkness, which conceals all essences [or subtle things].

Truth
{c} *Fire destroys all sophistry—that is, deceit—and maintains truth alone—that is, gold. Truth at last cannot be hidden. Dissimulation is of no avail. Dissimulation is to no purpose before so great a judge.*

{d} *Falsehood puts on a mask. Nothing is hidden under the sun. Fire is to represent truth because it destroys all sophistry and lies; and the mask is for lying and falsehood which conceal truth.*

[6]

{a} *No sooner is Virtue born than Envy comes into the world to attack it; and sooner will there be a body without a shadow than Virtue without Envy.*

{b} *Envy must be represented with a contemptuous motion of the hand towards heaven, because if she could she would use her strength against God; make her with her face covered by a mask of fair seeming; show her as wounded in the eye by a palm branch and by an* olive-branch, *and wounded in the ear by laurel and myrtle, to signify that victory and truth are odious to her. Many thunderbolts should proceed from her to signify her evil speaking. Let her be lean and haggard because she is in perpetual torment. Make her heart gnawed by a swelling serpent, and make her with a quiver with tongues serving as arrows, because she often offends with it. Give her a leopard's skin, because this creature kills the lion out of envy and by deceit. Give her too a vase in her hand full of*

{b}

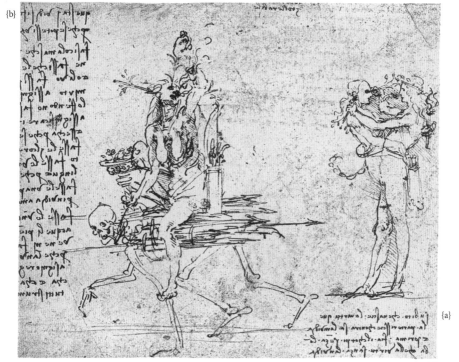

{a}

[6]

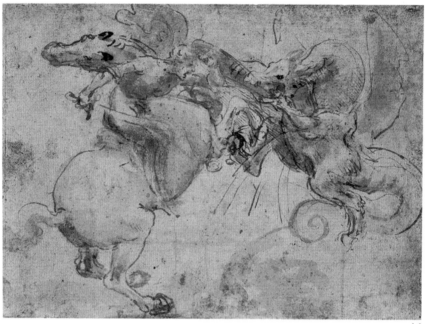

flowers and scorpions and toads and other venomous creatures; make her ride upon death, because Envy, never dying, never tires of ruling. Make her bridle, and load her with diverse kinds of arms because all her weapons are deadly.

You know that you cannot invent animals without limbs, each of which, in itself, must resemble those of some other animal. Hence if you wish to make an animal, imagined by you, appear natural—let us say a Dragon—take for its head that of a mastiff or hound, with the eyes of a cat, the ears of a porcupine, the nose of a greyhound, the brow of a lion, the temples of an old cock, the neck of water tortoise.

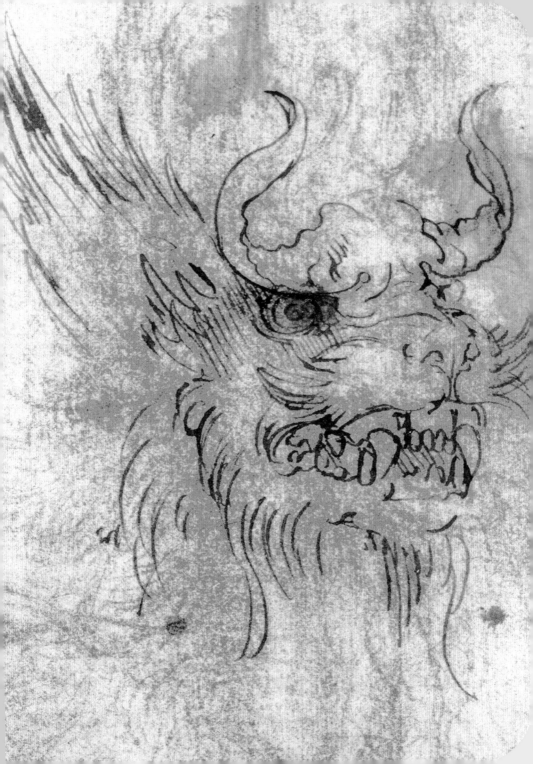

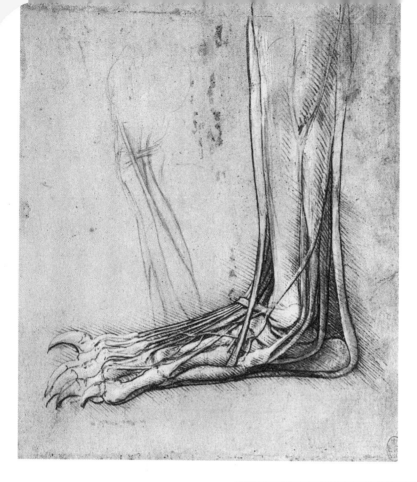

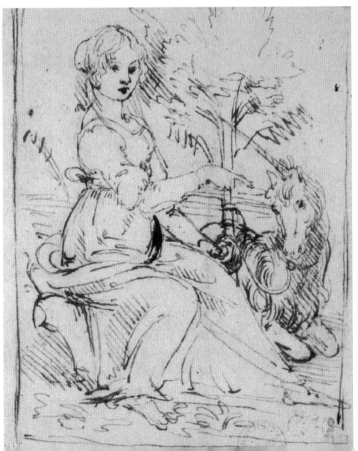

[8]
Of grotesque faces I need say nothing,
because they are kept in mind without
diffculty.

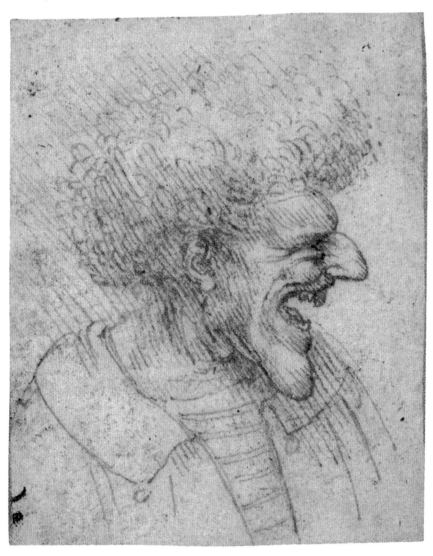

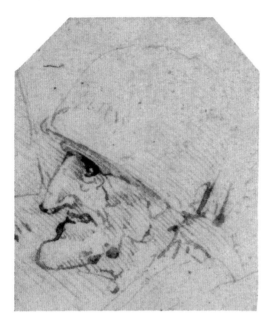

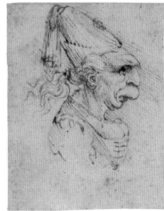

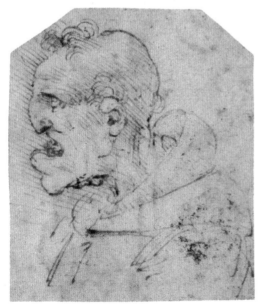

Studies and Sketches 171

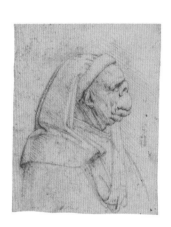

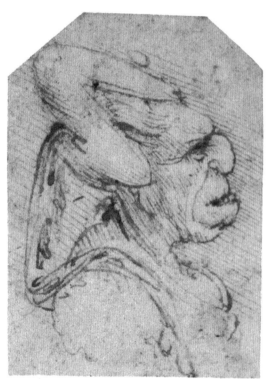

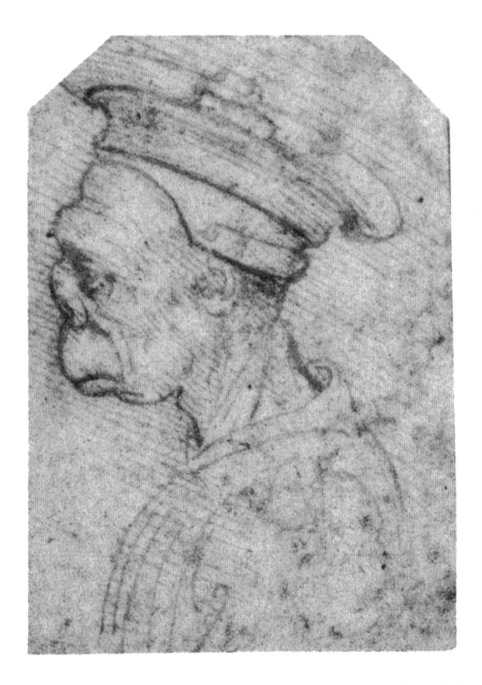

Part II

Observations and Order

The Renaissance concept of man as a microcosm of the larger universe had far-reaching implications. The search for correspondences between the human body and the world around us led Renaissance thinkers to posit parallels that seem more like poetic fancy than scientific inquiry to the modern reader.

Leonardo's extensive studies of structures, from human to cosmic, typify this approach to the world. The first chapter in this section, "Anatomy," shows his fascination with correspondences, whether between human and animal anatomy, or between the functioning of a body and social hierarchies. Human anatomy was, in a way, the basis from which all other observations flowed. Leonardo was a pioneer in this field, performing autopsies and dissections of corpses at a time when such empirical methods were frowned upon. But Leonardo recognized that in order to depict the human body accurately, one must first understand its underlying structures and organizing principles.

From there he moved on to man's immediate surroundings. "Botany and Landscape" highlights his observations on the environment, especially as they relate to pictorial depiction. In "Geography," he addresses the structures of the earth in anatomical terms, comparing the oceans to the blood and the soil to the flesh. This chapter also includes his exquisite maps of various regions of Italy and other countries, demonstrating his cartographic skills, as well as observations on rivers and land formations relevant to civil engineering.

In "Physical Sciences and Astronomy" we see the range of Leonardo's insatiable curiosity. From sophisticated discussions of force and motion to startlingly prescient thoughts on celestial bodies, this chapter shows the logical extension of the correlative framework that underlies much of Renaissance thinking.

The nerves with their muscles serve the tendons even as soldiers serve their leaders, and the tendons serve the common sense as the leaders their captain, and this common sense serves the soul as the captain serves his lord.

VI. Anatomy

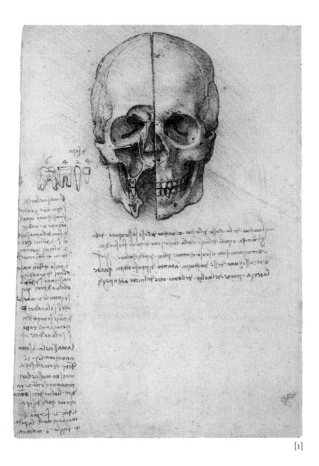

[1]
The divisions of the head are 10, viz. 5 external and 5 internal, the external are the hair, skin, muscle, fascia and the skull; the internal are the dura mater, the pia mater, [which enclose] the brain. The pia mater and the dura mater come again underneath and enclose the brain; then the rete mirabile, and the occipital bone, which supports the brain from which the nerves spring.

It is necessary to a painter that he should know the intrinsic forms [and structure] of man. The painter who is familiar with the nature of the sinews, muscles, and tendons, will know very well, in giving movement to a limb, how many and which sinews cause it; and which muscle, by swelling, causes the contraction of that sinew; and which sinews, expanded into the thinnest cartilage, surround and support the said muscle. Thus he will variously and constantly demonstrate the different muscles by means of the various attitudes of his figures, and will not do, as many who, in a variety of movements, still display the very same things [modeling] in the arms, back, breast, and legs. And these things are not to be regarded as minor faults.

There are eleven elementary tissues: cartilage, bones, nerves, veins, arteries, fascia, ligament and sinews, skin, muscle, and fat.

Describe which muscles disappear in growing fat, and which become visible in growing lean.

And observe that that part which on the surface of a fat person is most concave, when he grows lean becomes more prominent.

Where the muscles separate one from another you must give profiles and where they coalesce.

It often occurs that two muscles are joined together although they have to serve two limbs; and this has been done so that if one muscle were incapacitated by some injury the other muscle in part supplied the place of that which was lacking.

Remember that to be certain of the point of origin of any muscle, you must pull the sinew from which the muscle springs in such a way as to see that muscle move, and where it is attached to the ligaments of the bones.

You will never get any thing but confusion in demonstrating the muscles and their positions, origin, and termination, unless you first make a demonstration of thin muscles after the manner of linen threads; and thus you can represent them, one over another as nature has placed them; and thus, too, you can name them according to the limb they serve.

I have removed the skin from a man who was so shrunk by illness that the muscles were worn down and remained in a state like thin membrane, in such a way that the sinews instead of merging in muscles ended in wide membrane; and where the bones were covered by the skin they had very little over their natural size.

The body of any thing whatever that takes nourishment constantly dies and is constantly renewed; because nourishment can only enter into places where

the former nourishment has expired, and if it has expired it no longer has life. And if you do not supply nourishment equal to the nourishment that is gone, life will fail in vigor, and if you take away this nourishment, the life is entirely destroyed.

But if you restore as much is destroyed day by day, then as much of the life is renewed as is consumed, just as the flame of the candle is fed by the nourishment afforded by the liquid of this candle, which flame continually with a rapid supply restores to it from below as much as is consumed in dying above, and from a brilliant light is converted in dying into murky smoke. And this death is continuous, as the smoke is continuous. And the continuance of the smoke is equal to the continuance of the nourishment, and in the same instant all the flame is dead and all regenerated, simultaneously with the movement of its own nourishment.

[2]

Of the cause of breathing, of the cause of the motion of the heart, of the cause of vomiting, of the cause of the descent of food from the stomach, of the cause of emptying the intestines.

Of the cause of the movement of the superfluous matter through the intestines.

Of the cause of swallowing, of the cause of coughing, of the cause of yawning, of the cause of sneezing, of the cause of limbs getting asleep.

Of the cause of losing sensibility in any limb.

Of the cause of tickling.

Of the cause of lust and other appetites of the body, of the cause of urine and also of all the natural excretions of the body

[2]

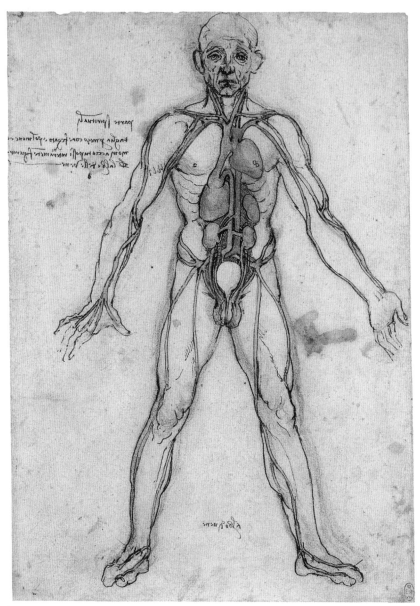

[3]

[3]

This depicting of mine of the human body will be as clear to you as if you had the natural man before you; and the reason is that if you wish thoroughly to know the parts of man, anatomically, you—or your eye—require to see it from different aspects, considering it from below and from above and from its sides, turning it about and seeking the origin of each member; and in this way the natural anatomy is suffcient for your comprehension.

But you must understand that this amount of knowledge will not continue to satisfy you; seeing the very great confusion that must result from the combination of tissues, with veins, arteries, nerves, sinews, muscles, bones, and blood, which, of itself, tinges every part the same color. And the veins, which discharge this blood, are not discerned by reason of their smallness. Moreover integrity of the tissues, in the process of the investigating the parts within them, is inevitably destroyed, and their transparent substance being tinged with blood does not allow you to recognize the parts covered by them, from the similarity of their blood-stained hue; and you cannot know everything of the one without confusing and destroying the other.

Hence, some further anatomy drawings become necessary. Of which you want three to give full knowledge of the veins and arteries, everything else being destroyed with the greatest care. And three others to display the tissues; and three for the sinews and muscles and ligaments; and three for the bones and cartilages; and three for the anatomy of the bones, which have to be sawn to show which are hollow and which are not, which have marrow and which are spongy, and which are thick from the outside inwards, and which are thin. And some are extremely thin in some parts and thick in others, and in some parts hollow or filled up with bone, or full of marrow, or spongy. And all these conditions are sometimes found in one and the same bone, and in some bones none of them.

And three you must have for the woman, in which there is much that is mysterious by reason of the womb and the fetus. Therefore by my drawings every part will be known to you, and all by means of demonstrations from three different points of view of each part; for when you have seen a limb from the front, with any muscles, sinews, or veins which take their rise from the opposite side, the same limb will be shown to you in a side view or from behind, exactly as if you had that same limb in your hand and were turning it from side to side until you had acquired a full comprehension of all you wished to know. In the same way there will be put before you three or four demonstrations of each limb, from various points of view, so that you will be left with a true and complete knowledge of all you wish to learn of the human figure.

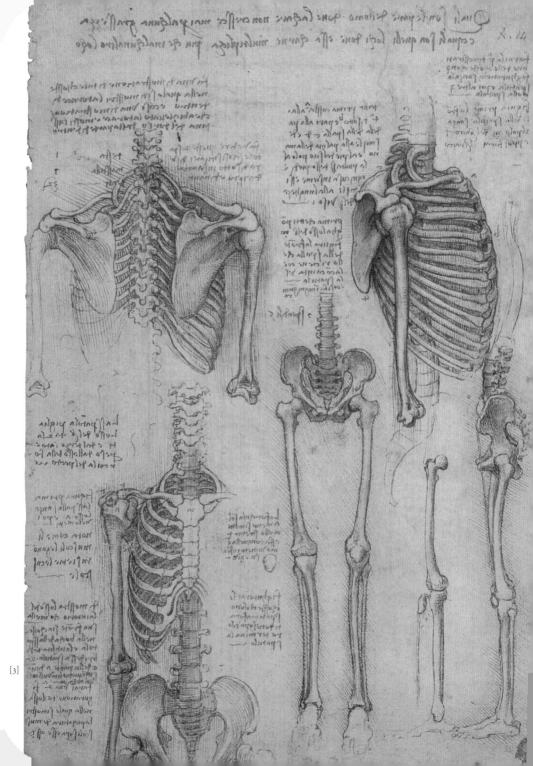

[3]

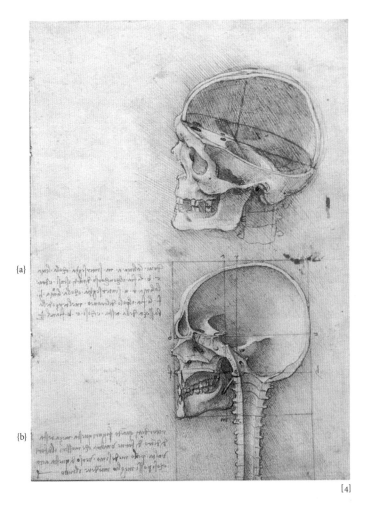

{a}

{b}

[4]

[4]

{a} *Where the line a m intersects the line c b there will be the meeting place of all the senses; and where the line r n intersects the line h f there will be the axis of the cranium in the third of the divisions of the head.*

{b} *Remember when you represent this half head from the inside to make another which shall show the outside turned in the same direction as this, so that you may better apprehend the whole.*

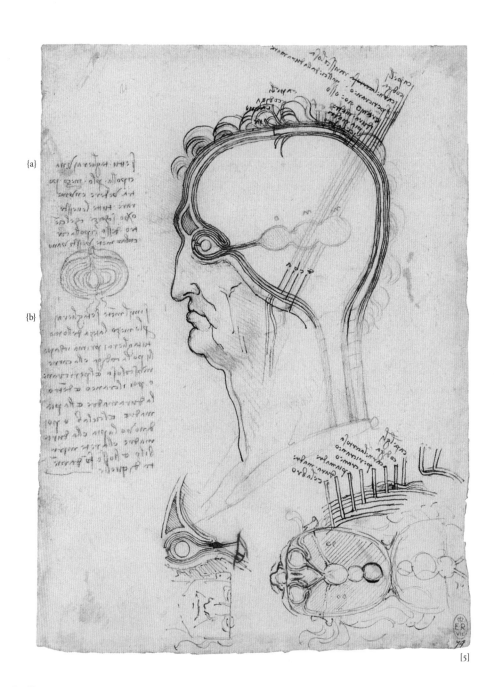

{a}

{b}

[5]

[5]

{a} *If you cut an onion down the center you will be able to see and count all the coatings or rinds that form concentric circles round the center of this onion.*

{b} *Similarly if you cut a man's head down the center you will cut through the hair first, then the skin and the muscular flesh and the pericranium, then the cranium and within the dura mater and the pia mater and the brain, then the pia and dura mater again and the rete mirabile and the bone, which is the foundation of these.*

[6]

{a} *Make the rule and give the measurement of each muscle, and give the reasons of all their functions, and in which way they work and what makes them work, etc.*

{b} *First draw the spine of the back; then clothe it by degrees, one after the other, with each of its muscles and put in the nerves and arteries and veins to each muscle by itself; and besides these note the vertebrae to which they are attached; which of the intestines come in contact with them; and which bones and other organs, etc.*

{a}

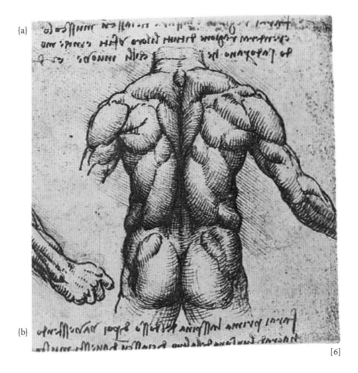

{b}

[6]

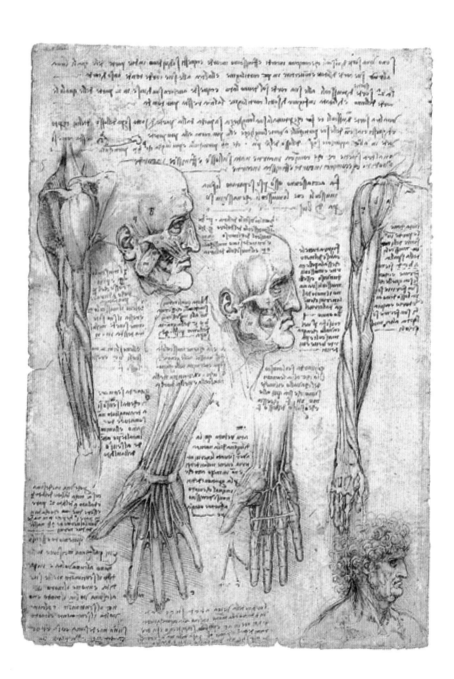

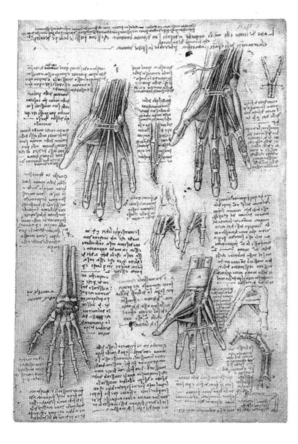

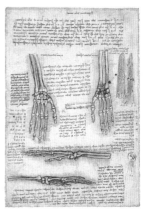

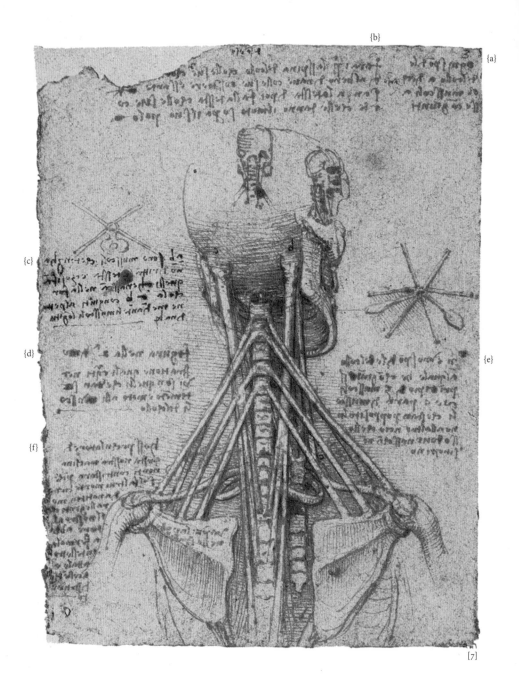

{a} Each of the vertebrae of the neck has ten muscles joined to it.

{b} You should show first the spine of the neck with its tendons like the mast of a ship with its shrouds without the head; then make the head with its tendons, which give it its motion upon its axis.

{c} a b are muscles that keep the head upright, and so do those that originate in the clavicle, c b, joined to the pubis by means of the longitudinal muscles.

{d} Show in the second demonstration which and how many are the nerves that give sensation and movement to the muscles of the neck.

{e} n is one of the vertebra of the neck to which is joined the beginning of three muscles, that is, of three pairs of muscles that are opposite each other, so that the bone where they have their origin may not break.

{f} O speculator! Concerning this machine of ours, let it not distress you that you impart knowledge of it through another's death, but rejoice that our Creator has ordained the intellect to such excellence of perception.

The lung is always full of a quantity of air, even when it has driven out that air which is necessary for its exhalation; and when it is refreshed by new air it presses on the sides of the chest, dilates them a little and pushes them outwards, for as may be seen and felt by placing the hand upon the chest during its breathing, the chest expands and contracts, and even more so when one heaves a big sigh.

For nature has so willed that this force should be created in the ribs of the chest and not in the membrane that ends the substance of the lung, lest by an excessive ingathering of air, in order to form some unusually deep sigh, this membrane may come to break and burst itself.

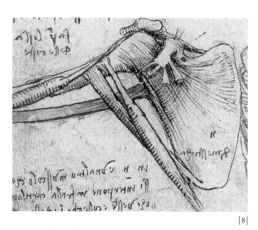

[8]

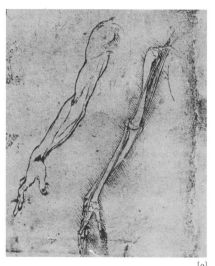

[9]

[8]

All the muscles that start at the shoulders, the shoulder-blade, and the chest, serve for the movement of the arm from the shoulder to the elbow. And all the muscles that start between the shoulder and the elbow, serve for the movement of the arm between the elbow and the hand. And all the muscles that start between the elbow and the hand, serve for the movement of the hand. And all the muscles that start in the neck, serve for the movement of the head and shoulders.

[9]

The arm, which has the two bones that interpose between the hand and the elbow, will be somewhat shorter when the palm of the hand is turned towards the ground than when it is turned towards the sky, if the man is standing on his feet with his arm extended. And this occurs because these two bones, in turning the palm of the hand towards the ground, come to intersect in such a way that that which proceeds from the right side of the elbow goes towards the left side of the palm of the hand, and that which proceeds from the left side of the elbow ends on the right side of the palm of this hand.

The arm is composed of thirty pieces of bone, because there are three in the arm itself and twenty-seven in the hand.

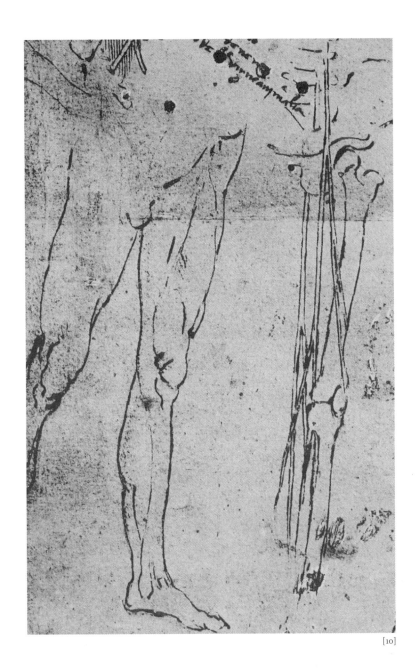

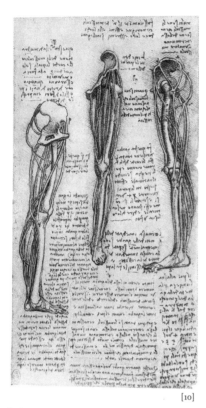

[10]

the leg so many and the feet so many and the toes so many. Then you should say: so many are the muscles that start from the bones and end in the bones, and so many are those that start from the bones and end in another muscle. In this way you describe every detail of each limb, and especially as regards the ramifications made by certain muscles in producing different tendons.

These four legs should be on one and the same sheet of paper so that you may be the better able to understand the positions of the muscles and to recognize them from different sides.

❦

The tendons that lower the toes of the feet start from the muscles that have their beginning in the sole of this foot; but the tendons that raise these toes do not have their beginning in the outer part of the thigh as some have written, but they start in the upper part of the foot called the instep. And if you desire to make certain of this, clasp the thigh with your hands a little above the knee and raise the toes of the feet, and you will perceive that the flesh of your thigh will not have any movement in it in its tendons or muscles; so it is quite true.

❦

The pieces of the bone of which a man's foot is composed number twenty-seven, taking into account the two that are beneath the base of the great toe of the foot.

[10]

The immediate causes of the movements of the legs are entirely separated from the immediate cause of the movement of the thigh, and this is what makes the power.

When you have finished the bones of the legs put the number of all the bones, and at the end of the tendons set down the number of these tendons. And you should do the same with the muscles, the sinews, the veins and arteries, saying: the thigh has so many, and

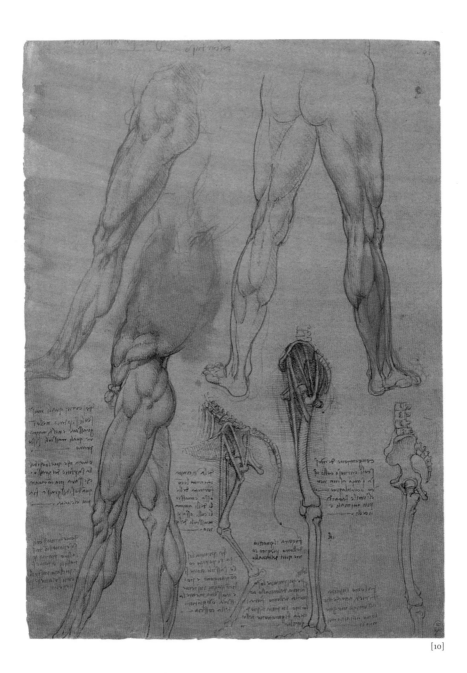

[11]

{a} Here I make a note to demonstrate the difference there is between man and the horse and in the same way with other animals. And first I will begin with the bones, and then will go on to all the muscles that spring from the bones without tendons and end in them in the same way, and then go on to those that start with a single tendon at one end.

[12]

The walking of man is always after the universal manner of walking in animals with 4 legs, inasmuch as just as they move their feet crosswise after the manner of a horse in trotting, so man moves his 4 limbs crosswise; that is, if he puts forward his right foot in walking he puts forward, with it, his left arm and vice versa, invariably.

《

The eyes of all animals have their pupils adapted to dilate and diminish of their own accord in proportion to the greater or less light of the sun or other luminary. But in birds the variation is much greater; and particularly in nocturnal birds, such as horned owls, and in the eyes of one species of owl; in these the pupil dilates in such a way as to occupy nearly the whole eye, or diminishes to the size of a grain of millet, and always preserves the circular form.

But in the Lion tribe, as panthers, leopards, ounces, tigers, lynxes, Spanish cats and other similar animals the pupil

{a}

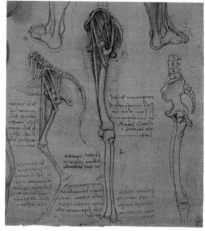

[11]

[12]

diminishes from the perfect circle to the figure of a pointed oval such as is shown in the margin. But man, having a weaker sight than any other animal, is less hurt by a very strong light and his pupil increases but little in dark places.

But in the eyes of these nocturnal animals, the horned owl—a bird that is the largest of all nocturnal birds—the power of vision increases so much that in the faintest nocturnal light (which we call darkness) it sees with much more distinctness than we do in the splendor of noonday, at which time these birds remain hidden in dark holes; or if indeed they are compelled to come out into the open air lighted up by the sun, they contract their pupils so much that their power of sight diminishes together with the quantity of light admitted.

《

I have found that in the composition of the human body as compared with the bodies of animals the organs of sense are duller and coarser. Thus it is composed of less ingenious instruments, and of spaces less capacious for receiving the faculties of sense. I have seen in the Lion tribe that the sense of smell is connected with part of the substance of the brain that comes down the nostrils, which form a spacious receptacle for the sense of smell, which enters by a great number of cartilaginous vesicles with several passages leading up to where the brain, as before said, comes down.

The eyes in the Lion tribe have a large part of the head for their sockets and the optic nerves communicate at once with the brain; but the contrary is to be seen in man, for the sockets of the eyes are but a small part of the head, and the optic nerves are very fine and long and weak, and by the weakness of their action we see by day but badly at night, while these animals can see as well at night as by day. The proof that they can see is that they prowl for prey at night and sleep by day, as nocturnal birds do also.

[13]
{a} In the case of this child the heart does not beat and it does not breathe because it lies continually in water. And if it were to breathe it would be drowned, and breathing is not necessary to it because it receives life and is nourished from the life and food of the mother. And this food nourishes such a creature in just the same way as it does the other parts of the mother, namely the hands, feet, and other members. And a single soul governs these two bodies, and the desires and fears and pains are common to this creature as to all the other animated members.

And from this it proceeds that a thing desired by the mother is often found engraved upon those parts of the child that the mother keeps in herself at the time of such desire; and a sudden fear kills both mother and child. We conclude therefore that a single soul governs the bodies and nourishes the two [bodies].

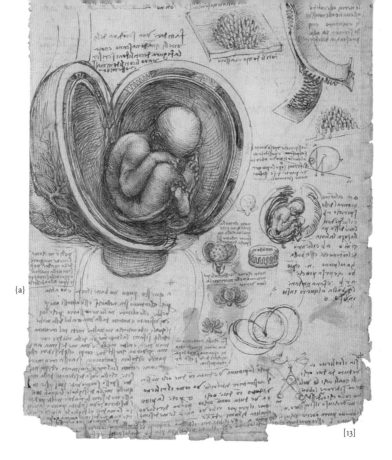

{a}

[13]

〘

The soul apparently resides in the seat of the judgment, and the judgment apparently resides in the place where all the senses meet, which is called the common sense.

〘

[Nature] puts the soul into the body which forms [the child]; that is the soul of the mother, which first constructs in the womb the form of the man and in due time awakens the soul that is to inhabit it. And this at first lies dormant and under the tutelage of the soul of the mother, who nourishes and vivifies it by the umbilical vein, with all its spiritual parts, and this happens because this umbilicus is joined to the placenta and the cotyledons, by which the child is attached to the mother. And these are the reason why a wish, a strong craving or a fright, or any other mental suffering in the mother, has more influence on the child than on the mother.

[14]
I wish to work miracles; it may be that I shall possess less than other men of more peaceful lives, or than those who want to grow rich in a day. I may live for a long time in great poverty, as always happens, and to all eternity will happen, to alchemists, the would-be creators of gold and silver, and to engineers who would have dead water stir itself into life and perpetual motion, and to those supreme fools, the necromancer and the enchanter.

And you, who say that it would be better to watch an anatomist at work than to see these drawings, you would be right, if it were possible to observe all the things that are demonstrated in such drawings in a single figure, in which you, with all your cleverness, will not see nor obtain knowledge of more than some few veins, to obtain a true and perfect knowledge of which I have dissected more than ten human bodies, destroying all the other members, and removing the very minutest particles of the flesh by which these veins are surrounded, without causing them to bleed, excepting the insensible bleeding of the capillary veins. And as one single body would not last so long, since it was necessary to proceed with several bodies by degrees, until I came to an end and had a complete knowledge; this I repeated twice, to learn the differences.

And if you should have a love for such things you might be prevented by loathing, and if that did not prevent you, you might be deterred by the fear of living in the night hours in the company of those corpses, quartered and flayed and horrible to see. And if this did not prevent you, perhaps you might not be able to draw so well as is necessary for such a demonstration; or, if you had the skill in drawing, it might not be combined with knowledge of perspective; and if it were so, you might not understand the methods of geometrical demonstration and the method of the calculation of forces and of the strength of the muscles; patience also may be wanting, so that you lack perseverance. As to whether all these things were found in me or not, the hundred and twenty books composed by me will give verdict Yes or No. In these I have been hindered neither by avarice nor negligence, but simply by want of time.

❆

Though human ingenuity may make various inventions, it will never devise any inventions more beautiful, nor more simple, nor more to the purpose than Nature does; because in her inventions nothing is wanting, and nothing is superfluous, and she needs no counterpoise when she makes limbs proper for motion in the bodies of animals.

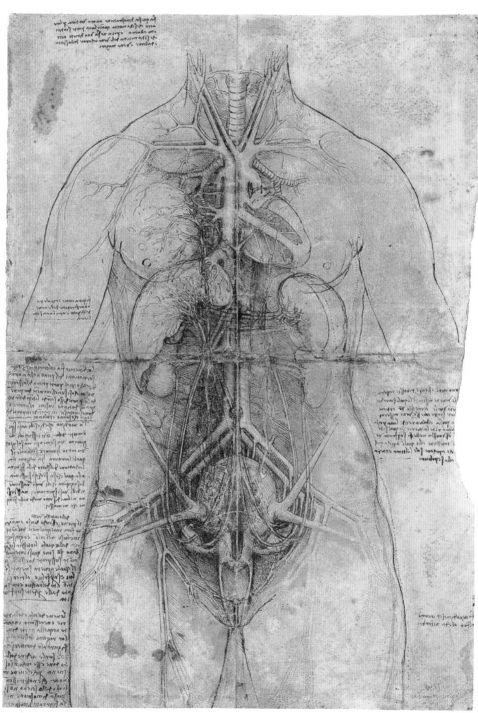

[14]

The definition of the soul I leave to the imaginations of friars, those fathers of the people who know all secrets by inspiration. I leave alone the sacred books; for they are supreme truth.

☾

Natural heat keeps blood in the veins at the top of the man, and when the man has died this blood becomes cold and is brought back into the low parts, and as the sun warms the man's head the amount of blood there increases, and it grows to such an excess there with the humors as to overload the veins and frequently to cause pains in the head.

It is the same with the springs that ramify through the body of the earth and, by the natural heat which is spread through all the body that contains them, the water stays in the springs and is raised to the high summits of the mountains. And the water that passes through a pent-up channel within the body of the mountain like a dead thing will not emerge from its first low state, because it is not warmed by the vital heat of the first spring. Moreover the warmth of the element of fire, and by day the heat of the sun, have power to stir up the dampness of the low places and draw this to a height in the same way as it draws the clouds and calls up their moisture from the expanses of the sea.

☾

Man has been called by the ancients a lesser world, and indeed the term is rightly applied, seeing that if man is compounded of earth, water, air, and fire, this body of the earth is the same. As man has within himself bones as a stay and framework for the flesh, so the world has the rocks that are the supports of the earth. As man has within him a pool of blood wherein the lungs as he breathes expand and contract, so the body of the earth has its ocean, that also rises and falls every six hours with the breathing of the world. As from the said pool of blood proceed the veins that spread their branches through the human body, in just the same manner the ocean fills the body of the earth with an infinite number of veins of water.

In this body of the earth there is lacking, however, the sinews, and these are absent because sinews are created for the purpose of movement. As the world is perpetually stable within itself no movement ever takes place there, and in the absence of any movement the sinews are not necessary. But in all other things man and the world show a great resemblance.

The sun gives spirit and life to plants, and the earth nourishes them with moisture.

VII. Botany and Landscape

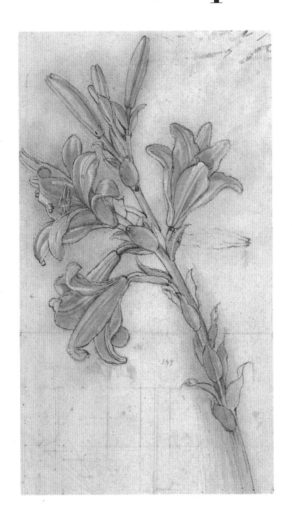

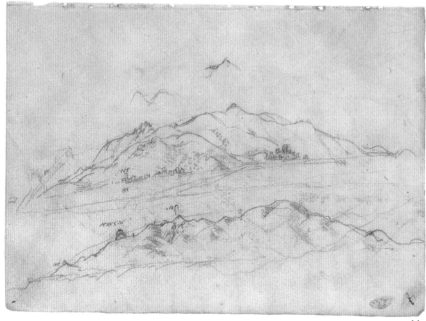

[1]

☾

Landscapes ought to be represented so that the trees are half in light and half in shadow; but it is better to make them when the sun is covered by clouds, for then the trees are lighted up by the general light of the sky and the general shadow of the earth; and these are so much darker in their parts, in proportion as these parts are nearer to the middle of the tree and to the earth.

[1]

The landscape has a finer azure [tone] when, in fine weather the sun is at noon than at any other time of the day, because the air is purified of moisture; and looking at it under that aspect you will see the trees of a beautiful green at the outside and the shadows dark towards the middle; and in the remoter distance the atmosphere that comes between you and them looks more beautiful when there is something dark beyond. And still the azure is most beautiful.

The objects seen from the side on which the sun shines will not show you their shadows. But, if you are lower than the sun, you can see what is not seen by the sun and that will be all in shade. The leaves of the trees, which come between you and the sun are of two principal colors that are a splendid luster of green,

and the reflection of the atmosphere that lights up the objects that cannot be seen by the sun, and the shaded portions that only face the earth, and the darkest which are surrounded by something that is not dark.

The trees in the landscape that are between you and the sun are far more beautiful than those you see when you are between the sun and them; and this is so because those that face the sun show their leaves as transparent towards the ends of their branches, and those that are not transparent—that is, at the ends—reflect the light; and the shadows are dark because they are not concealed by anything.

The trees, when you place yourself between them and the sun, will only display to you their light and natural

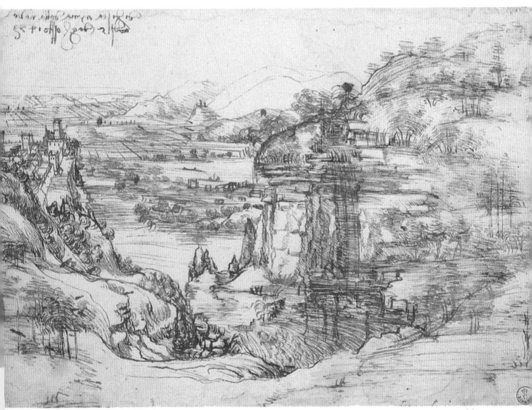

[1]

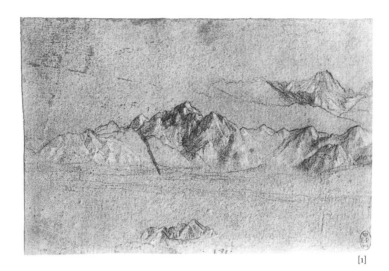

[1]

color, which, in itself, is not very strong, and, besides this, some reflected lights which, being against a background that does not differ very much from themselves in tone, are not conspicuous; and if you are lower down than they are situated, they may also show those portions on which the light of the sun does not fall and these will be dark.

But, if you are on the side whence the wind blows, you will see the trees look very much lighter than on the other sides, and this happens because the wind turns up the under side of the leaves, which, in all trees, is much whiter than the upper sides; and more especially, will they be very light indeed if the wind blows from the quarter where the sun is, and if you have your back turned to it.

«

In landscapes that represent [a scene in] winter, the mountains should not be shown blue, as we see in the mountains in the summer.

Among mountains seen from a great distance those will look of the bluest color that are in themselves the darkest; hence when the trees are stripped of their leaves, they will show a bluer tinge that will be in itself darker. Therefore, when the trees have lost their leaves they will look of a gray color, while, with their leaves, they are green. And in proportion as the green is darker than the gray hue, the green will be of a bluer tinge than the gray.

And also, the shadows of trees covered with leaves are darker than the shadows of those trees that have lost their leaves in proportion as the trees

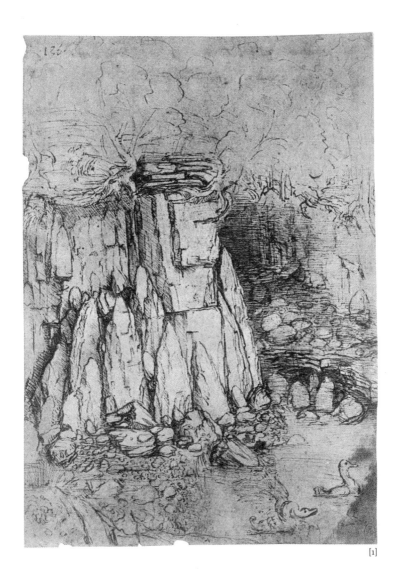

[1]

covered with leaves are denser than those without leaves—and thus my meaning is proved.

The definition of the blue color of the atmosphere explains why the landscape is bluer in the summer than in the winter.

I once made the experiment of leaving only one small root on a gourd and keeping this nourished with water; and the gourd brought to perfection all the fruits that it could produce, which were about sixty gourds of the long species. I set myself diligently to consider the source of its life, and I perceived that it was the dew of the night, which steeped it abundantly with its moisture through the joints of its great leaves, and thereby nourished the tree and its offspring, or rather the seeds that were to produce its offspring.

The rule as to the leaves produced on the last of the year's branches is that on twin branches they will grow in a contrary direction, that is, that the leaves in their earliest growth turn themselves round towards the branch, in such a way that the sixth leaf above grows over the sixth leaf below; and the manner of their turning is that if one turns towards its fellow on the right, the other turns to the left.

The leaf serves as a breast to nourish the branch or fruit that grows in the succeeding year.

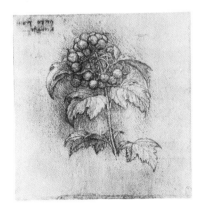

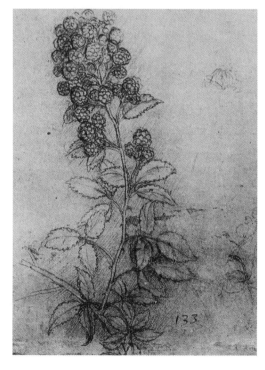

Describe landscapes with the wind, and the water, and the setting and rising of the sun.

All the leaves that hung towards the earth by the bending of the shoots with their branches, are turned up side down by the gusts of wind, and here their perspective is reversed; for, if the tree is between you and the quarter of the wind, the leaves that are towards you remain in their natural aspect, while those on the opposite side that ought to have, by being turned over, their points turned towards you.

Of the lights of dark leaves, the lights on such leaves that are darkest in color will most closely resemble the color of the atmosphere reflected in them. And this is due to the fact that the brightness of the illuminated part mingling with the darkness forms of itself a blue color. This brightness proceeds from the blue of the atmosphere, which is reflected in the smooth surface of these leaves, thereby adding to the blueness that this light usually produces when it falls upon dark objects.

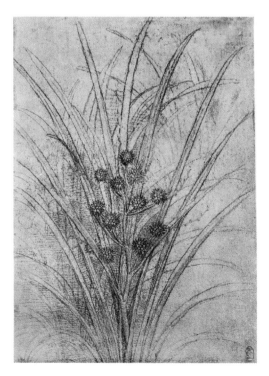

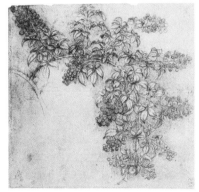

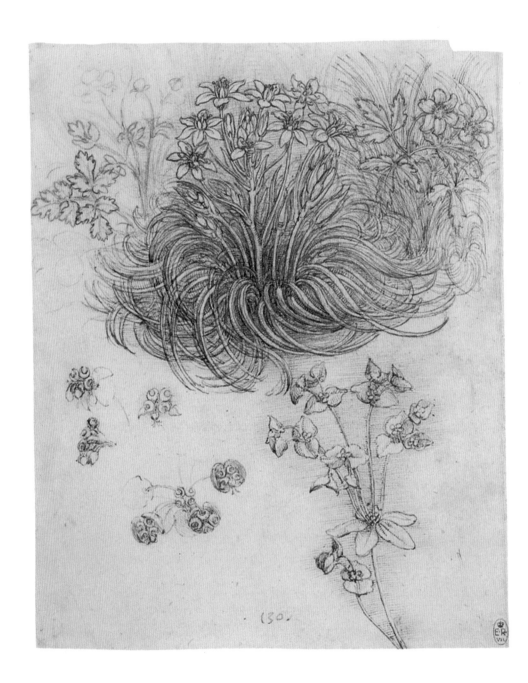

. 130.

But leaves of yellowish green do not, when they reflect the atmosphere, create a reflection that verges on blue; for every object when seen in a mirror takes in part the color of this mirror; therefore the blue of the atmosphere reflected in the yellow of the leaf appears green, because blue and yellow mixed together form a most brilliant green, and therefore the luster on light leaves that are yellowish in color will be a greenish yellow.

《

If m is the luminous body that lights up the leaf s, all the eyes that see the underside of the leaf will see it of a very beautiful light green because it is transparent. There will be many occasions when the positions of the leaves will be without shadows, and they will have the underside transparent and the right side shining.

The willow and other similar trees, which are pollarded every third or fourth year, put out very straight branches. Their shadow is towards the center where these branches grow, and near their extremities they cast but little shade because of their small leaves and few and slender branches.

Therefore the branches that rise towards the sky will have but little shadow and little relief, and the branches that point downwards towards the horizon spring from the dark part of the shadow. And they become clearer by degrees down to their extremities, and show themselves in strong relief being in varying stages of brightness against a background of shadow.

That plant will have least shadow which has fewest branches and fewest leaves.

[2]

All the branches of a tree at every stage of its height, when put together, are equal in thickness to the trunk [below them].

All the branches of a water [course] at every stage of its course, if they are of equal rapidity, are equal to the body of the main stream.

That portion of a tree which is farthest from the force that strikes it is the most injured by the blow because it bears most strain. Thus nature has foreseen this case by thickening them in that part where they can be most hurt; and most in such trees as grow to great great heights, as pines and the like.

[2]

《

In the composition of leafy trees be careful not to repeat too often the same color of one tree against the same color of another [behind it]; but vary it with a lighter, or a darker, or a stronger green.

[3]
Every year when the boughs of a plant [or tree] have made an end of maturing their growth, they will have made, when put together, a thickness equal to that of the main stem; and at every stage of its ramification you will find the thickness of the said main stem; as: i k, g h, e f, c d, a b, will always be equal to each other; unless the tree is pollard—if so the rule does not hold good.

All the branches have a direction that tends to the center of the tree m.

[4]
Every branch participates of the central shadow of every other branch and consequently [of that] of the whole tree. The form of any shadow from a branch or tree is circumscribed by the light that falls from the side whence the light comes; and this illumination gives the shape of the shadow, and this may be of the distance of a mile from the side where the sun is.

[3]

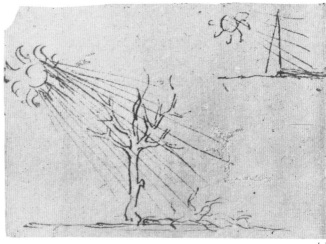

[4]

[6]

[5]

[6]

When the branches that grow the second year above the branch of the preceding year, are not of equal thickness above the antecedent branches, but are on one side, then the vigor of the lower branch is diverted to nourish the one above it, although it may be somewhat on one side.

But if the ramifications are equal in their growth, the veins of the main stem will be straight [parallel] and equidistant at every degree of the height of the plant.

{a} Wherefore, O Painter! you, who do not know these laws! In order to escape the blame of those who understand them, it will be well that you should represent every thing from nature, and not despise such study as those do who work [only] for money.

《

In general almost all the upright portions of trees curve somewhat turning the convexity towards the South; and their branches are longer and thicker and more abundant towards the South than towards the North. And this occurs because the sun draws the sap towards that surface of the tree which is nearest to it.

And this may be observed if the sun is not screened off by other plants.

[5]

{a} *Such as the growth of the ramification of plants is on their principal branches, so is that of the leaves on the shoots of the same plant. These leaves have four modes of growing one above another. The first, which is the most general, is that the sixth always originates over the sixth below; the second is that two third ones above are over the two third ones below; and the third way is that the third above is over the third below. [The last is shown in the fourth sketch.]*

The space between the insertion of one leaf to the rest is half the extreme length of the leaf or somewhat less, for the leaves are at an interval that is about the third of the width of the leaf.

The elm has more leaves near the top of the boughs than at the base; and the broad [surface] of the leaves varies little as to [angle and] aspect.

☾

A leaf always turns its upper side towards the sky so that it may the better receive, on all its surface, the dew which drops gently from the atmosphere. And these leaves are so distributed on the plant as that one shall cover the other as little as possible, but shall lie alternately one above another as may be seen in the ivy that covers the walls. And this alternation serves two ends. The first is to leave intervals by which the air and sun may penetrate between them. The second reason is that the drops that fall from the first leaf may fall onto the fourth or—in other trees—onto the sixth.

In the position of the eye which sees that portion of a tree illuminated which turns towards the light, one tree will never be seen to be illuminated equally with the other. To prove this, let the eye be c which sees the two trees b d that are illuminated by the sun a; I say that this eye c will not see the light in the same proportion to the shade, in one tree as in the other. Because, the tree that is nearest to the sun will display so much the stronger shadow than the more distant one, in proportion as one tree is nearer to the rays of the sun that converge to the eye than the other; etc.

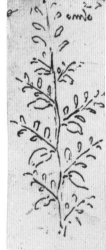

[7]

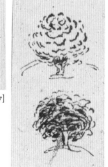

[8]

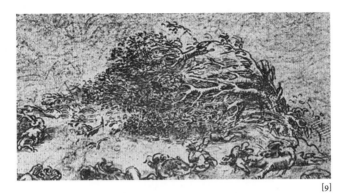

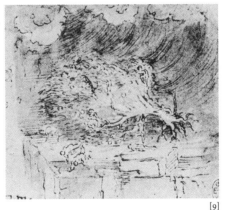

You see that the eye c sees nothing of the tree d but shadow, while the same eye c sees the tree b half in light and half in shade.

When a tree is seen from below, the eye sees the top of it as places within the circle made by its boughs.

Remember, O Painter! that the variety of depth of shade in any one particular species of tree is in proportion to the rarity or density of their branches.

[9]
Trees struck by the force of the wind bend to the side towards which the wind is blowing; and the wind being past they bend in the contrary direction, that is, in reverse motion.

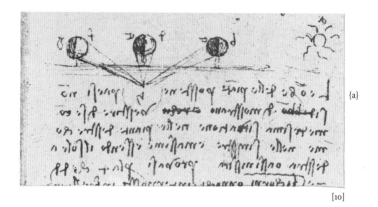

{a}

[10]

[10]

The shadows of trees placed in a land-scape do not display themselves in the same position in the trees on the right hand and those on the left; still more so if the sun is to the right or left. Opaque bodies placed between the light and the eye display themselves entirely in shadow.

{a} *The eye when placed between the opaque body and the light sees the opaque body entirely illuminated. When the eye and the opaque body are placed between darkness and light, it will be seen half in shadow and half in light.*

[11]

{a} *If the plant n grows to the thickness shown at m, its branches will correspond [in thickness] to the junction a b in consequence of the growth inside as well as outside.*

{b} *The branches of trees or plants have a twist wherever a minor branch is given off; and this giving off the branch forms a fork; this said fork occurs between two angles of which the largest will be that which is on the side of the larger branch, and in proportion, unless accident has spoilt it.*

☾

When a tree has had part of its bark stripped off, nature in order to provide for it supplies to the stripped por-tion a far greater quantity of nutritive moisture than to any other part. So that because of the first scarcity which has been referred to the bark there grows much more thickly than in any other place. And this moisture has such power of movement that after hav-ing reached the spot where its help is needed, it raises itself partly up like a ball rebounding, and makes various buddings and sproutings, somewhat after the manner of water when it boils.

Many trees planted in such a way as to touch, by the second year will have learnt how to dispense with the bark that grows between them and become grafted together; and by this method you will make the walls of the gardens continuous, and in four years you will even have very wide boards.

When many grains or seeds are sown so that they touch and are then covered by a board filled with holes the size of the seeds and left to grow underneath it, the seeds as they germinate will become fixed together and will form a beautiful clump. And if you mix seeds of different kinds together this clump will seem like jasper.

[11]

[12]

The willow and other similar trees, which have their boughs lopped every three or four years, put forth very straight branches, and their shadow is about the middle where these boughs spring; and towards the extreme ends they cast but little shade from having small leaves and few and slender branches.

Hence the boughs that rise towards the sky will have but little shade and little relief. And the branches that are at an angle from the horizon, downwards, spring from the dark part of the shadow and grow thinner by degrees up to their ends, and these will be in strong relief, being in gradations of light against a background of shadow.

That tree will have the least shadow which has the fewest branches and few leaves.

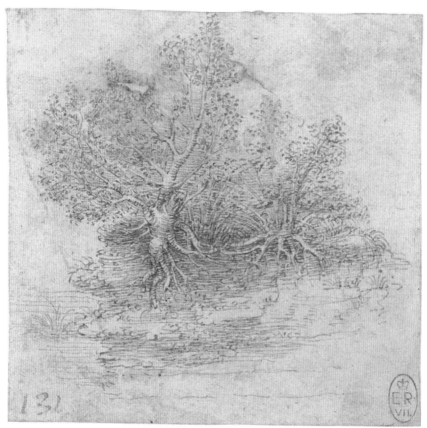

[12]

[13]
What outlines are seen in trees at a distance against the sky that serves as their background?

The outlines of the ramification of trees, where they lie against the illuminated sky, display a form that more nearly approaches the spherical on proportion as they are remote. And the nearer they are the less they appear in this spherical form; as in the first tree a which, being near to the eye, displays the true form of its ramification. But this shows less in b and is altogether lost in c, where not merely the branches of the tree cannot be seen but the whole tree is distinguished with difficulty.

The trees and plants that are most thickly branched with slender branches ought to have less dark shadow than those trees and plants that, having broader leaves, will cast more shadow.

[13]

[14]
When the leaves are interposed between the light and the eye, then that which is nearest to the eye will be the darkest, and the most distant will be the lightest, not being seen against the atmosphere. This is seen in the leaves which are away from the center of the tree; that is, towards the light.

[14]

[15]

{a} *That part of the body will be most illuminated which is hit by the luminous ray coming between right angles.*

☾

The colors of the shadows in mountains at a great distance take a most lovely blue, much purer than their illuminated portions. And from this it follows that when the rock of a mountain is reddish the illuminated portions are violet and the more they are lighted the more they display their proper color.

☾

In representing wind, besides the bending of the boughs and the reversing of their leaves towards the quarter whence the wind comes, you should also represent them amid clouds of fine dust mingled with the troubled air.

[16]

{a} *The clouds do not show their rounded forms excepting on the sides that face the sun; on the others the roundness is imperceptible because they are in the shade.*

{b} *If the sun is in the East and the clouds in the West, the eye placed between the sun and the clouds sees the edges of the rounded forms composing these clouds as dark, and the portions that are surrounded by this dark [edge] are light. And this occurs because the edges of the rounded forms of these clouds are turned towards the upper or lateral sky, which is reflected in them.*

{c} *Of the redness of the atmosphere near the horizon.*

{a}

[15]

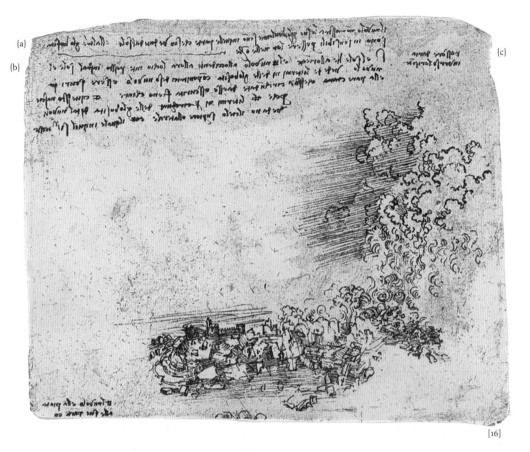

{a}

{b}

{c}

[16]

[17]

{a} *Both the cloud and the tree display no roundness at all on their shaded side.*

《

I have already been to see a great variety (of atmospheric effects). And lately over Milan towards Lago Maggiore I saw a cloud in the form of an immense mountain full of rifts of glowing light, because the rays of the sun, which was already close to the horizon and red, tinged the cloud with its own hue. And this cloud attracted to it all the little clouds that were near while the large one did not move from its place; thus it retained on its summit the reflection of the sunlight till an hour and a half after sunset, so immensely large was it; and about two hours after sunset such a violent wind arose, that it was really tremendous and unheard of.

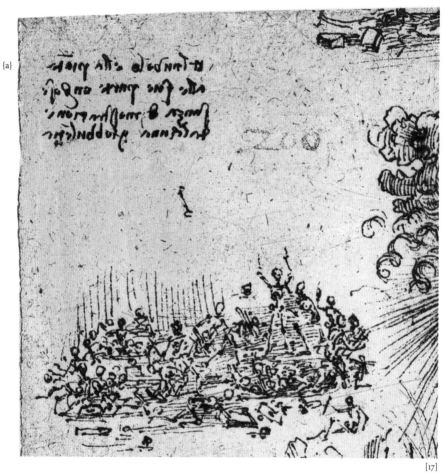

[17]

[18]

When clouds come between the sun and the eye all the upper edges of their round forms are light, and towards the middle they are dark, and this happens because towards the top these edges have the sun above them while you are below them; and the same thing happens with the position of the branches of trees; and again the clouds, like the trees, being somewhat transparent, are lighted up in part, and at the edges they show thinner.

But, when the eye is between the cloud and the sun, the cloud had the

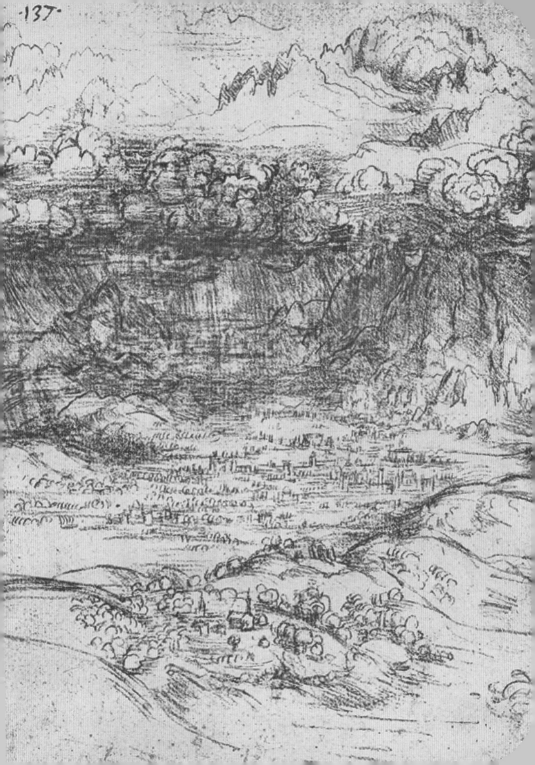

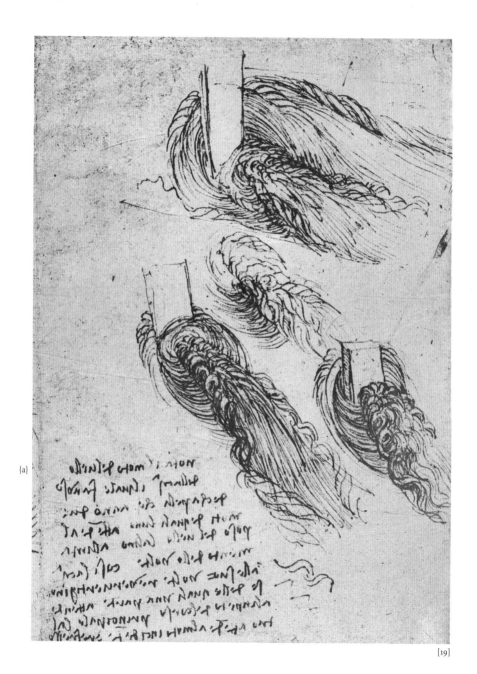

{a}

[19]

contrary effect to the former, for the edges of its mass are dark and it is light towards the middle. And this happens because you see the same side as faces the sun, and because the edges have some transparency and reveal to the eye that portion which is hidden beyond them, and which, as it does not catch the sunlight like that portion turned towards it, is necessarily somewhat darker. Again, it may be that you see the details of these rounded masses from the lower side, while the sun shines on the upper side and as they are not so situated as to reflect the light of the sun, as in the first instance they remain dark.

The black clouds, which are often seen higher up than those which are illuminated by the sun, are shaded by other clouds, lying between them and the sun.

Again, the rounded forms of the clouds that face the sun show their edges dark because they lie against the light background; and to see that this is true, you may look at the top of any cloud that is wholly light because it lies against the blue of the atmosphere, which is darker than the cloud.

[19]

Observe the motion of the surface of the water which resembles that of hair, and has two motions, of which one goes on with the flow of the surface, the other forms the lines of the eddies; thus the water forms eddying whirlpools one part of which are due to the impetus of the principal current and the other to the incidental motion and return flow.

Two weaknesses leaning together create a strength. Therefore the half of the world leaning against the other half becomes firm.

VIII. Geography

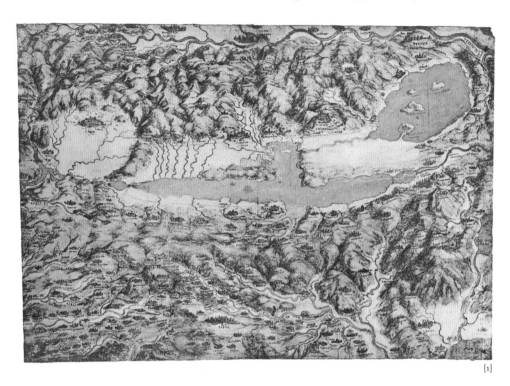

[1]

[1]
Nothing originates in a spot where there is no sentient, vegetable, and rational life; feathers grow upon birds and are changed every year; hairs grow upon animals and are changed every year, excepting some parts, like the hairs of the beard in lions, cats, and their like. The grass grows in the fields, and the leaves on the trees, and every year they are, in great part, renewed. So that we might say that the earth has a spirit of growth; that its flesh is the soil, its bones the arrangement and connection of the rocks of which the mountains are composed, its cartilage the tufa, and its blood the springs of water.

The pool of blood that lies round the heart is the ocean, and its breathing, and the increase and decrease of the blood in the pulses, is represented in the earth by the flow and ebb of the sea; and the heat of the spirit of the world is the fire that pervades the earth, and the seat of the vegetative soul is in the fires, which in many parts of the earth find vent in baths and mines of sulfur, and in volcanoes, as at Mount Etna in Sicily, and in many other places.

[2]

The water that rises in the mountains is the blood which keeps the mountain in life. If one of its veins be open either internally or at the side, nature, which assists its organisms, abounding in increased desire to overcome the scarcity of moisture thus poured out is prodigal there in diligent aid, as also happens with the place at which a man has received a blow. For one sees then how as help comes the blood increases under the skin in the form of a swelling in order to open the infected part.

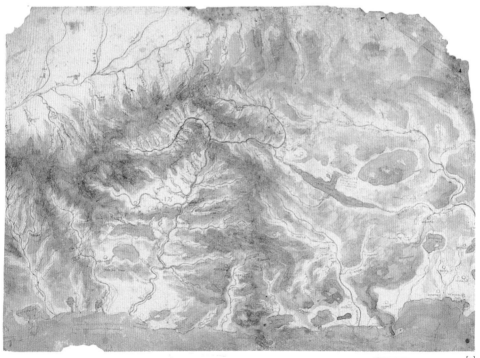

[2]

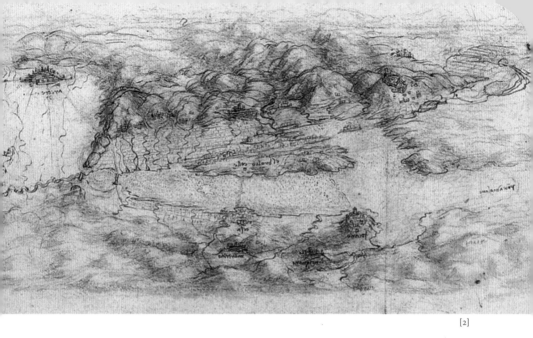

Similarly life being severed at the topmost extremity (of the mountain) nature sends her fluid from its lowest foundations up to the greatest height of the severed passage, and as this is poured out there it does not leave it bereft of vital fluid down to the end of its life.

《

I say that just as the natural heat of the blood in the veins keeps it in the head of man—for when the man is dead the cold blood sinks to the lower parts— and when the sun is hot on the head of a man the blood increases and rises so much, with other humors, that by pressure in the veins pains in the head are often caused; in the same way veins ramify through the body of the earth, and by the natural heat which is distrib- uted throughout the containing body,

the water is raised through the veins to the tops of mountains.

And this water, which passes through a closed conduit inside the body of the mountain like a dead thing, cannot come forth from its low place unless it is warmed by the vital heat of the spring time. Again, the heat of the element of fire and, by day, the heat of the sun have power to draw forth the moisture of the low parts of the moun- tains and to draw them up, in the same way as it draws the clouds and collects their moisture from the bed of the sea.

《

A river that flows from mountains deposits a great quantity of large stones in its bed, which still have some of their angles and sides, and in the course of its flow it carries down smaller stones with the angles more worn; that is to

say the large stones become smaller. And farther on it deposits coarse gravel and then smaller, and as it proceeds this becomes coarse sand and then finer, and going on thus the water, turbid with sand and gravel, joins the sea.

And the sand settles on the sea-shores, being cast up by the salt waves; and there results the sand of so fine a nature as to seem almost like water, and it will not stop on the shores of the sea but returns by reason of its lightness, because it was originally formed of rotten leaves and other very light things. Still, being almost—as was said—of the nature of water itself, it afterwards, when the weather is calm, settles and becomes solid at the bottom of the sea. There, by its fineness, it becomes compact and by its smoothness resists the waves that glide over it; and in this shells are found; and this is white earth, fit for pottery.

[3]

Every part of the depth of earth in a given space is composed of layers, and each layer is composed of heavier or lighter materials, the lowest being the heaviest. And this can be proved, because these layers have been formed by the sediment from water carried down to the sea, by the current of rivers that flow into it.

{a} The heaviest part of this sediment was that which was first thrown down, and so on by degrees; and this is the action of water when it becomes stagnant, having first brought down the mud

[3]

whence it first flowed. And such layers of
soil are seen in the banks of rivers, where
their constant flow has cut through them
and divided one slope from the other to
a great depth. Where in gravelly strata
the waters have run off, the materials
have, in consequence, dried and been
converted into hard stone. And this hap-
pened most in what was the finest mud;
whence we conclude that every portion
of the surface of the earth was once at the
center of the earth, and vice versa, etc.

❦

When nature is on the point of creating
stones it produces a kind of sticky paste,
which as it dries, forms itself into a
solid mass together with whatever it has
enclosed there, which, however, it does
not change into stone but preserves
within itself in the form in which it has
found them.

This is why leaves are found whole
within the rocks that are formed at the
bases of the mountains, together with
a mixture of different kinds of things,
just as they have been left there by
the floods from the rivers which have
occurred in the autumn seasons. And
there the mud caused by the successive
inundations has covered them over,
and then this mud grows into one mass
together with the aforesaid paste, and
becomes changed into successive layers
of stone, which correspond with the
layers of the mud.

[4]

Since things are much more ancient than
letters, it is no marvel if, in our day, no
records exist of these seas having covered
so many countries; and if, moreover,
some records had existed, war and
conflagrations, and laws have consumed
everything ancient. But sufficient for
us is the testimony of things created in
the salt waters, and found again in high
mountains far from the seas.

❦

In course of time the level of the sea be-
came lower, and as the salt water flowed
away this mud became changed into
stone; and such of these shells as had lost
their inhabitants became filled up in their
stead with mud. And consequently dur-
ing the process of change of all the sur-
rounding mud into stone, this mud also
which was within the frames of the half
opened shells, since by the opening of the
shell it was joined to the rest of the mud,
became also itself changed into stone.
And therefore all the frames of these
shells were left between two petrified sub-
stances, namely that which surrounded
them and that which they enclosed.

These are still to be found in many
places, and almost all the petrified
shellfish in the rocks of the mountains
still have their natural frame round
them, and especially those which were of
a sufficient age to be preserved by reason
of their hardness, while the younger
ones, which were already in great part
changed into chalk, were penetrated by
the viscous and petrifying moisture.

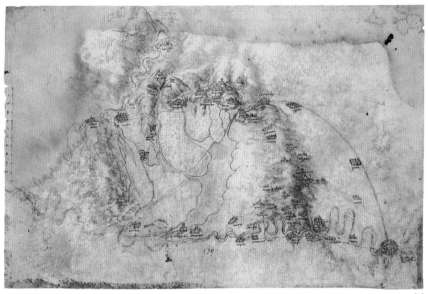

«

If you choose to say that it was the deluge which carried these shells away from the sea for hundreds of miles, this cannot have happened, since that deluge was caused by rain, and rain naturally forces the rivers to rush towards the sea with all the things they carry with them, and not to bear the dead things of the seashores to the mountains.

And if you choose to say that the deluge afterwards rose with its waters above the mountains, the movement of the sea must have been so sluggish in its rise against the currents of the rivers, that it could not have carried, floating upon it, things heavier than itself. And even if it had supported them, in its receding it would have left them strewn about, in various spots. But how are we to account for the corals that are found every day towards Monte Ferrato in Lombardy, with the holes of the worms in them, sticking to rocks left uncovered by the currents of rivers?

These rocks are all covered with stocks and families of oysters, which as we know, never move, but always

remain with one of their halves stuck to a rock, and the other they open to feed themselves on the animalcules that swim in the water, which, hoping to find good feeding ground, become the food of these shells. We do not find that the sand mixed with seaweed has been petrified, because the weed that was mingled with it has shrunk away, and this the Po shows us every day in the debris of its banks.

[5]

I perceive that the surface of the earth was from of old entirely filled up and covered over in its level plains by the salt waters, and that the mountains, the bones of the earth, with their wide bases, penetrated and towered up amid the air, covered over and clad with much high-lying soil.

Subsequently the incessant rains have caused the rivers to increase and by repeated washing have stripped bare part of the lofty summits of these mountains, leaving the site of the earth, so that the rock finds itself exposed to the air, and the earth has departed from these places. And the earth from off the slopes and the lofty summits of the mountains has already descended to their bases, and has raised the floors of the seas that encircle these bases, and caused the plain be uncovered, and in some parts has driven away the seas from there over a great distance.

Where there is life there is heat, and where vital heat is, there is movement of vapor. This is proved, inasmuch as we see that the element of fire by its heat always draws to itself damp vapors and thick mists as opaque clouds, which it raises from seas as well as lakes and rivers and damp valleys. And these being drawn by degrees as far as the cold region, the first portion stops, because heat and moisture cannot exist with cold and dryness; and where the first portion stops the rest settle, and thus one portion after another being added, thick and dark clouds are formed.

They are often wafted about and borne by the winds from one region to another, where by their density they become so heavy that they fall in thick rain. And if the heat of the sun is added to the power of the element of fire, the clouds are drawn up higher still and find a greater degree of cold, in which they form ice and fall in storms of hail. Now the same heat, which holds up so great a weight of water as is seen to rain from the clouds, draws them from below upwards, from the foot of the mountains, and leads and holds them within the summits of the mountains, and these, finding some fissure, issue continuously and cause rivers.

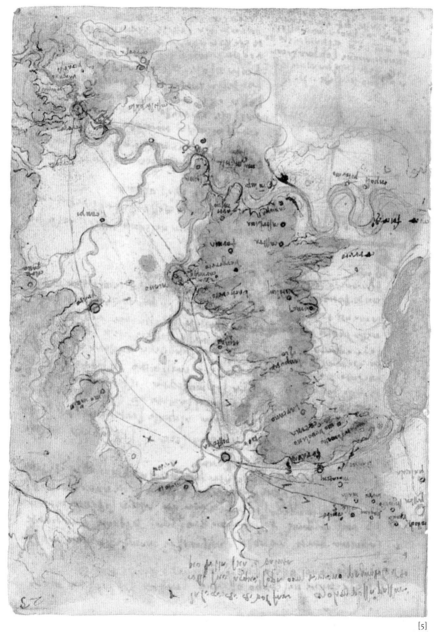

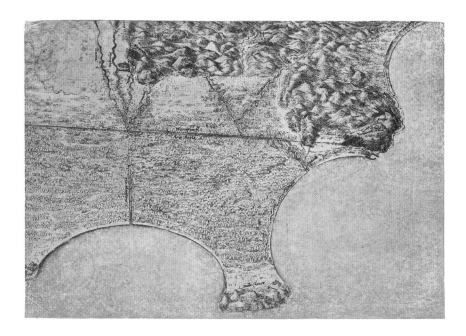

《

Of the four elements water is the second least heavy and the second in respect of mobility. It is never at rest until it unites with its maritime element, where, when not disturbed by the winds, it establishes itself and remains with its surface equidistant from the centre of the world.

It is the increase and humor of all vital bodies. Without it nothing retains its first form. It unites and augments bodies by its increase.

Nothing lighter than itself can penetrate it without violence. It readily raises itself by heat in thin vapor through the air. Cold causes it to freeze. Stagnation makes it foul. That is, heat sets it in movement, cold causes it to freeze, immobility corrupts it.

It assumes every odor, color, and flavor, and of itself it has nothing. It percolates through all porous bodies. Against its fury no human defense avails, or if it should avail it is not for long. In its rapid course it often serves as a support to things heavier than itself. It can lift itself up by movement or bound as far as it sinks down. It submerges with itself in headlong course things lighter than itself.

The mastery of its course is sometimes on the surface, sometimes in the center, sometimes at the bottom. One portion rises over the transverse course

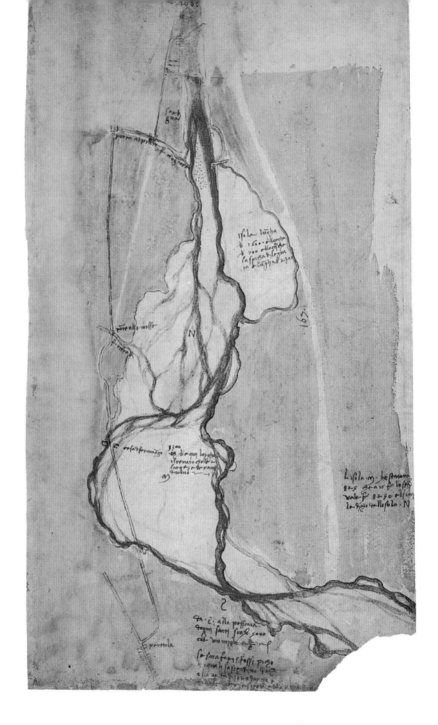

of another, and but for this the surfaces of the running waters would be without undulations. Every small obstacle whether on its bank or in its bed will be the cause of the falling away of the bank or bed opposite to it.

When the water is low it does more damage to the bank in its course than it does when it flows in full stream. Its parts do not weigh upon the parts placed beneath them. No river will ever keep its course in the same direction between its banks. Its upper parts do not impart weight to the lower.

《

Among irremediable and destructive terrors, the inundations caused by impetuous rivers ought to be set before every other awful and terrifying source of injury. But in what tongue or with what words am I to express or describe the awful ruin, the inconceivable and pitiless havoc, wrought by the deluges of ravening rivers, against which no human resource can avail?

[6]

Fire consumes that which feeds it and is itself consumed with its food. The movement of water, which is created by the slopes of the valleys, does not end and die until it has reached the lowest level of the valley; but fire is caused by what feeds it, and the movement of water by its wish to descend. The food of the fire is disunited, and the mischief caused by it is disunited and separated, and the fire dies when it lacks food. The slope of the valley is continuous and the

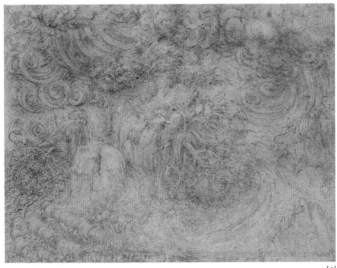

[6]

mischief done by the destructive course of the river will be continuous until, attended by its valleys, it ends in the sea, the universal base and only resting place of the wandering waters of the rivers.

Rivers can lay waste the high mountains with their swelling and exulting waves, cast down the strongest banks, tear up the deep-rooted trees, and with ravening waves laden with mud from crossing the ploughed fields carry with them the unendurable labors of the wretched weary tillers of the soil, leaving the valleys bare and mean by reason of the poverty that is left there.

《

For in a succession of raging and seething [waves], gnawing and tearing away the high banks, growing turbid with the earth from the ploughed fields, destroying the houses therein and uprooting the tall trees, it carries these as its prey down to the sea, which is its lair, bearing along with it men, trees, animals, houses, and lands, sweeping away every dike and every kind of barrier, bearing with it the light things, and devastating and destroying those of weight, creating big landslips out of small fissures, filling up with its floods the low valleys, and rushing headlong with insistent and inexorable mass of waters.

What a need there is of flight, for whoso is near! O how many cities, how many lands, castles, villas, and houses has it consumed!

How many of the labors of wretched husbandmen have been rendered idle and profitless! How many families has it brought to naught, and overwhelmed! What shall I say of the herds of cattle that have been drowned and lost!

《

Among straight rivers that occur in land of the same character, with the same abundance of water and with equal breadth, length, depth, and declivity of course, that will be the slower which is the more ancient.

This may be proved with straight rivers. That will be most winding which is the oldest, and that which winds will become slower as it acquires greater length.

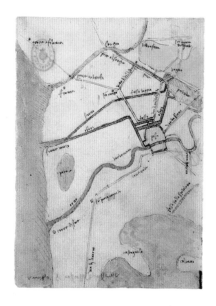

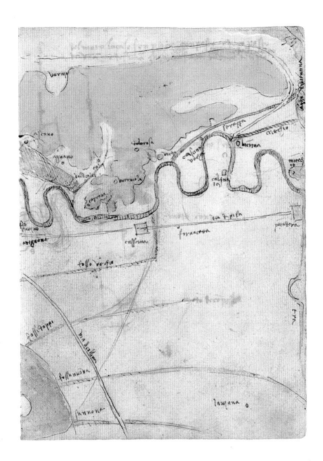

Of waters which descend from equal altitudes to equal depths, that will be the slower which moves by the longer way.

Of rivers which are at their commencement, that will be the slower which is the more ancient, and this arises from the fact that the course is continually acquiring length by reason of the additional meanderings of the river.

Where the channel of the river is more sloping, the water has a swifter current; and where the water is swifter it wears the bed of its river more away and deepens it more and causes the same quantity of water to occupy less space.

The shorter the course of the rivers, the greater will be their speed. And so also conversely it will be slower in proportion as their course has greater length.

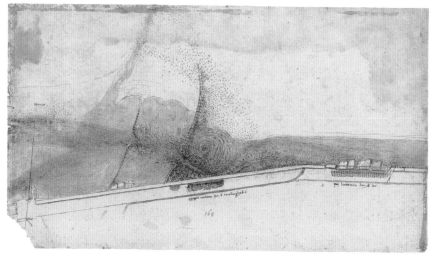

[7]

[7]
Rivers when straight flow with a much greater impetus in the center of their breadth than they do at their sides.

When the water has struck on the sides of rivers with equal percussion, if it find a part of the river narrower it will leap towards the middle of the river and these waves will make a new percussion between themselves. As a consequence they will return again towards the banks equally. And that water, of conical shape, which is enclosed between the first percussion made upon the bank and the second made in the centre of the stream, will slacken at its base and be swift near to its crest. Striking the bottom, they will afterwards rise equally to the height of the intersection; but always that of the center will be swifter than that which leaps back.

Water that moves along an equal breadth of river and on an equal bed will have as many different thicknesses as there are different slants in the bed where it runs. And by as much as it is swifter in one place than another, so proportionately it will be shallower.

[8]
All inland seas, and the gulfs of those seas, are made by rivers that flow into the sea.

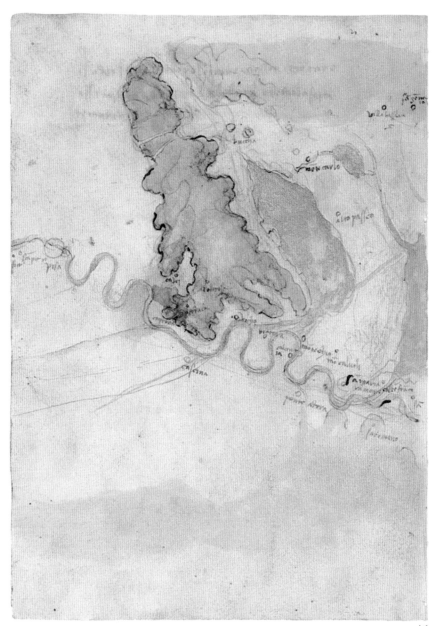

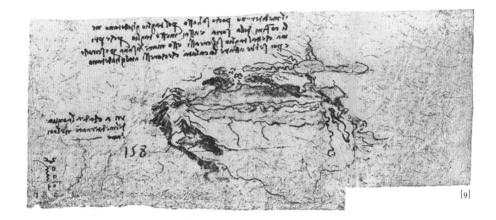

[9]

The surface of the Red Sea is on a level with the ocean.

A mountain may have fallen and closed the mouth of the Red Sea and prevented the outlet of the Mediterranean, and the Mediterranean Sea thus overfilled had for outlet the passage below the mountains of Gades; for, in our own times a similar thing has been seen, a mountain fell seven miles across a valley and closed it up and made a lake. And thus most lakes have been made by mountains, as the lake of Garda, the lakes of Como and Lugano, and the Lago Maggiore.

{a} *The Mediterranean fell but little on the confines of Syria, in consequence of the Gaditanean passage, but a great deal in this passage, because before this cutting was made the Mediterranean sea flowed to the South East, and then the fall had to be made but its run through the Straits of Gades.*

{b} *At a the water of the Mediterranean fell into the ocean.*

All the plains that lie between the sea and mountains were formerly covered with salt water.

Every valley has been made by its own River; and the proportion between valleys is the same as that between river and river.

☾

In many places there are streams of water that swell for six hours and ebb for six hours; and I, for my part, have seen one above the lake of Como called Fonte Pliniana, which increases and ebbs, as I have said, in such a way as it turn the stones of two mills; and when it fails it falls so low that it is like looking at water in a deep pit.

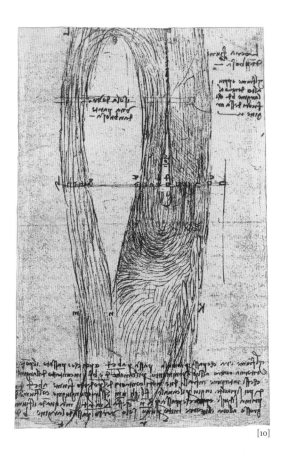

[10]

[10]

{a} *The river Loire at Amboise.*

{b} *The river is higher within the bank b d than outside that bank.*

{c} *The island where there is a part of Amboise.*

{d} *This is the river that passes through Amboise; it passes at a b c d, and when it has passed the bridge it* turns back, against the original current, by the channel d e, b f in contact with the bank which lies between the two contrary currents of the said river, a b, c d, and d e, b f. It then turns down again by the channel f l, g h, n m, and reunites with the river from which it was at first separated, which passes by k n, which makes k m, r t. But when the river is very full it flows all in one channel passing over the bank b d.

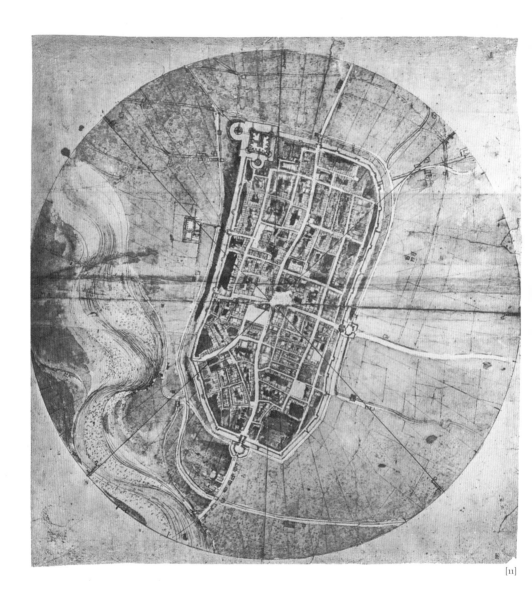

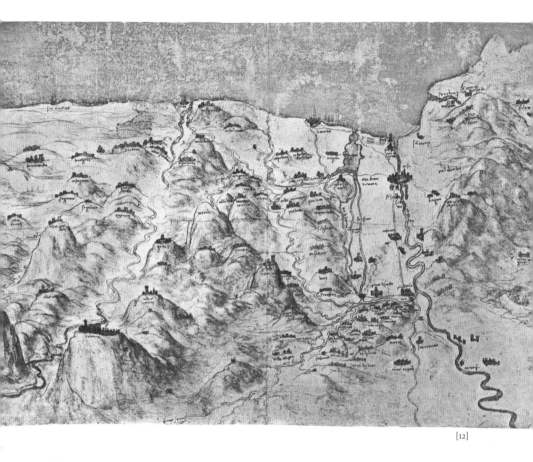

Imola as regards Bologna is five points
from the West towards the North West
at a distance of 20 miles.

Castel San Pietro lies exactly North
West of Imola, at a distance of 7 miles.

Faenza, as regards Imola, lies
exactly half way between the East and
South East at a distance of 10 miles; and

Forli lies in the same direction from
Imola at a distance of 20 miles; and
Forlimpopolo lies in the same direction
from Forli at a distance of 25 miles.

Bertinoro is seen from Imola two
points from the East towards the South
East at a distance of 27 miles.

[12]

In the mountains of Verona the red marble is found all mixed with cockle shells turned into stone. Some of them have been filled at the mouth with the cement that is the substance of the stone; and in some parts they have remained separate from the mass of the rock that enclosed them, because the outer covering of the shell had interposed and had not allowed them to unite with it; while in other places this cement had petrified those that were old and almost stripped the outer skin.

[13]

{a} *To the Devatdar of Syria, Lieutenant of the Sacred Sultan of Babylon.*

{b} *The recent disaster in our Northern parts, which I am certain will terrify not you alone but the whole world, which shall be related to you in due order, showing first the effect and then the cause.*

{c} *Finding myself in this part of Armenia to carry into effect with due love and care the task for which you sent me; and to make a beginning in a place that seemed to me to be most to our purpose, I entered into the city of Calindra, near to our frontiers. This city is situated at the base of that part of the Taurus mountains which is divided from the Euphrates and looks towards the peaks of the great Mount Taurus to the West. These peaks are of such a height that they seem to touch the sky, and in all the world there is no part of the earth, higher than its*

summit, and the rays of the sun always fall upon it on its East side, four hours before daytime, and being of the whitest stone it shines resplendently and fulfils the function to these Armenians that a bright moonlight would in the midst of the darkness. And by its great height it outreaches the utmost level of the clouds by a space of four miles in a straight line. This peak is seen in many places towards the West, illuminated by the sun after its setting the third part of the night. This it is, which with you we formerly in calm weather had supposed to be a comet, and appears to us in the darkness of night, to change its form, being sometimes divided in two or three parts, and sometimes long and sometimes short. And this is caused by the clouds on the horizon of the sky that interpose between part of this mountain and the sun, and by cutting off some of the solar rays the light on the mountain is intercepted by various intervals of clouds, and therefore varies in the form of its brightness.

{d} *The praise and confession of the faith.*

The sudden inundation, to its end.

The destruction of the city.

The death of the people and their despair.

The preacher's search, his release and benevolence.

Description of the cause of this fall of the mountain.

The mischief it did.

Fall of snow.

The finding of the prophet.

His prophesy.

The inundation of the lower portion of Eastern Armenia, the draining of which was effected by the cutting through the Taurus Mountains.

How the new prophet showed that this destruction would happen as he had foretold.

Description of the Taurus Mountains and the river Euphrates.

{e} *Why the mountain shines at the top, from half to a third of the night, and looks like a comet to the inhabitants of the West after the sunset, and before day to those of the East.*

Why this comet appears of variable forms, so that it is now round and now long, and now again divided into two or three parts, and now in one piece, and when it is to be seen again. {f}

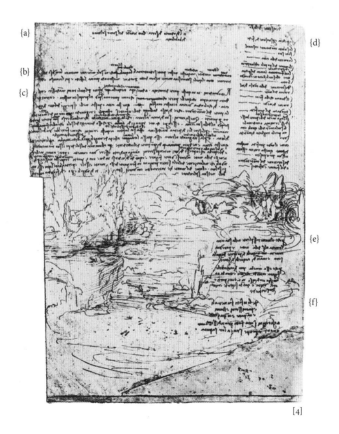

{a}
{b}
{c}
{d}
{e}
{f}

[4]

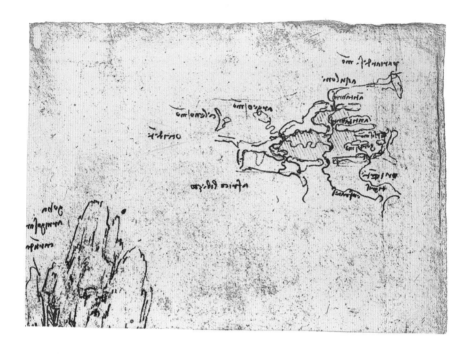

[14]

{a} *Of the Shape of the Taurus Moun-tains.*

{b} *I am not to be accused, O De-vatdar, of idleness, as your chidings seem to hint; but your excessive love for me, which gave rise to the benefits you have conferred on me, is that which has also compelled me to the utmost painstaking in seeking out and diligently investigating the cause of so great and stupendous an effect. And this could not be done with-out time; now in order to satisfy you fully as to the cause of so great an effect, it is requisite that I should explain to you the form of the place, and then I will proceed to the effect, by which I believe you will be amply satisfied.*

{c} *Do not be aggrieved, O Devat-dar, by my delay in responding to your pressing request, for those things which you require of me are of such a nature that they cannot be well expressed with-out some lapse of time; particularly be-cause, in order to explain the cause of so great an effect it is necessary to describe with accuracy the nature of the place; and by this means I can afterwards easily satisfy your abovementioned request.*

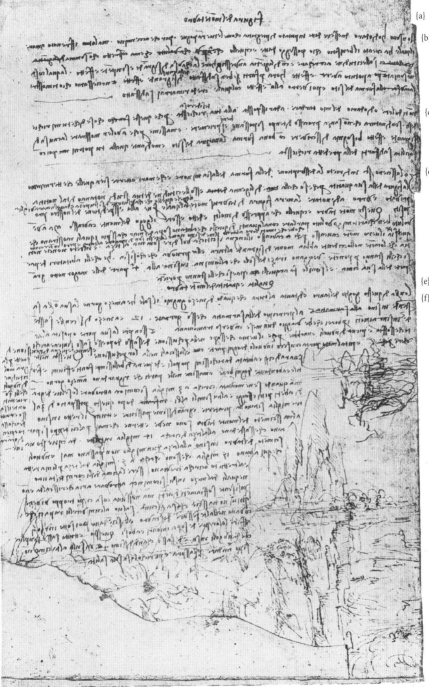

{d} I will pass over any description of the form of Asia Minor, or as to what seas or lands form the limits of its outline and extent, because I know that by your own diligence and carefulness in your studies you have not remained in ignorance of these matters; and I will go on to describe the true form of the Taurus Mountain, which is the cause of this stupendous and harmful marvel, and which will serve to advance us in our purpose. This Taurus is that mountain which, with many others, is said to be the rights of Mount Caucasus; but wishing to be very clear about it, I desired to speak to some of the inhabitants of the shores of the Caspian Sea, who give evidence that this must be the true Caucasus, and that though their mountains bear the same name, yet these are higher; and to confirm this in the Scythian tongue Caucasus means a very high peak, and in fact we have no information of there being, in the East or in the West, any mountain so high. And the proof of this is that the inhabitants of the countries to the West see the rays of the sun illuminating a great part of its summit for as much as a quarter of the longest night. And in the same way, in those countries that lie to the East.

{e} Of the Structure and Size of Mount Taurus.

{f} The shadow of this ridge of the Taurus is of such a height that when, in the middle of June, the Sun is at its meridian, its shadow extends as far as the borders of Sarmatia, twelve days off; and in the middle of December it extends as far as the Hyperborean mountains, which are at a month's journey to the North. And the side which faces the wind is always free from clouds and mists, because the wind which is parted in beating on the rock, closes again on the further sides of that rock, and in its motion carries with it the clouds from all quarters and leaves them where it strikes. And it is always full of thunderbolts from the great quantity of clouds that accumulate there, whence the rock is all riven and full of huge debris. This mountain, at its base, is inhabited by a very rich population and is full of most beautiful springs and rivers, and is fertile and abounding in all good produce, particularly in those parts that face to the South. But after mounting about three miles we begin to find forests of great fir trees, and beech and other similar trees; after this, for a space of three more miles, there are meadows and vast pastures. And all the rest, as far as the beginning of the Taurus, is eternal snows that never disappear at any time, and extend to a height of about fourteen miles in all. From this beginning of the Taurus up to the height of a mile the clouds never pass away; thus we have fifteen miles, that is, a height of about five miles in a straight line. And the summit of the peaks of the Taurus is as much, or about that. There, halfway up, we begin to find a scorching air and never feel a breath of wind; but nothing

can live long there. There nothing is brought forth save a few birds of prey that breed in the high fissures of Taurus and descend below the clouds to seek their prey. Above the wooded hills all is bare rock, that is, from the clouds upwards, and the rock is the purest white. And it is impossible to walk to the high summit on account of the rough and perilous ascent.

Force arises from dearth or abundance; it is the child of physical motion, and the grandchild of spiritual motion, and the mother and origin of gravity.

IX.
Physical Sciences
and Astronomy

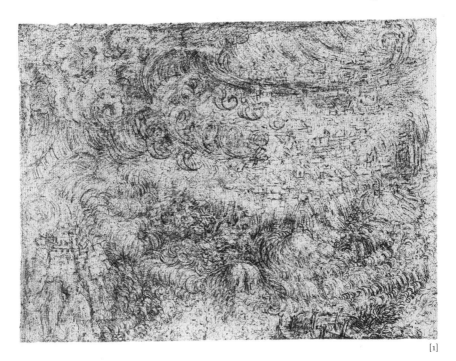

[1]
Force I define as an incorporeal agency, an invisible power, which by means of unforeseen external pressure is caused by the movement stored up and diffused within bodies that are withheld and turned aside from their natural uses; imparting to these an active life of marvelous power it constrains all created

things to change of form and position, and hastens furiously to its desired death, changing as it goes according to circumstances.

When it is slow its strength is increased, and speed enfeebles it. It is born in violence and dies in liberty; and the greater it is, the more quickly it is consumed. It drives away in fury whatever opposes its destruction. It desires to conquer and slay the cause of opposition, and in conquering destroys itself. It waxes more powerful where it finds the greater obstacle. Everything instinctively flees from death. Everything, when under constraint, itself constrains other things. Without force nothing moves.

The body in which it is born grows neither in weight nor in form. None of the movements that it makes are lasting.

It increases by effort and disappears when at rest. The body within which it is confined is deprived of liberty. Often also by its movement it generates new force.

《

Gravity is limited to the elements of water and earth; but this force is unlimited, and by it infinite worlds might be moved if instruments could be made by which the force could be generated.

Force, with physical motion, and gravity, with resistance are the four external powers on which all actions of mortals depend.

《

The earth is not in the center of the Sun's orbit nor at the center of the universe, but in the center of its companion elements, and united with them. And any one standing on the moon, when it and the sun are both beneath us, would see this, our earth, and the element of water upon it just as we see the moon, and the earth would light it as it lights us.

《

No movement can ever be so slow that a moment of stability is found in it.

That movement is slower which covers less distance in the same time.

That movement is swifter which covers a greater distance in the same time.

Movement can extend to infinite degrees of slowness.

And the power of the movement can extend to infinite degrees of slowness and likewise to infinite degrees of swiftness.

《

I say that the blue that is seen in the atmosphere is not its own color, but is caused by the heated moisture having evaporated into the most minute imperceptible particles, which the beams of the solar rays attract and cause to seem luminous against the deep intense darkness of the region of fire that forms a covering above them.

《

Weight, force, a blow, and impetus are the children of movement because they are born from it.

Weight and force always desire their death, and each is maintained by violence.

Impetus is frequently the cause why movement prolongs the desire of the thing moved.

《

Force is nothing else than a spiritual capacity, an invisible power that is created and implanted by accidental violence by sensible bodies in insensible ones, giving to these a semblance of life; and this life is marvelous in its workings, constraining and transforming in place and shape all created things, running with fury to its own destruction, and producing different effects in its course as occasion requires.

Tarrying makes it great and quickness makes it weak.

It lives by violence and dies from liberty.

It transforms and constrains every body with change of position and form.

Great power gives it great desire of death.

It drives away with fury whatever opposes its destruction.

Transmuter of various forms.

Lives always in hostility to whoever controls it.

Always sets itself against natural desires.

From small beginnings it slowly becomes larger, and makes itself a dreadful and marvelous power.

Always it desires to grow weak and to spend itself.

Itself constrained it constrains every body.

Without it nothing moves.

Without it no sound or voice is heard.

Its true seed is in sentient bodies.

《

If a power can move a body through a certain space in a certain time it does not necessarily follow that the half of this power will move the whole of the body over half the space in the whole of that time, or over the whole of the space in double the time.

《

If a power moves a weight a certain distance in a certain time the same power will move the half of this weight double the distance in the same time.

Or this whole power [will move] all the weight half the distance in half the time, or the whole power in the same time will move double the weight half the distance, or the whole power in half the time [will move] the whole weight half the distance.

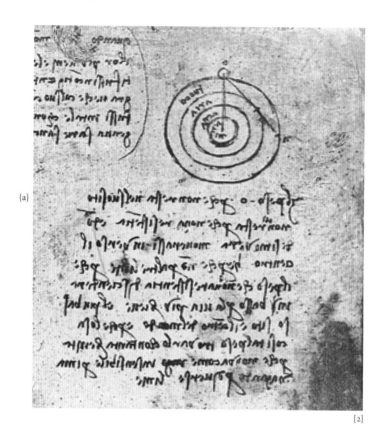

{a}

[2]

{a} *Why does not the weight o remain in its place? It does not remain because it has no resistance. Where will it move to? It will move towards the center [of gravity]. And why by no other line? Because a weight that has no support falls by the shortest road to the lowest point, which is the center of the world. And why does the weight know how to find it by so short a line? Because it is not independent and does not move about in various directions.*

«

Every heavy substance not held back out of its natural place desires to descend more by a direct line than by an arc. This is shown because every body, whatever it may be, that is away from its natural place, which preserves it, desires to regain its first perfection in as brief a space of time as possible. And since the chord is described in a less time than the arc of the same chord it follows from this that every

body that is away from its natural place desires to descend more speedily by a chord than by an arc.

《

A heavy substance of uniform thickness and weight, placed in a position of equilibrium, will have a straight descent with equal height in each of its parts without ever deviating from the position of its first equilibrium, if the air be motionless and of uniform resistance, and this movement will be very slow as will be proved.

But if the heavy substance of uniform thickness be situated slantwise in air of uniform resistance then its descent will be made slantwise and it will be more rapid than the first aforesaid.

《

I ask if a weight of a pound falling two braccia bury itself in the earth the depth of a hand, how deeply will it bury itself if it falls forty braccia, and how far a weight of two pounds will bury itself if it falls two braccia?

《

Impetus is that which under another name is termed derived movement, which arises out of primary movement, that is to say, when the movable thing is joined to its mover.

In no part of the derived movement will one ever find a velocity equal to that of the primary movement. This is proved, because at every stage of movement as with the cord of the bow

there is a loss of the acquired power that has been communicated to it by its mover. And because every effect partakes of its cause the derived movement of the arrow goes lessening its power by degrees, and thus participates in the power of the bow which as it was produced by degrees is so destroyed.

The impetus impressed by the mover on the movable thing is infused in all the united parts of this movable thing.

《

If two balls strike together at a right angle one will deviate more from its first course than the other in proportion as it is less than the other.

The part of a log first severed from the end of it by the stroke of the axe flies off to a greater distance than any other part carried away by the same blow.

This is because the part of the log that first receives the blow receives it in the first stage of its power and consequently goes farther. The second part flies a less distance because the fury of the blow has already subsided, the third still less, and so also the fourth.

《

A body with a thicker, harder surface will cause the objects that strike against it to separate from it with a more powerful and rapid rebound.

《

An arrow shot from the prow of a ship in the direction in which the ship is moving will not appear to stir from the

place at which it was shot if the ship's movement be equal to that of the arrow.

But if the arrow from such a ship be shot in the direction from whence it is going away with the above mentioned rate of speed, this arrow will be separated from the ship with twice its movement.

[3]

The heavier the thing the more power attends its movement.

This is seen with jumpers who have their feet joined, who in order to make a greater jump throw back their clenched hands and then move them forward violently as they take off for the jump, finding that by this movement the jump becomes greater.

And there are many who to increase this jump take two heavy stones in their two hands and use them for the same purpose as they used to use their fists; their leap becomes much greater.

«

If someone descends from one step to another by jumping from one to the other and then you add together all the forces of the percussions and the weights of these jumps, you will find that they are equal to the entire percussion and weight that such a man would produce if he fell by a perpendicular line from the top to the bottom of the height of this staircase.

Furthermore if this man were to fall from a height, striking stage by stage upon objects that would bend in the

[3]

manner of a spring, in such a way that the percussion from the one to the other was slight, you will find that at the last part of his descent this man will have his percussion as much diminished by comparison with what it would have been in a free and perpendicular line, as it would be if there were taken from it all the percussions joined together that were given at each stage of the said descent upon the aforesaid springs.

《

Many small blows cause the nail to enter into the wood, but if you join these blows together in one single blow it will have much more power than it had separately in its parts. But if a power of percussion drives a nail entirely into a piece of wood, this same power can be divided into ever so many parts, and though the percussion of these occur on the nail for a long time they can never penetrate to any extent in the said wood.

If a ten-pound hammer drives a nail into a piece of wood with one blow, a hammer of one pound will not drive the nail altogether into the wood in ten blows. Nor will a nail that is less than the tenth part [of the first] be buried more deeply by the said hammer of a pound in a single blow although it may be in equal proportions to the first named, because what is lacking is that the hardness of the wood does not diminish the proportion of its resistance, that is, that it is as hard as at first.

If you wish to treat of the proportions of the movement of the things that have penetrated into the wood when driven by the power of the blow, you have to consider the nature of the weight that strikes and the place where the thing struck buries itself.

《

All seas have their flow and ebb in the same period, but they seem to vary because the days do not begin at the same time throughout the universe; in such wise as that when it is midday in our hemisphere, it is midnight in the opposite hemisphere; and at the Eastern boundary of the two hemispheres the night begins which follows on the day, and at the Western boundary of these hemispheres begins the day, which follows the night from the opposite side. Hence it is to be inferred that the above mentioned swelling and diminution in the height of the seas, although they take place in one and the same space of time, are seen to vary from the above mentioned causes.

《

Let the earth make whatever changes it may in its weight, the surface of the sphere of waters can never vary in its equal distance from the center of the world.

《

If the sea bears down with its weight upon its bed, a man who lay on this bed and had a thousand braccia of water on his back would have enough to crush him.

《

Quality of the sun:

The sun has substance, shape, movement, radiance, heat, and generative power; and these qualities all emanate from itself without its diminution.

《

Some say that the sun is not hot because it is not the color of fire but is much paler and clearer. To these we may reply that when liquefied bronze is at its maximum of heat it most resembles the sun in color, and when it is less hot it has more of the color of fire.

[4]

Some might say that the air surrounding the moon as an element catches the light of the sun as our atmosphere does, and that it is this which completes the luminous circle on the body of the moon.

Some have thought that the moon has a light of its own, but this opinion is false, because they have founded it on that dim light seen between the homes of the new moon, which looks dark where it is close to the bright part. And this difference of background arises from the fact that the portion of that background which is conterminous with the bright part of the moon, by comparison with that brightness looks darker than it is; while at the upper part, where a portion of the luminous circle is to be seen of uniform width, the result is that the moon, being brighter there than the medium or background on which it is seen by comparison with that darkness it looks more luminous at that edge than it is.

If you want to see how much brighter the shaded portion of the moon is than the background on which it is seen, conceal the luminous portion of the moon with your hand or with some other more distant object.

《

The moon has no light in itself; but so much of it as faces the sun is illuminated, and of that illumined portion we see so much as faces the earth. And the moon's night receives just as much light as is lent it by our waters as they reflect the image of the sun, which is mirrored in all those waters that are on the side towards the sun. The outside or surface of the waters forming the seas of the moon and of the seas of our globe is always ruffled little or much, or more or less. And this roughness causes an extension of the numberless images of the sun that are repeated in the ridges and hollows, the sides and fronts of the innumerable waves; that is to say, in as many different spots on each wave as our eyes find different positions to view them from.

This could not happen if the aqueous sphere that covers a great part of the moon were uniformly spherical, for then the images of the sun would be one to each spectator, and its reflections would be separate and

independent and its radiance would always appear circular; as is plainly to be seen in the gilt balls placed on the tops of high buildings. But if those gilt balls were rugged or composed of several little balls, like mulberries, which are a black fruit composed of minute round globules, then each portion of these little balls, when seen in the sun, would display to the eye the luster resulting from the reflection of the sun, and thus, in one and the same body many tiny suns would be seen; and these often combine at a long distance and appear as one.

[4]

☾

The stars are visible by night and not by day, because we are beneath the dense atmosphere, which is full of innumerable particles of moisture, each of which independently, when the rays of the sun fall upon it, reflects a radiance. And so these numberless bright particles conceal the stars; and if it were not for this atmosphere the sky would always display the stars against its darkness.

☾

If you look at the stars, cutting off the rays (as may be done by looking through a very small hole made with the extreme point of a very fine needle, placed so as almost to touch the eye), you will see those stars so minute that it would seem as though nothing could be smaller; it is in fact their great distance that is the reason of their diminution,

for many of them are very many times larger than the star which is the earth with water. Now reflect what this, our star, must look like at such a distance, and then consider how many stars might be added—both in longitude and latitude—between those stars that are scattered over the darkened sky.

☾

What is that thing which does not give itself, and which if it were to give itself would not exist?

It is the infinite, which if it could give itself would be bounded and finite, because that which can give itself has a boundary with the thing that surrounds it in its extremities, and that which cannot give itself is that which has no boundaries.

Part III

Practical
Matters

Leonardo's genius reached far beyond artistic matters, although that is the main source of his reputation today. He considered himself much more than an artist; his aspirations were loftier. Although Leonardo never received the classical training of the truly educated classes, he acquired expertise in a number of fields thought to be suitable for intellectuals.

Among these was architecture, considered a much nobler pursuit than painting, a mere artisanal craft. Renaissance architects placed great emphasis on classical proportions. Leonardo's preoccupations, highlighted in the "Architecture and Planning" chapter, ranged beyond these formal considerations to the gritty details of engineering such as arch stability and weight-bearing capacity.

In contrast, the "Sculpture and Metalwork" chapter deals with the minutiae of smelting and casting. Leonardo denounced sculptures as "less intellectual than painting." Consisting largely of his sketches for a sculpture commission that he never completed, this chapter shows that, despite the low regard in which he held such pursuits, he was nevertheless well versed in the demanding technical aspects of metal casting.

The "Inventions" chapter features Leonardo's most wildly creative ideas. Rope-making machines, weapons, flying contraptions—all were fair game for his restless imagination. Of course, some of his whimsies, which surely seemed like the ravings of a madman to his contemporaries, came to pass: he described parachutes, flying machines, and armored cars.

And finally, the "Practical Advice" and "Philosophy, Aphorisms, and Miscellaneous Writings" chapters show Leonardo's more didactic, reflective side. His musings wander from the proper training for young painters to allegories of various vices and virtues. They remind us that, in addition to his skills as an artist, scientist, and inventor, Leonardo had an extraordinary capacity to appreciate the human condition.

The ancient architects, beginning with the Egyptians, were the first to build and construct large cities and castles, public and private buildings of fine form, large and well proportioned.

X. Architecture and Planning

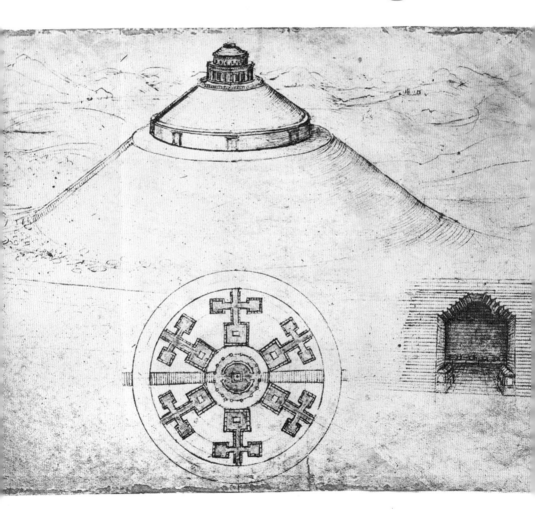

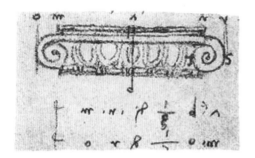

[1]

An arch is nothing other than a strength caused by two weaknesses; for the arch in buildings is made up of two segments of a circle, and each of these segments being in itself very weak desires to fall, and as the one withstands the downfall of the other the two weaknesses are converted into a single strength.

When once the arch has been set up it remains in a state of equilibrium, for the one side pushes the other as much as the other pushes it; but if one of the segments of the circle weighs more than the other the stability is ended and destroyed, because the greater weight will subdue the less. Next to giving the segments of the circle equal weight it is necessary to load them equally, or you will fall into the same defect as before.

[1]

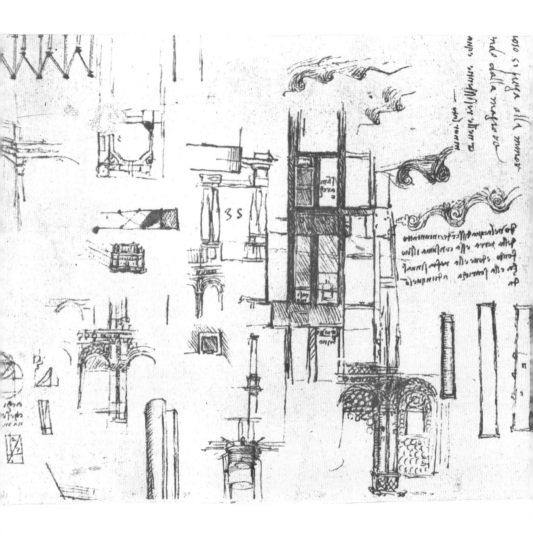

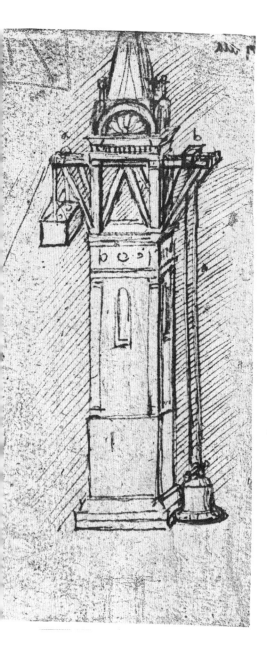

That part of the arch that is nearer to the horizontal offers least resistance to the weight placed on it.

The arch that is doubled to four times of its thickness will bear four times the weight that the single arch could carry, and more in proportion as the diameter of its thickness goes a smaller number of times into its length. That is to say that if the thickness of the single arch goes ten times into its length, the thickness of the doubled arch will go five times into its length. Hence as the thickness of the double arch goes only half as many times into

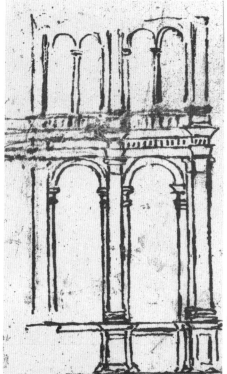

[2]

its length as that of the single arch does, it is reasonable that it should carry half as much more weight as it would have to carry if it were in direct proportion to the single arch. Hence as this double arch has four times the thickness of the single arch, it would seem that it ought to bear four times the weight; but by the above rule it is shown that it will bear exactly eight times as much.

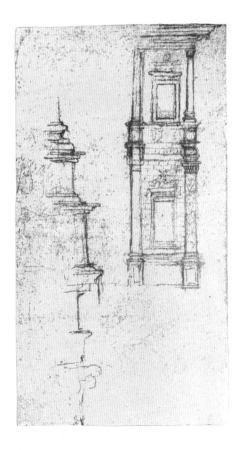

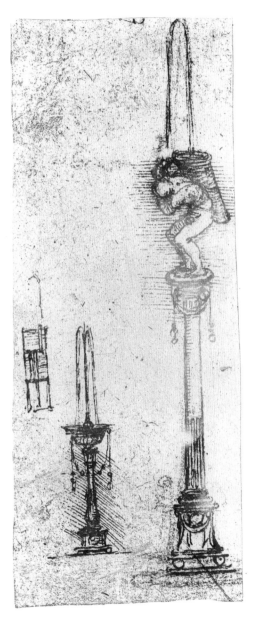

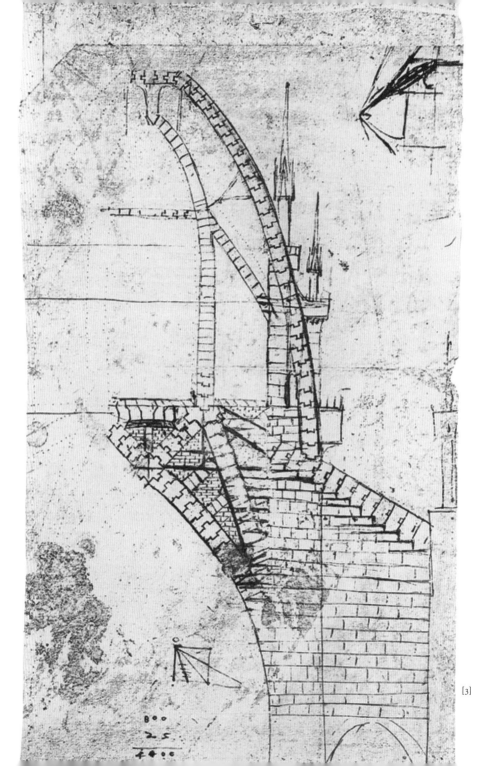

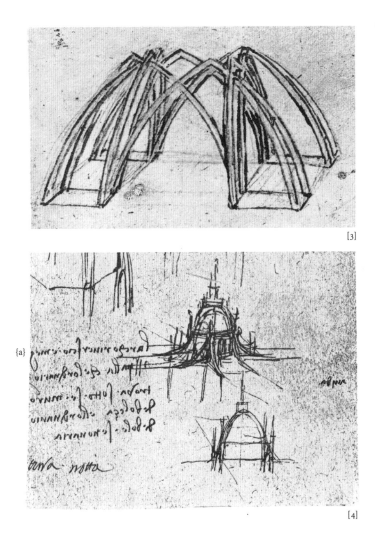

[3]

[a]

[4]

[3]
The way to give stability to the arch is to fill the spandrels with good masonry up to the level of its summit.

[4]
{a} *The inverted arch is better for giving a shoulder than the ordinary one, because the former finds below it a wall resisting its weakness, whilst the latter finds in its weak part nothing but air.*

[5]

{a} *The plinth must be as broad as the thickness of the wall against which the plinth is built.*

[6]

{a} *On the second day of February 1494. At Sforzesca I drew twenty-five steps, 2/3 braccia to each, and eight braccia wide.*

[7]

{a} *The construction of the stairs: The stairs c d go down to f g, and in the same way f g goes down to h k.*

[8]

{a} *The way in which the poles ought to be placed for tying bunches of juniper on to them. These poles must lie close to the framework of the vaulting and tie the bunches on with osier withes, so as to clip them even afterwards with shears.*

{b} *Let the distance form one circle to another be half a braccia; and the juniper [sprigs] must lie top downwards, beginning from below.*

{c} *Round this column tie four poles to which willows about thick as a finger must be nailed and then begin from the bottom and work upwards with bunches of juniper sprigs, the tops downwards, that is, upside down.*

{a}

[5]

{a}

[6]

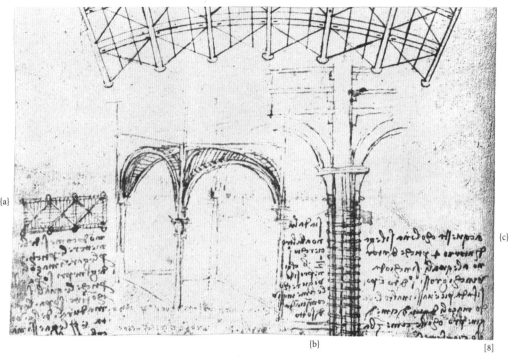

{a}

{c}

{b} [8]

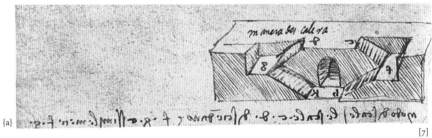

{a}

[7]

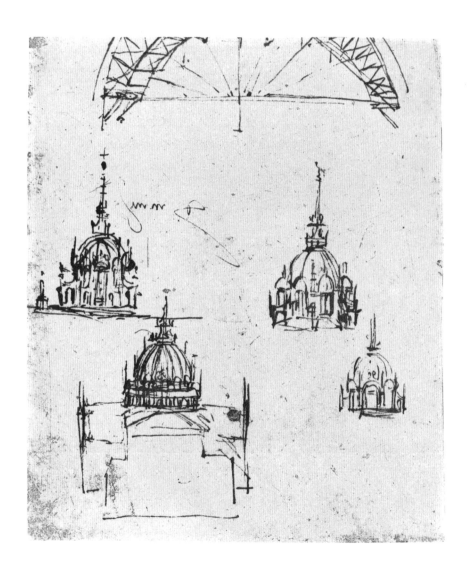

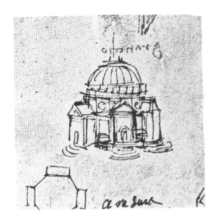

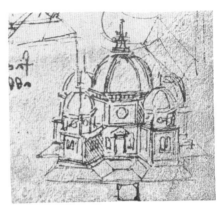

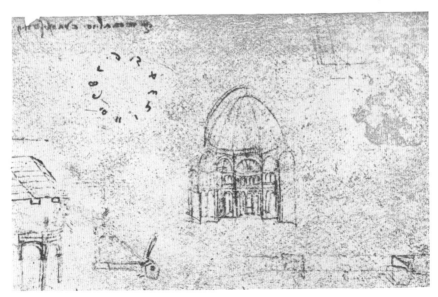

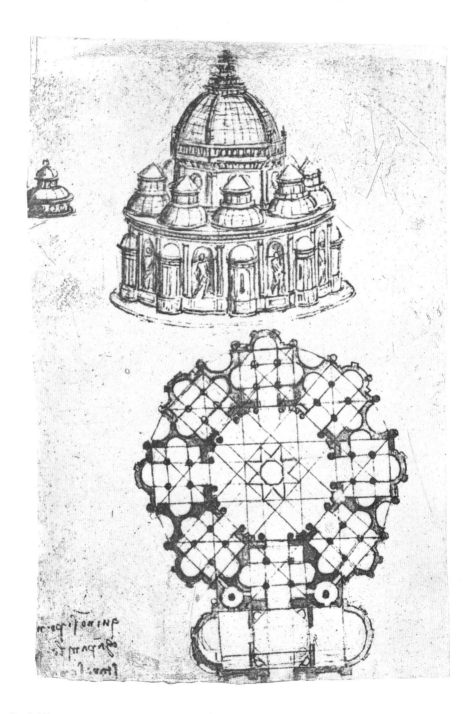

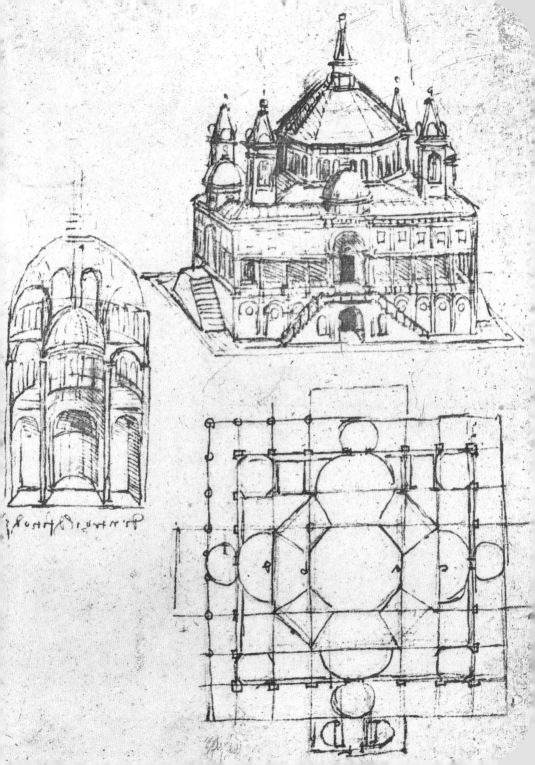

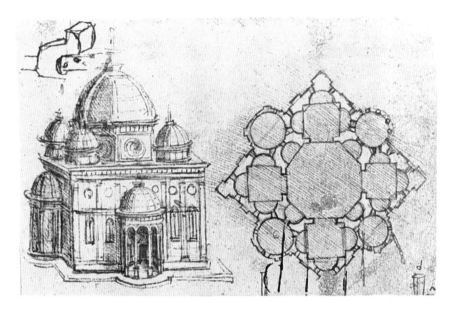

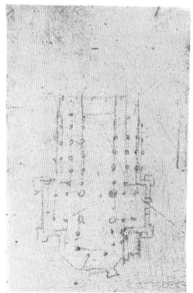

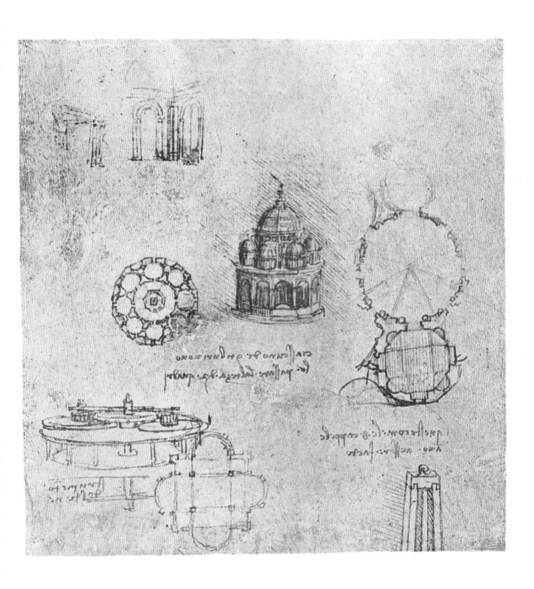

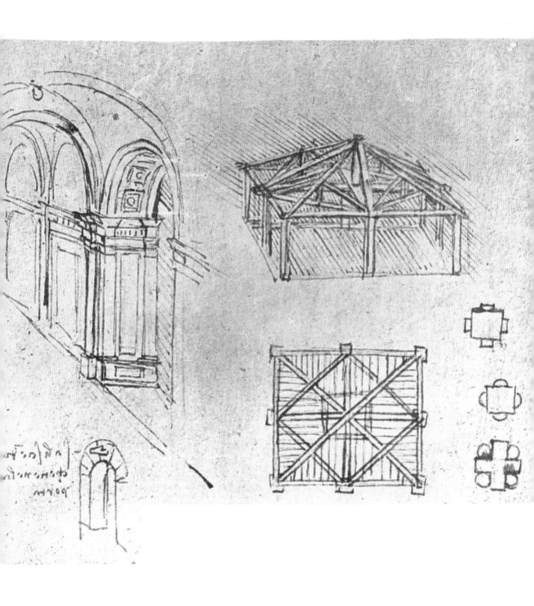

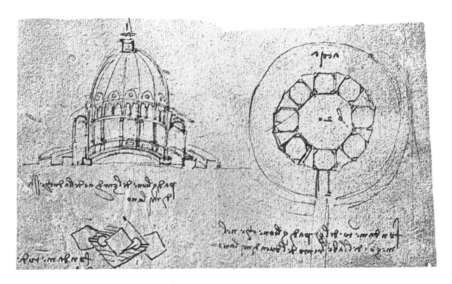

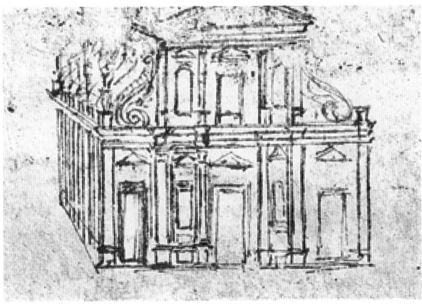

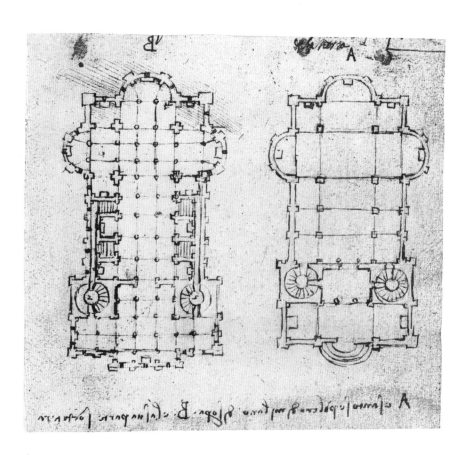

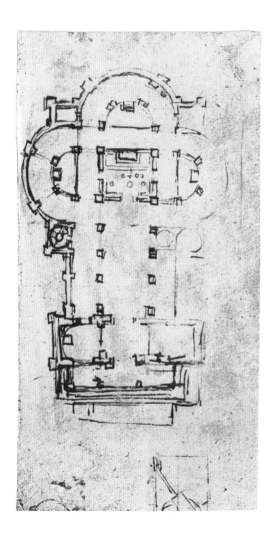

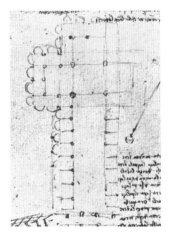

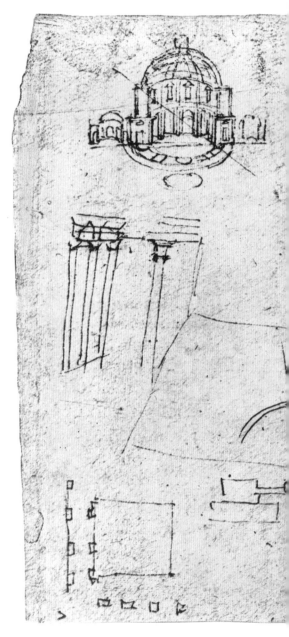

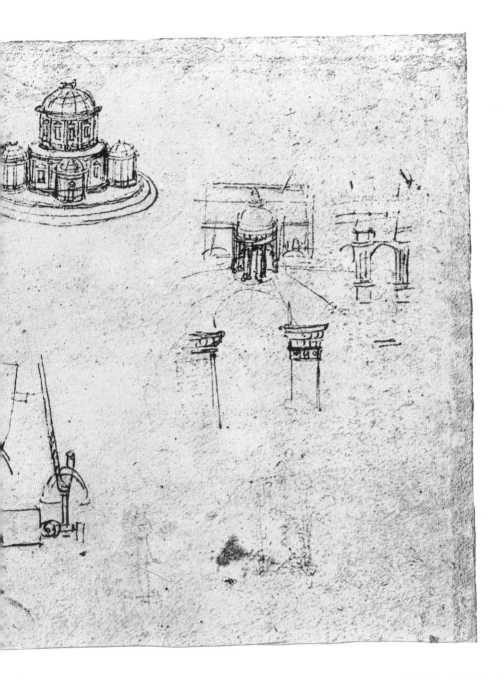

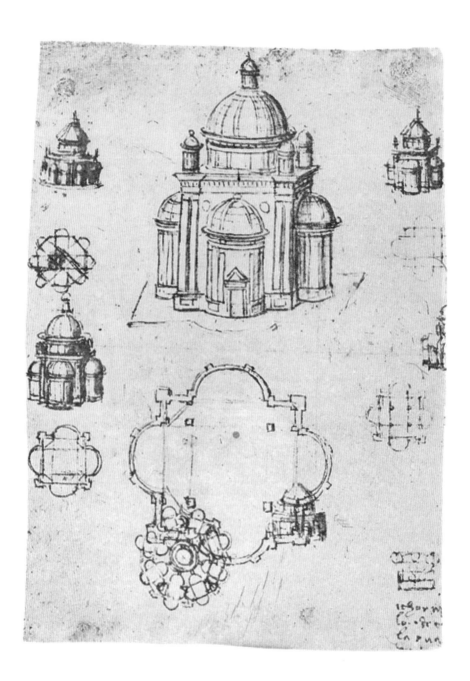

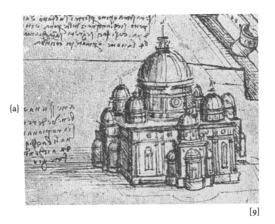

{a}

[9]

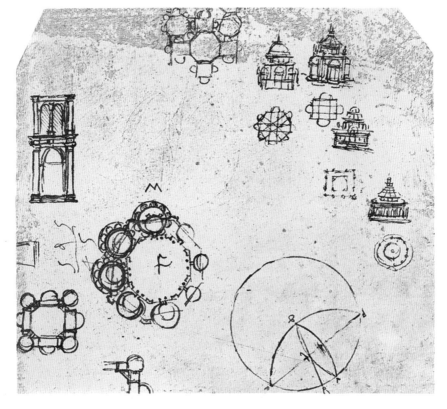

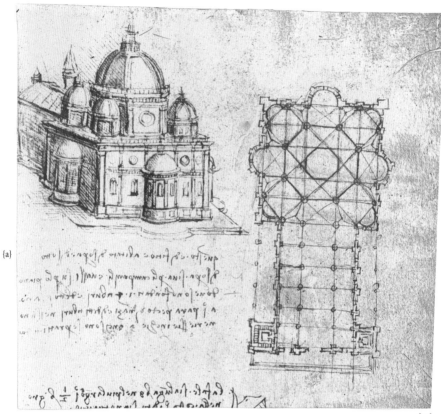

[10]

[9]
{a} *It never looks well to see the roofs of a church; they should rather be flat and the water should run off by gutters made in the frieze.*

[10]
{a} *This building is inhabited below and above; the way up is by the campaniles, and in going up one has to use the platform, where the drums of the four domes are, and this platform has a parapet in front, and none of these domes communicate with the church, but they are quite separate.*

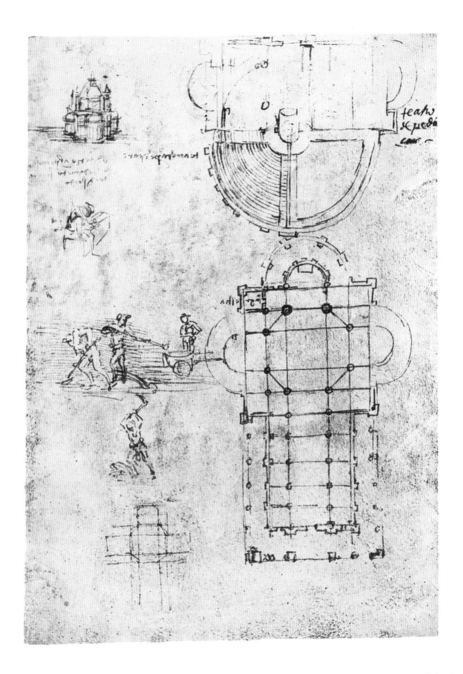

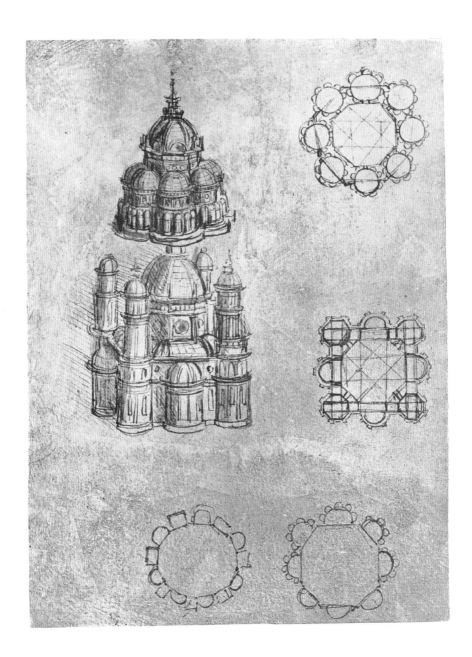

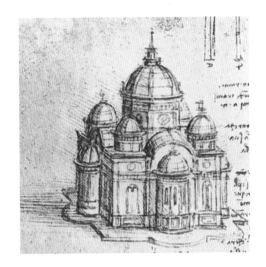

[11]
{a} *This edifice would also produce a good effect if only the part above the lines a b, c d were executed.*

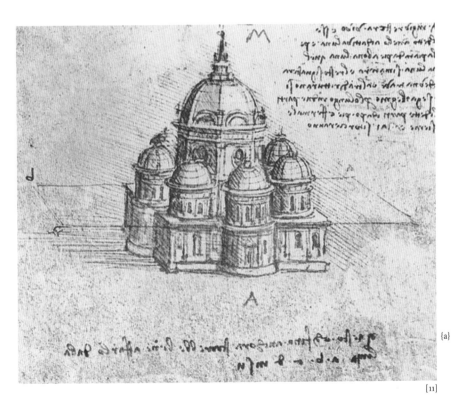

{a}

[11]

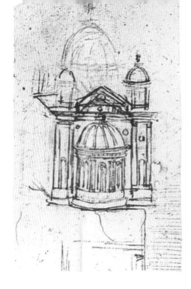

[12]

{a} The main division of the façade of this palace is into two portions; that is to say, the width of the court-yard must be half the whole façade.

{b} In the angle a may be the keeper of the stable.

{c} Jousting in boats, that is, the men are to be in boats.

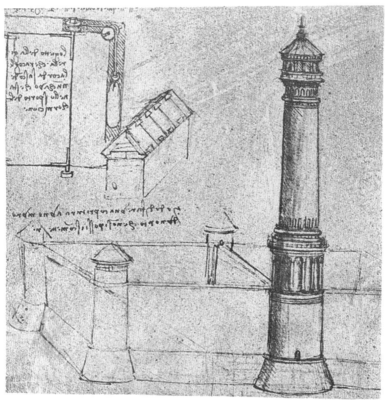

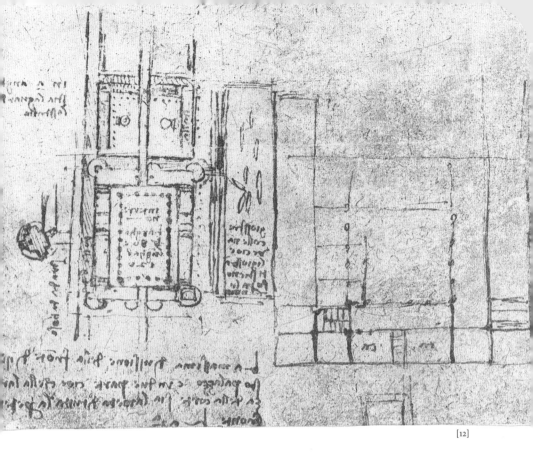

The rooms that you mean to use for dancing or to make different kinds of jumps or various movements with a crowd of people should be on the ground floor, for I have seen them collapse and so cause the death of many. And above all see that every wall, however thin it may be, has its foundations on the ground or on well planted arches.

Let the mezzanines of the dwellings be divided by walls made of narrow bricks, and without beams because of the risk of fire.

All the privies should have ventilation openings through the thickness of the walls, and in such a way that air may come in through the roofs.

Let the mezzanines be vaulted, and these will be so much the stronger as they are fewer in number.

Let the bands of oak be enclosed in the walls to prevent them from being damaged by fire.

Let the privies be numerous and be connected one with another, so that the smell may not spread through the rooms, and their doors should all close automatically.

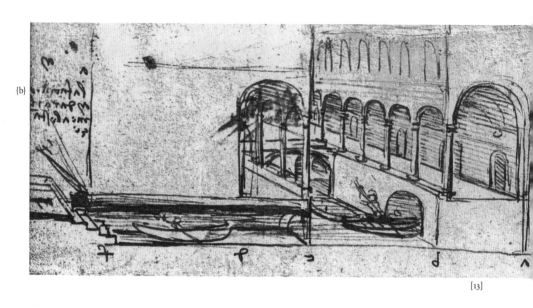

[13]

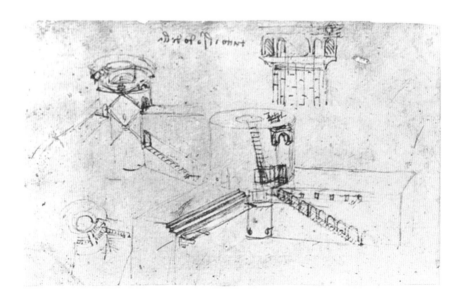

[13]

{a} *The front a m will give light to the rooms.*

a e will be 6 braccia—a b 8 braccia —b e 30 braccia, in order that the rooms under the porticoes may be lighted. c d f is the place where the boats come to the houses to be unloaded.

In order to render this arrangement practicable, and in order that the inundation of the rivers may not penetrate into the cellars, it is necessary to chose an appropriate situation, such as a spot near a river that can be diverted into canals in which the level of the water will not vary either by inundations or drought. The construction is shown below; and make choice of a fine river, which the rains do not render muddy, such as the Ticino, the Adda and many others.

The construction to oblige the waters to keep constantly at the same level will be a sort of dock, situated at the entrance of the town; or better still, some way within, in order that the enemy may not destroy it.

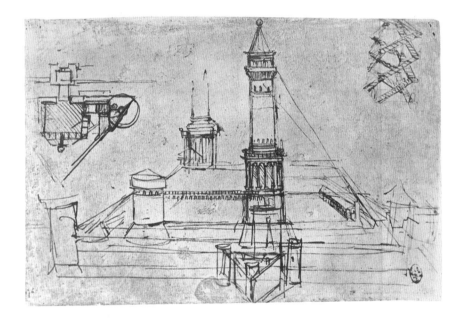

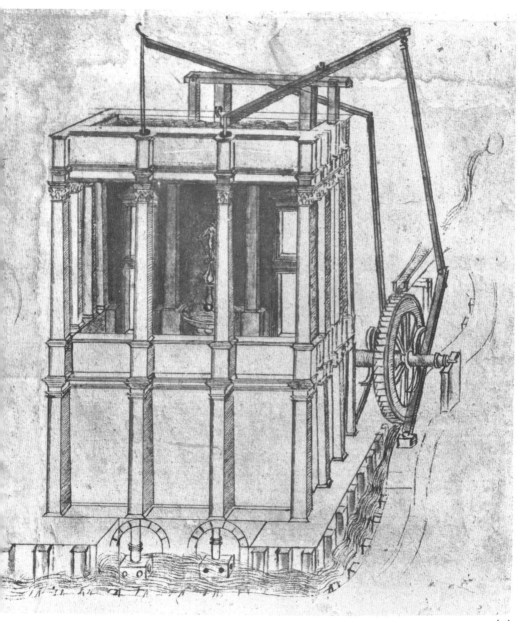

[14]
The main underground channel does not receive turbid water, but that water runs in the ditches outside the town with four mills at the entrance and four at the outlet, and this may be done by damming the water above Romorantin.

There should be fountains made in each piazza.

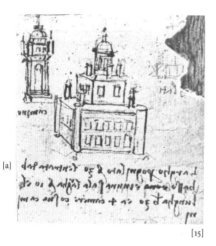

stable, i.e., where the hay is, that part must have at its outer end a window through which by simple means the hay is brought up to the loft, as is shown by the machine E. And let this be erected in a place six braccia wide, and as long as the stable, as seen at k p.

The other two parts, which are on either side of this, are again divided; those nearest to the hay-loft are p s, and only for the use and circulation of the servants belonging to the stable; the other two, which reach to the outer walls, are seen at s k, and these are made for the purpose of giving hay to the mangers, by means of funnels, narrow at the top and wide over the manger, in order that the hay should not choke them. They must be well plastered and clean. As to the giving the horses water, the troughs must be of stone and above them [cisterns of] water. The mangers may be opened as boxes are uncovered by raising the lids.

[15]

[15]
{a} *30 braccia wide on each side; the lower entrance leads into a hall 10 braccia wide and 30 braccia long with four recesses, each with a chimney.*

[16]
{a} *The first story [or terrace] must be entirely solid.*

[17]
{a} *Steps at [the castle of] Urbino.*

[18]
The manner in which one must arrange a stable. You must first divide its width in three parts, its depth matters not; and let these three divisions be equal. The middle part shall be for the use of the stablemasters; the two side ones for the horses. Now, in order to attain to what I promise, that is to make this place, contrary to the general custom, clean and neat: as to the upper part of the

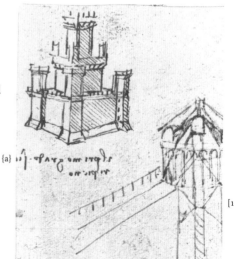

[16]

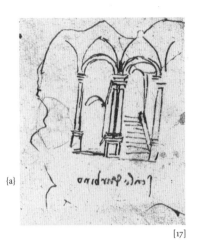

{a}

[17]

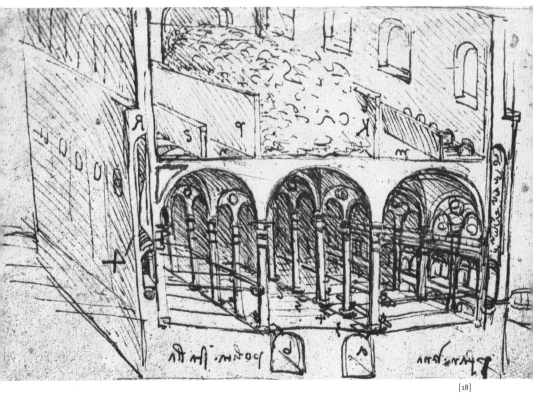

[18]

{a}

[19]

[4]

[19]

{a} *On St. Mary's day in the middle of August, at Cesena, 1502.*

[20]

{a} *The bridge of Pera at Constantinople, 40 braccia wide, 70 braccia high above the water, 600 braccia long; that is 400 over the sea and 200 on the land, thus making its own abutments.*

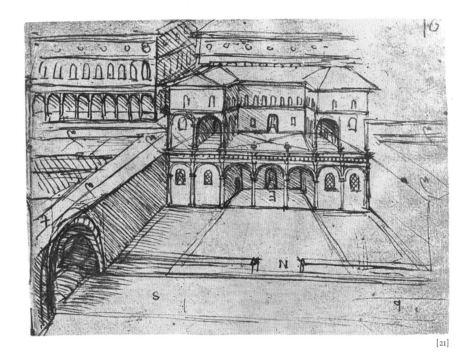

[21]

[21]

The roads m are six braccia higher than the roads p s, and each road must be 20 braccia wide and have 1/2 braccio slope from the sides towards the middle; and in the middle let there be at every braccio an opening, one braccio long and one finger wide, where the rain water may run off into hollows made on the same level as p s. And on each side at the extremity of the width of the said road let there be an arcade, six braccia broad, on columns; and understand that he who would go through the whole place by the high level streets can use them for this purpose, and he who would go by the low level can do the same.

By the high streets no vehicles and similar objects should circulate, but they are exclusively for the use of gentlemen. The carts and burdens for the use and convenience of the inhabitants have to go by the low ones.

One house must turn its back to the other, leaving the lower streets between them. Provisions, such as wood, wine, and such things are carried in by the doors n, and privies, stables, and other fetid matter must be emptied away underground.

From one arch to the next must be 300 braccia, each street receiving its light through the openings of the upper streets, and at each arch must be a winding stair on a circular plan because the corners of square ones are always fouled. They must be wide, and at the first vault there must be a door entering into public privies and the said stairs lead from the upper to the lower streets and the high level streets begin outside the city gates and slope up till at these gates they have attained the height of six braccia. Let such a city be built near the sea or a large river in order that the dirt of the city may be carried off by the water.

❦

[A plan for laying out a water garden:]

The staircase is one braccio and three quarters wide and it is bent like a knee, and altogether it is sixteen braccia with thirty-two steps half a braccio wide and a quarter high; and the landing where the staircase turns is two braccia wide and four long, and the wall that divides one staircase from the other is half a braccio; but the breadth of the staircase will be two braccia and the passage half a braccio wider; so that this large room will come to be twenty-one braccia long and ten and half braccia wide, and so it will serve well; and let us make it eight braccia high, although it is usual to make the height tally with the width; such rooms however seem to me depressing for they are always somewhat in shadow because of their great height, and the staircases would then be too steep because they would be straight.

By means of the mill I shall be able at any time to produce a current of air; in the summer I shall make the water spring up fresh and bubbling, and flow along in the space between the tables. The channel may be half a braccio wide, and there should be vessels there with wines always of the freshest, and other water should flow through the garden, moistening the orange trees and citron trees according to their needs. These citron trees will be permanent, because their situation will be so arranged that they can easily be covered over, and the warmth that the winter season continually produces will be the means of preserving them far better than fire, for two reasons: one is that this warmth of the springs is natural and is the same as warms the roots of all the plants; the second is that the fire gives warmth to these plants in an accidental manner, because it is deprived of moisture and is neither uniform nor continuous, being warmer at the beginning than at the end, and very often it is overlooked through the carelessness of those in charge of it.

The herbage of the little brooks ought to be cut frequently so that the clearness of the water may be seen upon its shingly bed, and only those plants should be left that serve the fishes for food, such as watercress and other plants like these.

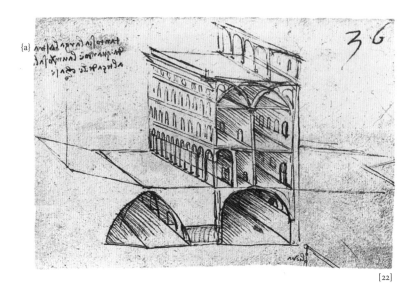

[handwritten annotation]

[22]

The fish should be such as will not make the water muddy, that is to say, eels must not be put there nor tench, nor yet pike because they destroy the other fish.

By means of the mill you will make many water conduits through the house, and springs in various places, and a certain passage where, when anyone passes, from all sides below the water will leap up, and so it will be there ready in case anyone should wish to give a shower-bath from below to the women or others who shall pass there.

Overhead we must construct a very fine net of copper that will cover over the garden and shut in beneath it many different kinds of birds, and so you will have perpetual music together with the scents of the blossom of the citrons and the lemons.

With the help of the mill I will make unending sounds from all sorts of instruments, which will sound for so long as the mill shall continue to move.

[22]
{a} *Let the width of the streets be equal to the average height of the houses.*

[23]
{a} *First write the treatise on the causes of the giving way of walls and then, separately, treat of the remedies.*

Parallel cracks are constantly appearing in buildings erected in mountainous places where the rocks are stratified and the stratification runs obliquely, for, in these oblique seams, water and other moisture often penetrates, bearing with it a quantity of greasy and

slimy earth; and, since this stratification does not continue down to the bottom of the valleys, the rocks go slipping down their slope, and never end their movement until they have descended to the bottom of the valley, carrying with them after the manner of a boat such part of the building as they have severed from the rest.

{b} The remedy for this is to build numerous piers under the wall that is slipping away, with arches from one to another, and well rooted. And let the pillars have their bases firmly set in the stratified rock so that they may not break away.

{c} In order to find the solid part of these strata, it is necessary to make a shaft at the foot of the wall of great depth through the strata; and in this shaft, on the side from which the hill slopes, smooth and flatten a space one palm wide from the top to the bottom; and after some time this smooth portion made on the side of the shaft, will show plainly which part of the hill is moving.

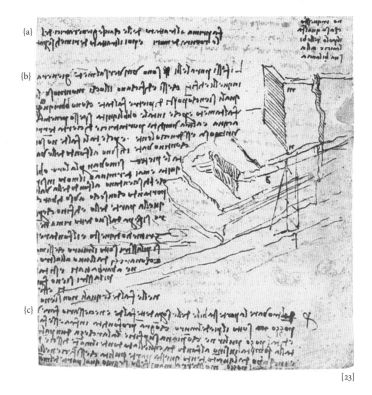

[23]

{a}

{b}

{c}

{d}

{e}

[23]

[24]

{a} *The window a is the cause of the crack at b; and this crack is increased by the pressure of n and m, which sink or penetrate into the soil in which foundations are built more than the lighter portion at b. Besides, the old foundation under b has already settled, and this the piers n and m have not yet done. Hence the part b does not settle down perpendicularly; on the contrary, it is thrown outwards obliquely, and it cannot on the contrary be thrown inwards, because a portion like this, separated from the main wall, is larger outside than inside and the main wall, where it is broken, is of the same shape and is also larger outside than inside; therefore, if this separate portion were to fall inwards the larger would have to pass through the smaller—which is impossible. Hence it is evident that the portion of the semicircular wall when disunited from the main wall will be thrust outwards, and not inwards as the adversary says.*

{b} *When a dome or a half-dome is crushed from above by an excess of weight the vault will give way, forming a crack that diminishes towards the top and is wide below, narrow on the inner side and wide outside; as is the case with the outer husk of a pomegranate, divided into many parts lengthwise; for the more it is pressed in the direction of its length, that part of the joints will open most, which is most distant from the cause of the pressure; and for that reason the arches of the vaults of any apse should*

never be more loaded than the arches of the principal building. Because that which weighs most, presses most on the parts below, and they sink into the foundations; but this cannot happen to lighter structures like the said apses.

{c} *Which of these two cubes will shrink the more uniformly: the cube A resting on the pavement, or the cube b suspended in the air, when both cubes are equal in weight and bulk, and of clay mixed with equal quantities of water?*

{d} *The cube placed on the pavement diminishes more in height than in breadth, which the cube above, hanging in the air, cannot do. Thus it is proved. The cube shown above is better shown here below.*

{e} *The final result of the two cylinders of damp clay that is a and b will be the pyramidal figures below c and d. This is proved thus: The cylinder a resting on block of stone being made of clay mixed with a great deal of water will sink by its weight, which presses on its base, and in proportion as it settles and spreads, all the parts will be somewhat nearer to the base, because that is charged with the whole weight, etc.; and the case will be the same with the weight of b, which will stretch lengthwise in proportion as the weight at the bottom is increased, and the greatest tension will be the neighborhood of the weight that is suspended by it.*

[25]

{a} *Of cracks in walls, which are wide at the bottom and narrow at the top, and of their causes.*

That wall which does not dry uniformly in an equal time, always cracks.

{b} *A wall though of equal thickness will not dry with equal quickness if it is not everywhere in contact with the same medium. Thus, if one side of a wall were in contact with a damp slope and the other were in contact with the air, then this latter side would remain of the same size as before; that side which dries in the air will shrink or diminish and the side which is kept damp will not dry. And the dry portion will break away readily from the damp portion because the damp part not shrinking in the same proportion does not cohere and follow the movement of the part that dries continuously.*

Of arched cracks, wide at the top, and narrow below.

{c} *Arched cracks, wide at the top and narrow below are found in walled-up doors, which shrink more in their height than in their breadth, and in proportion as their height is greater than their width, and as the joints of the mortar are more numerous in the height than in the width.*

{d} *The crack diminishes less in r o than in m n, in proportion as there is less material between r and o than between n and m.*

{e} *Any crack made in a concave wall wide below and narrow at the top; and this originates, as is here shown at bed, in the side figure.*

{f} *1. That which gets wet increases in proportion to the moisture it imbibes.*

{g} *2. And a wet object shrinks, while drying, in proportion to the amount of moisture that evaporates from it.*

[26]

{a} *The cracks in walls will never be parallel unless the part of the wall that separates from the remainder does not slip down.*

That is to say that the walls must be all built up equally, and by degrees, to equal heights all round the building, and the whole thickness at once, whatever kind of walls they may be. And although a thin wall dries more quickly than a thick one it will not necessarily give way under the added weight day by day and thus, although a thin wall dries more quickly than a thick one, it will not give way under the weight that the latter may acquire from day to day. Because if double the amount of it dries in one day, one of double the thickness will dry in two days or thereabouts; thus the small addition of weight will be balanced by the smaller difference of time. The adversary says that a, which projects, slips down. And here the adversary says that r slips and not c.

{a}

{b}

{d}

{e}

{f}

{g}

{c}

{a}

[26]

The part of the wall which does not slip is that in which the obliquity projects and overhangs the portion that has parted from it and slipped down.

When the crevice in the wall is wider at the top than at the bottom, it is a manifest sign that the cause of the fissure in the wall is remote from the perpendicular line through the crevice.

[27]
The first and most important thing is stability.

{a} *As to the foundations and other public buildings, the depths of the foundations must be at the same proportions to each other as the weight of material that is to be placed upon them.*

❦

That beam which is more than 20 times as long as its greatest thickness will be of brief duration and will break in half; and remember, that the part built into the wall should be steeped in hot pitch and filleted with oak boards likewise so steeped. Each beam must pass through its walls and be secured beyond the walls with sufficient chaining, because in consequence of earthquakes the beams are often seen to come out of the walls and bring down the walls and floors; whilst if they are chained they will hold the walls strongly together and the walls will hold the floors.

Again I remind you never to put plaster over timber. Since by expansion and shrinking of the timber produced by damp and dryness such floors often crack, and once cracked their divisions gradually produce dust and an ugly effect. Again remember not to lay a floor on beams supported on arches; for, in time the floor that is made on beams

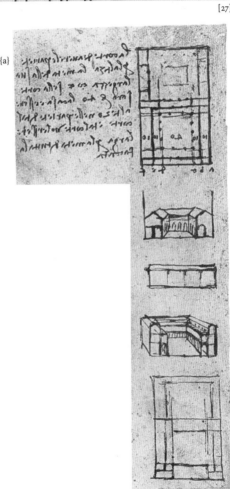

[27]

[a]

[29]

[28]

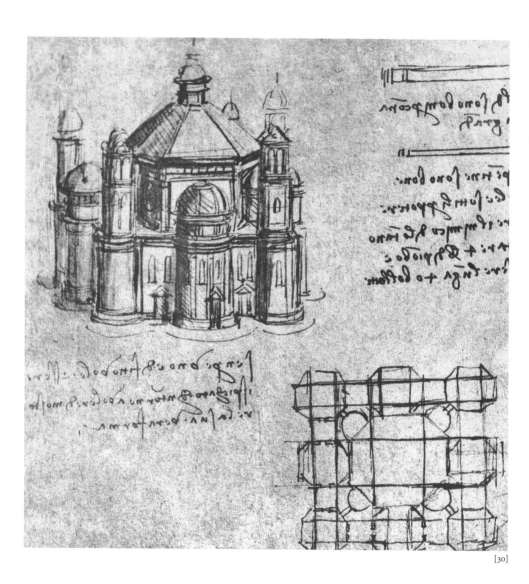

[30]

settles somewhat in the middle while that part of the floor that rests on the arches remains in its place; hence, floors laid over two kinds of supports look, in time, as if they were made in hills.

[28]

Stones laid in regular courses from bottom to top and built up with an equal quantity of mortar settle equally throughout, when the moisture that made the mortar soft evaporates.

[29]

{a} *In the courtyard, the walls must be half the height of its width, that is, if the court be 40 braccia, the house must be 20 high as regards the walls of the said courtyard; and this courtyard must be half as wide as the whole front.*

[30]

{a} *A building should always be detached on all sides so that its form may be seen.*

Sculptured figures that appear in motion will, in their standing position, actually look as if they were falling forward.

XI. Sculpture and Metalwork

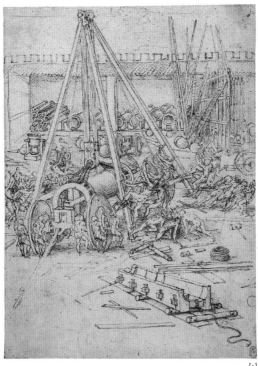

[1]
Of the length of the body of the gun: if you want it to throw a ball of stone, make the length of the gun to be six, or as much as seven diameters of the ball; and if the ball is to be of iron make it as much as 12 balls, and if the ball is to be of lead, make it as much as 18 balls. I mean when the gun is to have the mouth fitted to receive 600 lbs. of stone ball, and more.

Sculpture is less intellectual than painting, and lacks many characteristics of nature. I myself, having exercised myself no less in sculpture than in painting and doing both one and the other in the same degree, it seems to me that I can, without invidiousness, pronounce an opinion as to which of the two is of the greatest merit and difficulty and perfection.

In the first place sculpture requires a certain light, that is, from above, a picture carries everywhere with it its own light and shade. Thus sculpture owes its importance to light and shade, and the sculptor is aided in this by the nature of the relief, which is inherent in it, while the painter, whose art expresses the accidental aspects of nature, places his effects in the spots where nature must necessarily produce them.

The sculptor cannot diversify his work by the various natural colors of objects; painting is not defective in any particular. The sculptor when he uses perspective cannot make it in any way appear true; that of the painter can appear like a hundred miles beyond the picture itself. Their works have no aerial perspective whatever, they cannot represent transparent bodies, they cannot represent luminous bodies, nor reflected lights, nor lustrous bodies—as mirrors and the like polished surfaces, nor mists, nor dark skies, nor an infinite number of things that need not be told for fear of tedium.

As regards the power of resisting time, though they have this resistance, a picture painted on thick copper covered with white enamel on which it is painted with enamel colors and then put into the fire again and baked, far exceeds sculpture in permanence. It may be said that if a mistake is made it is not easy to remedy it; it is but a poor argument to try to prove that a work be the nobler because oversights are irremediable; I should rather say that it will be more difficult to improve the mind of the master who makes such mistakes than to repair the work he has spoilt.

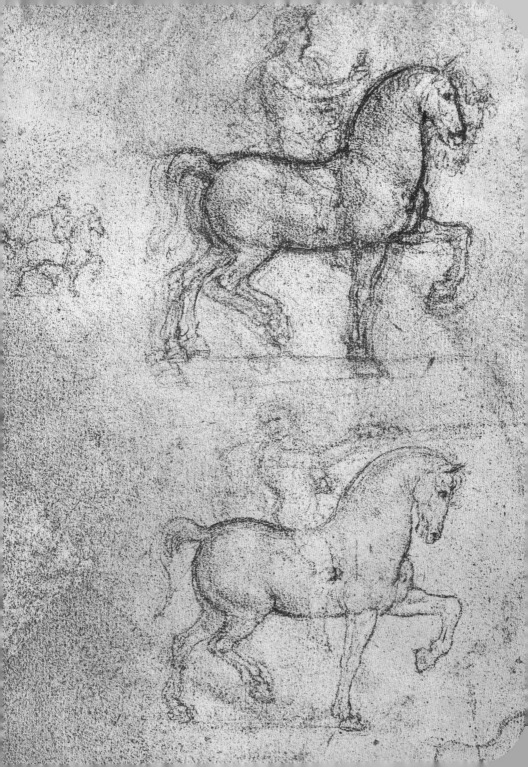

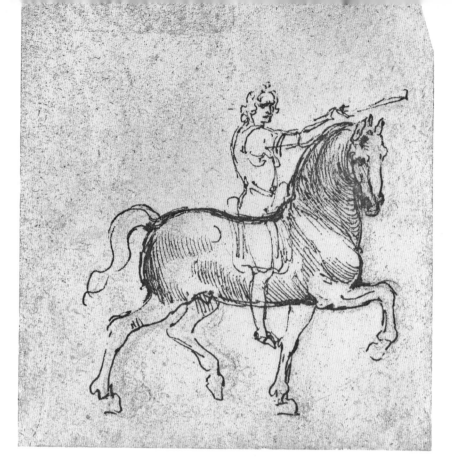

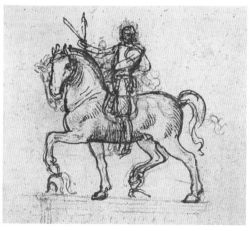

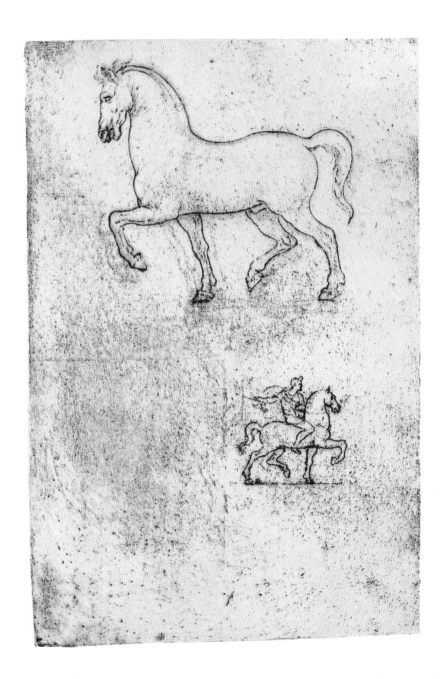

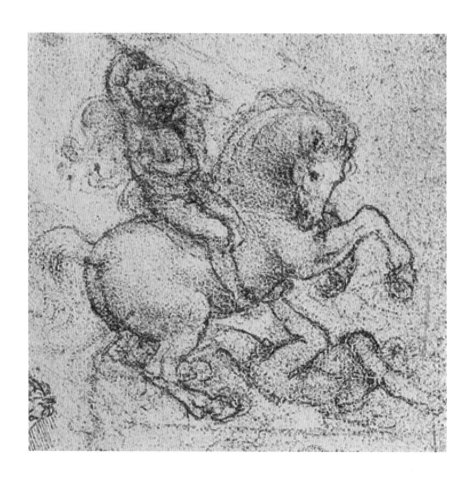

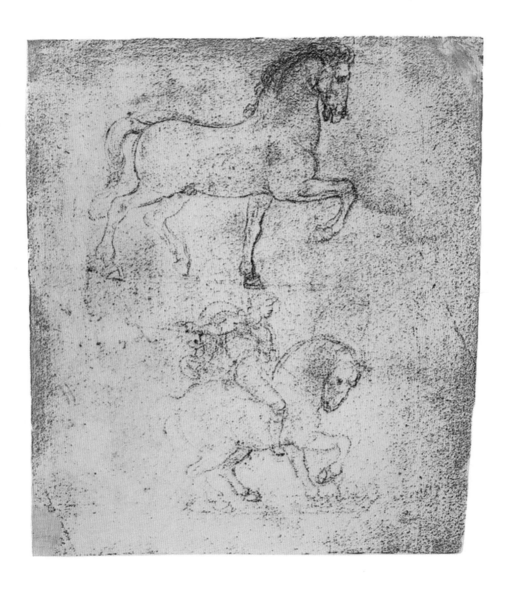

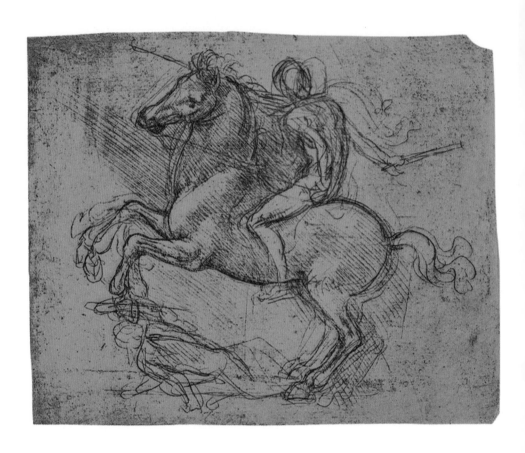

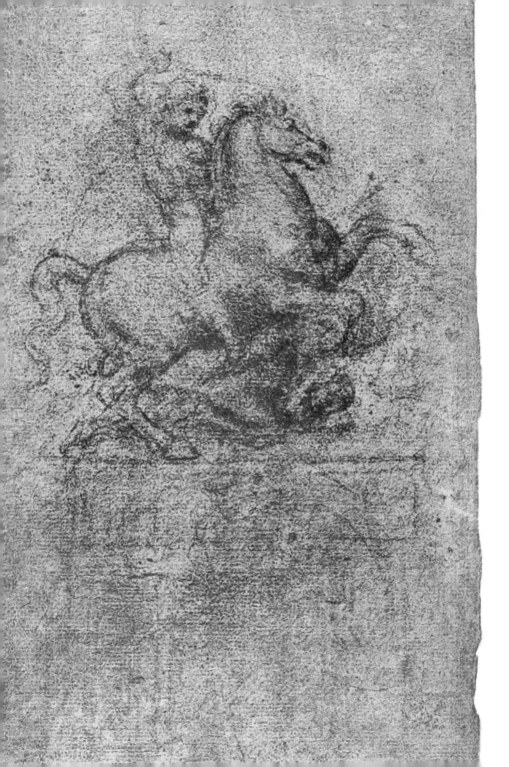

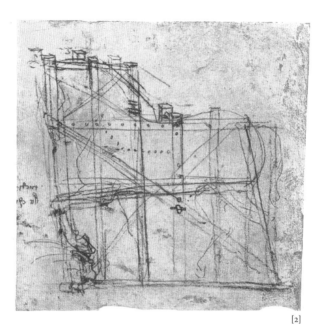

[2]

[2]

Three braces, which bind the mold. If you want to make simple casts quickly, make them in a box of river sand wetted with vinegar.

When you shall have made the mold upon the horse you must make the thickness of the metal in clay.

Observe in alloying how many hours are wanted for each hundredweight. In casting each one, keep the furnace and its fire well stopped up. Let the inside of all the molds be wetted with linseed oil or oil of turpentine, and then take a handful of powdered borax and Greek pitch with aqua vitae, and pitch the mold over outside so that being under ground the damp may not damage it.

To manage the large mold make a model of the small mold, make a small room in proportion.

Make the vents in the mold while it is on the horse.

Hold the hoofs in the tongs, and cast them with fish glue. Weigh the parts of the mold and the quantity of metal it will take to fill them, and give so much to the furnace that it may afford to each part its amount of metal. And this you may know by weighing the clay of each part of the mold to which the quantity in the furnace must correspond. And this is done in order that the furnace for the legs when filled may not have to furnish metal from the legs to help out the head, which would be impossible.

[3]

{a} *Make the horse on legs of iron, strong and well set on a good foundation; then grease it and cover it with a coating, leaving each coat to dry thoroughly layer by layer, and this will thicken it by the breadth of three fingers. Now fix and bind it with iron as may be necessary. More-over take off the mold and then make the thickness. Then fill the mold by degrees and make it good throughout; encircle and bind it with its irons and bake it inside where it has to touch the bronze.*

{b} *Of making the mold in pieces: Draw upon the horse, when finished, all the pieces of the mold with which you wish to cover the horse, and in lay-ing on the clay cut it in every piece, so that when the mold is finished you can take it off, and then recompose it in its former position with its joins, by the countersigns.*

{c} *The square blocks a b will be between the cover and the core; that is in the hollow where the melted bronze is to be. And these square blocks of bronze will support the intervals between the mold and the cover at an equal distance, and for this reason these squares are of great importance.*

{d} *The clay should be mixed with sand.*

{e} *Take wax, to return [what is not used] and to pay for what is used.*

{f} *Dry it in layers.*

{g} *Make the outside mold of plaster, to save time in drying and the expense in wood; and with this plaster enclose the iron [props] both outside and inside to a thickness of two fingers; make terra cotta.*

{h} *And this mold can be made in one day. Half a boat load of plaster will serve you.*

{i} *Good.*

{j} *Dam it up again with glue and clay, or white of egg, and bricks and rubbish.*

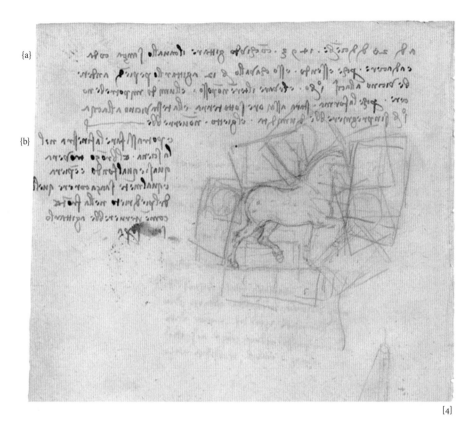

{a}

{b}

[4]

[4]

{a} *This day, the 20th of December, 1493, I have decided to cast the horse without tail and lying on the side. And because the horse measures 12 braccia, if I cast it upside down, the water would be as close as one braccio. And as I cannot remove the soil, humidity might harm the mold for many hours. And the head, being one braccio from the water, might then become impregnated with humidity, and the cast would not succeed.*

{b} *And the window can be made on the back. The bronze will find the same depth and will fill up evenly without having the metal of the hind leg run to the front, which is what would happen if the horse were cast upside down.*

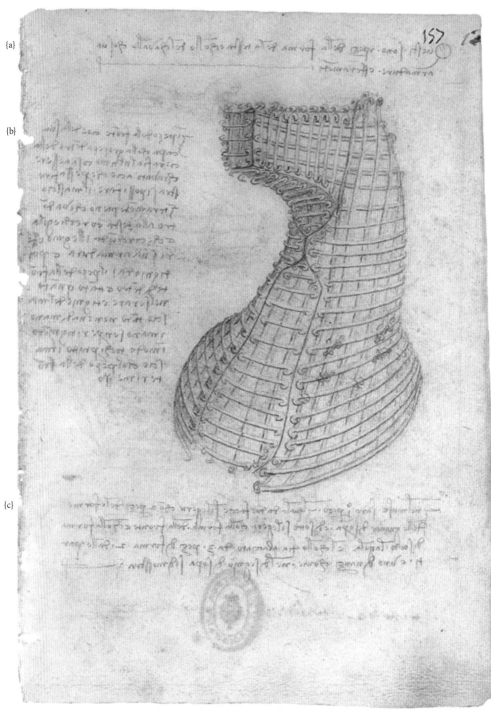

[5]

{a} *These are the pieces belonging to the mold of the head and neck of the horse along with their armatures and irons.*

{b} *The piece of forehead, that is, the piece of its form which has the thickness of wax on the inside, must be the thing to be locked in order to make an entirely solid core through this opening. This core goes on the inside of the head, ears, and neck, and is surrounded by the wooden and iron armature. Afterwards, you shall stain the piece of the forehead on the inside and remove it, little by little, always staining again so long as the core touches the piece of the forehead once it is put in its place.*

{c} *The muzzle shall have a piece that will be fastened on both sides with two mold pieces belonging to the upper part of the cheeks. And below, it shall be fastened to the mold of the forehead and the mold under the throat. The neck must be embraced by three mold pieces, two on the sides and one in front, as shown above.*

❨

If you wish to make a figure in marble, first make one of clay, and when you have finished it, let it dry and place it in a case that should be large enough, after the figure is taken out of it, to receive also the marble, from which you intend to reveal the figure in imitation of the one in clay.

After you have put the clay figure into this said case, have little rods that will exactly slip in to the holes in it, and thrust them so far in at each hole that each white rod may touch the figure in different parts of it. And color the portion of the rod that remains outside black, and mark each rod and each hole with a countersign so that each may fit into its place.

Then take the clay figure out of this case and put in your piece of marble, taking off so much of the marble that all your rods may be hidden in the holes as far as their marks. And to be the better able to do this, make the case so that it can be lifted up; but the bottom of it will always remain under the marble and in this way it can be lifted with tools with great ease.

❨

How to make lead combine with other metals: if you wish for the sake of economy to put lead with the metal, and in order to lessen the amount of the tin that is necessary, first alloy the lead with the tin and then put above the molten copper.

❨

Of alloying the metal: the metal used for bombards must invariably be made with six or even eight parts to a hundred; that is, six parts of tin to one hundred of copper, but the less you put in, the stronger will be the bombard.

When the tin should be added to copper: the tin should be put with the copper when you have the copper changed into a fluid state.

How the process of melting may be expedited: you can expedite the process of melting when the copper is two-thirds changed to a fluid state. With a chestnut rod you will then be able frequently to manage to stir the remainder of the copper that is still in one piece amid the melted part.

《

How casts ought to be polished: make a bunch of iron wire as thick as thread, and [use this to] scrub them with water. Hold a bowl underneath that it may not make a mud below.

《

Stucco for molding: Take of butter six parts, of wax two parts, and as much fine flour as when put with these two things melted, will make them as firm as wax or modeling clay.

Glue: Take mastic, distilled turpentine, and white lead.

《

How to remove the rough edges of the bronze: you should make an iron rod, which may be of the shape of a large chisel, and rub it along the edges that remain upon the casts of the guns and that are caused by the joins in the mold; but see that the rod is a good weight and let the strokes be long and sweeping.

To facilitate the melting: first alloy part of the metal in the crucible and then put it in the furnace: this being in a molten state will make a beginning in the melting of the copper.

To guard against the copper cooling in the furnace: when the copper begins to cool in the furnace proceed instantly as soon as you see this to slice it up with a stirring pole while it is in a paste, or if it has become entirely cold, cut it as you would lead, with broad large chisels.

For the making of a large cast: if you have to make a cast of a hundred thousand pounds, make it with five furnaces with two thousand pounds for each, or as much as three thousand pounds at most.

《

To make a plaster cast for bronze: take for every two cupfuls of plaster one of burnt ox-horn, and mix them together and make the cast.

For casting: tartar burnt and powdered with plaster and used in casting causes such plaster to adhere together when it is annealed; then it is dissolved in water.

For mirrors, thirty of tin upon a hundred of copper; but first clarify the two metals and plunge them in water and granulate them, and then fuse the copper and put it upon the tin.

《

When you want to take a cast in wax, burn the scum with a candle, and the cast will come out without bubbles.

[6]
{a} *Mint at Rome.*

{b} *It can also be made without a spring. But the screw above must always be joined to the part of the movable sheath.*

{c} *All coins that do not have the rim complete are not to be accepted as good; and to secure the perfection of their rim it is requisite that, in the first place, all the coins should be a perfect circle. And to do this a coin must before all be made perfect in weight, and size, and thickness.*

Therefore have several plates of metal made of the same size and thickness, all drawn through the same gauge so as to come out in strips. And out of these strips you will stamp the coins, quite round, as sieves are made for sorting chestnuts. And these coins can then be stamped in the way indicated above, etc.

{d} *The hollow of the die must be uniformly wider than the lower, but imperceptibly.*

{e} *This cuts the coins perfectly round and of the exact thickness, and weight; and saves the man who cuts and weighs, and the man who makes the coins round. Hence it passes only through the hands of the gauger and of the stamper, and the coins are very superior.*

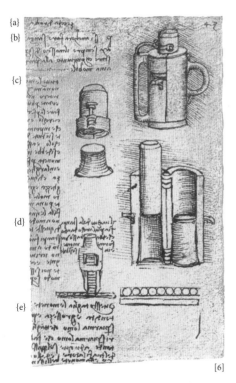

{a}
{b}
{c}
{d}
{e}

[6]

Science is the observation of things possible, whether present or past. Prescience is the knowledge of things that may come to pass, though but slowly.

XII. Inventions

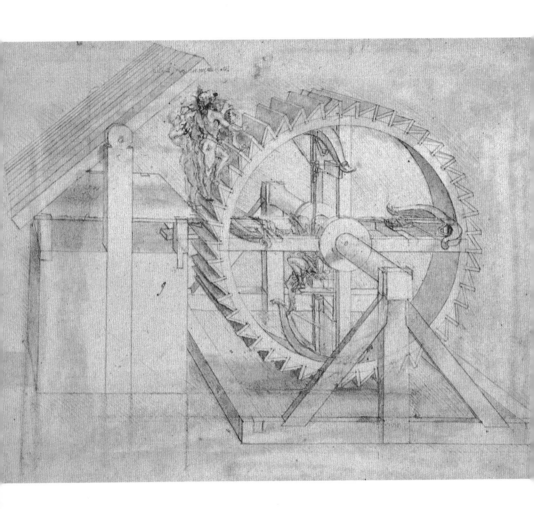

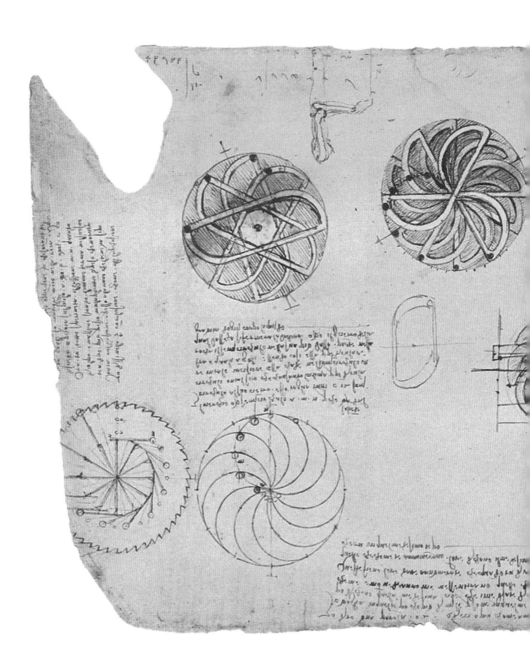

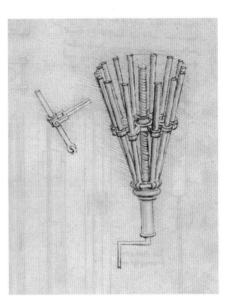

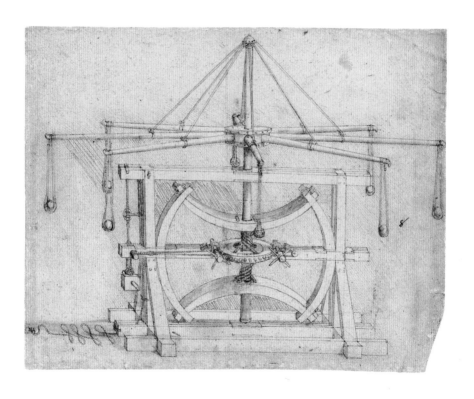

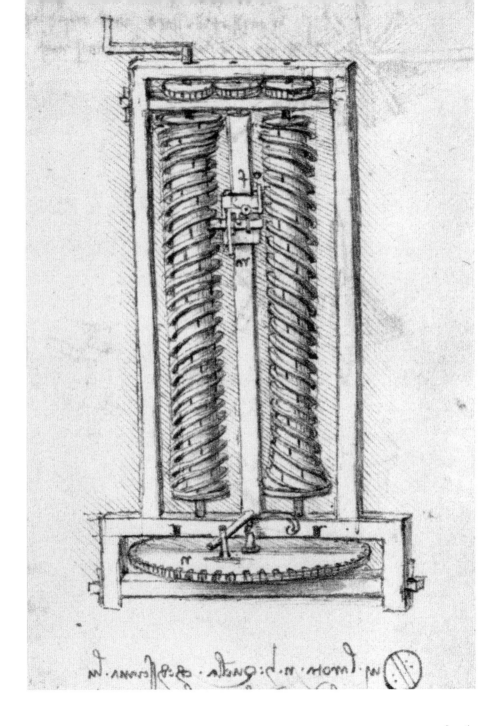

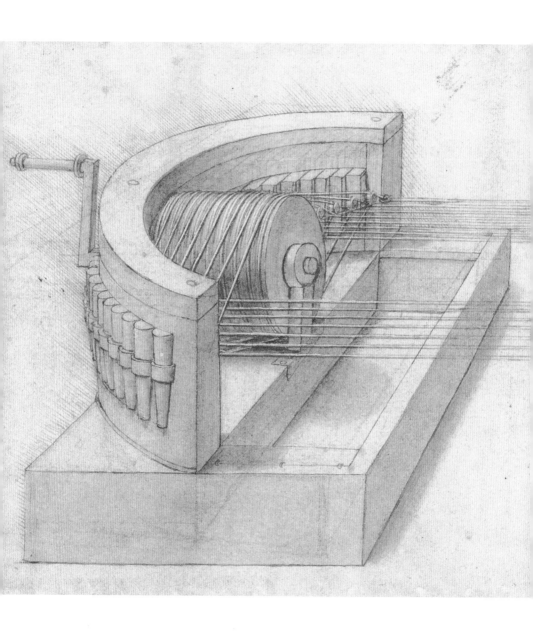

101

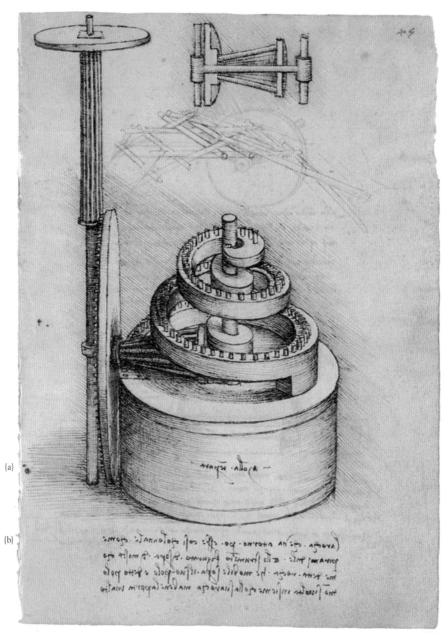

{a}

{b}

[1]

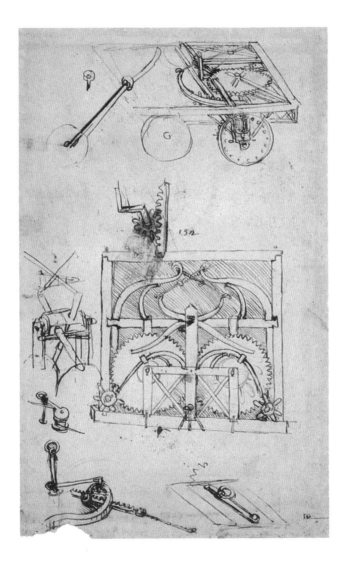

[1]
{a} *Tempered spring.*

　{b} *The pinion turning around may be of either cylindrical or conical shape.*

And the instrument depicted above shows how the said pinion is movable around its axle. And this axle lifts the pinion without turning around with it.

{a}

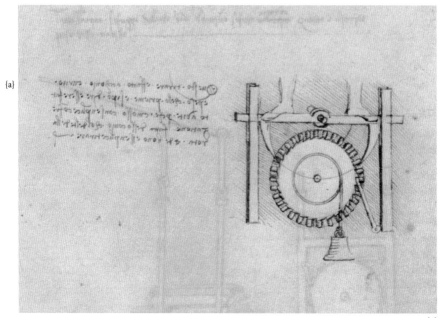

[2]

《

Instrumental or mechanical science is the noblest and above all others the most useful, seeing that by means of it all animated bodies that have movement perform all their actions; and the origin of these movements is at the center of their gravity, which is placed in the middle with unequal weights at the sides of it, and it has scarcity or abundance of muscles, and also the action of a lever and counter-lever.

[2]
{a} *Method by which a wheel always turning in the same direction will move a screw first to the right and then to the left.*

[3]
{a} *This lifting device is based on a curved wedge forced down by a weight. You may say that it works like a screw, because it is put in motion by simple friction between the wedge and the tooth of the wheel. This is a good and simple lifting device.*

{a}

[3]

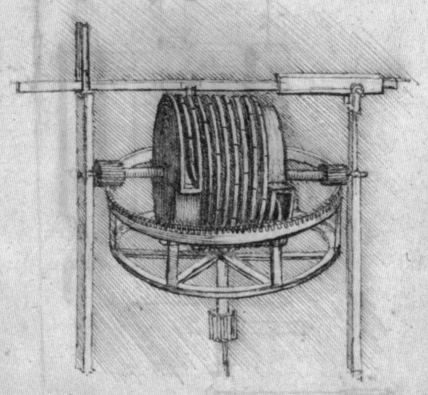

mirror-writing (Leonardo's hand)

{a}

{b}

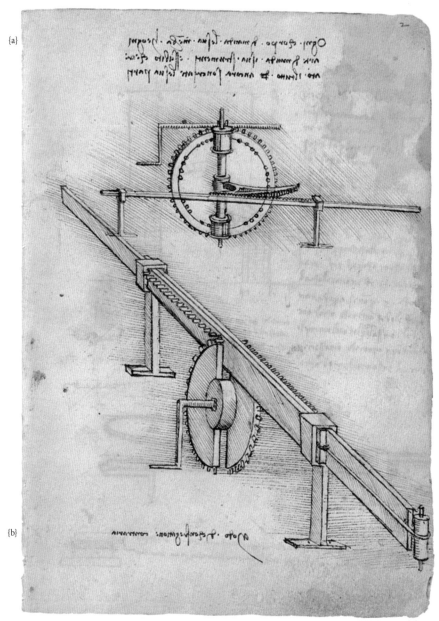

[4]

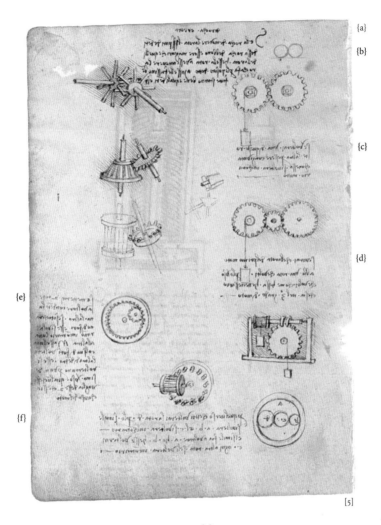

[4]

{a} *Every body requires its members and every art its instruments. And the moment that the whole is created, its parts are also created.*

{b} *Method of contrariwise friction.*

[5]

{a} *Of pinion and wheel.*

{b} *If the pinion must move the wheel, the spacings of the pinion's teeth must be wider than those of the wheel's teeth. And, if the wheel turns the pinion,*

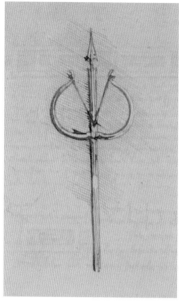

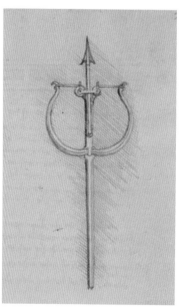

the opposite should be made. However, if both were well constructed, having equal teeth and spacing would be satisfactory.

{c} If you turn one of these wheels, the other, meshing with it, will turn in the opposite direction.

{d} If you wish to have a wheel that turns in the same direction as does the movement of the first wheel, this wheel, by necessity, must have a motion of the third degree.

{e} If you have two wheels that turn each other with their teeth, if they touch at the outside, they will turn contrariwise to each other. But if one of the wheels turns the inside of the other wheel with its outside, both wheels will then turn in the same direction regardless of which wheel causes the motion.

{f} Regardless of the direction you turn wheel d, a and b shall turn in the same way. And wheel c will turn contrariwise. The same will happen when turning a and b. But if you turn wheel c, every other wheel will turn in the opposite direction.

[6]
1. I have plans for bridges, very light and strong and suitable for carrying very easily, with which to pursue and at times defeat the enemy; and others solid and indestructible by fire or assault, easy and convenient to carry away and place in position. And plans for burning and destroying those of the enemy.

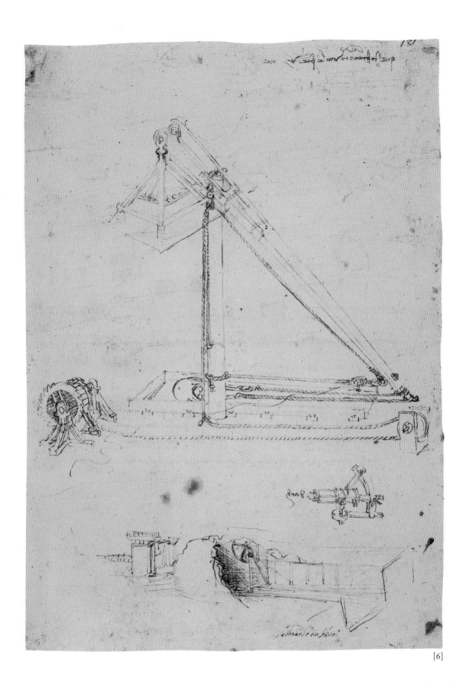

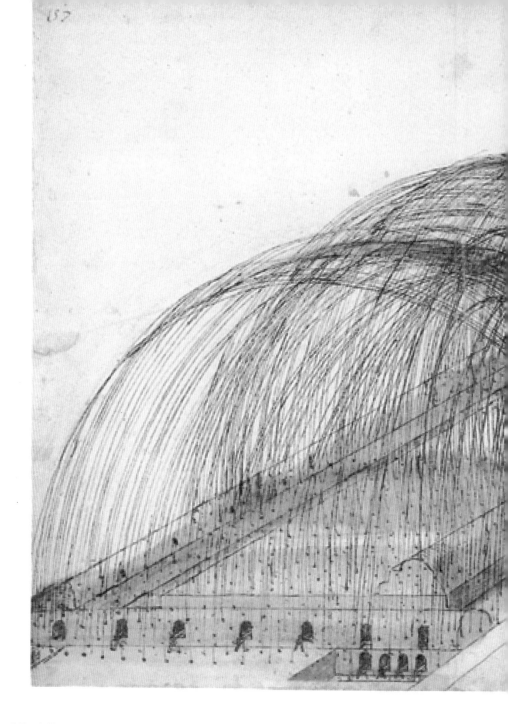

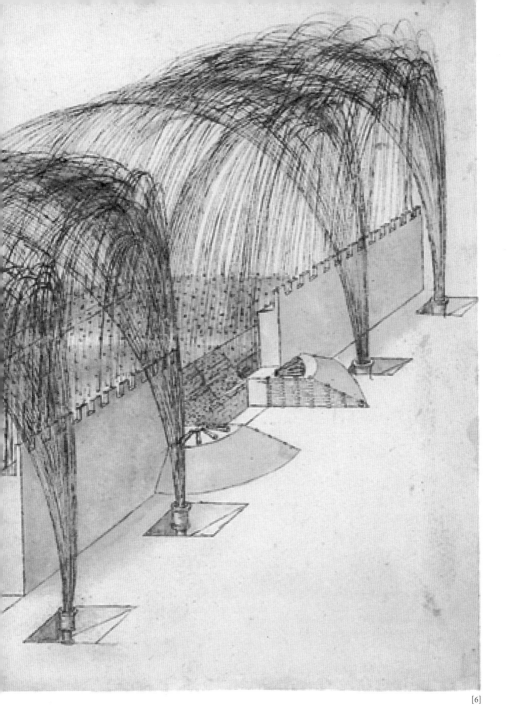

2. When a place is besieged I know how to cut off water from the trenches, and how to construct an infinite number of bridges, mantlets, scaling ladders, and other instruments that have to do with the same enterprise.

3. Also if a place cannot be reduced by the method of bombardment, either through the height of its glacis or the strength of its position, I have plans for destroying every fortress or other stronghold unless it has been founded upon rock.

4. I have also plans for making cannon, very convenient and easy of transport, with which to hurl small stones in the manner almost of hail, causing great terror to the enemy from their smoke, and great loss and confusion.

5. Also I have ways of arriving at a certain fixed spot by caverns and secret winding passages, made without any noise even though it may be necessary to pass underneath trenches or a river.

[6]

6. Also I can make armored cars, safe and unassailable, which will enter the serried ranks of the enemy with their artillery, and there is no company of men at arms so great that they will not break it. And behind these the infantry will be able to follow quite unharmed and without any opposition.

7. Also, if need shall arise, I can make cannon, mortars, and light ordnance, of very beautiful and useful shapes, quite different from those in common use.

8. Where it is not possible to employ cannon, I can supply catapults, mangonels, trabocchi, and other engines of wonderful efficacy not in general use. In short, as the variety of circumstances shall necessitate, I can supply an infinite number of different engines of attack and defense.

9. And if it should happen that the engagement was at sea, I have plans for constructing many engines most suitable either for attack or defense, and ships that can resist the fire of all the heaviest cannon, and powder and smoke.

10. In time of peace I believe that I can give you as complete satisfaction as anyone else in architecture in the construction of buildings both public and private, and in conducting water from one place to another.

Also I can execute sculpture in marble, bronze, or clay, and also painting, in which my work will stand comparison with that of anyone else whoever he may be.

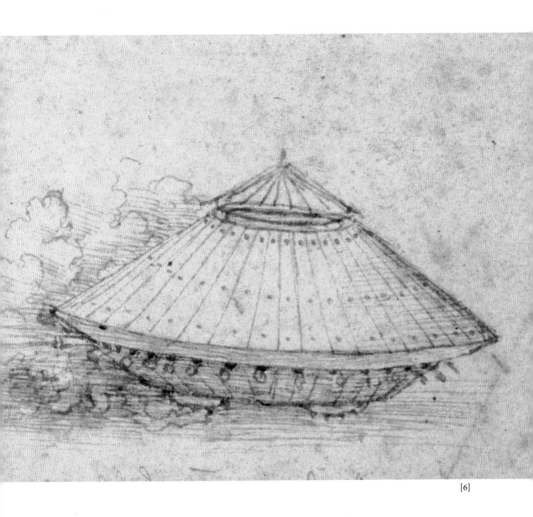

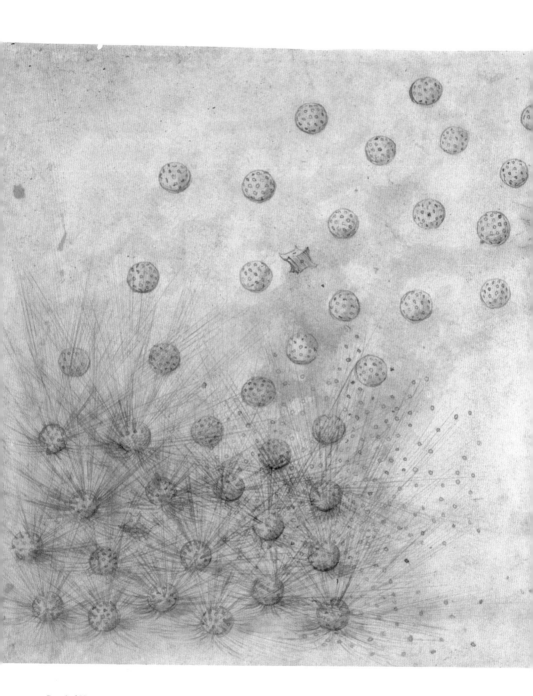

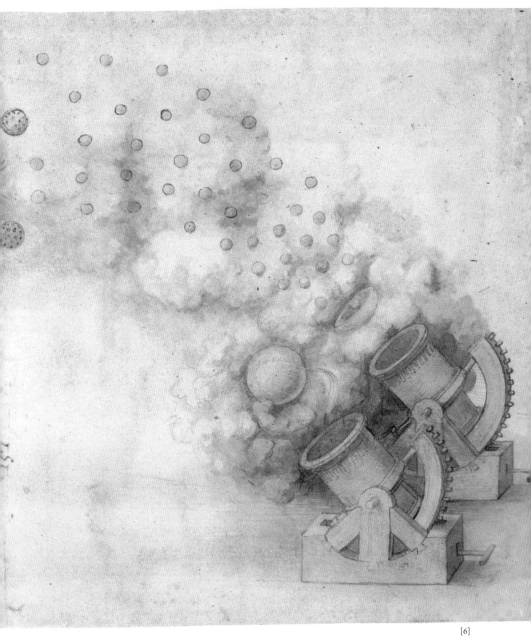

[6]

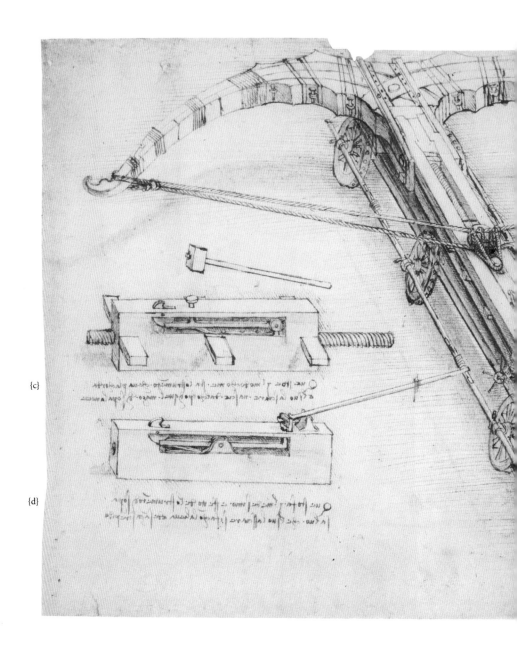

{c}

{d}

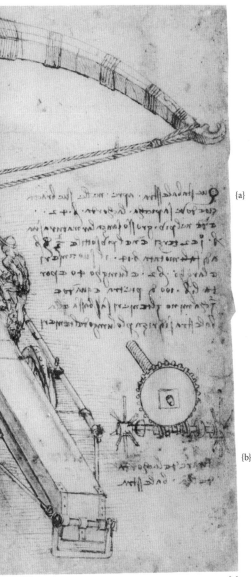

{a} *The open arms of this crossbow—which is where the rope is secured—measure 42 braccia in width, while its broadest section measures one braccio and two thirds and, when it is fired, the rope-stretcher comes down and the crossbow straightens itself out along its whole length.*

{b} *Stretch the rope on the crossbow.*

{c} *This is how an instrument operated by a rope works. The rope is released by a blow of the mallet above the bolt knob.*

{d} *This one performs the same action.*

{a}

{b}

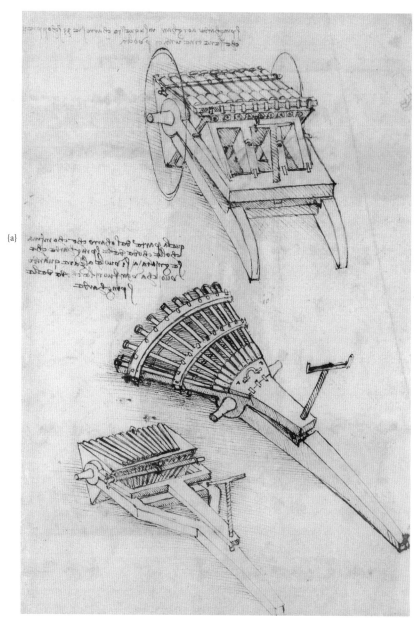

{a}

[8]

[8]

{a} *The part of the carriage that is adjacent to the arquebus tails, and which is identified by a, should be lifted when the arquebus tails are to be moved outwards.*

[9]

{a} *If a man have a tent made of linen of which the apertures have all been stopped up, and it be twelve braccia across and twelve in depth, he will be able to throw himself down from any great height without sustaining any injury.*

«

An object offers as much resistance to the air as the air does to the object. You may see that the beating of its wings against the air supports a heavy eagle in the highest and rarest atmosphere, close to the sphere of elemental fire. Again you may see the air in motion over the sea, fill the swelling sails and drive heavily laden ships. From these instances, and the reasons given, a man with wings large enough and duly connected might learn to overcome the resistance of the air, and by conquering it, succeed in subjugating it and rising above it.

«

No impetus created by any movement whatever can be immediately consumed, but if it finds an object that has a great resistance it consumes itself in a reflex movement.

The impetus acquired by the beating of the wings in the slanting descent of birds is the reason for these birds descending for a long space without beating their wings and for the said slant.

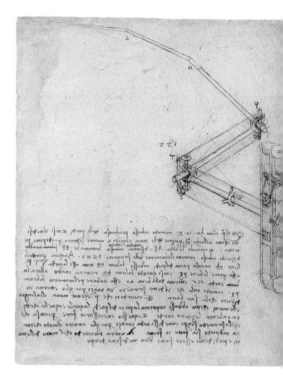

{a}

[9]

The first book deals with flying without motion of the wings. The bird that desires to descend lowers its wings from its middle down, at the side it wants to descend, and this steers it, along line a b. Afterwards, it turns round, in the face of site a b, and descends with the same obliquity, turning on itself until facing the place where it desires to land. When the north wind blows and the bird faces the east, with its tail leeward, this means that the bird desires to rise in circles, by the favor of the wind, which helps the bird's motion by holding down its tail and aiding it above obliquely; the wind makes the bird partially rotate, as a result of the resistance of the wind's streams breaking at the upper part of the tail. And this occurs until the bird turns facing the wind. Afterwards, when it turns towards the west the bird is struck from beneath by the wind and it is made to turn and to continue its circular motion. When the kite, in its circling motion, rises and returning presents the upper wing to the onrush of the wind, it would often be overturned were it not for the fact that it immediately changes the position of the upper wing, which was windward, by letting it down and placing it, from its middle on, leeward.

When the north wind blows, and the bird desires to fly south-east, that is, to sirocco, it will lower half of its southern wing receiving in it the percussion of the wind. On this account, it would approach the south, were it not that an oblique position towards the east is taken up, with the front part kept low, and for this, it moves towards the south-east.

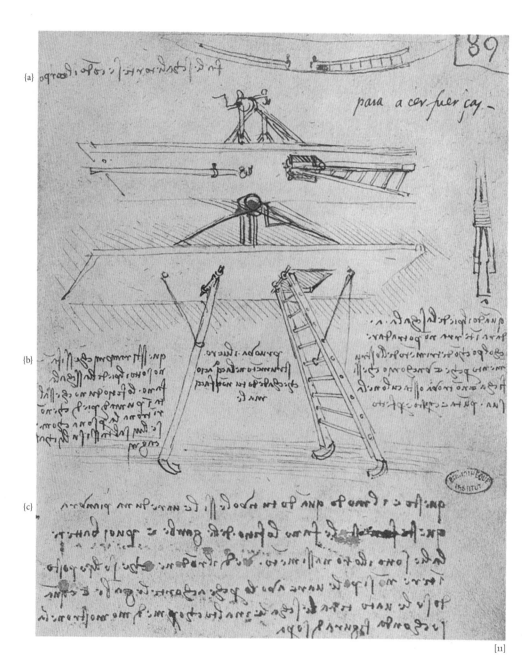

para a cer fuer cay -

{a}

{b}

{c}

[89]

[11]

[11]

{a} *Make the ladders curved to correspond with the body.*

{b} *When the foot of the ladder a touches the ground it cannot give a blow to cause injury to the instrument because it is a cone that buries itself and does not find any obstacle at its point, and this is perfect.*

{c} *Make trial of the actual machine over the water so that if you fall you do not do yourself any harm.*

{d} *These hooks that are underneath the feet of the ladder act in the same way as when one jumps on the points of one's toes, for then one is not stunned as is the person who jumps upon his heels.*

{e} *This is the procedure when you wish to rise from an open plain: these ladders serve the same purpose as the legs and you can beat the wings while it is rising. Observe the swift, how when it has settled itself upon the ground it cannot rise flying because its legs are short. But when you have raised yourself, draw up the ladders as I show in the second figure above.*

[12]

{a} *If you wish to see a real test of the wings make them of pasteboard covered by net, and make the rods of cane, the wing being at least twenty braccia in length and breadth, and fix it over a plank of a weight of two hundred pounds, and make in the manner represented above a force that is rapid; and if the plank of two hundred pounds is raised up before the wing is lowered the test is satisfactory, but see that the force works rapidly, and if the aforesaid result does not follow do not lose any more time.*

{b} *If by reason of its nature this wing ought to fall in four spaces of time and you by your mechanism cause it to fall in two, the result will be that the plank of two hundred pounds will be raised up.*

{c} *You know that if you find yourself standing in deep water holding your arms stretched out and then let them fall naturally, the arms will proceed to fall as far as the thighs and the man will remain in the first position.*

{d} *But if you make the arms, which would nàturally fall in four spaces of time, fall in two then know that the man will quit his position and moving violently will take up a fresh position on the surface of the water.*

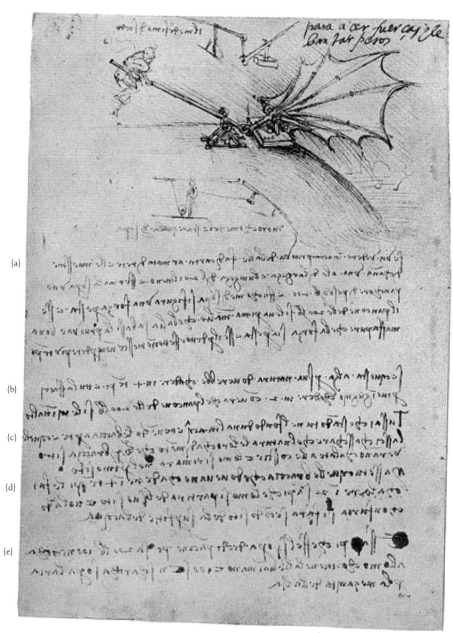

{e} *And know that if the above named plank weighs two hundred pounds a hundred of these will be borne by the man who holds the lever in his hand and a hundred will be carried upon the air by the medium of the wing.*

☾

You will perhaps say that the sinews and muscles of a bird are incomparably more powerful than those of man, because all the girth of so many muscles and of the fleshy parts of the breast goes to aid and increase the movement of the wings, while the bone in the breast is all in one piece and consequently affords the bird very great power, the wings also being all covered with a network of thick sinews and other very strong ligaments of gristle, and the skin being very thick with various muscles.

But the reply to this is that such great strength gives it a reserve of power beyond what it ordinarily uses to support itself on its wings, since it is necessary for it whenever it may so desire either to double or treble its rate of speed in order to escape from its pursuer or to follow its prey. Consequently in such a case it becomes necessary for it to put forth double or treble the amount of effort, and in addition to this to carry through the air in its talons a weight corresponding to its own weight. So one sees a falcon carrying a duck and an eagle carrying a hare; which circumstance shows clearly enough where the excess of strength is spent; for they need but little force in order to sustain themselves, and to balance themselves on their wings, and flap them in the pathway of the wind and so direct the course of their journeyings; and a slight movement of the wings is sufficient for this, and the movement will be slower in proportion as the bird is greater in size.

Man is also possessed of a greater amount of strength in his legs than is required by his weight. And in order to show the truth of this, place a man to stand upon the seashore, and observe how far the marks of his feet sink in; and then set another man on his back, and you will see how much deeper the marks of his feet will be.

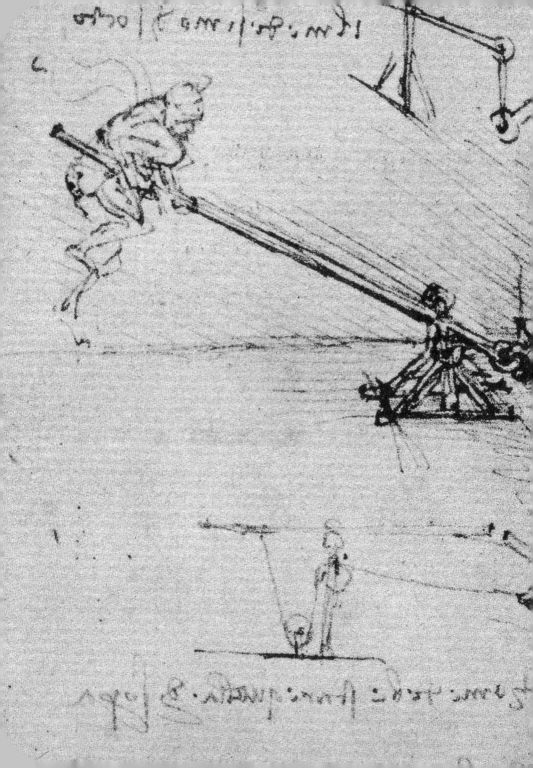

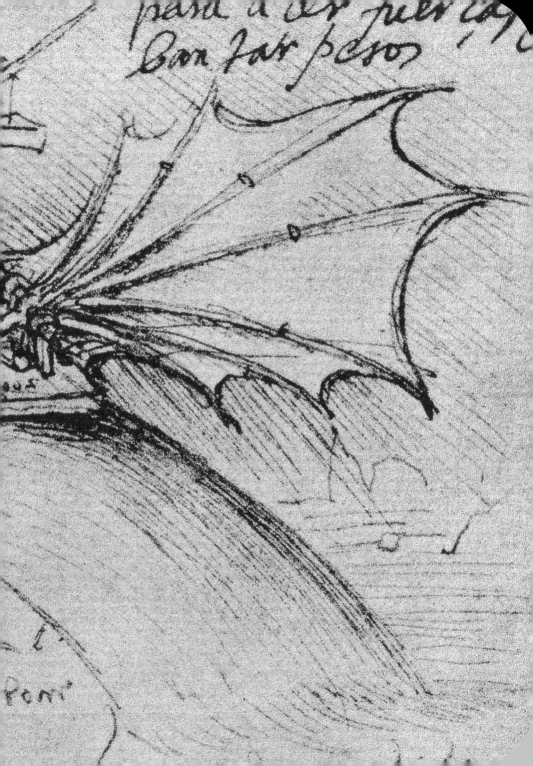

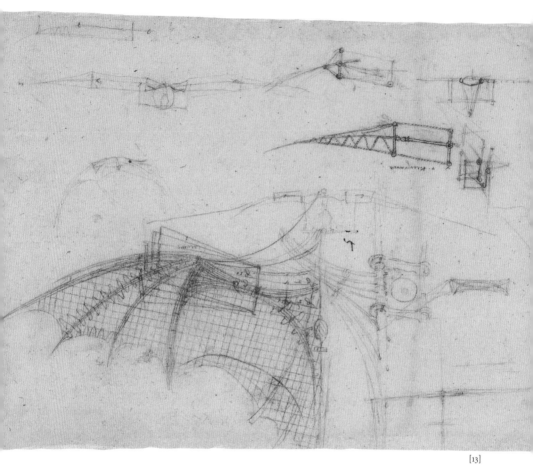

[13]

[13]
Remember that your bird should have no other model than the bat, because its membranes serve as an armor or rather as a means of binding together the pieces of its armor, that is the framework of the wings.

And if you take as your pattern the wings of feathered birds, these are more powerful in structure of bone and sinew, because they are penetrable, that is to say, the feathers are separated from one another and the air passes through them. But the bat is aided by its membrane, which binds the whole together and is not penetrated by the air.

[14]

{a} *Let the outer extremity of the screw be of steel wire as thick as a cord, and from the circumference to the center let it be eight braccia.*

{b} *I find that if this instrument made with a screw be well made, that is to say, made of linen of which the pores are stopped up with starch, and be turned swiftly, the said screw will make its spiral in the air and it will rise high. Take the*

example of a wide and thin ruler whirled very rapidly in the air, you will see that your arm will be guided by the line of the edge of the said flat surface.

{c} *The framework of the above mentioned linen should be of long, stout cane. You may make a small model of pasteboard, of which the axis is formed of fine steel wire, bent by force, and as it is released it will turn the screw.*

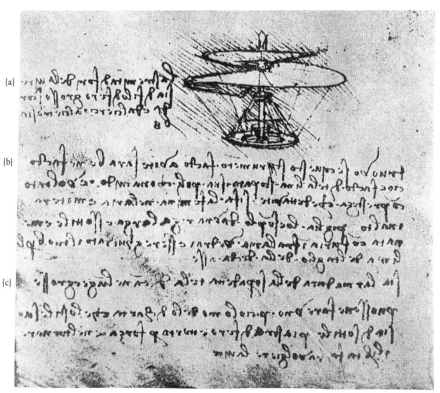

{a}

{b}

{c}

Under the body between the pit and the fork of the throat should be a chamois skin and put it there with the head and the feet.

Hold a windlass with the hands, and with feet and hands together you will exert a force equal to four hundred pounds, and it will be as rapid as the movement of the heels.

Every body that does not bend, although these are each in itself of different size and weight, will throw equal weights upon all the supports, which are equidistant from their center of gravity, this center being in the middle of the breadth of this body.

[15]
{a} *This can be made with one pair of wings and also with two.*

{b} *If you should wish to make it with one, the arms will raise it by means of a windlass, and two vigorous kicks with the heels will lower it, and this will be useful.*

{c} *And if you wish to make it with two pairs, when one leg is extended it will lower one pair of wings and at the same time the windlass worked by the hands will raise the others, helping also considerably those that fall, and by turning the hands first to the right and then to the left you will help first the one and then the other. This instrument resembles the large one on the opposite page except that in this the traction is twisted on the wheel M and goes to the feet.*

{d} *In place of the feet you should make a ladder in three parts of three poles of fir, light and slender, as is represented here in front, and it should be ten braccia in length.*

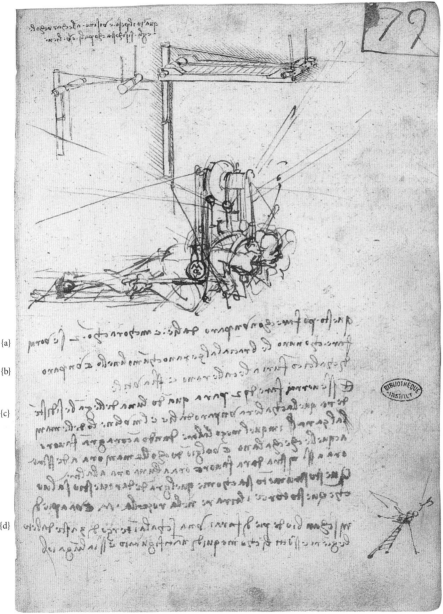

{a}

{b}

{c}

{d}

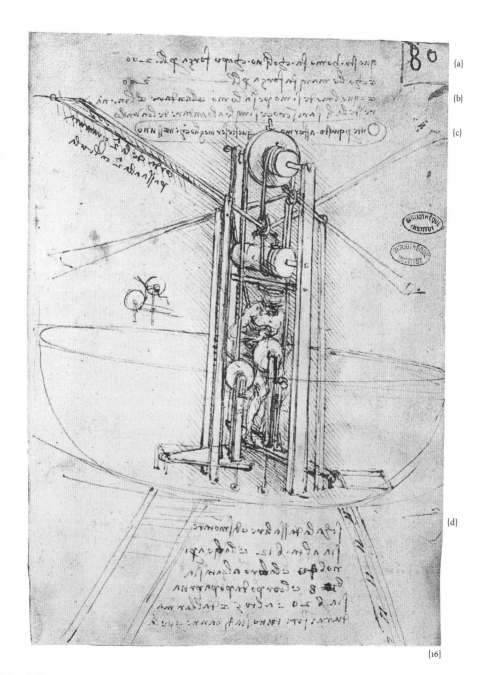

[16]

{a} *This man exerts with his head a force that is equal to two hundred pounds, and with his hands a force of two hundred pounds; and this is what the man weighs.*

{b} *The movement of the wings will be crosswise after the manner of the gait of the horse.*

{c} *So for this reason I maintain that this method is better than any other.*

{d} *Ladder for ascending and descending; let it be twelve braccia high, and let the span of the wings be forty braccia, and their elevation eight braccia, and the body from stern to prow twenty braccia and its height five braccia and let the outside cover be all of cane and cloth.*

☾

Man when flying must stand free from the waist upwards so as to be able to balance himself, as he does in a boat, so that the center of gravity in himself and in the machine may counterbalance each other, and be shifted as necessity demands for the changes of its center of resistance.

[17]

{a} *a twists the wing, b turns it with a lever, c lowers it, d raises it up, and the man who controls the machine has his feet at f d; the foot f lowers the wings, and the foot d raises them. The pivot M should have its center of gravity out of the perpendicular so that the wings as they fall down also fall towards the man's feet; for it is this that causes the bird to move forward.*

{b} *This machine should be tried over a lake, and you should carry a long wineskin as a girdle so that in case you fall you will not be drowned.*

{c} *It is also necessary that the action of lowering the wings should be done by the force of the two feet at the same time, so that you can regulate the movement and preserve your equilibrium by lowering one wing more rapidly than the other according to need, as you may see done by the kite and other birds. Also the downward movement of both the feet produces twice as much power as that of one: it is true that the movement is proportionately slower. The raising is by the force of a spring or if you wish by the hand, or by drawing the feet towards you, and this is best, for then you will have the hands more free.*

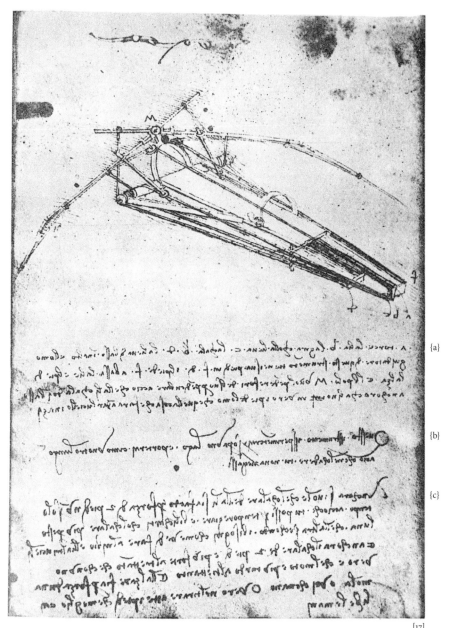

The destruction of these machines may come about in two ways, the first of which is when the machine breaks, the second is when it turns edgewise or almost on its edge because it ought always to descend with a long slant and almost in a level line.

As regards the preventing of the machine from being broken, one may guard against this by making it as strong as possible in whatever line it may turn, that is either edgewise falling with head or tail in front, or with the point of the right or left wing, or along lines that bisect or are the quarterings of these lines.

As regards constructing the machine in such a way that in descending whatever may be the direction that it takes, it finds the remedy prepared; and this you will do by causing its center of gravity to be above that of the weight which it carries, always in a vertical line, and the one always at a sufficient distance from the other, that is that if the machine is thirty braccia in width the centers are four braccia apart, and as has been said one is beneath the other, and the heavier is below, because as it descends the heavier part always constitutes itself in part the guide of the movement. In addition to this, if the bird wishes to fall with its head down-wards with a fraction of the slant that would cause it to turn over, this will not be able to happen, because the lighter part would be beneath the heavier and the light would be descending before the heavy, which is impossible in a descent of any length.

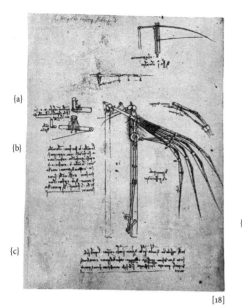

{a}

{b}

{c}

[18]

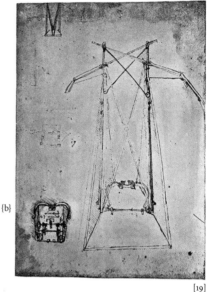

{b}

[19]

[18]

{a} *Spring with lock n o is a wire that holds the spring, and it is not straight. Spring of wing.*

{b} *The spring b should be strong, and the spring a feeble and bendable, so that it may easily be made to meet the spring b, and between a b let there be a small piece of leather, so that it is strong, and these springs should be of ox horn, and to make the model you will make it with quills.*

{c} *Take instead of the spring filings of thin and tempered steel, and these filings will be of uniform thickness and length between the ties, and you will have the springs equal in strength and power of resistance if the filings in each are equal in number.*

[19]
{a} *The foundation of the movement.*

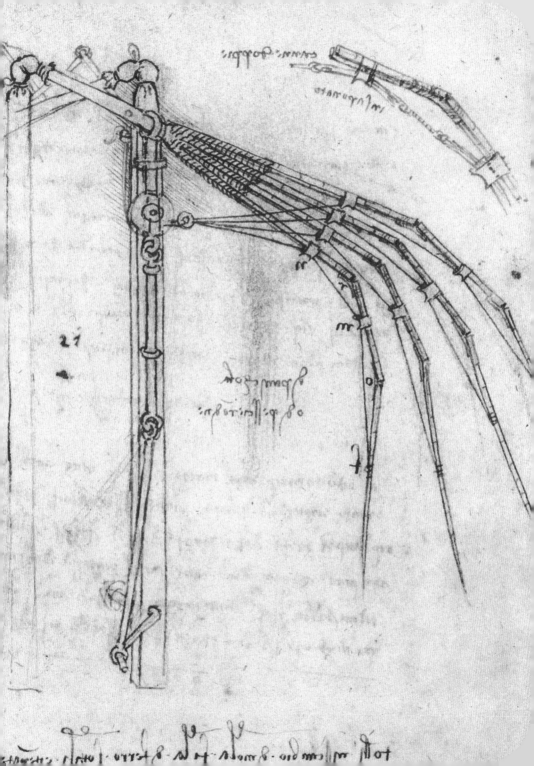

Wisdom is the daughter of experience.

XIII.
Practical Advice

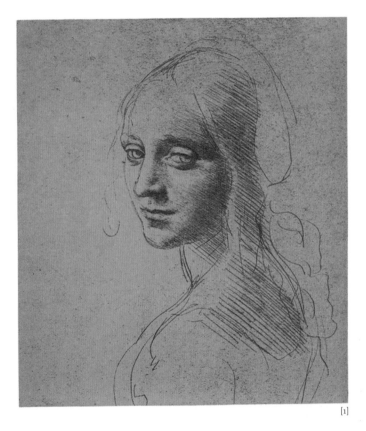

[1]

[1]
Of the selection of beautiful faces: it seems to me to be no small charm in a painter when he gives his figures a pleasing air, this grace, if he have it not by nature, he may acquire by incidental study in this way.

Look about you and take the best parts of many beautiful faces, of which the beauty is confirmed rather by public fame than by your own judgment; for you might be mistaken and choose faces that have some resemblance to your own. For it would seem that such resemblances often please us; and if you should be ugly, you should select faces that were not beautiful and you would then make ugly faces, as many painters do. For often a master's work resembles himself. So select beauties as I tell you, and fix them in your mind.

《

If you, who draw, desire to study well and to good purpose, always go slowly to work in your drawing; and discriminate in the lights, which have the highest degree of brightness, and to what extent and likewise in the shadows, which are those that are darker than the others and in what way they intermingle; then their masses and the relative proportions of one to the other. And note in their outlines, which way they tend; and which part of the lines is curved to one side or the other, and where they are more or less conspicuous and consequently broad or fine. And finally, that your light and shade blend without strokes and borders [but] looking like smoke. And when you have thus schooled your hand and your judgment by such diligence, you will acquire rapidity before you are aware.

《

Of a method of learning well by heart: when you want to know a thing you have studied in your memory proceed in this way: when you have drawn the same thing so many times that you think you know it by heart, test it by drawing it without the model; but have the model traced on flat thin glass and lay this on the drawing you have made without the model, and note carefully where the tracing does not coincide with your drawing, and where you find you have gone wrong; and bear in mind not to repeat the same mistakes. Then return to the model, and draw the part in which you were wrong again and again till you have it well in your mind. If you have no flat glass for tracing on, take some very thin kidskin parchment, well oiled and dried. And when you have used it for one drawing you can wash it clean with a sponge and make a second.

《

Of the order of learning to draw: first draw from drawings by masters done from works of art and from nature and not from memory. And having acquired that practice, under the criticism of his master, he should next practice drawing objects in relief of a good style.

《

Of studying in the dark, when you wake, or in bed before you go to sleep: I myself have proved it to be of no small use, when in bed in the dark, to recall in fancy the external details of forms

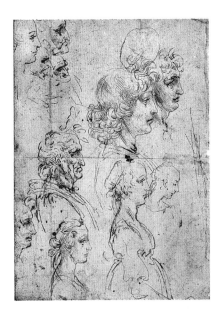

previously studied, or other noteworthy things conceived by subtle speculation; and this is certainly an admirable exercise, and useful for impressing things on the memory.

《

In objects of minute size the extent of error is not so perceptible as in large ones; and the reason is that if this small object is a representation of a man or of some other animal, from the immense diminution the details cannot be worked out by the artist with the finish that is requisite. Hence it is not actually complete; and, not being complete, its faults cannot be determined.

For instance: look at a man at a distance of 300 braccia and judge attentively whether he be handsome or ugly, or very remarkable or of ordinary appearance. You will find that with the utmost effort you cannot persuade yourself to decide. And the reason is that at such a distance the man is so much diminished that the character of the details cannot be determined. And if you wish to see how much this man is diminished [by distance] hold one of your fingers at a span's distance from your eye, and raise or lower it till the top joint touches the feet of the figure you are looking at, and you will see an incredible reduction. For this reason we often doubt as to the person of a friend at a distance.

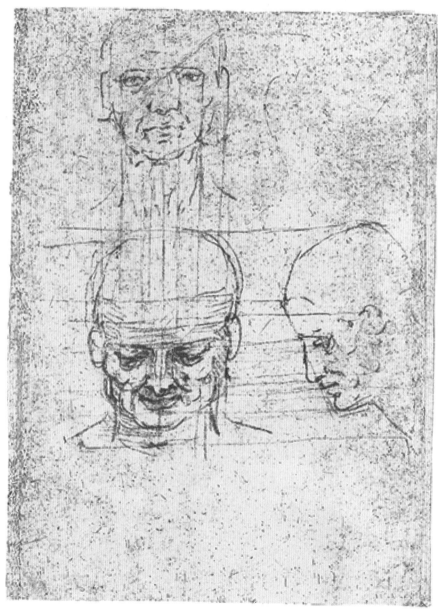

[2]

To draw a head in which the features shall agree with the turn and bend of the head, pursue this method. You know that the eyes, eyebrows, nostrils, corners of the mouth, and sides of the chin, the jaws, cheeks, ears and all the parts of a face are squarely and straightly set upon the face.

Therefore when you have sketched the face draw lines passing from one corner of the eye to the other; and so for the placing of each feature; and after having drawn the ends of the lines beyond the two sides of the face, look if the spaces inside the same parallel lines on the right and on the left are equal. But be sure to remember to make these lines to the point of sight.

《

If you want to acquire facility for bearing in mind the expression of a face, first make yourself familiar with a variety of [forms of] several heads, eyes, noses, mouths, chins and cheeks, and necks and shoulders. And to put a case, noses are of 10 types: straight, bulbous, hollow, prominent above or below the middle, aquiline, regular, flat, round, or pointed. These hold good as to profile. In full face they are of 11 types; these are equal, thick in the middle, thin in the middle, with the tip thick and the root narrow, or narrow at the tip and wide at the root; with the nostrils wide or narrow, high or low, and the openings wide or hidden by the point.

And you will find an equal variety in the other details; which things you must draw from nature and fix them in your mind. Or else, when you have to draw a face by heart, carry with you a little book in which you have noted such features; and when you have cast a glance at the face of the person you wish to draw, you can look, in private, which nose or mouth is most like, or there make a little mark to recognize it again at home.

[3]

Of a mode of drawing a place accurately: have a piece of glass as large as a half sheet of royal folio paper and set thus firmly in front of your eyes that is, between your eye and the thing you want to draw; then place yourself at a distance of 2/3 of a braccia from the glass, fixing your head with a machine in such a way that you cannot move it at all. Then shut or entirely cover one eye and with a brush or red chalk draw upon the glass that which you see beyond it. Then trace it on paper from the glass, afterwards transfer it on to good paper, and paint it if you like, carefully attending to the aerial perspective.

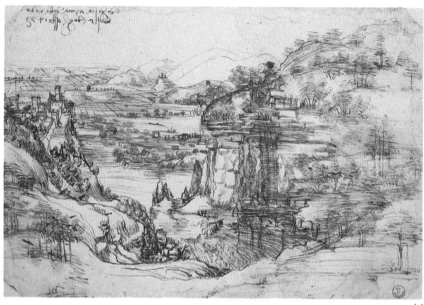

[3]

[4]

Of the nature of the folds in drapery:
that part of a fold which is farthest
from the ends where it is confined will
fall most nearly in its natural form.
Every thing by nature tends to remain
at rest. Drapery, being of equal density
and thickness on its wrong side and
on its right, has a tendency to lie flat;
therefore when you give it a fold or plait
forcing it out of its flatness note well
the result of the constraint in the part
where it is most confined; and the part
that is farthest from this constraint you
will see replaces most into the natural
state; that is to say, lies free and flowing.

[5]

You ought not to give to drapery a great
confusion of many folds, but rather
only introduce them where they are
held by the hands or the arms; the rest
you may let fall simply where it is its
nature to flow; and do not let the nude
forms be broken by too many details
and interrupted folds.

How draperies should be drawn
from nature: that is to say, if you want
to represent woolen cloth draw the
folds from that; and if it is to be silk,
or fine cloth or coarse, or of linen or
of crepe, vary the folds in each and do
not represent dresses, as many do, from
models covered with paper or thin
leather, which will deceive you greatly.

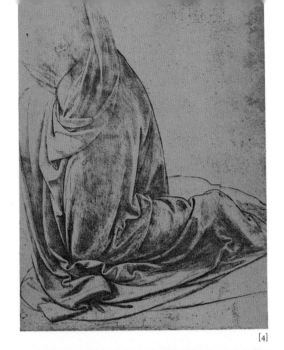

[4]

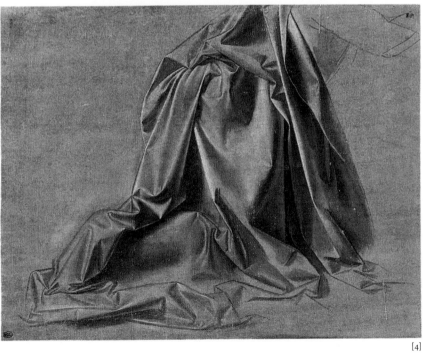

[4]

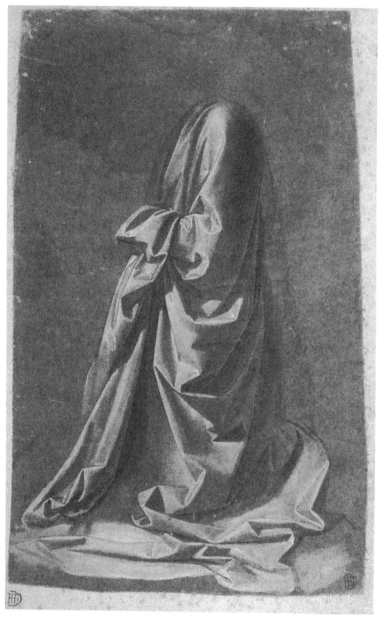

[5]

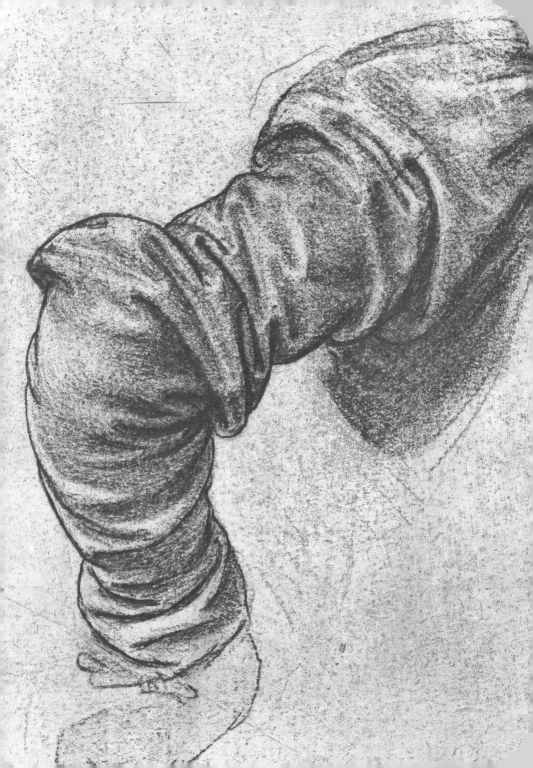

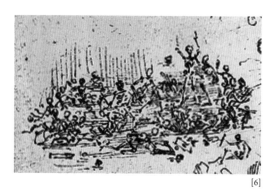

[6]

[6]

[6]

[7]

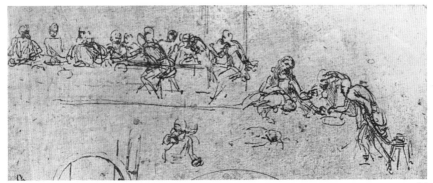

[7]

❦

When you draw from nature stand at a distance of 3 times the height of the object you wish to draw.

[6]

Compose subjects, the studies for which should be taken from natural actions and made from time to time, as circumstances allow; and pay attention to them in the streets and piazza and fields, and note them down with a brief indication of the forms. Thus for a head make an O, and for an arm a straight or a bent line, and the same for the legs and the body, and when you return home work out these notes in a complete form.

[7]

Let your sketches of historical pictures be swift and the working out of the limbs not be carried too far, but limited to the position of the limbs, which you can afterwards finish as you please and at your leisure.

❦

On the site of the studio: small rooms or dwellings discipline the mind, large ones weaken it.

[8]

{a} *The painter's window and its advantage.*

{b} *The painter who works from nature should have a window, which he can raise and lower. The reason is that sometimes you will want to finish a thing you are drawing close to the light.*

Let a b c d be the chest on which the work may be raised or lowered, so that the work moves up and down and not the painter. And every evening you can let down the work and shut it up above so that in the evening it may be in the fashion of a chest, which, when shut up, may serve the purpose of a bench.

《

A broad light high up and not too strong will render the details of objects very agreeable.

《

The light for drawing from nature should be high up, and come from the North in order that it may not vary. And if you have it from the South, keep the window screened with cloth, so that with the sun shining the whole day the light may not vary. The height of the light should be so arranged as that every object shall cast a shadow on the ground of the same length as itself.

《

In selecting the light that gives most grace to faces, if you should have a courtyard that you can at pleasure cover with a linen awning that light will be good. Or when you want to take a portrait, do it in dull weather, or as evening falls, making the sitter stand with his back to one of the walls of the courtyard. Note in the streets, as evening falls, the faces of the men and women, and when the weather is dull, what softness and delicacy you may perceive in them. Hence, O Painter! Have a court arranged with the walls tinted black and a narrow roof projecting

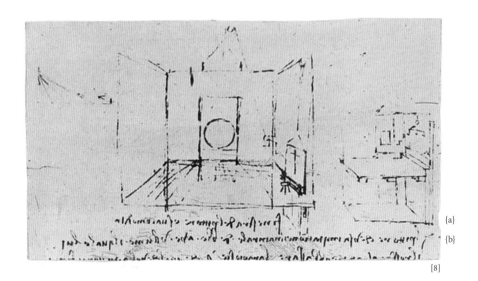

{a}

{b}

[8]

within the walls. It should be 10 braccia wide and 20 braccia long and 10 braccia high and covered with a linen awning. Or else paint a work towards evening or when it is cloudy or misty, and this is a perfect light.

《

An object will display the greatest difference of light and shade when it is seen in the strongest light, as by sunlight, or, at night, by the light of a fire. But this should not be much used in painting because the works remain crude and ungraceful.

An object seen in a moderate light displays little difference in the light and shade; and this is the case towards evening or when the day is cloudy, and works then painted are tender and every kind of face becomes graceful. Thus, in everything extremes are to be avoided. Too much light gives crudeness; too little prevents our seeing. The medium is best.

《

To the end that well-being of the body may not injure that of the mind, the painter or draughtsman must remain solitary, and particularly when intent on those studies and reflections that will constantly rise up before his eye, giving materials to be well stored in the memory.

While you are alone you are entirely your own [master] and if you have one companion you are but half your own, and the less so in proportion to the indiscretion of his behavior. And if you have many companions you will fall deeper into the same trouble. If you should say: "I will go my own way and withdraw apart, the better to study the forms of natural objects," I tell you, you will not be able to help often listening to their chatter.

And so, since one cannot serve two masters, you will badly fill the part of a companion, and carry out your studies of art even worse. And if you say: "I will withdraw so far that their words cannot reach me and they cannot disturb me," I can tell you that you will be thought mad. But, you see, you will at any rate be alone.

And if you must have companionship find it in your studio. This may assist you to have the advantages that arise from various speculations. All other company may be highly mischievous.

《

A painter needs such mathematics as belong to painting. And the absence of all companions who are alienated from his studies; his brain must be easily impressed by the variety of objects that successively come before him, and also free from other cares. And if, when considering and defining one subject, a second subject intervenes—as happens when an object occupies the mind—then he must decide which of these cases is the more difficult to work out, and follow that up until it becomes quite clear, and then work out the explanation of the other.

And above all he must keep his mind as clear as the surface of a mirror, which assumes colors as various as those of the different objects. And his companions should be like him as to their studies, and if such cannot be found he should keep his speculations to himself alone, so that at last he will find no more useful company [than his own].

《

I say and insist that drawing in company is much better than alone, for many reasons. The first is that you would be ashamed to be seen behindhand among the students, and such shame will lead you to careful study. Secondly, a wholesome emulation will stimulate you to be among those who are more praised than yourself, and this praise of others will spur you on. Another is that you can learn from the drawings of others who do better than yourself; and if you are better than they, you can profit by your contempt for their defects, while the praise of others will incite you to further merits.

《

A painter ought to be curious to hear the opinions of everyone on his work. Certainly while a man is painting he ought not to shrink from hearing every opinion. For we know very well that a man, though he may not be a painter, is familiar with the forms of other men and very capable of judging whether they are humpbacked, or have one shoulder higher or lower than the other

or too big a mouth or nose, and other defects. And as we know that men are competent to judge of the works of nature, how much more ought we to admit that they can judge of our errors, since you know how much a man may be deceived in his own work.

And if you are not conscious of this in yourself study it in others and profit by their faults. Therefore be curious to hear with patience the opinions of others, consider and weigh well whether those who find fault have ground or not for blame, and if so, amend. But if not, make as though you had not heard, or if he should be a man you esteem show him by argument the cause of his mistake.

《

We know very well that errors are better recognized in the works of others than in our own; and that often, while reproving little faults in others, you may ignore great ones in yourself. To avoid such ignorance, in the first place make yourself a master of perspective, then acquire perfect knowledge of the proportions of men and other animals, and also as far as concerns the forms of buildings and other objects that are on the face of the earth. These forms are infinite, and the better you know them the more admirable will your work be.

And in cases where you lack experience, do not shrink from drawing them from nature. But, to judge your own pictures I say that when you paint you should have a flat mirror and often

look at your work as reflected in it, when you will see it reversed, and it will appear to you like some other painter's work, so you will be better able to judge of its faults than in any other way.

Again, it is well that you should often leave off work and take a little relaxation, because when you come back to it you are a better judge; for sitting too close at work may greatly deceive you. Again, it is good to retire to a distance, because the work looks smaller and your eye takes in more of it at glance and sees more easily the discords or disproportion in the limbs and colors of the objects.

❦

Those who are in love with practice without knowledge are like the sailor who gets into a ship without rudder or compass and who never can be certain whether he is going. Practice must always be founded on sound theory, and to this, perspective is the guide and the gateway. And without this nothing can be done well in the matter of drawing.

❦

I know that many will call this useless work; and they will be those of whom Demetrius declared that he took no more account of the wind that came out their mouth in words, than of that they expelled from their lower parts. Men who desire nothing but material riches and are absolutely devoid of that wisdom which is the food and the only true riches of the mind. For so much worthier as the soul is than the body, so much nobler are the possessions of the soul than those of the body. And often, when I see one of these men take this work in his hand, I wonder that he does not put it to his nose, like a monkey, or ask me if it is something good to eat.

I am fully conscious that, not being a literary man, certain presumptuous persons will think that they may reasonably blame me, alleging that I am not a man of letters. Foolish folks! Do they not know that I might retort as Marius did to the Roman Patricians by saying that they, who deck themselves but in the labors of others will not allow me my own. They will say that I, having no literary skill, cannot properly express that which I desire to treat of, but they do not know that my subjects are to be dealt with by experience rather than by words. And [experience] has been the mistress of those who wrote well. And so, as mistress, I will cite her in all cases.

❦

Though I may not, like them, be able to quote other authors, I shall rely on that which is much greater and more worthy: on experience, the mistress of their Masters. Why go about puffed up and pompous, dressed decorated with [the fruits], not of their labors, but of those of others. And they will not allow me my own. They will scorn me as an inventor; but how much more might they—who are not inventors but vaunters and declaimers of the works of others—be blamed.

All our knowledge has its origin
in our perceptions.

XIV. Philosophy, Aphorisms, and Miscellaneous Writing

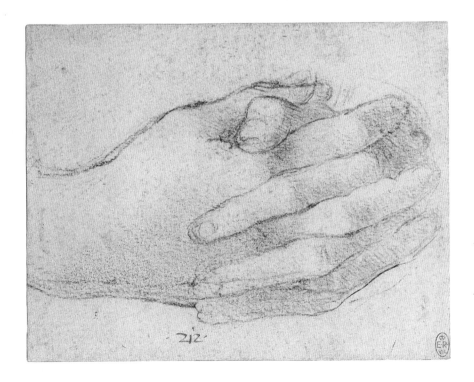

· 212·

Just as eating contrary to the inclination is injurious to the health, so study without desire spoils the memory, and it retains nothing that it takes in.

《

The acquisition of any knowledge whatever is always useful to the intellect, because it will be able to banish the useless things and retain those that are good. For nothing can be either loved or hated unless it is first known.

《

He who offends others does not secure himself.

《

The sorest misfortune is when your views are in advance of your work.

《

Obstacle cannot crush me
Every obstacle yields to stern resolve
He who is fixed to a star does not change his mind.

《

Such as harm is when it hurts me not, is good which avails me not.

《

Some there are who are nothing else than a passage for food and augmenters of excrement and fillers of privies, because through them no other things in the world, nor any good effects are produced, since nothing but full privies results from them.

《

Necessity is the mistress and guide of nature.
Necessity is the theme and the inventress, the eternal curb and law of nature.

《

To keep in health, this rule is wise: Eat only when you want and relish food. Chew thoroughly that it may do you good. Have it well cooked, unspiced and undisguised. He who takes medicine is ill advised.

《

No counsel is more trustworthy than that which is given upon ships that are in peril.

[1]
{a} *The common concepts of the mind are the following:*

{b} *Things which are equal to the same thing are also equal to one another. (First)*

{c} *If equal things are added to equal things, the wholes are equal. (Second)*

{d} *If equals are subtracted from equals, the remainders are equal. (Third)*

{e} *If equals are subtracted from unequals, the remainders are unequal. (Fourth)*

{f} *And if equals are added to unequals, the wholes are unequal. (Fifth)*

{g} *If two things are equal to another thing, they will be equal to one another. (Sixth)*

{h} *If two things are both a half of the same thing, they will also be equal to one another. (Seventh)*

{i} *If a thing is placed near another, superposing it, and there is no excess between them, they will be equal to one another. (Eighth)*

{j} *Every whole is greater than the part. (Ninth)*

[2]

Words that do not satisfy the ear of the hearer weary him or vex him, and the symptoms of this you will often see in such hearers in their frequent yawns; you therefore, who speak before men whose good will you desire, when you see such an excess of fatigue, abridge your speech, or change your discourse.

And if you would see in what a man takes pleasure, without hearing him speak, change the subject of your discourse and when you presently see him intent, without yawning or wrinkling his brow, you may be certain that the matter of which you are speaking is such as is agreeable to him.

☾

It is as great an error to speak well of a worthless man as to speak ill of a good man.

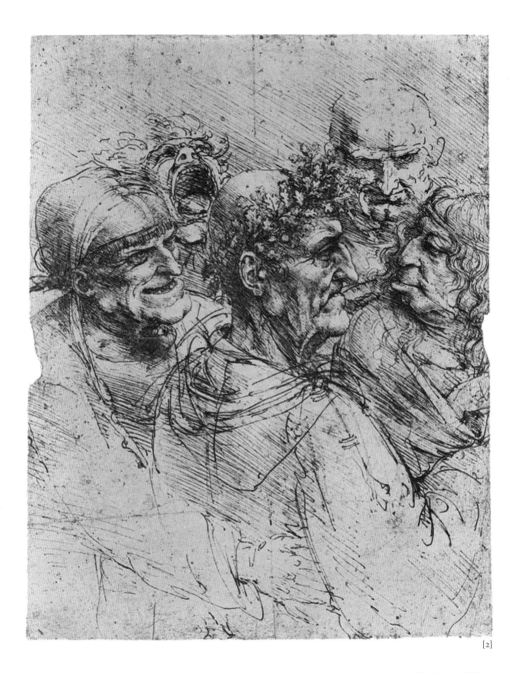

A priest while going the round of his parish on the Saturday before Easter in order to sprinkle the houses with holy water as was his custom, coming to the studio of a painter, and there beginning to sprinkle the water upon some of his pictures, the painter turning round with some annoyance asked him why he sprinkled his pictures in this manner. The priest replied that it was the custom and that it was his duty to act thus, that he was doing a good deed and that whoever did a good deed might expect a recompense as great or even greater; for so God had promised that for every good deed which we do on the earth we shall be rewarded a hundredfold from on high. Then the painter, having waited until the priest had made his exit, stepped to the window above and threw a large bucket of water down on to his back, calling out to him, "See there is the reward that comes to you a hundredfold from on high as you said it would, on account of the good deed you did me with your holy water with which you have half ruined my pictures."

The Franciscan friars at certain seasons have periods of fasting, during which no meat is eaten in their monasteries, but if they are on a journey, as they are then living on almsgiving, they are allowed to eat whatever is set before them. Now a couple of these friars traveling under these conditions chanced to alight at an inn at the same time as a certain merchant and sat down at the same table, and on account of the poverty of the inn nothing was served there except one roasted cockerel. At this the merchant, as he saw that it would be scant fare for himself, turned to the friars and said, "On days like these if I remember rightly you are not permitted in your monasteries to eat any kind of meat." The friars on hearing these words were constrained by their rule to admit without any attempt at argument that this was indeed the case. So the merchant had his desire and devoured the chicken, and the friars fared as best they could.

Now after having dined in this wise all three table companions set out on their journey together, and having gone a certain distance they came to a river of considerable breadth and depth, and as they were all three on foot, the friars by reason of their poverty and the other from niggardliness, it was necessary according to the custom of the country that one of the friars who had no shoes and stockings should carry the merchant on his shoulders; and consequently the friar having given him his clogs to hold took the man on his back. But as it so happened that the friar, when he found himself in the middle of the stream, bethought himself of another of his rules. Coming to a standstill after the manner of St. Christopher, he raised his head towards him who was weighing heavily upon him and said, "Just tell me, have you

any money about you?" "Why you know quite well that I have," replied the other. "How do you suppose a merchant like me could travel about otherwise?" "Alas!" said the friar, "Our rule forbids us to carry any money on our backs," and he instantly threw him into the water.

《

A man wishing to prove on the authority of Pythagoras that he had been in the world on a former occasion, and another not allowing him to conclude his argument, the first man said to the second, "And this is a token that I was here on a former occasion, I remember that you were a miller." The other, who felt provoked by his words, agreed that it was true, for he also remembered as a token that the speaker had been the ass which had carried the flour for him.

《

A painter was asked why he had made his children so ugly, when his figures, which were dead things, he had made so beautiful. His reply was that he made his pictures by day and his children at night.

《

The oyster, being thrown out with other fish near to the sea from the house of a fisherman, prayed to a rat to take him to the sea. The rat, who was intending to devour him, bade him open, but then as he bit him the oyster squeezed his head and held it; and the cat came and killed the rat.

《

While the dog was asleep on the coat of a sheep, one of its fleas, becoming aware of the smell of the greasy wool, decided that this must be a place where the living was better and safer from the teeth and nails of the dog than getting his food on the dog as he did. Without more reflection therefore it left the dog and entering into the thick wool began with great toil to try to pass to the roots of the hairs; which enterprise however after much sweat it found to be impossible, owing to these hairs being so thick as almost to touch each other, and there being no space there where the flea could taste the skin. Consequently after long labor and fatigue it began to wish to go back to its dog which however had already departed, so that after long repentance and bitter tears it was obliged to die of hunger.

《

The ass having fallen asleep upon the ice of a deep lake, the heat of its body caused the ice to melt, and the ass being under water awoke to his great discomfort, and was speedily drowned.

《

The ape on finding a nest of small birds approached them with great joy, but as they were already able to fly he could only catch the smallest. Filled with joy he went with it in his hand to his hiding place; and having commenced to look at the tiny bird he began to kiss it; and in his uncontrollable affection he gave

it so many kisses and turned it over and squeezed it, until he took away its life. This is said for those who by being too fond of their children bring misfortune upon them.

⟪

The hawk, being unable to endure with patience the way in which the duck was hidden from him when she fled before him and dived beneath the water, desired also to follow in pursuit beneath the water. Getting its wings wetted it remained in the water; and the duck raised herself in the air and mocked at the hawk as it drowned.

⟪

The idle fluttering moth, not contented with its power to fly wherever it pleased through the air, was enthralled by the seductive flame of the candle and resolved to fly into it. But its joyous movement was the occasion of instant mourning. For in the said flame its delicate wings were consumed, and the wretched moth, having fallen down at the foot of the candlestick all burnt, after much weeping and contrition, wiped the tears from its streaming eyes, and lifting up its face exclaimed, "False light, how many are there like me who have been miserably deceived by you in times past! Alas! If my one desire was to behold the light, ought I not to have distinguished the sun from the false glimmer of filthy tallow?"

[3]

The fig tree, standing near to the elm, and perceiving that her boughs bore no fruit themselves, yet had the hardihood to keep away the sun from her own, unripe figs, rebuked her, saying, "O Elm, are you not ashamed to stand in front of me? Only wait until my children are fully grown and you will see where you will find yourself." But when her offspring were ripe a regiment of soldiers came to the place, and they tore off the branches of the fig tree in order to take her figs, and left her all stripped and broken.

And as she thus stood maimed in all her limbs the elm questioned her saying, "O Fig tree, how much better was it to be without children than to be brought by them to so wretched a pass."

⟪

The privet, on feeling its tender branches, laden with new fruit, pricked by the sharp claws and beak of the troublesome blackbird, complained to her with pitiful reproaches, beseeching her that even if she plucked off her delicious fruit she would at any rate not deprive her of her leaves that protected her from the scorching rays of the sun, nor with her sharp claws rend away and strip bare her tender bark.

But to this the blackbird replied with insolent rebuke, "Silence! rude bramble! Know you not that Nature has made you to produce these fruits for my sustenance? Cannot you see that you came into the world in order to supply

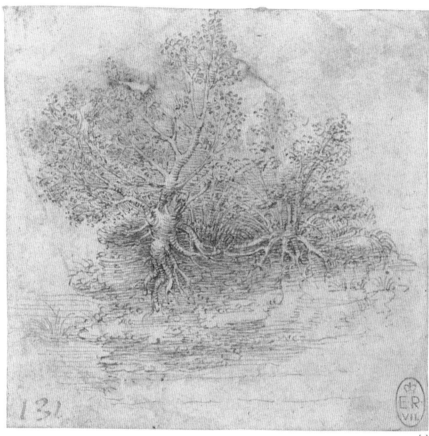

[3]

me with this very food? Know you not, vile thing that you are, that next winter you will serve as sustenance and food for the fire?" To which words the tree listened patiently and not without tears.

But a short time afterwards the blackbird was caught in a net, and some boughs were cut to make a cage in order to imprison her, and among the rest were some cut from the tender privet to serve for the rods of the cage. And these, on perceiving that they would be the cause of the blackbird being deprived of liberty, rejoiced and uttered these words. "We are here, O blackbird, not yet consumed by the fire as you said; we shall see you in prison before you see us burnt."

《

A nut that found itself carried by a
crow to the top of a lofty campanile,
having there fallen into a crevice and
so escaped its deadly beak, besought
the wall by that grace which God had
bestowed upon it in causing it to be
so exalted and great, and so rich in
having bells of such beauty and of
such mellow tone, that it would deign
to give it succor; that insomuch as it
had not been able to drop beneath its
old father's green branches and lie in
the fallow earth covered by his fallen
leaves the wall would not abandon it,
for when it found itself in the fierce
crow's cruel beak it had vowed that if it
escaped thence it would end its days in
a small hole. At these words the wall,
moved with compassion, was content
to give it shelter in the spot where it
had fallen. And within a short space of
time the nut began to burst open and
to put its roots in among the crevices of
the stones, and push them farther apart
and throw up shoots out of its hollow,
and these soon rose above the top of
the building; and as the twisted roots
grew thicker they commenced to tear
asunder the walls and force the ancient
stones out of their old positions. Then
the wall too late and in vain deplored
the cause of its destruction, and in a
short time it was torn asunder and a
great part fell in ruin.

《

The flint on being struck by the steel
marveled greatly and said to it in a
stern voice, "What arrogance prompts
you to annoy me? Trouble me not, for
you have chosen me by mistake; I have
never done harm to anyone." To which
the steel made answer, "If you will be
patient you will see what a marvelous
result will issue forth from you."

At these words the flint was
pacified and patiently endured its mar-
tyrdom, and it saw itself give birth to
the marvelous element of fire, which by
its potency became a factor in innumer-
able things.

This is said for those who are dis-
mayed at the outset of their studies, and
then set out to gain the mastery over
themselves and in patience to apply
themselves continuously to those stud-
ies, from which one sees result things
marvelous to relate.

《

Once upon a time the razor emerg-
ing from the handle that served it as a
sheath, and placing itself in the sun, saw
the sun reflected on its surface, at which
thing it took great pride, and turning
it over in its thoughts it began to say
to itself, "Am I to go back any more to
that shop from which I have just now
come away? No surely! It cannot be the
pleasure of the gods that such radiant
beauty should stoop to such vile uses!
What madness would that be which
should induce me to scrape the lathered
chins of rustic peasants and to do such

menial service? Is this body made for actions such as these? Certainly not! I will go and hide myself in some retired spot, and there pass my life in tranquil ease."

And so having hidden itself away for some months, returning one day to the light and coming out of its sheath, it perceived that it had acquired the appearance of a rusty saw, and that its surface no longer reflected the sun's radiance. In vain with useless repentance it bemoaned its irreparable hurt, saying to itself, "Ah how much better would it have been to have let the barber use that lost edge of mine that had so rare a keenness! Where now is the glittering surface? In truth the foul insidious rust has consumed it away!"

The same thing happens with minds which in lieu of exercise give themselves up to sloth; for these like the razor lose their keen edge, and the rust of ignorance destroys their form.

[4]
Some flames had already lived for a month in a glass furnace when they saw a candle approaching in a beautiful and glittering candlestick. They strove with great longing to reach it; and one of their number left its natural course and

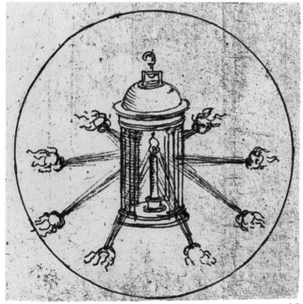

[4]

wound itself into an unburned brand upon which it fed, and then passed out at the other end by a small cleft to the candle, which was near, and flung itself upon it, and devouring it with the utmost voracity and greed consumed it almost entirely; then desirous of prolonging its own life, it strove in vain to return to the furnace that it had left, but was forced to droop and die together with the candle. So at last in lamentation and regret it was changed to foul smoke, leaving all its sisters in glowing and abiding life and beauty.

《

Patience serves us against insults precisely as clothes do against the cold. For if you multiply your garment as the cold increases, that cold cannot hurt you; in the same way increase your patience under great offences, and they cannot hurt your feelings.

[5]
{a} *Stubborn rigor.*

{b} *Doomed rigor.*

《

THE PELICAN
This bears a great love to its young; and if it finds them slain in the nest by a serpent it pierces itself to the heart in their presence, and by bathing them with a shower of blood it restores them to life.

《

OYSTER FOR TREASON
This opens completely when the moon is full: and when the crab sees it, it throws a piece of stone or a twig into it and thus prevents it from closing up, so that it serves the crab for a meal.

So it may be with the mouth when it tells its secret, that it puts itself at the mercy of the indiscreet listener.

《

CROCODILE FOR HYPOCRISY
This animal seizes a man and instantly kills him; and after he is dead it mourns for him with a piteous voice and many tears, and having ended its lament it cruelly devours him. It is thus with the hypocrite, whose face is bathed with tears over every slight thing, showing himself thus to have the heart of a tiger; he rejoices in his heart over another's misfortunes with a face bedewed with tears.

TOAD
The toad shuns the light of the sun: if however it be kept in it by force it puffs itself out so much as to hide its head below and deprives itself of its rays. So acts whoever is the enemy of clear and radiant virtue, who cannot maintain itself in its presence save by force, with puffed up courage.

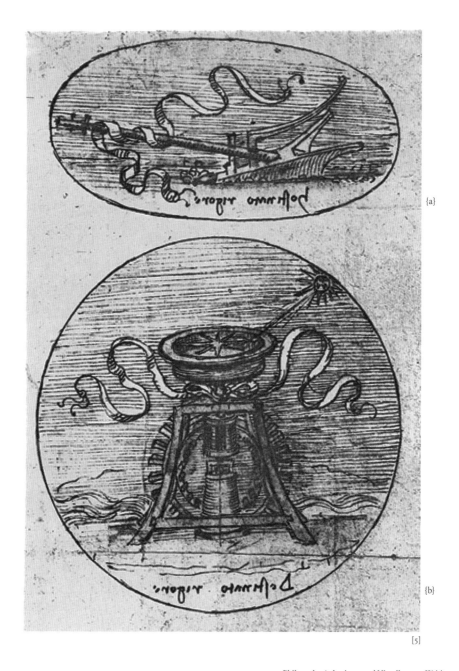

{a}

{b}

[5]

THE CATERPILLAR FOR VIRTUE IN GENERAL

The caterpillar which through the care exercised in weaving round itself its new habitation with admirable design and ingenious workmanship, afterwards emerges from it with beautiful painted wings, rising on these towards heaven.

[6]

CONSTANCY

For constancy the phoenix serves as a type; for understanding by nature its renewal it is steadfast to endure the burning flames that consume it, and then it is reborn anew.

INTEMPERANCE

The unicorn, through its lack of temperance, and because it does not know how to control itself for the delight that it has for young maidens, forgets its ferocity and wildness; and laying aside all fear it goes up to the seated maiden and goes to sleep in her lap, and in this way the hunters take it.

HUMILITY

Of humility one sees the supreme instance in the lamb, which submits itself to every animal. And when they are given as food to lions in captivity they submit themselves to them as to their own mothers, in such a way that it has often been seen that the lions are unwilling to kill them.

PRIDE

The falcon from its haughtiness and pride thinks to overcome and lord it over all the other birds of prey, because it wishes to reign alone. And many times the falcon has been seen to attack the eagle, the queen of birds.

ABSTINENCE

The wild ass, if when going to the spring to drink, it should find the water muddy, has never so great a thirst as to cause it not to abstain from drinking and wait until the water grows clear.

LEWDNESS

The bat, by reason of its unbridled lewdness, does not follow any natural law in pairing, but male goes with male, female with female, as they chance to find themselves together.

☾

ANGER

It is said of the bear that when he goes to the beehives to take the honey from them, the bees commence to sting him, so that he leaves the honey and rushes to avenge himself. And wishing to take vengeance upon all those who are biting him, he fails to take vengeance on any, with the result that his course becomes changed to frenzy, and in his exasperation he throws himself upon the ground, vainly trying to defend himself with his hands and feet.

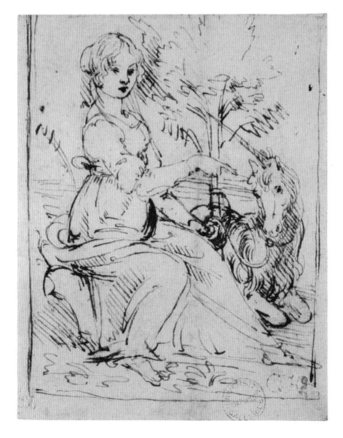

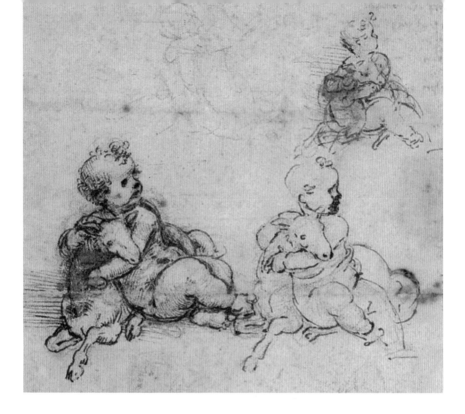

JUSTICE

We may compare the virtue of justice to
the king of the bees, who orders and ar-
ranges everything on a system, because
some bees are ordered to go among the
flowers, others are ordered to work,
others to fight with the wasps, others
to take away the dirt, others to accom-
pany and attend the king. And when he
becomes old and has no wings they

carry him, and if any one of them fails
in his duty that one is punished without
any forgiveness.

TRUTH

Although partridges steal each other's
eggs, nevertheless the children born
from these eggs always return to their
true mother.

DECEIT

The fox, when he sees a flock of magpies or jackdaws or birds of this kind, instantly throws himself on the ground with mouth open in such a way as to seem dead: the birds think to peck at his tongue and he bites off their heads.

MAGNANIMITY

Of the eagle it is said that it never has so great a hunger that it does not leave of its prey to those birds which are round about; and as these are not able to forage for themselves it is necessary that they pay court to the eagle, since by this means they are fed.

A LIE

The mole has very small eyes and always remains underground; it lives as long as it stays in concealment, and as soon as ever it comes to the light it instantly dies, because it becomes known. So it is with a lie.

FORTITUDE

The lion never feels fear; on the contrary it fights with a stout heart in fierce combat against the crowd of hunters, always seeking to injure the first who has injured him.

FEAR OR COWARDICE

The hare is always timid, and the leaves that fall from the trees in autumn keep it always in fear and often cause it to flee.

《

Where fortune enters, there envy lays siege and strives against it, and when this departs it leaves anguish and remorse behind.

《

When fortune comes, seize her with a firm hand. In front, I counsel you, for behind she is bald.

《

The bee may be likened to deceit, for it has honey in its mouth and poison behind.

《

The gold-finch is a bird of which it is related that, when it is carried into the presence of a sick person, if the sick man is going to die, the bird turns away its head and never looks at him; but if the sick man is to be saved the bird never loses sight of him but is the cause of curing him of all his sickness.

Like unto this is the love of virtue. It never looks at any vile or base thing, but rather clings always to pure and virtuous things and takes up its abode in a noble heart; as the birds do in green woods on flowery branches. And this Love shows itself more in adversity than in prosperity; as light does, which shines most where the place is darkest.

《

What is fair in men, passes away, but not so in art.

《

O Time! Consumer of all things; O envious age! thou dost destroy all things and devour all things with the relentless teeth of years, little by little in a slow death. Helen, when she looked in her mirror, seeing the withered wrinkles made in her face by old age, wept and wondered why she had twice been carried away.

《

He who suffers time to slip away and does not grow in virtue: the more one thinks about him the sadder one becomes.

No man has a capacity for virtue who sacrifices honor for gain. Fortune is powerless to help one who does not exert himself.

《

If anyone wishes to see how the soul dwells in its body, let him observe how this body uses its daily habitation. That is to say, if this is devoid of order and confused, the body will be kept in disorder and confusion by its soul.

《

Movement will cease before we are weary of being useful.

Movement will fail sooner than usefulness.

Death sooner than weariness.

In serving others I cannot do enough.

No labor is sufficient to tire me.

Hands into which ducats and precious stones fall like snow; they never become tired by serving, but this service is only for its utility and not for our own benefit.

Naturally nature has so disposed me.

I am never weary of being useful.

《

One's thoughts turn towards Hope.

《

Men are in error when they lament the flight of time, accusing it of being too swift, and not perceiving that it is suffcient as it passes; but good memory, with which nature has endowed us, causes things long past to seem present.

《

The water you touch in a river is the last of that which has passed, and the first of that which is coming. Thus it is with time present.

Life, if well spent, is long.

BIBLIOGRAPHY

ENGLISH

Ahl, Diane Cole, ed. *Leonardo da Vinci's Sforza Monument Horse: The Art and the Engineering.* Bethlehem, Pa., and London, 1995.

Allison, Ann H. "Antique Sources of Leonardo's Leda." *The Art Bulletin* 56, no. 3 (September 1974), pp. 375–84.

Ames-Lewis, Francis. *Drawing in Early Renaissance Italy.* 1981. 2d ed. New Haven and London, 1999.

Ames-Lewis, Francis. "Leonardo's Botanical Drawings." *Achademia Leonardi Vinci: Journal of Leonardo Studies and Bibliography of Vinciana* 10 (1997), pp. 117–24, and unpaginated figures.

Ames-Lewis, Francis. "Leonardo da Vinci's 'Kneeling Leda': The Evolution of an Expressive Figure-Composition." *Drawing* 11, no. 4 (November–December 1989), pp. 73–76.

Ames-Lewis, Francis, and Anka Bednarek, eds. *Nine Lectures on Leonardo da Vinci.* London, [1990].

Arasse, Daniel. *Leonardo da Vinci: The Rhythm of the World.* New York, 1998.

Bambach, Carmen C. "A Leonardo Drawing for the Metropolitan Museum of Art: Studies for a Statue of *Hercules*." Apollo 153, no. 469 (March 2001), pp. 16–23.

Baroni, Costantino. "Leonardo as Architect." In *Leonardo da Vinci* 1980, pp. 238–60.

Belt, Elmer. "Leonardo da Vinci's Studies of the Aging Process." *Geriatrics 7* (1952), pp. 205–10.

Blunt, Anthony, et. al. *Leonardo da Vinci: Anatomical Drawings from the Royal Collection, Windsor Castle.* Exh. cat., Florence, Palazzo Vecchio. Florence, 1979.

Borenius, Tancred. "Leonardo's Madonna with the Children at Play." *The Burlington Magazine* 56, no. 324 (March 1930), pp. 142–47.

Borne, F[rançois] J. *"Horse and Rider.* A Mirror of Leonardo's Culture." In *Old Master Drawings, including Leonardo da Vinci's* Horse and Rider. Sale cat., Christie's, London, Tuesday, July 10, 2001, pp. 51–55.

Brachert, Thomas. "A Musical Canon of Proportion in Leonardo da Vinci's *Last Supper.*" *The Art Bulletin* 53, no.4 (December 1971), pp. 461–66.

Brambilla Barcilon, Pinin, and Pietro C. Marani. *Leonardo: The Last Supper.* Translated by Harlow Tighe. Chicago and London, 2001.

Bramly, Serge. *Leonardo: Discovering the Life of Leonardo da Vinci.* Translated by Siân Reynolds. New York, 1991.

Brinton, Selwyn. *Leonardo at Milan.* London, 1911.

Brown, David Alan. "The Profile of a Youth and Leonardo's Annunciation." *Mitteilungen des Kunsthistorischen Institutes in Florenz* 15 (1971), pp. 265–72.

Brown, David Alan. "Leonardo and the Idealized Portrait in Milan." *Arte lombarda*, no. 67 (1983), pp. 102–16.

Brown, David Alan. Leonardo's Last Supper: *Precedents and Reflections. Leonardo's* Last Supper: *Before and After.* Exh. cat., Washington D.C., National Gallery of Art. Washington, D.C., 1983.

Brown, David Alan. Leonardo's Last Supper: *The Restoration. Leonardo's* Last Supper: *Before and. After.* Exh. cat., Washington D.C., National Gallery of Art. Washington, D.C., 1983.

Brown, David Alan. "Leonardo's 'Head of an Old Man' in Turin: Portrait or Self-Portrait?" In *Studi di storia dell'arte in onore di Mina Gregori,* edited by Miklós Boskovits, pp. 75–78. Milan, 1994.

Brown, David Alan. *Leonardo da Vinci: Origins of a Genius.* New Haven and London, 1998.

Brown, David Alan, et al. *Virtue and Beauty: Leonardo's* Ginevra de' Benci *and Renaissance Portraits of Women.* Exh. cat., Washington, D.C., National Gallery of Art. Washington, D.C., 2001.

Brummer, Hans Henrik. "The *editio princeps* of Leonardo da Vinci's Treatise on Painting Dedicated to Queen Christina." *Achademia Leonardi Vinci: Journal of Leonardo Studies and Bibliography of Vinciana* 6 (1993), pp. 117–25, and unpaginated figures.

Budny, Virginia. "The Poses of the Child in the Composition Sketches by Leonardo da Vinci for *The Madonna and Child with a Cat* and in Other Works Related to this Group." *Weatherspoon Gallery Association Bulletin* (1979–80), pp. 4–12.

Budny, Virginia. "The Sequence of Leonardo's Sketches for *The Virgin and Child with Saint Anne and Saint John the Baptist.*" *The Art Bulletin* 65, no. 1 (March 1983), pp. 34–50.

Bull, David. "Two Portraits by Leonardo: *Ginevra de' Benci and the Lady with an Ermine.*" *Artibus et historiae,* no. 25 (1992), pp. 67–83.

B[urroughs], B[ryson]. "Drawings by Leonardo da Vinci on Exhibition." *The Metropolitan Museum of Art Bulletin* 13, no. 10 (October 1918), pp. 214–17.

Bush, Virginia. "Leonardo's Sforza Monument and Cinquecento Sculpture." *Arte lombarda* 50 (1978), pp. 47–68.

Butterfield, Andrew. "Leonardo: Draughtsman of Genius." In *Old Master Drawings, including Leonardo da Vinci's* Horse and Rider. Sale cat., Christie's, London, Tuesday, July 10, 2001, pp. 48–50.

Calder, Ritchie. *Leonardo and the Age of the Eye*. London, 1970.

Chastel, André. *The Genius of Leonardo da Vinci: Leonardo da Vinci on Art and the Artist*. New York, 1961.

Christiansen, Keith. "Letters: Leonardo's Drapery Studies." *The Burlington Magazine* 132, no. 1049 (August 1990), pp. 572–73.

Cianchi, Marco, et al. *Leonardo's Machines*. Translated by Lisa Goldenberg Stoppato. Florence, 1988.

Clark, Kenneth. "Leonardo's *Adoration of the Shepherds* and *Dragon Fight*." *The Burlington Magazine* 62, no. 358 (January 1933), pp. 20–26.

Clark, Kenneth. *A Catalogue of the Drawings of Leonardo da Vinci in the Collection of His Majesty the King, at Windsor Castle*. 2 vols. Cambridge, 1935.

Clark, Kenneth. *Leonardo da Vinci: An Account of His Development as an Artist*. Cambridge, 1939.

Clark, Kenneth. *Selected Drawings from Windsor Castle: Leonardo da Vinci*. London, 1954.

Clark, Kenneth. *Leonardo da Vinci: An Exhibition of Drawings by Leonardo da Vinci from the Royal Collection,* 1969–1970. Exh. cat., London, The Queen's Gallery, Buckingham Palace. London, 1969.

Clark, Kenneth. *Leonardo da. Vinci.* 1939; 1959. Revised edition with an introduction by Martin Kemp. London, 1988.

Clayton, Martin. *Leonardo da Vinci: A Curious Vision*. Exh. cat., London, The Queen's Gallery, Buckingham Palace. New York and London, 1996.

Clayton, Martin. "*Leonardo's Gypsies,* and the *Wolf and the Eagle*." *Apollo* 155 (August 2002), pp. 27–33.

Clayton, Martin. *Ten Drawings by Leonardo da Vinci: A Golden Jubilee Celebration*. Exh. cat., Exhibition travelling through Great Britain, sponsored by the Royal Collection. London, 2002.

Clayton, Martin. *Leonardo da Vinci: The Divine and the Grotesque*. Exh. cat., Edinburgh, The Queen's Gallery, Palace of Holyroodhouse; London, The Queen's Gallery, Buckingham Palace. London, 2002.

Clayton, Martin, and Ron Philo. *Leonardo da Vinci, The Anatomy of Man: Drawings from the Collection of Her Majesty Queen Elizabeth II*. Exh. cat., Houston, Museum of Fine Arts; Philadelphia Museum of Art; Boston, Museum of Fine Arts. Houston, 1992.

Il Codice Atlantico di Leonardo da Vinci nella Biblioteca Ambrosiana di Milano. Transcriptions and concordance by Augusto Marinoni. 12 vols. Florence, 1973–75.

Leonardo da Vinci: The Madrid Codices. Transcription, translation, and commentary by Ladislao Reti. 5 vols. New York, 1974.

Colenbrander, Herman T. "Hands in Leonardo Portraiture." *Achademia Leonardi Vinci: Journal of Leonardo Studies and Bibliography of Vinciana* 5 (1992), pp. 37–43, and unpaginated figures.

Douglas, Langston R. *Leonardo da Vinci: His "San Donato of Arezzo and the Tax-Collector."* [London, 1933].

Douglas, Langton R. *Leonardo da Vinci: His Life and His Pictures*. Chicago, 1944.

Leonardo Drawings: 50 Works. Dover Art Library. New York, 1980.

Dragstra, Rolf. "The Vitruvian Proportions for Leonardo's Construction of the 'Last Supper.'" *Raccolta Vinciana*, no. 27 (1997), pp. 83–104.

Eissler, Kurt R. *Leonardo da Vinci: Psychoanalytic Notes on the Enigma*. New York, 1961.

Emboden, William A. *Leonardo da Vinci on Plants and Gardens*. London, 1987.

Fairbrother, Trevor, and Chiyo Ishikawa, eds. *Leonardo Lives: The Codex Leicester and Leonardo da Vinci's Legacy of Art and Science*. Exh. cat., Seattle Art Museum. Seattle, 1997.

Farago, Claire, ed. *Leonardo da Vinci: Selected Scholarship*. 5 vols. New York, 1999.

Farago, Claire J. "Leonardo's *Battle of Anghiari:* A Study in the Exchange between Theory and Practice." *The Art Bulletin 76,* no. 2 (June 1994), pp. 301–30.

Farago, Claire J. "Leonardo's Color and Chiaroscuro Reconsidered: The Visual Force of Painted Images." *The Art Bulletin 73,* no. 1 (March 1991), pp. 63–88.

Farago, Claire [J.], et al. *Leonardo da Vinci: Codex Leicester, A Masterpiece of Science.* Based on the translation of the Codex Leicester by Carlo Pedretti. Introductory essays by Martin Kemp, Owen Gingerich, and Carlo Pedretti. Exh. cat., New York, American Museum of Natural History. New York, 1996.

Farago, Claire J. *Leonardo da Vinci's* Paragone: *A Critical Interpretation with a New Edition of the Text in the* Codex Urbinas. Leiden, 1992.

Farago, Claire J. *"The Battle of Anghiari:* A Speculative Reconstruction of Leonardo's Design Process." *Achademia Leonardi Vinci: Journal of Leonardo Studies and Bibliography of Vinciana 9* (1996), pp. 73–86, and unpaginated figures.

Franck, Jacques. "The Last Supper, 1497–1997: The Moment of Truth." *Achademia Leonardi Vinci: Journal of Leonardo Studies and Bibliography of Vinciana* 10 (1997), pp. 165–82, and unpaginated figures.

Freud, Sigmund. *Leonardo da Vinci and a Memory of His Childhood,* translated by Alan Tyson, edited by James Strachey, in collaboration with Anna Freud. New York, 1964.

Galluzzi, Paolo, ed. *Leonardo da Vinci, Engineer and Architect.* Introduction by Carlo Pedretti. Exh. cat., The Montreal Museum of Fine Arts. Montreal, 1987.

Galluzzi, Paolo. *Mechanical Marvels: Inventions in the Age of Leonardo.* Florence, 1997.

Goldscheider, Ludwig. *Leonardo da Vinci.* London and New York, 1943.

Goldscheider, Ludwig. *Leonardo da Vinci: The Artist.* Oxford and London, 1945.

Goldscheider, Ludwig, ed. *Leonardo da Vinci: Landscapes and Plants.* New York, 1952.

Goldscheider, Ludwig. *Leonardo da Vinci: Life and Work, Paintings and Drawings, with the Leonardo Biography by Vasari, 1568.* 1943. 6th edition, revised. London, 1959.

Gombrich, Ernst [H]. "Leonardo's Grotesque Heads: Prolegomena to their Study." In *Leonardo: Saggi e ricerche* 1954, pp. 197–219, pls. 107–12.

Gombrich, E[rnst] H. "Leonardo's Method for Working Out Compositions." In *Norm and Form,* pp. 58–63. Studies in the Art of the Renaissance, 1. London, 1966.

Gould, Cecil. "Leonardo's 'Neptune' Drawing." *The Burlington Magazine* 94, no. 595 (October 1952), pp. 289–95.

Gould, Cecil. "Leonardo's Great Battle-Piece: A Conjectural Reconstruction." *The Art Bulletin* 36, no. 2 (June 1954), pp. 117–29, figs. 1–19.

Gould, Cecil. "On the Critique of Leonardo's Drawings." In *Leonardo: Saggi e ricerche* 1954, pp.187–95.

Gould, Cecil. *Leonardo: The Artist and the Non-Artist.* Boston and London, 1975.

Grabski, Josef, and Janusz Walek, eds. Leonardo da Vinci (1452–1519): *Lady with an Ermine from the Czartoryski Collection, National Museum, Cracow.* Vienna, 1991.

Gronau, Georg. *Leonardo da Vinci.* Chicago and New York, 1914.

Hager, Serafina, ed. *Leonardo, Michelangelo, and Raphael in Renaissance Florence from 1500 to 1508.* Washington, D.C., 1992.

Heydenreich, Ludwig H. *Leonardo: The Last Supper.* Art in Context. New York, 1974.

Hind, Charles Lewis. *Drawings of Leonardo da Vinci.* London, 1907.

Hochstetler Meyer, Barbara. "Leonardo's *Battle of Anghiari:* Proposals for Some Sources and a Reflection." *The Art Bulletin* 66, no. 3 (September 1984), pp. 367–82.

Hochstetler Meyer, Barbara. "Leonardo's Hypothetical Painting of *Leda and the Swan.*" *Mitteilungen des Kunsthistorischen Institutes in Florenz* 34, no. 3 (1990), pp. 279–94.

Hochstetler Meyer, Barbara, and Alice Wilson Glover. "Botany and Art in Leonardo's *Leda and the Swan.*" *Leonardo* 22, no. 1 (1989), pp. 75–82.

Holly, Michael Ann. "Writing Leonardo Backwards." Chap. 5 in *Past Looking: Historical Imagination and the Rhetoric of the Image,* pp. 112–48. Ithaca and London, 1996.

Keele, Kenneth D. *Leonardo da Vinci: Anatomical Drawings from the Queen's Collection at Windsor Castle.* Introduction by Anthony Blunt. Exh. cat., Washington, D.C., National Museum of History and Technology, Smithsonian Institution; Los Angeles County Museum of Art. Los Angeles, 1976.

Keele, Kenneth D. *Leonardo da Vinci's Elements of the Science of Man.* New York and London, 1983.

Keele, Kenneth D., and Carlo Pedretti. *Leonardo da Vinci: Corpus of Anatomical Drawings in the Collection of Her Majesty the Queen.* 3 vols. London, 1979–80.

Keele, Kenneth D., and Jane Roberts. *Leonardo da Vinci: Anatomical Drawings from the Royal Library, Windsor Castle.* Exh. cat., New York, The Metropolitan Museum of Art. New York, 1983.

Kemp, Martin. "Analogy and Observation in the Codex Hammer." In *Studi vinciani in memoria di Nando de Toni,* pp. 103–34. Brescia, 1986.

Kemp, Martin. *Leonardo da Vinci: The Marvellous Works of Nature and Man.* 1981. Reprint. London, 1989.

Kemp, Martin, ed. *Leonardo on Painting: An Anthology of Writings by Leonardo da Vinci, with a Selection of Documents Relating to his Career as an Artist.* Translated by Martin Kemp and Margaret Walker. New Haven and London, 1989.

Kemp, Martin. "Looking at Leonardo's Last Supper." In *Appearance, Opinion, Change: Evaluating the Look of Paintings,* pp. 14–21. London, 1990.

Kemp, Martin. "Leonardo da Vinci: The National Gallery of Scotland's First Leonardo." *National Art-Collections Fund Review* 88 (1992), pp. 16–20.

Kemp, Martin, and Jane Roberts. *Leonardo da Vinci.* Exh. cat., London, Hayward Gallery. Exhibition held by the South Bank Center. London, 1989.

Kemp, Martin, and Alastair Smart. "Leonardo's *Leda* and the Belvedere *River-Gods:* Roman Sources and a New Chronology." *Art History 3,* no. 2 (June 1980), pp. 182–93.

Kemp, Martin, and Marina Wallace. *Spectacular Bodies: The Art and Science of the Human Body from Leonardo to Now.* Exh. cat., London, Hayward Gallery. London, 2000.

Kwakkelstein, Michael W. "Leonardo da Vinci's Grotesque Heads and the Breaking of the Physiognomic Mould." *Journal of the Warburg and Courtauld Institutes* 54 (1991), pp. 127–36.

Kwakkelstein, Michael W. *Leonardo da Vinci as a Physiognomist: Theory and Drawing Practice.* Leiden, 1994.

Kwakkelstein, Michael W. "The Use of Sculptural Models by Italian Renaissance Painters: Leonardo da Vinci's *Madonna of the Rocks* Reconsidered in Light of His Working Procedures." *Gazette des Beaux-Arts,* ser. 6, 133 (1999), pp. 182–98.

Bora, Giulio, et al. *The Legacy of Leonardo: Painters in Lombardy,* 1490–1530, edited by Francesco Porzio. Milan, 1998.

Leonardo da Vinci. [1939]. Rev. ed. New York, [1980].

Letze, Otto, and Thomas Buchsteiner. *Leonardo da Vinci: Scientist, Inventor, Artist.* Exh. cat., Boston, Museum of Science, Tübingen, Institut für Kulturaustausch. Tübingen, 1997.

MacCurdy, Edward. *The Mind of Leonardo da Vinci.* London, 1928.

McCurdy [sic], Edward. "The Drawings of Leonardo da Vinci." *Apollo* 12, no. 69 (September 1930), pp. 173–82; 12, no. 70 (October 1930), pp. 249–57.

MacCurdy, Edward, ed. *The Notebooks of Leonardo da Vinci.* 2 vols. London, 1938.

Marani, Pietro C. *Leonardo da Vinci: The Complete Paintings.* New York, 2000.

McLanathan, Richard. *Images of the Universe. Leonardo da Vinci: The Artist as Scientist.* Garden City, N.Y., 1966.

Leonardo da Vinci: Treatise on Painting (Codex Urbinas Latinus 1270). Translated and annotated by A. Philip McMahon; introduced by Ludwig Heydenreich. 2 vols. Princeton, N.J., 1956.

Morley, Brian. "The Plant Illustrations of Leonardo da Vinci." *The Burlington Magazine* 121, no. 918 (September 1979), pp. 553–62.

Leonardo da Vinci, a Man on a World Scale, the World on a Human Scale . . . : Codex Leicester Exhibit. Exh. cat., Lisbon, Mosteiro dos Jerónimos. Lisbon, 1998.

Müntz, Eugène. *Leonardo da Vinci, Artist, Thinker, and Man of Science.* 2 vols. London and New York, 1898.

Nagel, Alexander. "Leonardo and *Sfumato.*" *Res*, no. 24 (Autumn 1993), pp. 7–20.

Nathan, Johannes. "Workshop Practices of Leonardo da Vinci: Background Material and the Example of the *Leda.*" M.A. Thesis, University of London, The Courtauld Institute of Art, 1990.

Nathan, Johannes. "Some Drawing Practices of Leonardo da Vinci: New Light on the *St. Anne.*" *Mitteilungen des Kunsthistorischen Institutes in Florenz* 36, nos. 1–2 (1992), pp. 85–102.

Nathan, Johannes. "The Working Methods of Leonardo da Vinci and Their Relation to Previous Artistic Practice." Ph.D. diss., University of London, The Courtauld Institute of Art, 1996.

Neufeld, Günther. "Leonardo da Vinci's *Battle of Anghiari:* A Genetic Reconstruction." *The Art Bulletin* 33, no. 3 (September 1949), pp. 170–83.

O'Malley, C[harles] D., ed. *Leonardo's Legacy: An International Symposium.* Berkeley and Los Angeles, 1969.

O'Malley, Charles D., and J[ohn] B[ertrand] de C[usance] M[orant] Saunders. *Leonardo da Vinci on the Human Body: The Anatomical, Physiological, and Embryological Drawings of Leonardo da Vinci.* New York, 1952.

Ottino della Chiesa, Angela. *L'opera completa di Leonardo pittore.* Preface by Mario Pomilio. Milan. 1967. English edition introduced by L. D. Ettlinger. London, 1985.

Nepi Sciré, Giovanna, and Pietro C. Marani, eds. *Leonardo & Venice.* Exh. cat., Venice, Palazzo Grassi. Milan, 1992.

Panofsky, Erwin. *The Codex Huygens and Leonardo da Vinci's Art Theory: The Pierpont Morgan Library Codex M.A. 1139.* London, 1940.

Payne, Robert. *Leonardo.* London, 1979.

Pedretti, Carlo. *Leonardo da Vinci: Fragments at Windsor Castle from the Codex Atlanticus.* London, 1957.

Pedretti, Carlo. *A Chronology of Leonardo da Vinci's Architectural Studies After 1500.* Geneva, 1962.

Pedretti, Carlo. *Leonardo da Vinci on Painting: A Lost Book (Libro A) Reassembled from the Codex Vaticanus Urbinas 1270 and from the Codex Leicester.* Berkeley and Los Angeles, 1964.

Pedretti, Carlo. "Leonardo da Vinci: Manuscripts and Drawings of the French Period, 1517–1518." *Gazette des Beaux-Arts,* ser. 6, 76 (1970), pp. 285–318.

Pedretti, Carlo. *Leonardo da Vinci: The Royal Palace at Romorantin.* Cambridge, Mass., 1972.

Pedretti, Carlo. *Leonardo: A Study in Chronology and Style.* Berkeley and Los Angeles, 1973.

Pedretti, Carlo. *The Literary Works of Leonardo da Vinci, Compiled and Edited from the Original Manuscripts by Jean Paul Richter: Commentary.* 2 vols. Berkeley and Los Angeles, 1977.

Pedretti, Carlo. "Notes: Reconstruction of a Leonardo Drawing." *Master Drawings* 16, no. 2 (Summer 1978), pp. 151–56, pl. 26.

Pedretti, Carlo. *The Codex Atlanticus of Leonardo da Vinci: A Catalogue of Its Newly Restored Sheets.* 2 vols. New York, 1978–79.

Pedretti, Carlo. *The Codex Leicester by Leonardo da Vinci.* Sale cat., Christie, Manson and Woods, London, Friday, December 12, 1980.

Pedretti, Carlo, ed. *The Drawings and Miscellaneous Papers of Leonardo da Vinci in the Collection of Her Majesty the Queen at Windsor Castle.* Vol. 1, *Landscapes, Plants, and Water Studies.* London and New York, 1982.

Pedretti, Carlo. *Leonardo Architect.* 1981. London, 1986.

Pedretti, Carlo. *The Codex Hammer of Leonardo da Vinci.* Translated into English and annotated by Carlo Pedretti. Florence, 1987.

Pedretti, Carlo, ed. *The Drawings and Miscellaneous Papers of Leonardo da Vinci in the Collection of Her Majesty The Queen at Windsor Castle.* Vol. 2, *Horses and Other Animals.* London and New York, 1987.

Pedretti, Carlo. "Leonardo as a Sculptor: A Bibliography." *Achademia Leonardi Vinci: Journal of Leonardo Studies and Bibliography of Vinciana* 2 (1989), pp. 131–47, and unpaginated figures.

Pedretti, Carlo. *The Leonardo da Vinci Codex Hammer.* Sale cat., Christie, Manson and Woods, New York, Friday, November 11, 1994.

Pedretti, Carlo. *Leonardo: The Machines.* Florence, 1999.

Pedretti, Carlo, and Kenneth Clark. *Leonardo da Vinci: Nature Studies from the Royal Library at Windsor Castle.* Exh. cat., Malibu, The J. Paul Getty Museum; New York, The Metropolitan Museum of Art. [New York], 1980.

Pedretti, Carlo. *Leonardo: Studies for the* Last Supper *from the Royal Library at Windsor Castle.* Introduction by Kenneth Clark. Exh. cat., Washington, D.C., National Gallery of Art; Milan, Castello Sforzesco. Washington, D.C., 1983.

Pedretti, Carlo, and Jane Roberts. *Leonardo da Vinci: The Codex Hammer, formerly The Codex Leicester.* Exh. cat, Washington, D.C., Corcoran Gallery of Art; Los Angeles County Museum of Art; London, Royal Academy of Arts; Florence, Palazzo Vecchio; Paris, Musée Jacquemart André; Edinburgh, Royal Scottish Academy; Stockholm, Nationalmuseum; Baltimore, The Walters Art Gallery; Moscow, Pushkin Museum of Fine Arts; Leningrad, Hermitage Museum. Los Angeles, 1981. Florentine and American editions: *The Codex Hammer of Leonardo da Vinci: The Waters, the Earth, the Universe.*

Pedretti, Carlo, and Patricia Trutty-Coohill. *The Drawing of Leonardo da Vinci and His Circle in America*. Florence, 1993.

Penny, Nicholas. "Exhibition Reviews: National Gallery of Scotland, Leonardo's Madonna of the Yarnwinder." *The Burlington Magazine* 134, no. 1073 (August 1992), pp. 542–44.

Philipson, Morris. *Leonardo da Vinci: Aspects of the Renaissance Genius*. New York, 1966.

Ponting, Kenneth G. *Leonardo da Vinci, Drawings of Textile Machines*. Bradford-on-Avon, 1979.

Popham, A[rthur] E[wart]. *The Drawings of Leonardo da Vinci*. London, 1945. 2d ed. London, 1947.

Popham, Arthur Ewart. *Leonardo da Vinci*. London, 1957.

Popham, A[rthur] E[wart]. *The Drawings of Leonardo da Vinci*. 1945. Revised and with an introductory essay by Martin Kemp. London, 1994.

Reti, Ladislao. "Leonardo da Vinci and the Graphic Arts: The Early Invention of Relief-Etching." *The Burlington Magazine* 113, no. 817 (April 1971), pp. 188–95.

Reti, Ladislao, ed. *The Unknown Leonardo*. New York, 1974.

Reti, Ladislao, and Bern Dibner. *Leonardo da Vinci, Technologist*. Norwalk, Conn., 1969.

Richter, Jean Paul. *The Literary Works of Leonardo da Vinci Compiled and Edited from the Original Manuscripts*. 1883. 3d ed. 2 vols. London, 1970.

Roberts, Jane. *Italian Master Drawings, Leonardo to Canaletto, from the British Royal Collection*. Exh. cat., Washington, D.C., National Gallery of Art; The Fine Arts Museums of San Francisco; The Art Institute of Chicago. Washington, D.C., 1987.

Rosci, Macro. *The Hidden Leonardo*. Chicago, 1977.

Røsstad, Anna. *Leonardo da Vinci, the Man and the Mystery*. Translated by Ann Zwick. Oslo, 1995.

Leonardo da Vinci Drawings. Leonardo da Vinci, Quincentenary Exhibition, 1452–1952. Exh. cat., London, Royal Academy of Arts, Diploma Gallery. London, 1952.

Leonardo da Vinci: Anatomical Drawings from the Royal Collection. Introduction by Carlo Pedretti. Exh. cat., London, Royal Academy of Arts. London, 1977.

Rzepińska, Maria. "Light and Shadow in the Late Writings of Leonardo da Vinci." Raccolta Vinciana, no. 19 (1962), pp. 259–66.

Rzepińska, Maria. "Leonardo's Colour Theory." "Achademia Leonardi Vinci: Journal of Leonardo Studies and Bibliography of Vinciana 6 (1993), pp. 11–33, and unpaginated figures.

Scaglia, Gustina. "Leonardo da Vinci's Drawing in the Pierpont Morgan Library: Its Travels from Milan to La Rochelle (1519–1572)." Arte lombarda, nos. 113–15 (1995), pp. 27–36.

Schofield, Richard. "Leonardo's Milanese Architecture: Career, Sources, and Graphic Techniques." Achademia Leonardi Vinci: Journal of Leonardo Studies and Bibliography of Vinciana 4 (1991), pp. 111–57, and unpaginated figures.

Schott, G. D. "Some Neurological Observations on Leonardo da Vinci's Handwriting." Journal of the Neurological Sciences 42, no. 3 (August 1979), pp. 321–29.

Shapley, John. "A Lost Cartoon for Leonardo's Madonna with St. Anne." The Art Bulletin 7, no. 3 (March 1925), pp. 96–102.

Shearman, John. "Leonardo's Colour and Chiaroscuro." Zeitschrift für Kunstgeschichte 25 no. 1 (1962), pp. 13–47.

Sirén, Osvald. Leonardo da Vinci. New Haven and London, 1916.

Snow-Smith, Joanne. "Leonardo's Virgin of the Rocks (Musée du Louvre): A Franciscan Interpretation." Studies in Iconography 11 (1987), pp. 35–94.

Steinberg, Leo. "Leonardo's Last Supper." The Art Quarterly 36, no. 4 (Winter 1973), pp. 297–410.

Steinberg, Leo. *Leonardo's Incessant Last Supper.* New York, 2001.

Steinitz, Kate Trauman. *Manuscripts of Leonardo da Vinci: Their History, with a Description of the Manuscript Editions in Facsimile.* Los Angeles, 1948.

Stites, Raymond S. "The Bronzes of Leonardo da Vinci." *The Art Bulletin* 12, no. 3 (September 1930), pp. 254–69.

Suida, Wilhelm. "Leonardo's Activity as a Painter—A Sketch." *In Leonardo: Saggi e ricerche* 1954, pp. 313–29, pls. 124–29.

Tanaka, Hidemichi. "Leonardo's Isabella d'Este: A New Analysis of the *Mona Lisa* in the Louvre." *Annali dell'Istituto giapponese di cultura in Roma* 3 (1976–77), pp. 23–34.

Thiis, Jens. *Leonardo da Vinci: The Florentine Years of Leonardo and Verrocchio.* 1909. Translated by Jessie Muir. London, 1913.

Todd, Edwin M. *The Neuroanatomy of Leonardo da Vinci.* Preface by Carlo Pedretti, foreword by Kenneth D. Keele. Santa Barbara, 1983.

Travers Newton, H. "Leonardo da Vinci as Mural Painter: Some Observations on His Materials and Working Methods." *Arte lombarda,* no. 66 (1983), pp. 71–88.

Travers Newton, H., and John R. Spencer. "On the Location of Leonardo's *Battle of Anghiari.*" *The Art Bulletin* 64, no. 1 (March 1982), pp. 45–52.

Trutty-Coohill, Patricia. "Narrative to Icon: The San Diego Luini and Leonardo's Language of the Dumb." *Achademia Leonardi Vinci: Journal of Leonardo Studies and Bibliography of Vinciana* 1 (1988), pp. 27–31, and unpaginated figures.

Trutty-Coohill, Patricia. "Bracketing Theory in Leonardo's *Five Grotesque Heads.*" *In Enjoyment: From Laughter to Delight in Philosophy, Literature, the Fine Arts, and Aesthetics,* edited by Anna-Teresa Tymieniecka, pp. 87–102. Analecta Husserliana, 56. Dordrecht and Boston, 1998.

Trutty-Coohill, Patricia. "Comic Rhythms in Leonardo da Vinci." In *Enjoyment: From Laughter to Delight in Philosophy, Literature, the Fine Arts, and Aesthetics,* edited by Anna-Teresa Tymieniecka, pp. 185–202. Analecta Husserliana, 56. Dordrecht and Boston, 1998.

Turner, Richard. "Words and Pictures: The Birth and Death of Leonardo's Medusa." *Arte lombarda,* no. 66 (1983), pp. 103–11.

Turner, A. Richard. *Inventing Leonardo.* New York, 1993.

Valentiner, W[ilhelm] R[einhold]. "Leonardo as Verrocchio's Coworker." *The Art Bulletin* 12, no. 1 (March 1930), pp. 43–89.

Valentiner, Wilhelm Reinhold, et al. *Leonardo da Vinci: Loan Exhibition 1452–1519.* Exh. cat., Los Angeles County Museum of Art. Los Angeles, 1949.

Veltman, Kim H. *Leonardo's Method.* Brescia, 1993.

Veltman, Kim H., with Kenneth D. Keele. *Studies on Leonardo da Vinci: Linear Perspective and the Visual Dimensions of Science and Art.* Munich, 1986.

Venerella, John, trans, and ed. *The Manuscripts of Leonardo da Vinci in the Institut de France.* Ente Raccolta Vinciana. Milan, 1999–. Manuscripts A through M in progress.

Venturi, Adolfo. *Leonardo da Vinci pittore.* Istituto di Studii Vinciani in Roma, 2. Bologna, 1920.

Wasserman, Jack. "A Re-discovered Cartoon by Leonardo da Vinci," *The Burlington Magazine* 112, no. 805 (April 1970), pp. 194–204.

Wasserman, Jack. "The Dating and Patronage of Leonardo's Burlington House Cartoon." *The Art Bulletin 53,* no. 3 (September 1971), pp. 312–25.

Wasserman, Jack. *Leonardo da Vinci.* Abridged edition of *Leonardo,* 1975. New York, 1984.

Weil-Garris Posner, Kathleen. *Leonardo and Central Italian Art, 1515–1550.* New York, 1974.

Wilde, Johannes. "Michelangelo and Leonardo." *The Burlington Magazine 95,* no. 600 (March 1953), pp. 65–77.

Winternitz, Emanuel. *Leonardo da Vinci as a Musician.* New Haven and London, 1982.

Zammattio, Carlo, ed. *Leonardo the Scientist*. New York, 1980.

Zubov, Vasilii P. *Leonardo da Vinci*. Cambridge, Mass., 1968.

Zwijnenberg, Robert. *The Writings and Drawings of Leonardo da Vinci: Order and Chaos in Early Modern Thought*. Translated by Caroline A. van Eck. Cambridge, 1999.

FRENCH

Le séjour de Léonard de Vinci, en France. Exh. cat., Château d'Amboise. Amboise, 1952.

Arasse, Daniel. *L'univers de Léonard de Vinci*. Paris, 1978.

Arasse, Daniel. *Léonard de Vinci: Le rythme du monde*. Paris, 1997.

Béguin, Sylvie. *Léonard de Vinci au Louvre*. Paris, 1983.

Corbeau, André. *Les manuscrits de Léonard de Vinci: Examen critique et historique del leurs élements extremes*. Caen, 1968.

Courajod, Louis. "Léonard de Vinci et la statue de Francesco Sforza." *L'Arte* 4 (1879).

Demonts, Louis. *Dessins de Léonard de Vinci*. Paris, [1921].

De Toni, Giovan Battista. *Le piante e gli animali in Leonardo da Vinci*. Bologna, 1922.

Florisoone, Michel, and Roseline Bacou. *Hommage à Léonard de Vinci: Exposition en l'honneur du cinquième centenaire de sa naissance.* Exh. cat., Paris, Musée du Louvre. Paris, 1952.

Galichon, Emile. "Un dessin de Léonard de Vinci pour le tableau de l'Adoration des mages." *Gazette des Beaux-Arts,* ser. 1, 23 (1867), pp. 530–36.

Geymüller, Heinrich de. "Les derniers travaux sur Léonard de Vinci." *Gazette des Beaux-Arts,* ser. 2, 33 (1886), pp. 357–76; 34 (1886), pp. 143–64; 274–96.

Gruyer, [François-]A[natole]. "Léonard de Vinci au Musée du Louvre." *Gazette des Beaux-Arts,* ser. 2, 35 (1887), pp. 449–72; 36 (1887), pp. 89–107.

Hevesy, André de. "Autour de Léonard de Vinci oeuvres retrouvées—oeuvres perdues." *Gazette des Beaux-Arts,* ser.6, 5 (1931), pp. 103–14.

Hevesy, André de. "Dans l'atelier de Léonard de Vinci: Boltraffio et ses modèles." *L'amour de l'art* 13, no. 8 (October 1932), pp. 260–66.

Heydenreich, Ludwig-Heinrich. "La Sainte Anne de Léonard de Vinci." *Gazette des Beaux-Arts,* ser. 6, 10 (1933), pp. 205–19. Reprinted in *Leonardo-Studien,* Munich, 1988, pp. 13–22.

Hohenstatt, Peter. *Léonard de Vinci.* Cologne, 1998.

Lebel, Robert. *Léonard de Vinci ou la fin de l'humilité.* Paris, 1952.

Exposition d'œuvres de Léonard de Vinci organisée à l'occasion du quatrième centenaire de sa mort au Château de Cloux, en France le 2 mai 1549. Exh. cat., Paris, Musée du Louvre. Paris, 1919.

Viatte, Françoise, with Catherine Monbeig Goguel, and Madeleine Pinault. *Léonard de Vinci: Les études de draperie.* Exh. cat., Paris, Musée du Louvre. Paris, 1989.

Marani, Pietro C. *Léonard de Vinci,* une carrière de peintre. Paris, 1999.

Marotte, Léon, and Henri Longon. *Léonardo da Vinci: Cinquante-six dessins reproduits en fac-similé.* Paris, 1928.

Mazenta, [Giovanni] Ambrogio. *Le memorie su Leonardo da Vinci.* Milan, 1919.

M[ercillon], H[enri]. "Les dessins de Vinci: L'intelligence et le regard." *Connaissance des arts,* no. 446 (April 1989), pp. 79–87.

Müntz, Eugène. *Léonard de Vinci: L'artiste, le penseur, le savant.* Paris, 1899.

Léonard de Vinci, homme de science, 1452–1519. Exh. cat., Paris, Palais de la Découverte. Paris, 1952.

Pedretti, Carlo. *Léonard de Vinci, Architecte.* 1983. Paris, 1988.

Pedretti, Carlo, and Jane Roberts. *Le Codex Hammer de Léonard de Vinci: Les eaux, la terre, l'univers.* Swedish and Russian editions were also published.

Rosci, Marco. *Léonard de Vinci.* 1976. Paris, 1978.

Sartoris, Alberto. *Léonard architecte.* Paris, 1952.

Sirén, Osvald. *Léonard de Vinci: L'artiste e l'homme: Édition entièrement refondue et mis à jour.* 3 vols. Paris and Brussels, 1928.

Steinitz, Kate Trauman. "Le Dessin de Léonard de Vinci pour la représentation de la Danae de Baldassare Taccone," In *Le lieu théâtral à la Renaissance,* edited by Jean Jacquot, pp. 35–40. Paris, 1964.

Dessins et manuscrits de Léonard de Vinci. Exh. cat., Tours, Musée des Beaux-Arts. Tours, 1956.

Valéry, Paul. "Introduction à la méthode de Léonard de Vinci." *Variété,* 1894. In Paul Valéry, *Œuvres,* edited by Jean Hytier, vol. 1, pp. 1153–99. Paris, 1957.

Viatte, Françoise. *Léonard de Vinci—Isabelle d'Este.* Paris, 1999.

GERMAN

Baur, Otto, Barbara Bott, Sigrid Braunfels-Esche, Kenneth D. Keele, Heinz Ladendorf, and Marielene Putscher et al. *Leonardo da Vinci: Anatomie, Physiognomik, Proportion und Bewegung*. Vol. 1. Cologne, 1984.

Bock, Franz. "Leonardofragen." *Repertorium für kunstwissenschaft* 39 (1916), pp. 153–65, 218–30.

Bode, Wilhelm von. *Studien über Leonardo da Vinci*. Berlin, 1921.

Bode, Wilhelm von. *Leonardo da Vinci: Ausgewählte Handzeichnungen*. Berlin, [1950].

Esche, Sigrid. *Leonardo da Vinci: Das anatomische Werk*. Basel, 1954.

Gronau, Georg. "Ein Jugendwerk des Leonardo da Vinci." *Zeitschrift für bildende Kunst* 23, no. 10 (1912), pp. 253–59.

Grossing, Helmuth. "Zu den Technikzeichnungen Leonardo da Vincis." In *Poesis et pictura: Studien zum Verhältnis von Text und Bild in Handschriften und alten Drucken*, edited by Stephan Fussel and Joachim Knape, pp. 107–29. Baden-Baden, 1989.

Herzfeld, Marie. "Über ein Skizzenblatt Leonardos als beitrag zur Charakterdeutung des Meisters." *Mitteilungen des Kunsthistorischen Institutes in Florenz* 4, no. 1 (July 1932), pp. 1–24.

Heydenreich, Ludwig H. *Leonardo da Vinci*. 1943. 2 vols. New York and Basel, 1954.

Heydenreich, Ludwig H. *Leonardo da Vinci: Das Abendmahl*. Stuttgart, 1958.

Heydenreich, Ludwig H. "Bemerkungen zu den Entwürfen Leonardos für das Grabmal des Gian Giacomo Trivulzio." In *Studien zur Geschichte der europäischen Plastik: Festschrift Theodor Müller, zum 19. April 1965*, pp. 179–94. Munich, 1965.

Hildebrandt, Edmund. *Leonardo da Vinci*. Berlin, 1927.

Ludwig, Heinrich. *Lionardo da Vinci. Das Buch von der Malerei, nach dem Codex Vaticanus (Urbinas) 1270 herausgegehnen, übersetzt und erläutert von Heinrich Ludwig.* 3 vols. Vienna, 1882.

Möller, Emil. "Wie sah Leonardo aus?" *Belvedere* 9–10 (1926), pp. 29–46.

Möller, Emil. "Salai und Leonardo da Vinci." *Jahrbuch der Kunsthistorischen Sammlungen in Wien,* n.s., 2 (1928), pp. 139–61.

Möller, Emil. "Die Madonna mit den Spielenden Kindern aus der Werkstatt Leonardos." *Zeitschrift fur Bildende Kunst* 62 (1928–29), pp. 217–27.

Möller, Emil. *Das Abendmahl des Lionardo da Vinci*. Veröffentlichungen des Instituts für Europäische Geschichte Mainz, 1. Baden-Baden, 1952.

Müller-Walde, Paul. *Leonardo da Vinci: Lebenskizze und Forschungen über sein Verhältnis zur florentiner Kunst und zu Rafael*. Munich, 1889.

Nesselrath, Arnold. "Leonardo da Vinci: Bühender hl. Hieronymus um 1482." In *Hoch Renaissance im Vatikan: Kunst und Kultur im Rom der Päpste I, 1503–1534*, pp. 552–53. Exh. cat., Bonn, Kunstund Austellungshalle der Bundesrepublik Deutschland. Bonn, 1999.

Nicodemi, Giorgio. *Leonardo da Vinci: Gemälde, Zeichnungen, Studien*. Leipzig, 1939.

Ost, Hans. *Leonardo-Studien*. Berlin and New York, 1975.

Ost, Hans. *Das Leonardo Porträt in der Kgl. Bibliothek Turin und andere Fäschungen des Giuseppe Bossi*. Berlin, 1980.

Popp, Anny E. *Leonardo da Vinci: Zeichnungen*. Munich, 1928.

Rosenberg, Adolf. *Leonardo da Vinci*. Künstler-Monographien, 33. Bielefeld and Leipzig, 1898.

Seidlitz, Woldemar von. *Leonardo da Vinci: Der Wendepunkt der Renaissance.* Rev. ed. Vienna, 1935.

Suida, Wilhelm. "Leonardo da Vinci und seine Schule in Mailand." *Monatshefte für Kunstwissenschaft* 12 (1919), pp. 257–78; 13 (1920), pp. 28–51, 251–97.

Suida, Wilhelm. *Leonardo und sein Kreis.* Munich, 1929.

Zöllner, Frank. "Die Bedeutung von Codex Huygens und Codex Urbinas für die Proportions- und Bewegungsstudien Leonardos da Vinci." *Zeitschrift für Kunstgeschichte* 52, no. 3 (1989), pp. 334–52.

Zöllner, Frank. *Leonardo da Vinci: Das Porträt der Lisa del Giocondo, Legende und Geschichte.* Frankfurt, 1994.

Zöllner, Frank. *Leonardo da Vinci, 1452-1519.* Cologne, 2000.

ITALIAN

Accordi, Bruno. *Conoscenze geologiche di Leonardo: Influssi sul suo ciclo pittorico. Atti della VII Giornata leonardiana, Brescia, 7 ottobre, 1984.* Brescia, 1987.

Ames-Lewis, Francis. "Leonardo da Vinci e il disegno a matita." *Raccolta Vinciana,* no. 29 (2001), pp. 1–40.

Baldacci, Antonio. "Le piante di Leonardo da Vinci nei codici della Biblioteca Reale del Castello di Windsor." *Memorie della R. Accademia delle Scienze dell'Istituto di Bologna, Classe di scienze naturali* 10 (1922–23), pp. 77–82.

Baldini, Umberto, ed. *Leonardo: Tutta la pittura.* La scheda d'arte. Florence, 1988.

Baldini, Umberto. *Un Leonardo inedito.* Florence, 1992.

Baratta, Mario. *Leonardo da Vinci e I problemi della terra.* Turin, 1903.

Baratta, Mario. "Leonardo da Vinci negli studi per la navigazione dell'Arno." *Bollettino della Società Geografica Italiana,* ser. 5, 6 (1905), pp. 739–61, 893–921.

Beltrami, Luca. *La "destra mano" di Leonardo da Vinci e le lacune nella edizione del Codice Atlantico.* Analecta Ambrosiana, 2. Milan, 1909.

Beltrami, Luca, and Carlo Fumagalli. *Disegni di Leonardo e della sua scuola alla Biblioteca Ambrosiana.* Milan, 1904.

Bora, Giulio, et al. *I leonardeschi: L'eredità di Leonardo in Lombardia.* Miland, 1998.

Bottari, Stefano. *Leonardo.* Bergamo, 1942.

Bovi, Arturo. *Leonardo, filosofo, artista, uomo.* Milan, 1952.

Bovi, Arturo. *L'opera di Leonardo per il monumento Sforza a Milano.* Florence, 1959.

Brambilla Barcilon, Pinin, and Pietro C. Marani. *Leonardo: L'Ultima Cena.* Milan, 1999.

Brizio, Anna Maria. "Arte e scienza in Leonardo." *Almanacco italiano* 75 (1975), pp. 324–30.

Brunetti, Giulia, et al. *Quinto centenario della nascita di Leonardo da Vinci: Mostra di disegni, manoscritti e documenti.* Exh. cat., Florence, Biblioteca Medicea Laurenziana. Florence, 1952.

Calvi, Gerolamo. *Il codice di Leonardo da Vinci (idraulica e cosmografica) della Biblioteca di Lord Leicester in Holkham Hall.* Reale Istituto Lombardo di Scienze e Lettere. Milan, 1909.

Calvi, Gerolamo. "Contributi alla biografia di Leonardo da Vinci: (Periodo Sforzesco)." *Archivio storico lombardo* 43, no. 3 (1916), pp. 417–508.

Calvi, G[erolamo]. "L'Adorazione dei Magi di Leonardo da Vinci." *Raccolta Vinciana,* no. 10 (1919), pp.1–44.

Calvi, Gerolamo. *I manoscritti di Leonardo da Vinci dal punto di vista cronologico, storico e biografico.* Bologna, 1925.

Calvi, Girolamo. *I manoscritti di Leonardo da Vinci dal punto di vista cronologico, storico e biografico.* New edition, edited by Augusto Marinoni. Busto Arsizio, 1982.

Caroli, Flavio. *Leonardo: Studi di fisiognomica.* Milan, 1991.

Carotti, Giulio. *Le opere di Leonardo, Bramante e Raffaello.* Milan, 1905.

Carotti, Giulio. *Leonardo da Vinci, pittore, scultore, architetto: Studio biografico critico.* Turin, 1921.

Carpiceci, Alberto Carlo. *L'architettura di Leonardo: Indagine e ipotesi su tutta l'opera di Leonardo architetto.* Florence, 1978.

Carpiceci, Alberto Carlo. *L'architettura di Leonardo: Indagine e ipotesi su tutta l'opera di Leonardo architetto.* 2d edition, revised and enlarged. Florence, 1984.

Castelfranco, Giorgio. *Leonardo: I grandi maestri del disegno.* Milan, 1952.

Castelfranco, Giorgio. *La pittura di Leonardo da Vinci.* Milan, 1956.

Chastel, André. *Leonardo da Vinci: Studi e ricerche 1952–90.* Turin, 1995.

Cogliati Arano, Luisa. *Disegni di Leonardo e della sua cerchia alle Gallerie dell'Accademia.* Exh. cat., Venice, Gallerie dell'Accademia. Venice, 1966.

Comitato nazionale per le onoranze a Leonardo da Vinci nel quinto centenario della nascita (1452–1952). *Leonardo: Saggi e ricerche,* edited by Achille Marazza. [Rome, 1954].

D'Arrigo, Agatino. *Leonardo da Vinci e il regime della spiaggia di Cesenatico.* Rome, 1940.

Dell'Aqua, Gian *Alberto, ed. Leonardo e Milano.* Milan, 1982.

De Toni, Giovanni. *Macchine di Leonardo: Mostra di modelli.* Exh. cat., Brescia, Sale dell'Ateneo di Brescia. Brescia, 1987.

Galluzzi, Paolo, ed. *Prima di Leonardo: Cultura delle macchine a Siena nel Rinascimento.* Exh. cat., Siena, Magazzini del Sale. Milan, 1991.

Heydenreich, Ludwig H., ed. *I disegni di Leonardo da Vinci e della sua scuola, conservati nella galleria dell'Accademia di Venezia.* Florence, 1949.

Kemp, Martin. *Leonardo da Vinci: Le mirabili operazioni della natura e del'uomo.* Milan, 1982.

Kemp, Martin. *Leonardo e lo spazio dello scultore.* Lettura Vinciana, 27 (20 aprile 1987). Vinci, 1988.

Laurenza, Domenico. *De figura umana: Fisiognomica, anatomia e arte in Leonardo.* Florence, 2001.

Lesca, Giuseppe. *Leonardo da Vinci: Saggio sulla vita e le opere.* Bergamo, 1919.

Ligabue, Giancarlo. *Leonardo da Vinci e i fossili.* Venice, 1977.

Maccagni, Carlo. *Riconsiderando il problema delle fonti di Leonardo: L'elenco di libri ai fogli 2 verso-3 recto del codice 8936 della Biblioteca Nacional di Madrid,* Lettura Vinciana, 10 (15 aprile 1970). Florence, 1971.

[Marani, Pietro, ed.]. *Leonardo: La pittura.* 1977. Rev. ed. Florence, 1985.

Marani, Pietro C., Marco Rossi, and Alessandro Rovetta, eds. *L'Ambrosiana e Leonardo.* Exh. cat., Milan, Biblioteca-Pinacoteca Ambrosiana. Milan, 1998.

Pedretti, Carlo, ed. *Leonardo da Vinci: Libro di pittura. Codice Urbinate lat. 1270 nella Biblioteca Apostolica Vaticana.* Critical transcription by Carlo Vecce. 2 vols. Florence, 1995.

Malaguzzi Valeri, Francesco. *Leonardo da Vinci e la scultura.* Bologna, 1922.

Marani, Pietro C. *Disegni di fortificazioni da Leonardo a Michelangelo.* Exh. cat., Florence, Casa Buonarroti. Florence, 1984.

Marani, Pietro C. *Il Cenacolo di Leonardo.* Milan, 1986.

Marani, Pietro C. *Leonardo.* Milan, 1994.

Marani, Pietro C. *Leonardo: Una carriera di pittore.* Milan, 1999.

Marchini, Giuseppe. "Leonardo e le scale." *Antichità viva* 24, nos. 1–3 (January–June 1985), pp. 180–85.

Marinoni, Augusto. *I rebus di Leonardo da Vinci raccolti e interpretati.* Florence, 1954.

Marinoni, Augusto. *La matematica di Leonardo da Vinci.* Milan, 1982.

Marinoni, Augusto. *Leonardo da Vinci: I manocritti dell'Institut de France, Il manocritto A.* Florence, 1990.

Marinoni, Augusto. *Leonardo da Vinci, Il Codice Atlantico della Biblioteca Ambrosiana di Milano.* 3 vols. Florence, 2000.

Marinoni, Augusto, and Marco Meneguzzo. *I disegni di Leonardo,* Milan, 1981.

Marinoni, Augusto, and Marco Meneguzzo. *Leonardo da Vinci disegni.* Verona, 1981.

Mazzocchi Doglio, Mariangela, and Giampiero Tintori. *Leonardo e gli spettacoli del suo tempo.* Exh. cat., Milan, Rotonda di Via Besana. Milan, 1983.

Natali, Antonio. "Dubbi, difficoltà e disguidi nell' Annunciazione di Leonardo." In *L'Annunciazione di Leonardo: La montagna sul mare,* edited by Antonio Natali, pp. 36–59. Cinisello Balsamo, 2000.

Ottino della Chiesa, Angela. *L'opera completa di Leonardo pittore.* Preface by Mario Pomilio. Milan. 1967.

Pedretti, Carlo, et al. *Leonardo: Il Codice Hammer e la Mappa di Imola presentati da Carlo Pedretti. Arte e scienza a Bologna in Emilia e Romagna nel primo Cinquecento.* Exh. cat., Bologna, Palazzo del Podestà. Florence, 1985.

Nepi Sciré Giovanna, and Pietro C. Marani, eds. *Leonardo & Venezia.*

Marani, Pietro C., et. al. *Il genio e le passioni—Leonardo e il Cenacolo: Precedenti, innovazioni, riflessi di un capolavoro.* Exh. cat., Milan, Palazzo Reale. Milan and Florence, 2001.

Pedretti, Carlo. *Leonardo da Vinci e il poeta bolognese Gerolamo Pandolfi da Casio de' Medici.* Bologne, 1951.

Pedretti, Carlo. "Gli ultimi disegni di Leonardo." *Bibliothèque d'Humanisme et Renaissance* 20 (1958), pp. 565–68.

Pedretti, Carlo. *Leonardo da Vinci inedito: Tre saggi.* Florence, 1968.

Pedretti, Carlo. *Leonardo.* Bologna, 1979.

Pedretti, Carlo. *Leonardo architetto.* 1978. Rev. ed. Milan, 1981.

Pedretti, Carlo. *Leonardo da Vinci: Studi di natura dalla Biblioteca Reale nel Castello di Windsor.* Florence, 1982.

Pedretti, Carlo, ed. *Disegni di Leonardo da Vinci e della sua cerchia nella Biblioteca Reale di Torino.* Florence, 1990.

Pedretti, Carlo. *Leonardo da Vinci: La Battaglia di Anghiari e le armi fantastiche.* Florence, 1992.

Pedretti, Carlo. *Leonardo a Venezia.* Rome, 1994.

Pedretti, Carlo. *Leonardo: Studi per it Cenacolo della Biblioteca Reale nel Castello di Windsor.*

Pedretti, Carlo, and Gigetta Dalli Regoli. *I disegni di Leonardo da Vinci e della sua cerchia nel Gabinetto Disegni e Stampe della Galleria degli Uffizi a Firenze.* Florence, 1985.

Pedretti, Carlo, and Pietro C. Marani. *Leonardo da Vinci, architetto militare prima di Gradisca.* Milan, 1988.

Pedretti, Carlo, and Jane Roberts. *Il Codice Hammer di Leonardo da Vinci: Le acque, la terra, l'universo;*

Piantanida, Sandro, and Costantino Baroni. *Leonardo da Vinci: Edizione curata dalla Mostra di Leonardo da Vinci in Milano.* Novara, [1939].

Reale Commissione Vinciana. *I manoscritti e i disegni di Leonardo da Vinci: Il Codice Forster I . . .* 5 vols. Rome, 1930–36.

Rosci, Marco. *Leonardo. Milan,* 1979.

Rosci, Marco. *Leonardo.* Milan, 1982.

Scaglia, Gustina. *Alle origini degli studi tecnologici di Leonardo.* Lettura Vinciana, 20 (20 aprile 1980). Vinci, 1981.

Scarpati, Claudio. *Leonardo scrittore.* Milan, 2001.

Seidlitz, W[oldemar] von. "I disegni di Leonardo da Vinci a Windsor." *L'Arte* 14 (1911), pp. 269–89.

Solmi, Edmondo, et al. *Leonardo da Vinci: Conference fiorentine.* Milan, 1910.

Spencer, John. "Il progetto per il cavallo di bronzo per Francesco Sforza." *Arte lombarda,* nos. 38–39 (1973), pp. 23–35.

Starnazzi, Carlo. "Leonardo da Vinci: La rappresentazione cartografica e pittorica del paesagio toscano." *L'universo* 5 (October 1996), pp. 695–704.

Starnazzi, Carlo. "Leonardo da Vinci: Un cartografo tra Euclide e Tolomeo." *L'universo* 4 (1998), pp. 544–56.

Tanaka, Hidemichi. *Leonardo da Vinci: La sua arte e la sua vita.* Tokyo, 1983.

Vecce, Carlo, ed. *Leonardo da Vinci: Scritti.* Milan, 1992.

Vecce, Carlo. *Leonardo.* Rome, 1998.

Venturi, Adolfo. "L'uso della mano sinistra nella scrittura e nei disegni di Leonardo da Vinci. *L'Arte* 42 (1939), pp. 165–73.

Vezzosi, Alessandro. *Il disegno dell'universo: Leonardo e la sua scuola nelle raccolte italiane*. Introduced and coordinated by Carlo Pedretti. Exh. cat., Tokyo, 1987.

Vezzosi, Alessandro. *Leonardo: Arte, Scienza e Utopia*. Exh. cat., Toronto, J. D. Carrier Art Gallery. Toronto, 1987.

Vezzosi, Alessandro. *Leonardo da Vinci: Arte e scienza dell'universo*. Milan, 1996.

Weil-Garris Brandt, Kathleen. *Leonardo e la scultura*. Lettura Vinciana, 38 (18 aprile 1998). Florence, 1999.

Zeri, Federico, and Stefano Zuffi. *Leonardo da Vinci: Della natura, peso e moto delle acque: Il Codice Leicester*. Exh. cat., Venice, Palazzo Querini-Dubois. Venice, 1995.

Zöllner, Frank. La Battaglia *di Anghiari di Leonardo da Vinci fra mitologia e politica*. Lettura Vinciana, 37 (18 aprile 1997). Florence, 1998.

Zöllar, Frank. *Leonardo da Vinci, 1452–1519*. Rome, 2002.

INDEX

abstinence, 404
advice. *See* practical advice
aerial perspective, *124*, 124–126
allegorical creatures, 11
alloys, 322, 327–328
almsgiving, 396–397
Amboise, river at, 241, *241*
anatomy
 of animals, *194*, 194–195
 of arms, 190, *190*
 of arteries, *180*, 181, 185, 192
 of bones, *177*, 177–178, 181, *182–183*,
 183, 185, *186–188*, 189–190, *190–194*, 192, 194
 causes in body and, 179, *179*
 of children, 195–196, *196*
 environment compared with, 199
 of eyes, 194–195
 of feet, 192
 geography and, 175, *225–227*, 225–228
 of hands, *186–187*
 of head, 177, *177*, 183, *183–184*, 185, *186*,
 188, 189
 of horses, 194
 inventions and, 197
 learning, 197, *198*
 of legs, *191–194*, 192, 194
 of limbs, 181, *182*, *186*, 190, *190–194*, 192, 194
 of muscles, 176, 178, 181, 185, *185–186*, 189–190,
 190, *193*, 193–194
 of nerves, 176–178, 181, 185, 189, 195
 observations flowing from, 175
 painter and, 94, 178
 soul and, 195–196, 199
 of tendons, 176, 178, *188*, 189, 192, 194
 of veins, *180*, 181, 185, 192, 199
 of walking, 194, *194*
 women's, 181
ancient architecture, 162
Andrew, *143*
anger, 404
angle, 120
animals. *See also specific animals*
 anatomy of, *194*, 194–195
 human bodies compared with, *194*, 194–195
 limbs of, 166, *166*
 nocturnal, 134–135, 194–195
 in philosophy and miscellaneous writing, 397–399,
 402, 404, 407–408
 sketches and studies of, *158–161*, 166, *166–169*
antique, painting, *44*, 46
ape, 397–398

aperture, 133
aphorisms, philosophy and, 261, *391*, 392, *393*, 394
arches
 in architecture, 264, *264–269*, 266–267, 269, *271*
 cracks and, 306, *307*
 inverted, 269, *269*
 loading, 264, 266–267, *266–268*
 stability of, 269, *269*
architecture
 ancient, 162
 arches in, 264, *264–269*, 266–267, 269, *271*
 beams in, 291, 308
 bridge of Pera, 299, *299*
 at Cesena, *298*, 299
 of churches, *285–289*, 286
 columns in, 270, *270–271*
 cracks in, 302, *304*, 305–306, *307–308*, 308
 of detached buildings, *310*, 311
 fountains in, 295, *295*
 inventions and, 348
 light in, *292*, 293
 mortar in, *309*, 311
 painting and, 261
 of palaces, 290–291, *291*, 296, *296*
 plans, *263–300*
 as practical matter, 261
 problems in, 302–308, *303–304*, *307–310*, 311
 of roofs, *285*, 286
 stability of, 269, *269*, 308, *309*, 311
 of stables, 296, *297*
 stairs in, 270, *270–271*, 296, *297*
 water and, *292–295*, 293–295
Armenia, 244, *245*
armored cars, 348
arms
 anatomy of, 190, *190*
 bent, 70, *70*
 of human figures, 66–67, *66–67*, 69–70, 69–71, *95*
 measurements of, 66–67, *66–67*, *69–70*, 69–71
 positions of, 94
arrows, 29, 255–256
art, 11, 408
arteries, *180*, 181, 185, 192
ass, 397, 404
astronomy
 earth in, 252
 moon in, 258–259, *259*
 Renaissance thinking and, 175
 stars in, 259
 sun in, 252, 258–259

diminishing perspective. *See* linear perspective
direct light, 101–102
discourse, boring, 394, *395*
dissection, 197
distance, perspective and, 121–126
dog, 397
dome, crushed, *304*, 305
doomed rigor, 402, *403*
downhill movement, 79, *79*
dragon, 166, *166–167*
drapery folds, 380, *381–383*
drawing. *See also* sketches and studies
 advice for, *375*, 376–380, *377–378*, *380–386*, 385–
 388
 in company, 388
 drapery folds, 380, *381–383*
 first, 12
 head, 379, *380*
 historical pictures, *384–385*, 385
 learning, 376
 from nature, 385–386, 388
 places, 379, *380*
 talent and, 46
 theory in, 389
dreams, seeing in, 118
dress
 clinging to limbs, 88
 cloaks, 88, *88–91*
 light, 98
duck, 398
dust
 in battles, *28*, 28–29, 35
 in sunbeams, 127
 in tempests, 38

eagle, 361
ear, 14, 58
earth
 in astronomy, 252
 layers of, *228*, 228–229
 spirit of growth of, *225*, 225–226
 veins in, 227
eating, 392
elm tree, 212
enamel, 314
environment
 anatomy compared with, 199
 depiction of, 175
Envy, 163, *163*, *165*, 165–166, 408
errors, 388, 394, 409
evil thinking, 163, *163*
exercise, of mind, 400–401
expanding shadow, 109
experience
 advice on, 374, 388–389
 wisdom as daughter of, 374
eye
 anatomy of, 194–195
 aperture of, 133

light seen by, *99*, 99–100, 134–136
measurements, 58, *58*, 61–62, *61–62*
owl's, 134–135, 194–195
in painting, 14, 16, 25, 44, 46
perception by, 120, 130–137, *132*
perspective and, 120
power of, 137
pupil of, 100, 133–136, 194–195
seeing in dreams, 118
shadow seen by, *99*, 99–100, 135–136
sun seen by, 136
of women, 137

face
 beautiful, selection of, *375*, 375–376
 drawing, 379, *380*
 grotesque, 170, *170–173*
 light and, 386
 measurements, 58–59, *58–65*, 61–65
 as square, 59, *59–61*, 61
 ugly, 376
Faenza, *242*, 243
falcon, 361, 404
falsehood, 164, *164*
fantastic creatures, 11
fat, muscles and, 178
faults, 388
fear, 408
fig tree, 398, *399*
figures. *See also* human figures
 in battles, *28*, 28–29, *30*, 34–36, *34–36*
 in historical pictures, 25, *25–27*, 28
 light thrown upon, *20–21*, 21
 passion animating, 50
 shadow on, 25
 in tempests, 38
fire, 23, 164, *164*, 252
 in geography, *235*, 235–236
 in philosophy and miscellaneous writing, 398, *401*,
 401–402
fleas, 397
flint, 400
floods, 236, 293
flying
 birds, 355–356, *357*, 361, 364, *364*
 center of gravity in, 366, 369
 inventions, *355*, 355–356, *357–358*, 359, *360*, 361,
 362–365, 364–366, *367–368*, 369, *370*, 371–372,
 372–373
 wind and, 356, *357*
 wings for, 355–356, 359, *360*, 361, *363–364*, 364,
 366, 369, 371–372
food, 392
foot, 74–75, *74–75*, 192
force
 gravity, 250, 252
 in physical sciences, 250–253, *251*
foreshortening, 114, *115*
fortitude, 408

width, 56, *56*
mechanical science, 340
Mediterranean Sea, 240, *240*
memory, 376, 409
men
 limbs of, 94
 old, 82, *82-83, 86*, 94
metalwork. *See* sculpture and metalwork
mill, 301-302
mind
 common concepts of, 392, *393*, 394
 exercise of, 400-401
 of painter, *13*, 13-14, 138, 388
 riches of, 389
mint, for coins, 329, *329*
minute objects, 377
mirrors
 color and, 128, 130, 209
 light and, 130
 in metalwork, 328
 in painting, 13, *17*, 18, 25, 138, 388-389
miscellaneous writing. *See* philosophy and
 miscellaneous writing
mist, 125-126
molds
 for horses, 322, *322-323*, 324
 plaster, 324, 328
 in sculpture and metalwork, 322, *322-323*, 324, 328
 stucco for, 328
mole, 408
moon, 258-259, *259*
mortar, *309*, 311
moth, 398
mother, 195-196
Mount Caucasus, 248
Mount Taurus, 244-246, *245*, 248-249
mountains
 geography and, 226-228, 231, 236, 240, 244-249,
 245-247
 in landscapes, 204, *204-205*, 218
 perspective and, *119*, 119-120
 in tempests, 42, *43*, 44
 visual perception and, *119*, 119-120
mouth, 58-59, *58-64*, 61-64
movement
 blow to right or left, 76, *76-77*
 ceasing, 409
 climbing steps, *79*, 79-81, *81*
 downhill, 79, *79*
 of hands, 71, *71*
 of human figures, *54*, 55, 76-81, *76-81*, 92
 limbs in, *54*, 55, 76, *76*
 in physical sciences, 252-257, *256*
 running, 78
 in sculpture and metalwork, 312
 of vapor, 231
muscles
 anatomy of, 176, 178, 181, 185, *185-186*, 189-190,
 190, 193, 193-194

fat and, 178
 measurements of, 185
 nerves and, 176
 shoulder, 51, *51*, 190, *190*
 variations in, 94, *95*

natural objects, painting, *44*, 46
nature
 drawing from, 385-386, 388
 necessity and, 392
necessity, 392
neck, of horse, *326*, 327
nerves
 anatomy of, 176-178, 181, 185, 189, 195
 muscles and, 176
 optic, 195
nocturnal animals, 134-135, 194-195
nose, 58-59, *58-63*, 61-63
nourishment, 178-179, 195, 200, 392
nut, 400

observations, order and, 175
obstacles, 392
old men, 82, *82-83, 86*, 94
opinions, on paintings, 388
optic nerve, 195
order, observations and, 175
ostrich, 137
owls, 134-135, 194-195
oyster, 397, 402

Pain, Pleasure and, *162*, 163
painter
 advice for, 385-388, *386*
 anatomy and, 94, 178
 botany and, 211
 mathematics needed by, 387
 mind of, *13*, 13-14, 138, 388
 personal faults corrected by, 55
 universal, 48, *49-50*
 window of, 385-386, *386*
painting
 antique, *44*, 46
 architecture and, 261
 battles, 28-29, *28-37*, 34-36
 diligence in, 45
 essentials of, 11
 eye in, 14, 16, 25, 44, 46
 forms depicted by, 14, *15*
 games, 46, *47*
 historical pictures, 25, *25-27*, 28
 human figures, 18, *19*, 76, *76*
 landscapes, 46, 48
 learning, *45*, 45-46
 light in, *20-24*, 21, 23, 25
 mirrors in, 13, *17*, 18, 25, 138, 388-389
 natural objects, *44*, 46
 opinions on, 388
 perspective in, 16, *16*, 46, 120

sculpture compared with, 314, *314*
tempests, 38, *38–43*, 40, 42, 44–45
works surpassed by, 14
palaces, 290–291, *291*, 296, *296*
paper, tinted, 28
particular light, 100, *101*
partridges, 407
parts, whole and, *342*, 343
passion, 50
patience, 400, 402
pelican, 402
Pera, bridge of, 299, *299*
perception, knowledge and, 390. *See also* visual
perception
personal faults, painter correcting, 55
perspective
 aerial, *124*, 124–126
 branches of, 121
 color and, 122–123, 126–129, *129*
 distance and, 121–126
 eye and, 120
 images in atmosphere and, *129*, 129–130
 light in, 126–128, 130–131
 linear, 121–122
 mathematical terms expressing, 120–121
 mist and, 125–126
 mountains, *119*, 119–120
 in painting, 16, *16*, 46, 120
 pyramidal lines in, 120, 129, *129*, 132–133
 shadow in, 107–108, *108*, 127–128, 131
 sun and, 126–127, 130–131
 theory, 389
 trees and, 123, *123*, 125
 visual perception and, 11, 119–137
Peter, *142*
Philip, *143*
philosophy and miscellaneous writing
 on almsgiving, 396–397
 animals in, 397–399, 402, 404, 407–408
 aphorisms and, 261, *391*, 392, *393*, 394
 on common concepts of mind, 392, *393*, 394
 on discourse, 394, *395*
 on exercise of mind, 400–401
 fig tree in, 398, *399*
 fire in, 398, *401*, 401–402
 on good deeds, 396
 on patience, 400, 402
 privet in, 398–399, *399*
 Pythagoras and, 397
 virtues in, 404–409, *405–407*
physical sciences
 blue and, 252
 force in, 250–253, *251*
 gravity in, 250, 252
 movement in, 252–257, *256*
 Renaissance thinking and, 175
 seas in, 257
 weight in, 253–257, *254*, *256*
pinion, *338*, 339, 343–344, *343–344*

places, drawing, 379, *380*
planning
 architecture, *263–300*
 roads, *300*, 300–302, *302*
 water garden, 301–302
plants. *See also specific plants*
 nourishment of, 200
 sun and, 202, 211
plaster
 molds of, 324, 328
 over timber, 308
Pleasure, Pain and, *162*, 163
plinth, 270, *270*
poetry, 14
point, 120
power, 253
practical advice, 261
 on drapery folds, 380, *381–383*
 on drawing, *375*, 376–380, *377–378*, *380–386*, 385–388
 on experience, 374, 388–389
 on light, 376, 386–387
 on minute objects, 377
 for painters, 385–388, *386*
 on selection of beautiful faces, *375*, 375–376
 on shadow, 376, 387
 on studios, 385–387, *386*
 on studying in dark, 376–377
practice, knowledge and, 120, 389
prescience, 330
pride, 404
primary light, 101, *101*
primary shadow, 107, 113, 115
privet, 398–399, *399*
privies, 291
proportion, in human figures, 11, *93*, 93–94
pupil, of eye, 100, 133–136, 194–195
pyramidal lines, in perspective, 120, 129, *129*, 132–133
pyramidal shadow, 108–109
Pythagoras, 397

rat, 397
razor, 400–401
reason, 11
red, 128
Red Sea, 240
reed, *162*, 163
reflected light, 102
Renaissance man, 175
repercussed shadow, 107
riches, of mind, 389
rigor, 402, *403*
rivers
 at Amboise, 241, *241*
 flooding by, 293
 in geography, 227–231, 235–238, *236–239*, 241, *241*
 seas made by, 238, *239*
 time and, 409
roads, *300*, 300–302, *302*